Simone Knewitz, Stefanie Mueller (eds.)
The Aesthetics of Collective Agency

I0092967

Editorial

This book series brings together critical perspectives on the discourses, narratives, and cultural practices that shape imaginaries of "the future." Positioning futures as *critical* asks us to recognize the role of worldmaking in the face of multiple planetary crises as a matter of urgency and risk. At the same time, critical futures signify a turn towards complexity beyond the rhetoric of utopia and dystopia. At the intersections of the environmental humanities, speculative fiction, and science & technology studies, *Critical Futures* offers opportunities to explore the potential of literature and the arts to shift habitual ways of ordering the world and strives to promote epistemologies, pedagogies, and ethics suited to the messy realities of more equitable and ecologically viable futures.

This series is edited by Moritz Ingwersen, Solvejg Nitzke, Regina Schober and Jens Temmen.

Advisory Board: Neda Atanasoski, Brent Ryan Bellamy, Florian Cord, Kylie Crane, Caroline Edwards, Julia Grillmayr, Anna McFarlane, Heike Paul and Alison Sperling.

Simone Knewitz is senior lecturer for North American Studies at Rheinische Friedrich-Wilhelms-Universität Bonn, Germany. Her research focuses on poetry and poetics, cultural aesthetics and rhetoric, and the intersections of law, economics, and culture. Her current projects explore collective agency in twenty-first century North American poetry and protest movements, and the politics of whiteness in contemporary U.S. political discourses.

Stefanie Mueller is Professor of North American Literature at Freie Universität Berlin, Germany. Her research areas include the environmental, legal, and economic humanities, with current research projects exploring citizenship in contemporary U.S. lyric poetry and law as well as the representation of the scales of climate change in literature.

Simone Knewitz, Stefanie Mueller (eds.)

The Aesthetics of Collective Agency

Corporations, Communities and Crowds
in the Twenty-First Century

[transcript]

Funded by Volkswagen Foundation

Bibliographic information published by the Deutsche Nationalbibliothek
The Deutsche Nationalbibliothek lists this publication in the Deutsche Nationalbibliografie; detailed bibliographic data are available in the Internet at https://dnb.dnb.de/

First published in 2024 by transcript Verlag, Bielefeld
© Simone Knewitz, Stefanie Mueller (eds.)

Cover layout: Maria Arndt, Bielefeld
Cover illustration: boti1985, istockphoto.com
Printed by: Elanders Waiblingen GmbH, Waiblingen
https://doi.org/10.14361/9783839468159
Print-ISBN: 978-3-8376-6815-5
PDF-ISBN: 978-3-8394-6815-9
ISSN of series: 2941-0258
eISSN of series: 2941-0266

Contents

Acknowledgments ..7

The Aesthetics of Collective Agency: An Introduction
Simone Knewitz and Stefanie Mueller 9

I. Key Concepts

Collective Agency
Simone Knewitz ... 23

Crowd
Martin Butler ... 37

Affordance
Alexander Starre ... 51

Genre
James Dorson .. 63

Digital Affect
Regina Schober .. 77

II. Digital Environments

Digital Technology and the Promise of Decentralization: A Reconstruction
of Popular Visions and Their Narrative Patterns
Jan-Felix Schrape .. 91

What About Knowledge? Agency and Proletarianization in Digital Environments
Matti Kangaskoski .. 113

Algorithmically Together: Platform Collectivity and the Memetic Politics of TikTok
Heather Suzanne Woods .. 133

III. Narrating Collectivity Beyond the Human

Constraints and Community in Multiplayer Video Games
Marco Caracciolo .. 155

Bureaucratic Form and the Future We
in Kim Stanley Robinson's *The Ministry for the Future*
Stefanie Mueller .. 173

IV. New Forms of Collective Activism

A Re-Invention of Language: War, National Community
and a Poetics of the First-Person Plural
Natalya Bekhta .. 193

From "Feminist Lies" to "White Replacement":
Digital Anti-Feminist Forums as Spaces of Collective Radicalization
Katharina Motyl .. 213

The Aesthetics of Oceanic Kinship in Climate Change Poetry and Activism
Katharina Fackler .. 241

Appendix

Contributors .. 263

Acknowledgments

Research is always a collective endeavor. This is especially true for this volume on *The Aesthetics of Collective Agency*, which is the result of several years of collaboration and conversation. We are therefore grateful to everyone who inspired and contributed to this book. However, our special gratitude goes to the Volkswagen Foundation for not only generously funding our symposium on "Corporations, Communities, Crowds: The Aesthetics of Collective Agency in Twenty-First Century Culture," which took place at Schloss Herrenhausen in Hannover in July 2022, but also for providing a fantastic environment for our conference. We especially want to thank Anke Harwardt-Feye and her team for taking care of all the logistics related to the event. We are also grateful to the Volkswagen Foundation for funding this publication whose making was inspired by the symposium. During the process of organizing the conference, Alexandra Herbst provided competent and reliable assistance and hence contributed to making the conference a success. Finally, we appreciate the support of the editors of the transcript series "Critical Futures," Moritz Ingwersen, Solvejg Nitzke, Regina Schober and Jens Temmen, and thank them for including our volume in their series.

The Aesthetics of Collective Agency: An Introduction

Simone Knewitz and Stefanie Mueller

Following the brutal killing of the African American George Floyd on May 25 in Minneapolis at the hands of white police officer Derek Chauvin, the summer of 2020 saw the broadest public protests against racialized violence in U.S. history, spanning across all fifty states (Putnam et al.). The turnout was particularly remarkable in terms of its interracial bent, as significant numbers of white people took to the streets alongside people of color—in Los Angeles, New York City and Washington D.C., 54 percent of protesters were white (Fisher). According to a study by the Pew Research Center, 60 percent of white adults in the U.S. backed the movement in June 2020; among white liberals, support even reached 92 percent (Thomas and Menasce Horowitz). Hitherto, the George Floyd protests constitute the apex of the Black Lives Matter movement that started out with a tweet-turned-hashtag shared by three black queer women, Alicia Garza, Opal Tometi and Patrisse Cullors, on Black Twitter in 2013 after Trayvon Martin's shooter, George Zimmerman, was acquitted of all charges (Garza 23). Seven years later, the persistent collective efforts of Black activists operating online and in the streets had succeeded not only in bringing the problem of structural racism into the mainstream national conscience, but also in inspiring related social justice movements all over the world.

In the specific form of its political protest, Black Lives Matter is emblematic for one shape collective organization takes in the twenty-first century: Activism operates outside formal political institutions, rejects hierarchical leadership roles in favor of horizontal and networked structures, and tightly interweaves online mobilization and street protest. The organizational forms of contemporary social movements come with their own specific affordances: They tend to bring people together on a platform of specific causes, often drawing on an affective register of indignation. In the case of Black Lives Matter, the precariousness of Black lives—most starkly visible in video footage that documents police violence—has become the center of political struggle (Koivunen et al. 2). Twenty-first-century (progressive) movements emphasize diversity and inclusivity and allow for varying forms of participation, including what has been labeled "hashtag activism" (see, e.g., Jackson et al.). If the range of possible participatory forms and low hierarchies enables movement visibility and bursts of engagement, this form of activism has simultaneously struggled

with becoming sustainable and achieving structural social change. Thus, if Black Lives Matter activists' campaign to "defund the police" in 2020 after Floyd's death resulted in the financial restructuring of police forces in some major American cities, budgets in many places had been restored again only a year later (Goodman).

The trajectory of the Black Lives Matter movement exemplifies how twenty-first-century culture is characterized by profound transformations of the forms of collective organization. The institutions of Western liberal democracies and their economic, political, and social systems (such as political parties, government agencies, unions and churches, corporations) still wield significant political power and continue to shape the ways in which states and societies are organized. Yet new forms of collective agency that are most visible in social protest movements like Black Lives Matter, MeToo, or Fridays For Future, but also the global rise of populism during the past decade, have increasingly put pressure on established systems of collective organization and challenged their legitimacy. Working across disciplinary divides, this volume sets out to interrogate the forms that collective agency takes in the twenty-first century, the conditions that have given rise to these new forms, and how both old and new forms of collective agency are interrogated in literature and media culture.

Our title highlights three organizing forms of collective life in the twenty-first century that speak to the continuity as well as the transformation in practices and aesthetics of collective agency. Corporations are both collective and individual entities, even subjects of rights and duties in the law. While maximizing shareholder value is not a legal imperative, the profit-motif certainly dominates corporate governance today and is a driver of neoliberal globalization. Over the past two decades, this development has accelerated in conjunction with the rise of digital media, as powerful media corporations have emerged and created new forms of collective cooperation that—despite the opportunities that they offer—also remain under the control of said corporations. In contrast to corporations, communities are defined by affective rather than legal ties. Communities are held together by common understandings, norms, rules, or etiquettes; they strive to establish a common history and traditions, which make them enduring rather than temporary. If a shared print culture was at the center of Benedict Anderson's seminal conceptualization of "imagined communities" (1983), in the twenty-first century, a shared digital culture has led to the proliferation of different kinds of communities while transforming established and institutionalized communal forms.

Finally, there is the concept of the crowd, which currently experiences a renaissance not only in the streets, but also in scholarly inquiry in the social sciences and humanities (see, e.g. Jonsson 2014; Borch 2012). First theorized by Gustave Le Bon as a distinct form of collectivity in 1896, crowds have traditionally been conceived rather negatively as primitive, violent and suggestible. They were associated at once with mass democracy and mass tyranny, at times configured as "the people" or "the mob"

(Dean 8–11). In the twenty-first century, they have received an inverted valorization with the idea of the "wisdom of crowds" (Surowiecki 2004) at work in the collective production of knowledge in the digital sphere. This appropriation of a form associated with political resistance for capital gain significantly impacts on the nature and conditions of political agency in the twenty-first century. Corporations, communities, and crowds therefore not only speak to the potential that forms carry to organize collective life and to the role that cultural conditions play in their unfolding. They also represent different degrees of institutionalization and hence of temporality: from the long durée that is encoded in the (potentially) immortal body of the corporation to the transitory existence of crowds. Such continuities and differences, we argue, point to the latent potentialities of different forms of collective life, as literary scholar Caroline Levine puts it (6), and therefore also to different forms and perhaps degrees of collective agency.

Collective agency, however, often seems elusive—whether as the goal of social movements or as a concept of scholarly inquiry. In their introduction to a recent special issue on group actors, Thomas Gehring and Johannes Marx note that the dominance of methodological individualism in the social sciences has heretofore prevented "a reliable conceptualization of non-hierarchical collective actors" (8). Rather than using the common, simple shortcut by which collective actors are treated as if they were individuals, they demand that scholars attend to the specificities of *collective* agency. As Simone Knewitz likewise notes in her essay in this volume, the concept of collective agency "remains haunted by the framework of individualism, which impacts our ability to conceptualize the collective capacity to act" (24). In the humanities, and in particular in North American literary studies, collectivity and collective agency have somewhat fallen out of fashion as the (realist) novel of the second half of the twentieth and the twenty-first century turned rigorously to the individual: from postwar concerns over *The Man in the Grey Flannel Suit* to the new sincerity of David Foster Wallace's generation. But as the essays in this volume demonstrate, the social, cultural, and environmental developments since the turn of the millennium have not only contributed to the proliferation of collective forms of organization and agency but have indeed brought new urgency to their study. In this volume, we examine their entanglement in such technoscientific, political, and environmental transformations as well as the narratives of critical futures that they afford, and to do so, we approach them from the vantage point of aesthetic form.

Our conceptualization of collective agency via its form(s) offers us the opportunity to create a dialogue across disciplines: The concept of form on which our conversation builds derives from a broad and functionalist understanding of aesthetics that has emerged in recent scholarship in English and American Studies. In the work of scholars such as Anna Kornbluh and Caroline Levine in particular, form refers to patterns, shapes, and configurations that create order—whether they are aesthetic, political, or social. Abandoning the post-structuralist credo of disruption

that has dominated Anglo-Saxon criticism since the second half of the twentieth century (and in many cases continues to do so), this revalorization of aesthetics is one that understands form as essential to order and order as a value (contrary to poststructuralist suspicions). In the words of Kornbluh, "[f]orm is composed relationality." She argues "that forming is a value unto itself: a value that animates literature, and a value that formalist literary critics can embrace as an alternative to destituent theory. Formalism should study how to compose and direct—rather than ceaselessly oppose—form, formalization, and forms of sociability" (4). This concept of form is explicitly transdisciplinary. In her study *Forms: Whole, Rhythm, Hierarchy, Network* (2015), Levine encourages scholars to analyze how forms carry over their specific affordances into different materials. "[F]orm," Levine writes, "always indicates *an arrangement of elements—an ordering, patterning, or shaping*" (3). At bottom, she insists, it is the primary work of *all* form to make order, and, as Kornbluh emphasizes, this order is essentially relationality.

This renaissance of aesthetics and in particular of the affordance formalism à la Levine is not without critics, of course. In *Life-Destroying Diagrams* (2022), Eugenie Brinkema presents an approach to form that runs explicitly counter to Levine's, a "disaffordance formalism" which reads form for form's sake rather than for politics (259). Levine's cheerful invitation to literary and cultural scholars to find forms at work basically everywhere is precisely the problem for Brinkema:

> Projects of finding and recovery [...] operate at the expense of the ongoing generation of new and unforeseen lines of thought. The point of radical formalism is not merely to displace contextualist readings, but to activate and launch the speculative potential of texts, one only available through readings that proceed without guarantee. Which is the heart of what reading form entails. One does not know in advance what is as yet undiscovered. (259–260)

While Brinkema's critique does not question the project of formalist aesthetics itself, but, one could say, merely its hermeneutic horizon, Dorothy Wang points to what she sees as troubling omissions in New Formalist conceptions. Wang criticizes Levine for her disregard of writers that have long theorized the relationship between the formal and the social, in particular "a long and substantial tradition of black intellectuals and cultural critics and practitioners who have thought hard and at great length about the inseparability of the formal and the social in the 'real world': Stuart Hall, C. L. R. James, Aimé Césaire, Amiri Baraka, Édouard Glissant, and, more recently, Fred Moten and the Afropessimists, among others." Wang thus faults the New Formalism for insufficiently engaging with form in the context of "larger sociopolitical structures" including "colonialism and white supremacist racial hierarchies" (223), and thereby makes evident that the New Formalism is neither as new nor quite as comprehensively attuned to the entanglements of social, political, and

aesthetic forms as it projects. Therefore, if many of the scholars in this volume do rely on Levine's work, we urge that it will be only the *beginning* of a longer and more diverse conversation about aesthetic and social forms, patterns, and configurations that shape the cultural imaginaries of collective futures and future collectivities.

While each scholar brings their own disciplinary backgrounds and approaches to the discussion of form, it is the concept of *affordance* that has indeed emerged as significant in many of the contributions and as lending itself particularly well to transdisciplinary inquiries. As Alexander Starre outlines in his contribution to this volume, the term, originally coined by psychologist James Gibson in 1979, was first picked up in design theory, most prominently, in Donald Norman's book *The Design of Everyday Things* (1988), then adopted by Levine to refer to "the potential uses or actions latent in materials and designs" (Levine 6; see also Starre 52). In doing so, Starre suggests, she and other scholars working in similar directions "have found a fitting rhetorical tool that can be used to tie together aesthetics and agency" (54).

In this spirit, the structure of *The Aesthetics of Collective Agency* seeks to afford and sustain such scholarly conversations across disciplines. It begins with a section of concise articles in which contributors discuss a number of key concepts (*collective agency, crowd, affordance, genre, digital affect*) that are particularly relevant to the discussions of collectivity and collective agency in this collection. These articles do not attempt to offer encyclopedic breadth or definitory surety but seek to encourage readers to make connections between the contributions, no matter how different their materials or approaches may appear at first. In the first of these, Simone Knewitz examines the overarching concept of collective agency by tracing the twenty-first-century conversation on political organization among political and cultural theorists of the left. She proposes that within these debates, collective agency functions as a desideratum—in the face of urgent global political, social, and ecological problems that can only be solved collectively, the pressing question appears to be how opportunities for political participation, all but eliminated by neoliberal individualism, can be reinvigorated. The article creates a dialogue between hegemonic and post-hegemonic conceptions of agency in contemporary political and cultural theory, but ultimately proposes a move beyond binarisms in the collective quest for a more desirable and sustainable future.

As Knewitz highlights, recent theoretical debates on collective agency have been very much animated by the new social movements of the twenty-first century that registered in the public sphere in the form of—both physical and virtual—crowds. Martin Butler's contribution approaches the concept of the crowd as a highly ambiguous signifier that has been used to render collectivity and collective agency in a variety of historical and medial constellations. Butler examines crowd discourse and its normativities in different domains ranging from politics to scholarship to popular culture. His article focuses on the discursive reemergence of the crowd in new media environments in the twenty-first century both to illustrate how this reemer-

gence is connected to the rise of new social movements in the recent past and to shed light on the ways in which the crowd as collective subject is constituted and takes shape in and through digital media, which, Butler argues, both require and provide different forms of making the crowd visible.

As already noted, the concept of affordance has recently become a widely discussed notion in the humanities, offering a productive way to model the complex relationships of art works and other cultural products with their audiences. Affordance thinking complicates critical accounts that accord direct political agency to texts just as much as it curtails conceptions of agency exclusively attuned to anthropocentric understandings of social and cultural environments. Alexander Starre's essay thus first sketches a brief history of the affordance concept in the works of Gibson, Norman, and Levine, before exploring, in the second part, the affordances of several suggestive medial artifacts and aesthetic forms that emerged in the context of Black Lives Matter activism in the United States. As Starre shows, forms as varied as the *New York Times* "1619 Project," crowdsourced anti-racist reading lists, and so-called "hashtag syllabi" reshape collective agency as they engage the constraints and potentialities of contemporary reading culture.

James Dorson approaches the concept of genre by arguing that the new respectability of genre fiction in twenty-first-century literature is not only symptomatic of a dissatisfaction with literary realism for representing changed realities, but also suggests new possibilities for imagining collective responses to the crises we face. By honing in on two critical aspects of genre fiction—institutionality and temporality—his essay shows how genre fiction shapes patterns of thought that are more amenable to thinking the collective than artistic forms centered around the singularity of creative expression. As a model of literary production based on the mutually constitutive relationship between parts and whole, genre fiction models a process of assemblage congruent with organizational logics. Besides the institutional affordances of genre fiction, popular genres also afford a more expansive definition of time than literary fiction centered around the individual psyche does.

In the section's final contribution, Regina Schober introduces the concept of digital affect to highlight the complex affective relations that circulate between human and digital technology. She discusses digital affect, as a form of collective agency, in relation to three dimensions: Firstly, digital affect can be thought of in terms of network effects: Digital culture is shaped by networks, which function as patterns of complex interaction and exchange. Viral affective responses within these networks engender ambivalent and collective patterns of spread. Secondly, it relates to invisible infrastructures and the "digital banal": The normalization of affective interactions with digital media often obscures the affective stakes of digital experience. Thirdly, digital affect is salient in relation to artificial intelligence, which prompts an array of affective responses that mirror societal hierarchies and reveal human-centric biases. Schober argues that literary fiction can denaturalize as well as "de-

blackbox" digital technology, emphasizing posthuman agency and responsibility. A focus on digital affect reveals a complex interplay between humans and technology, underlining an ethics of care, collective responsibility, and an understanding of affect as a multifaceted and relational force in the digital landscape.

The three sections that follow provide specific case studies which interrogate social, political, and aesthetic forms that afford collective agency in twenty-first-century culture and which ask how these forms overlap, collide, or mutually sustain one another across a variety of materials and media. The second section, "Digital Environments," brings together contributions that reflect on the affordances of digital infrastructures and the discourses that have proliferated on digital technological innovation. Jan-Felix Schrape's essay thus traces the discourse on technology-driven decentralization within the community of technological innovators as well as public debates and social sciences discourses, from the Californian do-it-yourself subculture of the 1960s, the computer counterculture of the 1970s and 1980s, and debates on cyberspace and Web 2.0 in the 1990s and 2000s to present-day ideas of decentralized economic systems. These debates, Schrape argues, share the prospect of overcoming existing social power configurations, the belief that new technological solutions will enable the transfer of hitherto centrally coordinated socio-economic activities to distributed peer-to-peer networks, and the conviction that technologies foster self-organized collectives and new, more potent forms of collective agency. Yet, these optimistic visions tend to obscure empirical developments that point in a contrary direction, towards a recentralization in the Internet economy.

Matti Kangaskoski's article builds on the concepts of knowledge and automation in Bernard Stiegler's philosophy to investigate the affordances and aesthetics of collective agency in the contemporary digital environment. As he stresses, the digital environment, and more specifically digital cultural interfaces such as social media, news apps, streaming services, has a form, and, contrary to what the interfaces promote, this form is far from being neutral or "natural." Driven by the energy of a specific business model, this form encourages certain kinds of actions and modes of engagement and discourages others, while automatically predicting users' behaviors and desires. Kangaskoski proposes that the form of the environment should be considered aesthetic in the sense that it governs its users' senses, experience, and intellect. Viewed in this way, aesthetics is also politics, a question of the sensibility of the "we," of a collection of actors. His essay probes questions such as the following: To what extent, then, does this aesthetic afford the time and processes that foster knowledge? To what extent does the environment enable agency, individual and collective? Are there better alternatives to the current forms of the digital environment?

If Kangaskoski raises fundamental questions regarding the aesthetics and affordances of digital media platforms, Heather Woods's contribution provides a concrete case study by examining how collectives form and participate in collective ac-

tion on the social media platform TikTok. TikTok is a popular short-form social media platform that combines video, audio, text, and hashtags to produce a multi-mediated experience for users. While it is often dismissed in academic and popular culture as a space for irreverent performance (e.g., dancing), TikTok influences socio-political landscapes on and off the platform. While other social media facilitate collective action, TikTok is a distinct communicative channel that mobilizes platform logics to draw together both the individual and collective through a carefully calibrated experience with a particular, intertextual, hypermobile, and circulatory medium: memes. Woods argues that TikTok's socio-political platform affordances invite users to engage in collective action via the collaborative co-creation of memetic content. To make this argument, the article advances a theory of platform collectivity, or the social condition of contingent, bounded togetherness characterized by shared affiliation in digital spaces.

The third section, "Narrating Collectivity beyond the Human," brings together essays which investigate texts that seek to narrate collectivity beyond the human. Marco Caracciolo's contribution thus examines the forms of collectivity that underlie the experience of online video games. If multiplayer gaming is often plagued by problems such as toxic remarks or skill-based harassment, this tendency can be countered by innovative forms of multiplayer games that are designed to constrain players' interactions and steer them towards more responsible or constructive behavior. Caracciolo focuses on two formal strategies that are implemented by games such as *Death Stranding* (Kojima Productions 2019) and *Elden Ring* (FromSoftware 2022): asynchronous gameplay and constrained communication. While these devices would seem to limit online play, they often have the opposite effect: They encourage creative interactions that are seen by many as particularly meaningful, not only during active gameplay but also in the exchanges that surround game experience. In this way, the article offers a case study on how formal constraints on aesthetic experience may enhance community building.

Stefanie Mueller's contribution examines the affordances of a bureaucratic register for the literary representation of collectivity in times of climate change. In her article on Kim Stanley Robinson's *The Ministry for the Future* (2020) she argues that the novel represents collectives and seeks to build collective agency by drawing on a type of discourse that is representative of the organizational form which is at the center of the novel's plot, a bureaucratic organization. Her analysis identifies the aesthetic and narrative strategies that draw on such a bureaucratic register—from meeting minutes to historical summaries, for example—and highlights their potential to represent collectives democratically. Yet, by discussing bureaucracy's inbuilt tendency towards impersonality, Mueller also questions whether the novel can address readers affectively or provide them with a *feeling* of shared agency.

The volume's final section, "New Forms of Collective Activism," delves into the new forms of political activism that have emerged in the twenty-first century.

Natalya Bekhta's contribution explores the discursive aspects of collective agency within the context of the war in Ukraine. She examines how Ukrainian society in the midst of war works towards finding a new language capable of articulating the dramatic transformations of the social reality and of the nation's own collective (self-)image. She traces this search for language through the function of personal pronouns in a range of works by Serhiy Zhadan and Kateryna Kalytko, including their interviews, essays, dramas and poetry. These two writers have a highly influential standing in contemporary Ukraine, which often leads them to explicitly grapple with the socio-aesthetic stakes of presuming to speak on behalf of a national community—that is, of presuming to speak a language of shared meanings.

If Bekhta highlights the power of language in constructing a national community, Katharina Motyl draws our attention to online platforms as spaces of collective radicalization and dissemination of right-wing ideologies. Her essay analyzes digital anti-feminist forums which encourage users to embrace alt-right ideologies at large, notably white nationalism. This contribution first introduces the four major groups constituting the anti-feminist manosphere and thinks through interconnections between digital media ecologies, anti-feminism, and the alt-right. Subsequently, it highlights the medial strategies alt-right agitators use to entice isolated, disaffected users to join the alt-right collective. Next, it identifies the aesthetics and affective appeals alt-right activists mobilize to conjure a sense of masculine and white domination, to then outline the arguments they make to present anti-feminism and white nationalism as ideologically congruent. The article concludes by arguing that the alt-right has succeeded in convincing white, male users that their feelings of marginalization constitute subversive knowledge regarding the true power dynamics in Western societies, which allegedly not only oppress men, but also privilege racial minorities over white people, who will soon be replaced unless they start resisting.

The final contribution in this section by Katharina Fackler traces how twenty-first-century climate change poetry re-imagines collective agency through tropes of oceanic kinship. It registers how notions of kinship have become central to scholarly, artistic, and activist interventions in debates about the relationship between the human and the more-than-human world. Analyzing Aka Niviâna and Kathy Jetñil-Kijiner's 2018 video poem "Rise," the article is particularly interested in the ways in which climate change poetry adapts and combines varying forms of oceanic kinship across different social and geographical scales. It suggests that the language of kinship can help nudge climate change discourse beyond dominant settler capitalist and settler environmentalist paradigms by centering Indigenous onto-epistemologies.

As a volume contributing to a book series on "Critical Futures," our essay collection overall is invested in establishing a dialogue between different critical perspectives on contemporary discourses, narratives, and practices that shape our collec-

tive visions of "the future." As the challenges to imagine more ecologically as well as socially and politically equitable futures rise in the twenty-first century, so does the need to interrogate hegemonic narratives of collectivity and collective welfare and to diversify standard concepts of collective agency. Taken together, the articles in this volume provide a rich and multi-faceted starting ground for a transdisciplinary discussion of collectivity and collective agency that acknowledges and takes seriously the crucial role that aesthetic forms play in how they emerge as well as in how they can be sustained.

Works Cited

Anderson, Benedict. *Imagined Communities: Reflections on the Origin and Spread of Nationalism*. 1983. Verso, 2006.

Borch, Christian. *The Politics of Crowds: An Alternative History of Sociology*. Cambridge University Press, 2012.

Brinkema, Eugenie. *Life-Destroying Diagrams*. Duke University Press, 2022.

Dean, Jodi. *Crowds and Party*. Verso, 2016.

Fisher, Dana R. "The Diversity of the Recent Black Lives Matter Protests Is a Good Sign for Racial Equity." *Brookings*, 8 July 2020, https://www.brookings.edu/arti cles/the-diversity-of-the-recent-black-lives-matter-protests-is-a-good-sign-f or-racial-equity/. Accessed 14 March 2024.

Garza, Alicia. "A Herstory of the #BlackLivesMatter Movement." *Are All the Women Still White? Rethinking Race, Expanding Feminisms*, edited by Janell Hobson, SUNY Press, 2016, pp. 23–28.

Gehring, Thomas, and Johannes Marx. "Group Actors: Why Social Science Should Care About Collective Agency." *Historical Social Research*, vol. 48, no. 3, 2023, pp. 7–39, https://doi.org/10.12759/hsr.48.2023.23.

Goodman, J. David. "A Year after 'Defund,' Police Departments Get Their Money Back." *New York Times*, 10 October 2021, https://www.nytimes.com/2021/10/10/ us/dallas-police-defund.html. Accessed 14 March 2024.

Jackson, Sarah J., Moya Bailey, and Brooke Foucault Welles. *#HashtagActivism: Networks of Race and Gender Justice*. MIT Press, 2020.

Jonsson, Stefan. "Dangerous, Chaotic and Unpleasant: Crowd Theory Today." *Lo Squadernos*, no. 33, 2014, pp. 9–12.

Koivunen, Anu, Katariina Kyrölä, and Ingrid Ryberg. "Vulnerability as a Political Language." *The Power of Vulnerability*, edited by Anu Koivunen, Katariina Kyrölä and Inbrid Ryberg, Manchester University Press, 2018, pp. 1–26.

Kornbluh, Anna. *The Order of Forms*. University of Chicago Press, 2019.

Levine, Caroline. *Forms: Whole, Rhythm, Hierarchy, Network*. Princeton University Press, 2015.

Putnam, Lara, Erica Chenoweth, and Jeremy Pressman. "The Floyd Protests Are the Broadest in U.S. History—and Are Spreading to White Small-Town America." *Washington Post*, 6 June 2020, https://www.washingtonpost.com/politics/2020/06/06/floyd-protests-are-broadest-us-history-are-spreading-white-small-town-america/. Accessed 14 March 2024.

Surowiecki, James. *The Wisdom of Crowds*. Anchor Books, 2004.

Thomas, Deja, and Juliana Menasce Horowitz. "Support for Black Lives Matter Has Decreased Since June But Remains Strong Among Black Americans." *Pew Research Center*, 16 September 2020, https://www.pewresearch.org/fact-tank/2020/09/16/support-for-black-lives-matter-has-decreased-since-june-but-remains-strong-among-black-americans/. Accessed 14 March 2024.

Wang, Dorothy. "The Future of Poetry Studies." *The Cambridge Companion to Twenty-First-Century American Poetry*, edited by Timothy Yu, Cambridge University Press, 2021, pp. 220–33.

I. Key Concepts

Collective Agency

Simone Knewitz

Within cultural discourses and (American) cultural studies scholarship of the first decades of the twenty-first century, the term "collective agency" has become a frequent buzzword. Always valorized positively, it appears in the context of contemporary social justice movements such as Black Lives Matter or MeToo and their accompanying hashtag activism within social media, in the analysis of literary and cultural practices that are deemed oppositional to the status quo, as well as in debates around climate change. "Collective agency" here is usually associated with the resistance against structural forms of domination and the empowerment of those groups most impacted by oppression. In these contexts, the term often remains vaguely defined and is being called up as a desideratum—the desire to regain control in the face of globalized structures of (racialized, financial) capitalism that have all but eliminated opportunities for political participation. Moreover, both the rise of authoritarian rightwing political formations and the widespread realization of impending ecological catastrophe raise the pressing question of how the collectivity of humans can establish (truly) democratic forms of collaboration to create a socially just and sustainable future.

This essay contributes to a much-needed conceptualization of the key concept of collective agency by tracing the twenty-first-century conversation on political organization among political and cultural theorists of the left. The occupation movements in numerous countries across the globe starting in 2011 have animated much of the recent theoretical debates on how the left should organize in response to political, economic, and ecological crises, to actively mold a post-neoliberal order. As Rodrigo Nunes has noted, political organization in the early twenty-first century is marked by specific historical conditions: the pervasive role of digital media in social life, along with the opportunities they provide for the formation of large-scale collectives; a crisis of confidence in liberal democratic institutions, as well as the decline of the traditional organizations that organized popular movements in the twentieth century (190). In the light of these trends, scholars have emphasized a number of central characteristics of the new social movements of the twenty-first century: the rejection of leadership figures as well as of established institutions such as unions and parties, the pursuit of new strategies and tactics of horizontal and networked

organization, and the heavy reliance on new digital media. Yet, whether these new forms of activism succeed in fostering collective political agency has been subject to intense debate. As the occupation movements, in the view of many, fell short of delivering substantial policy change, established institutions such as the party experienced a renaissance. Still, it remains an open question if a return to old forms can deliver the kind of transformations that have become urgent in our contemporary moment.

In the following, I will first trace the history of the concept of agency: arising in scholarly debates concurrently with neoliberalism in the 1970s, the term has always been strongly associated with the individual. The idea of collective agency thus remains haunted by the framework of individualism, which impacts our ability to conceptualize the collective capacity to act. In the subsequent sections I address some of the major contestations among the political left which emerge from the debate between hegemonic and post-hegemonic conceptions of collective agency: While the former current, paradigmatically represented by Ernesto Laclau and Chantal Mouffe, thinks of the political sphere as a vertically organized realm within the framework of the state, the latter, represented by Michael Hardt and Antonio Negri, opposes all state structures and hierarchies. This opposition leads to radically different outlooks on the forms that left political agency could assume. The final section builds on the work of Nunes and others in order to suggest that such binary thinking can and should be transcended in the collective quest for a more desirable and sustainable future.

"Devitalized Agency": Political Subjectivity under Neoliberalism

The term "agency" first gained salience in the humanities in the 1970s and 80s, responding to structuralism and its incapacity to account for the actions of individuals, as well as to political activism of the time, such as the feminist movement, which insisted that the personal was political and hence could challenge overarching power structures (Ahearn 12). Sociologist Anthony Giddens defined agency in terms of "the capability of the individual to 'make a difference' to a pre-existing state of affairs or course of events" (14). Being an agent involves the ability to make use of available knowledge and resources and a certain degree of "power in the sense of transformative capacity" (15; see also Kaun et al. 2).

Agency was thereby originally conceived through the prism of the individual, and it arose as a concept at the very moment when a specific form of individualism became a key characteristic of the neoliberal order emerging in the 1970s. At that time, the relationship between capitalism and democracy shifted from post-war Keynesianism to economic policies that affirmed free markets and financialization. As cultural critics of the political left argue, however, neoliberalism transcends the

economic sphere. Building on the work of Michel Foucault, Wendy Brown thus understands neoliberalism as a "governing rationality" which ultimately reaches "every dimension of human life" (*Undoing the Demos* 30). The individual here is enlisted to take up the position of an entrepreneur, engaging to enhance their value as human capital, while taking on responsibilities formerly born by social investments, e.g., in education, health care or social security (Brown, *In the Ruins* 38–39; Schram 60). According to Brown, neoliberalism reframes the idea of individual agency as "responsibilization" which "tasks the worker, student, consumer, or indigent person with discerning and undertaking the correct strategies of self-investment and entrepreneurship for thriving and surviving" and thus "solicits the individual as the only relevant and wholly accountable actor" (*Undoing the Demos* 132–33). Yet, as Brown makes clear, what is being celebrated here as individual agency and self-responsibility must ultimately be understood as a form of governance which organizes individuals instead of empowering them (*Undoing the Demos* 133).

Both Brown and Jodi Dean relate the emphasis on individual responsibility to "neoliberalism's dismantling of social institutions" (Dean, "Critique or Collectivity?" 173) and see in it not an enhancement, but a squashing of political forms of agency. Dean thus argues that "the celebration of autonomous individuality prevents us from foregrounding our commonality and organizing ourselves politically" (*Crowds* 4; see also Hardt and Negri, *Assembly* 157). She precisely takes issue with the construct of political agency as a capacity of individuals in which "agency [is] privileged over structure" and "the presumption that agents are individuals [which] formats the alternative of autonomy or subjugation as an opposition between individual and collective" (*Crowds* 73).

The individualization and economization of political life has contributed, as these and other scholars have argued, to a "hollowing out of contemporary liberal democracy" (Brown, *Undoing the Demos* 18), the consequences of which came to the fore in the first decade of the twenty-first century. Creating a rupture within the neoliberal order, the financial crisis of 2007–08 brought about not only economic turbulences, but also a political crisis of legitimacy (Gerbaudo, *The Mask* 30). The social movements of the second decade of the twenty-first century can thus be interpreted as discontent with what both Colin Crouch and Chantal Mouffe have called "post-democracy": the reduction of the substantial participation of citizens in political processes to the point that democracy "only signifies the presence of free elections and the defence of human rights" (*For a Left Populism* 16). While the formal components of democracy remain in place, actual political decisions are increasingly made by powerful elites (Crouch 4). Ali Aslam frames the kind of political subjectivity enabled under such post-democratic conditions as "devitalized agency": a passive form of agency, "without the world-making powers that draw citizens to public life because they believe it is receptive to their efforts" (*Ordinary Democracy* 6). Citizens experience their own position as having little control over the

circumstances of their existence and no active role within political processes and deliberation. In the face of such an impasse, many withdraw to nonpolitical spheres and try to find a sense of agency in the private realm and in consumption.

For scholars such as Brown, Dean, and Aslam, to think of agency as a capacity of the individual is a fraught enterprise that is ultimately in the service of larger structural formations and of depoliticizing populations. To counter neoliberal individualization we therefore need a revitalization of collective forms of organization that can truly exercise political agency. For these and other political and cultural theorists, the social movements emerging with the occupation movements after 2011 opened up a potential of alternative imaginaries and collective identities.

The Subject of Politics: Constructing Collective Identities

Activist organization in the context of the occupation movements was shaped by the idea of horizontalism which advocates for "leaderless" movements, in opposition to the vertical forms of organization characteristic of political struggle in the twentieth century. The rejection of hierarchical structures had its roots in the alterglobalization movements of the previous decades and was tied to the network paradigm as explanatory framework for collective organization (Nunes 160). According to Marianne Maeckelbergh, "horizontality refers to a decentralized network structure that produces non-hierarchical relationships between various nodes." Central to such horizontal networks is their rejection of "representation and delegation of command, allowing actors to reclaim 'control'" (109). W. Lance Bennett and Alexandra Segerberg have argued that the new movements were defined by a "logic of connective action" which distinguishes itself from older notions of collective action by working with personalized action frames and digital communication technologies, creating expansive and flexible networks which do not require that participants strongly identify with a cause or acquire membership of an institution. "These networks," Bennett and Segerberg explain, rely on "the organizational processes of social media, and their logic does not require strong organizational control or the symbolic construction of a united 'we'" (748).

According to such accounts, aggregates of individuals assume a collective capacity to act through technology which replaces affective forms of group formation. However, this blanket rejection of collective identity as a prerequisite for political agency has raised objections. Luc Boltanski and Eve Chiaporello have taken issue with the primarily positive valorization of the network paradigm and pointed to its deep entanglement with the logic of capitalism and its shortcomings for addressing questions of justice (103–108). Jan-Felix Schrape, in his contribution to this volume, points to the recurring discursive patterns within debates on technological innovation since the 1960s that project democratization through decentralization, which

however has never come to fruition (91). And Gerbaudo, countering Bennett and Segerberg's argument specifically, warns that we should not reduce movements to infrastructures: Technology is not purely instrumental, but also possesses symbolic functions—it becomes part of the protest culture itself and thereby lends coherence and a form of identification ("The Persistence" 266). While he concurs with Bennett and Segerberg on the use of personalized action frames within the occupation movements, he also identifies "a new desire for collectivity [...] in which individual users through the internet and beyond come to develop a sense of belonging to something bigger than themselves" ("The Persistence" 268). In other words, the sense of collective identity cannot simply be substituted with new technological forms of organization.

Different theorists emphasize that collective identities must be constructed out of social positions characterized by difference and particularity. Thus, Ernesto Laclau in his political theory strongly emphasizes that "the people" as a political category do not exist as "a *given* group" but emerge out of "an act of institution that creates a new agency out of a plurality of heterogeneous elements" (224). Laclau addresses what he sees as essential, but also rivaling components in the construction of the social: difference and equivalence. Political agency requires that differences and particularities be subsumed under a universalizing operation. The emergence of "the people" as a category depends on the creation of a "chain of equivalence" between different social demands—different particular grievances must be formed into one overarching one in order to form a popular identity (74–86). Laclau suggests that one particular demand becomes a stand-in for all other demands in the process of "crystallizing" a common identity. The chain of equivalence must ultimately be unified into a "stable system of signification." Ultimately, the process has to lead to the formation of a singular identity; the movement requires a leadership figure which acts as a projection screen, an (empty) signifier that unifies the people.

For Laclau, the construction of "the people" is a discursive operation, which encompasses both signifying processes and affective dimensions (111). Judith Butler, by contrast, puts an emphasis on the material component of bodies "acting in concert" as a way of constructing a collective political subject ("We, the People" 50). They conceive of popular sovereignty as "a performative exercise" which "necessarily involves a performative enactment of bodies" ("We, the People" 55). In *Notes toward a Performative Theory of Assembly* (2015), Butler points to the significance of public assemblies within occupation movements, as well as to what they see as bodies becoming "the object of many of the demonstrations that take precarity as their galvanizing condition" (*Notes* 9). For Butler, these occupations and demonstrations are a form of "exercising a plural and performative right to appear, one that asserts and instates the body in the midst of the political field, and which, in its expressive and signifying function, delivers a bodily demand for a more livable set of economic, social, and political conditions no longer afflicted by induced forms of precarity" (*Notes* 11).

In Butler's conception, precarity emerges as the unifying signifier which, in Laclau's sense, creates alliances between different social groups and subject positions that perform their precarity as a shared condition. Butler sees precariousness as a fundamental human condition, but also emphasizes that "the condition of precarity is differentially distributed"—the notion of precarity contains difference, but can also generate resistance "based on the demand that lives should be treated equally and that they should be equally livable" (*Notes* 67). Commenting on Butler's ideas, Sanford Schram notes that their "turn to precarity [...] reflects a profoundly political move enacted by movement actors themselves to bring together diverse groups uniting them around their shared economic marginalization" (61). The notion of the "precariat," coined by Guy Standing to refer to a new class of citizens that encompasses a diverse group of people of different social positions whose life conditions have become more fragile, from the poor to marginalized middle-class professionals, and many others who view their lives as increasingly precarious, underlines the unifying function of the concept (Schram 61). As Schram argues, "Butler's focus on precarity highlights how people's shared vulnerability becomes a basis for achieving political agency by way of public performances that serve to represent the common interests of those being variously marginalized by ongoing economic change" (62).

Like Laclau, both Butler and Schram place central importance on the question of how difference and identity come together in collective political action (Schram 63). The slogan of the Occupy movement, "We are the 99 percent," here exemplifies what Laclau refers to as an empty signifier that lends itself to broad identification. Several commentators have noted that the accompanying Tumblr page serves as an example of how diverse people come together under that banner (Gerbaudo, *The Mask* 149; Schram 64–65). The page collects images of people who tell their individual stories of precarity on handwritten notes that usually make up most of the photograph; the tumblr thus presents singular stories, which however collectively represent a shared condition (Occupy WallSt.). The individual and the collective are thus interwoven without reducing singular experiences. In "occupying" precarity, participants do not accept their condition, but "adopt this status as a source of their collective agency" (Schram 71).

While vulnerability has often been associated with victimhood, and thus been opposed to notions of resistance and agency, Butler's and Schram's reading of Occupy emphasizes precarity as a shared vulnerability and a mobilizing force that begets collective action and identification (Butler, "Rethinking" 14). Relatedly, commentators on Black Lives Matter have also pointed out how that movement makes vulnerability and the experience of social injury the basis of their activism. Black Lives Matter sets out to expose and challenge "all of the ways in which Black people are intentionally left powerless at the hands of the state [...] [and] Black lives are deprived of our basic human rights and dignity" (qtd. in Oliviero 265). The movement thus identifies "social injury as a condition of collective life" (Aslam, "The Future"

261). Negative affects, such as the persistent and collective experience of racialized violence, become the basis of political organizing and for envisioning alternative futures "in which bodily security is realized for all of those who identify as Black, including queer and trans-individuals" (Aslam, "The Future" 277).

The People vs. the Multitude: Models of Collectivity

As the previous sections have illustrated, contemporary political and cultural theories of the left have identified collective agency as a gap which results from the dismantling of social identities and institutions under neoliberalism. Hence, to construct new practices of "acting in concert" to foster new forms of collective identity appears pivotal. Yet what kind of collectivity should the left strive for? There is a rich vocabulary of terms referring to collective political agents, such as the crowd, the masses, the mob, the people, the multitude, the citizenry. Each of these terms comes with its own specific valences and a complex intellectual history, and has implications for the forms of social organization we envision. When conceptualizing collective agency in the twenty-first century, the use of each one of these terms may generate different models of collectivity.

In the face of new protest movements around the globe, the concept of the crowd has experienced a renaissance both in the streets and in scholarly inquiry (see, e.g., Borch; Dean, *Crowds*; Schnapp and Tiews). First theorized by Gustave Le Bon as a distinct form of collectivity in 1896, crowds have traditionally been conceived rather negatively as primitive, violent and suggestible. Crowds were taken to signify both mass democracy and mass tyranny, configured as "the people" or "the mob" (Dean, *Crowds* 8–11). In the twenty-first century, crowds have received an inverted valorization—and been appropriated by neoliberal discourses—with the idea of the "wisdom of crowds" (Surowiecki) at work in the collective production of knowledge in the digital sphere. Picking up on such notions of swarm-like intelligence, some scholars have described the occupation movements as "crowd-enabled networks" that manage to achieve new forms of coherent organization through aggregated action (Bennett et al. 234).

As described by Dean, following Le Bon, the power of crowds is in that they constitute a collective being, that they are more than an aggregation of individuals. Amassing in public space, crowds possess a radical potential that allows them to "poise themselves against democratic practices, systems, and bodies" and "reclaim[] for the people the political field" (Dean, *Crowds* 10, 11). But Dean also forcefully asserts that "the crowd does not have a politics. It is the opportunity for politics" (*Crowds* 8). By that she means that a crowd can generate a rupture which opens up possibilities to exercise political agency, but because of its transient, spontaneous character, the crowd lacks intentionality. In order to gain political subjectivity, the crowd must

become the people (*Crowds* 103). Yet, whether the objective should be to unify a collective subject, or whether the goal is the abolition of all centralizing (power) structures and hierarchies constitutes a major controversy among political theorists.

Thus, in conceptions of collectivity within recent theoretical debates, one major point of contestation emerges between hegemonic and post-hegemonic understandings of political agency (Katsambekis 170). In the post-hegemonic camp of theorists, John Holloway's programmatic book *Change the World Without Taking Power* (2002), a central reference text of the alterglobalization movement, envisioned a revolutionary transformation of social relations through the abolition of power structures (17–18). Michael Hardt and Antonio Negri point in a similar direction: In their influential work *Empire* (2000), as well as their subsequent publications *Multitude* (2004), *Commonwealth* (2009) and, most recently, *Assembly* (2017), they introduce the multitude as their preferred concept of collectivity. They conceive of the multitude as explicitly counterhegemonic, rejecting the idea of a "people," which, they argue, always implies the existence of oppressive political structures and hierarchical positions of leadership. As Jonsson explains, "multitude is the motley essence of humanity," it is "open, manifold, and boundless" (10). Unlike terms such as the crowd, the people, the masses, or the working class, Hardt and Negri argue, the multitude does not suggest a single identity or stress indifference; instead of a figure of unity, it denotes "an open and expansive network in which all differences can be expressed free and equally, a network that provides the means of encounter so that we can work and live in common" (Hardt and Negri, *Multitude* xiv). "Multitude" and related concepts such as the "swarm" and the "network" capture the effort to at once account for a postmodern conception of singular identities and the desire for horizontal political agency that exerts power from below. In their recent work, Hardt and Negri acknowledge the need for some leadership, but suggest it must exist only as "entrepreneurial function, not dictating to others or acting in their name or even claiming to represent them but as a simple operator of assembly within a multitude that is self-organized and cooperates in freedom and equality to produce wealth" (*Assembly* xviii).

Ernesto Laclau and Chantal Mouffe take issue with the post-hegemonic approach propagated by Hardt and Negri. Similar to Dean, they conceive of politics as a hegemonic struggle for power and see the construction of "the people" as the subject of politics as a prerequisite of democratic agency. Laclau has thus posited that "the political operation *par excellence* is always to be the construction of 'a people'" (153). In *On Populist Reason* he outlines populism as a political logic which he also views as constitutive of the political as such. In this framework, social orders need to be conceptualized as hegemonic formations and politics as the struggle for hegemony. A break occurs in a given social order if it is no longer able to meet social demands; this gap between the status quo and accumulating social demands serves as the starting point for the formation of a new internal antagonistic frontier, the

"people" vs. "power," in which those in power are constructed as an enemy. In her recent works, Mouffe similarly advocates for a radicalization of democracy that "aims at federating the democratic demands into a collective will to construct a 'we', a 'people confronting a common adversary: the oligarchy" (*For a Left Populism* 24).

Kevin Olson points out that among different forms of collectivity, that of the people is attributed with "a significance not shared by other collectivities," namely that it is "endow[ed] with normative value" (107, 121). The Western democratic imaginary posits the people as the source of political legitimacy and hence also of power. In other words, the concept of the people has a particular draw to mobilize and unify the agency of citizens that other concepts, such as the multitude, lack. If Laclau and Mouffe advocate for a reformation of the state, Hardt and Negri call upon us to "smash the state" (*Assembly* 133): They ultimately advocate that we should do away with all established (state) institutions and build new, nonhegemonic forms of collective organization from the realm of social relations (*Assembly* 14).

The hegemonic and counter-hegemonic positions appear all but irreconcilable in theory, yet much more blurred in activist practice. Thus, the occupation movements between 2011 and 2016 both advocated for horizontal organization and a reformation of state structures. Gerbaudo has described the new protest form as "citizenism" which he defines as "the ideology of the 'indignant citizen'" who is "outraged at being deprived of citizenship, chiefly understood as the possibility of individuals to be active members of their political community with an equal say on all important decisions, which is increasingly in question in the neoliberal 'post-democratic' condition" (*The Mask* 7). The protests, he argues, constitute a new form of democratic populism, which is decidedly not anti-statist, but seek to reclaim the state (*The Mask* 10). Yet he describes this new populism as different from traditional forms, as "a populism with a libertarian twist": "[C]itizenism appeals not to the People in its collectivity, but to the Citizen as an individual component of the People" (*The Mask* 17). The practices of the occupation movements thus point beyond the strong binary oppositions that mark the theoretical discourse on collective organization.

Beyond Horizontality vs. Verticality: Collective Agency in the Twenty-First Century

With the faltering of the occupation movements, and the rise of right-wing populism, theorists of the political left have increasingly stressed that the most urgent unresolved question is how to organize effectively in order to create a democratic and sustainable future. Much of the debate on collective agency during the last couple of decades has been dominated by the opposing positions of "horizontalists" and "verticalists": Should left politics be organized within the framework of the state or take power to abolish all state structures? Should we conceive of the political sphere

as an autonomous realm or as a continuum of social relations and material practices? Do we need the leadership by a vanguard that organizes political struggle and represents the people, or should we abolish all representative structures and let the people represent themselves? In short, what are the forms that social organization should take?

The discourse of horizontalism held much theoretical currency in the 2000s and during the occupation movements after 2011. Most recently, the pendulum swings in the opposite direction: Many left scholars now strongly advocate for concrete strategies that make use of existing institutions to transform, rather than to smash political structures. Caroline Levine, as well as Kai Heron and Jodi Dean, take issue with the inertia of the political left to go beyond fatalism and fantasies of revolution in order to pursue pragmatic paths in the battle against climate change. In a similar vein, Chantal Mouffe advocates for a "green democratic revolution" that is achieved through political organization within the structures of the state (*Towards*). In this context, the institution of the party has experienced a renaissance. For Dean, a strong proponent of party organization, enduring political struggle requires the party as an institution that provides both affective identification with a collective and stands up to the structural forces of capitalism that have long been using state institutions to secure and expand their powers. In the wake of the occupation movements, activists themselves began to embrace more formal organization structures, even the founding of new parties, as with Syriza in Greece or Podemos is Spain (Gerbaudo, *The Mask* 208). "The movement of the squares was thus not just a 'destituent' moment," Gerbaudo argues, "but also a 'constituent' moment: an event of foundation of a 'new politics' matching the requirements of the post-neoliberal era" (*The Mask* 210). In the U.S., Bernie Sanders's presidential campaigns have inspired progressive organizing within the Democratic Party (Lipsitz).

Yet, judging from the limited impact that leftwing parties and party factions could generate in the last years, it remains doubtful that sweeping transformations can be created through the institution of the political party alone. Moreover, it is unclear that parties are the best and only candidates for the creation of activist collective identities and affective identification, as Dean wants us to believe (*Crowds* 249). Though less stable in structures, social movements might be better suited to organize activism, whereas parties have the unique function of organizing electoral politics, and thus aim to generate majorities by targeting people outside activist circles. Parties are limited in their function as they are tied to the state and the exercise of state power. And the capacity of the state to act is also superseded by transnational powers (Nunes 232–33).

Both hegemonic and post-hegemonic theories have significant shortcomings when it comes to devising strategies that can produce social change. Laclau and Mouffe's greatest liability may be that their conceptualization of the political is founded on a theory of discourse, which makes it hard to account for the non-

discursive dimensions of lived experience (Nunes 252). "Left populism," Nunes notes, "is ultimately a much better theory on how to build consent or win elections than it is on how to produce change—which is something that may include winning elections, but is certainly also much more" (253). By contrast, Hardt and Negri attend to the necessity of rewiring the cultural scripts of everyday experience, but their radical rejection of power structures seems utopian. Their theory is based on the strong assumption that every member of the multitude will ultimately buy into radically democratic decision-making; this take, however, underestimates that many people are significantly invested in hierarchical thinking, not least illustrated by the success of authoritarian populism.

In his theory of political organization, Nunes proposes that we move beyond stifling oppositions and recognize that we need different, concurrent forms of organization that mediate between qualities of horizontality and verticality, diversity and unity, centralization and decentralization (13). He prompts us to think of the political sphere in terms of an ecology that comprises a diversity of initiatives and forms. In this sense, left politics would be organized as distributed action with different "organizing cores" (Nunes 203) and forms that assume different functions, with more or less centralization, weaker or stronger forms of leadership depending of the specific objectives of the initiatives. Crucially, Nunes differentiates between leadership as a *function* and as a (power) *position*: While a democratic movement may eschew hierarchical power relations, he convincingly shows that some degree of leadership "performing the function of concentrating and orienting the collective capacity to act in certain directions" remains indispensable (203).

Making the case that only political organization in a distributed fashion and on multiple levels may succeed in generating transformation, Nunes proposes that the left should start by identifying strategic wagers which "start from issues that are both structurally significant and have base-building potential" (217). Radical causes will only garner mass support if they can be connected to anxieties and discomfort people are experiencing in their everyday lives; an appeal to idealism is not enough. "Most people," Nunes writes, will not be moved by the idea of a different world alone, but "because they can either see themselves living better in it, or can no longer see themselves as surviving in this one. For that commitment to hold, it cannot prove incompatible with their well-being in the medium term, and must therefore offer material as well as 'non-material' returns" (219). Thus, long-term and aspirational goals must be imbricated with short-term improvements of people's lives.

The challenge of collective agency in the twenty-first century is not the design of new visions of an alternative, more livable future, but how to create roadmaps that will guide us from our present situation to a more desirable and sustainable one. These roadmaps will have to account for various types of resistance that we will invariably encounter, by forces that pursue contrary political and economic interests.

In the light of contemporary political crises and developments, this will not be an easy feat.

Works Cited

Ahearn, Laura M. "Agency." *Journal of Linguistic Anthropology*, vol. 9, no. 1/2, 1999, pp. 12–15, https://www.jstor.org/stable/43102414.

Aslam, Ali. *Ordinary Democracy: Sovereignty and Citizenship beyond the Neoliberal Impasse*. Oxford University Press, 2017.

—. "The Future of Bad Collectivity." *Law, Culture and the Humanities*, vol. 17, no. 2, 2021, pp. 261–79, https://doi.org/10.1177/1743872117713444.

Bennett, W. Lance, and Alexandra Segerberg. "The Logic of Connective Action: Digital Media and the Personalization of Contentious Politics." *Information, Communication & Society*, vol. 15, no. 5, 2012, pp. 739–68, https://doi.org/10.1080/1369118 X.2012.670661.

Bennett, W. Lance, Alexandra Segerberg, and Shawn Walker. "Organization in the Crowd: Peer Production in Large-Scale Networked Protests." *Information, Communication & Society*, vol. 17, no. 2, Feb. 2014, pp. 232–60, https://doi.org/10.1080 /1369118X.2013.870379.

Boltanski, Luc, and Ève Chiaporello. *The New Spirit of Capitalism*. Verso, 2007.

Borch, Christian. *The Politics of Crowds: An Alternative History of Sociology*. Cambridge University Press, 2012.

Brown, Wendy. *In the Ruins of Neoliberalism: The Rise of Antidemocratic Politics in the West*. Columbia University Press, 2019.

—. *Undoing the Demos: Neoliberalism's Stealth Revolution*. Zone Books, 2015.

Butler, Judith. *Notes toward a Performative Theory of Assembly*. Harvard University Press, 2015.

—. "Rethinking Vulnerability and Resistance." *Vulnerability in Resistance*, edited by Judith Butler, Zeynep Gambetti, and Leticia Sabsay, Duke University Press, 2016, pp. 12–27.

—. "'We, the People': Thoughts on Freedom of Assembly." *What Is a People?*, edited by Alain Badiou, Pierre Bourdieu, Judith Butler, Georges Didi-Huberman, Sadri Khiari, and Jacques Rancière, Columbia University Press, 2013, pp. 49–64.

Crouch, Colin. *Post-Democracy*. Polity, 2004.

Dean, Jodi. "Critique or Collectivity?: Communicative Capitalism and the Subject of Politics." *Digital Objects, Digital Subjects*, edited by David Chandler and Christian Fuchs, University of Westminster Press, 2019, pp. 171–82.

—. *Crowds and Party*. Verso, 2016.

Dean, Jodi, and Kai Heron. "Revolution or Ruin." *E-Flux Journal*, no. 110, 2020, htt ps://www.e-flux.com/journal/110/335242/revolution-or-ruin/. Accessed 25 June 2024.

Gerbaudo, Paolo. *The Mask and the Flag: Populism, Citizenism and Global Protest*. Oxford University Press, 2017.

—. "The Persistence of Collectivity in Digital Protest." *Information, Communication & Society*, vol. 17, no. 2, 2014, pp. 264–68, https://doi.org/10.1080/1369118X.2013.86 8504.

Giddens, Anthony. *The Constitution of Society: Outline of the Theory of Structuration*. Polity Press, 1984.

Hardt, Michael, and Antonio Negri. *Assembly*. Oxford University Press, 2017.

—. *Multitude: War and Democracy in the Age of Empire*. Penguin Press, 2004.

Holloway, John. *Change the World without Taking Power*. New ed., Pluto Press, 2010.

Jonsson, Stefan. "Dangerous, Chaotic and Unpleasant: Crowd Theory Today." *Lo Squaderno: Explorations in Space and Society*, no. 33, 2014, pp. 9–12.

Katsambekis, Giorgos. "The Multitudinous Moment(s) of the People: Democratic Agency Disrupting Established Binarisms." *Radical Democracy and Collective Movements Today: The Biopolitics of the Multitude versus the Hegemony of the People*, edited by Alexandros Kioupkiolis and Giorgos Katsambekis, Routledge, 2016, pp. 169–90.

Kaun, Anne, Maria Kyriakidou, and Julie Uldam. "Political Agency at the Digital Crossroads?" *Media and Communication*, vol. 4, no. 4, 2016, pp. 1–7, https://doi. org/10.17645/mac.v4i4.690.

Laclau, Ernesto. *On Populist Reason*. Verso, 2007.

Levine, Caroline. *The Activist Humanist: Form and Method in the Climate Crisis*. Princeton University Press, 2023.

Lipsitz, Raina. *The Rise of a New Left: How Young Radicals Are Shaping the Future of American Politics*. Verso, 2022.

Maeckelbergh, Marianne. *The Will of the Many: How the Alterglobalisation Movement Is Changing the Face of Democracy*. Pluto Press, 2009.

Mouffe, Chantal. *For a Left Populism*. Verso, 2018.

—. *Towards a Green Democratic Revolution: Left Populism and the Power of Affects*. Verso, 2022.

Nunes, Rodrigo Guimaraes. *Neither Vertical Nor Horizontal: A Theory of Organization*. Verso, 2021.

OccupyWallSt. "We Are the 99 Percent." *Tumblr*, https://wearethe99percent.tumblr. com/. Accessed 25 February 2024.

Oliviero, Katie. *Vulnerability Politics: The Uses and Abuses of Precarity in Political Debate*. New York University Press, 2018.

Olson, Kevin. "Fragile Collectivities, Imagined Sovereignties." *What Is a People?*, edited by Alain Badiou, Pierre Bourdieu, Judith Butler, Georges Didi-Huber-

man, Sadri Khiari, and Jacques Rancière, Columbia University Press, 2016, pp. 107–31.

Schnapp, Jeffrey T., and Matthew Tiews, editors. *Crowds*. Stanford University Press, 2006.

Schram, Sanford. *The Return of Ordinary Capitalism: Neoliberalism, Precarity, Occupy.* Oxford University Press, 2015.

Surowiecki, James. *The Wisdom of Crowds*. Anchor Books, 2005.

Crowd

Martin Butler

Introduction: Affecting Ambiguities

In their "Fact Check" published on January 22, 2017, even Fox News stated that then-U.S. President Donald J. Trump had clearly exaggerated the number of people attending his inauguration. When Trump claimed that the group size on the field in front of the Washington monument "looked like a million, a million and a half people," Fox News countered that "Trump is wrong. Photos of the National Mall from his inauguration make clear that the crowd did not extend to the Washington Monument. Large swaths of empty space are visible on the Mall." The dramatic battle over numbers shortly after the inauguration did not only offer a first glimpse at the tense relationship between POTUS and "the media" during the Trump administration. It also hinted at the former President's awareness of the importance of this number as a device to boost and legitimize his political agenda and a point of reference in his self-fashioning as a spokesperson of "the people" (in spite of losing the popular vote). The crowd, it seems, mattered (and still matters) to him as part and parcel of his populist performances. It mattered as a collective he could address, a subjectivity emancipated from and resisting the institutionalized political system ("the swamp") that needed to be overcome and replaced by and for the people.

"A crowd is as easily heroic as criminal," writes Gustave Le Bon in his famous *The Crowd: A Study of the Popular Mind* from 1895, which quickly became one of the main references in mass psychology's analysis of crowd dynamics and behavior (25). In a nutshell, his diagnosis renders the ambiguity inscribed into this kind of collective organization: A crowd can be disruptive, disturbing, deviant, understood as "the mob" that threatens the established socio-political order through an unruly presence of bodies in the streets (see also Borch 16–17). At the same time, it can be considered as "the people," and accordingly, as an articulation of a political will that has gone unheard for too long due to the failure of institutionalized politics. Unruliness, then, can thus also be conceived as the *conditio sine qua non* for societal transformation for the better.

Along these lines, William Mazarella argues that "[f]rom a liberal standpoint, the crowd, in all its face-to-face potentiality, constitutes at once the origin and

the nemesis of democracy, though never its permanently indispensable lifeblood" (Mazarella, qtd. in Hussain). Tellingly, the organic metaphor of "lifeblood" he employs hints both at the physical, or corporeal, and at the emotional, or affective, dimension inscribed to this form of collectivity. In this vein, then, the crowd—both heroic and criminal—is understood as an "intensive experience of substantive collectivity," and its "breach of the predictable and given creates the possibility that a political subject might appear" (Dean 5–6). The crowd, therefore, "index[es] collective power" (Dean 10) that is able to unsettle hierarchies and to make visible the struggle of established political institutions of representative democracies.

My contribution focuses on this indexical character of the term, as it takes a closer look at "the crowd" as a highly ambiguous signifier that has been used to render collectivity and collective agency in a variety of historical and medial constellations. I will proceed in two steps: First, I will provide a short sketch of (some of) the underpinning images and ideas that inform and are articulated through the crowd as signifier, the reconstruction of which, I believe, helps unravel the ambiguities constitutive of the semantics of the crowd. My aim is not to give a comprehensive overview of conceptualizations of the crowd as an object of inquiry—others have done so quite comprehensively, and I am indebted to their work (see, e.g., Borch; Penna; Schmidt; Schnapp and Tiews). Christian Borch's impressive reconstruction of the semantic implications and connotations of the crowd, for instance, analyzes "crowd semantics" (3) as "distinctly modern semantics, arguably even as *the* semantics of modernity" (5) and sets out to unfold the ways of "problematizing" (in the sense of Foucault) the crowd at different stages of the development of sociological thought (7–8). Even though Borch focuses on scholarly conceptualizations of the crowd, i.e., on "the evolution of sociological crowd thinking as a history of internal disciplinary endeavors" (3), his insights provide both a starting point and a frame of reference for an approach that sets out to examine the potential of "the crowd" as a signifier. Second, and on the basis of this historical reconstruction, I will draw specific attention to the discursive reemergence of the crowd (and its semantic and normative implications) in new media environments in the twenty-first century. Particularly in these environments, I argue, the ambiguities inscribed into the crowd as signifier come to the surface in many different ways. With the help of examples, then, I set out to explore the ways in which the crowd as collective subject is constituted and takes shape in and through new media. In so doing, I assume that, in contrast to (often politically motivated) collective action in the streets that we have been witnessing over the last decade, the virtuality of social media both requires and provides different forms of making the crowd visible. At the same time, the semantics of the crowd in discourse both on participatory cultures in the digital realm and in new social movements are informed by very similar normativities.

The Crowd and Its Discourse—Then/Now, Physical/Virtual

Despite the ambiguity expressed through his characterization of the crowd as both heroic and criminal, Le Bon's analysis was considerably clear-cut, ideologically speaking. For him, "the claims of the masses," i.e., the crowd's claims, "amount to nothing less than a determination to utterly destroy society as it now exists, with a view to making it hark back to that primitive communism which was the normal condition of all human groups before the dawn of civilization" (xvii). While this rather negative conceptualization of the crowd reverberated with a general re-emergence of the concept in the late nineteenth century (Schmidt 40), the concept remained insignificant far into the second half of the twentieth century (Schmidt 39). Even though the fascist regimes in Europe gave ample proof to the necessity of studying them (Hussain), another rise in discursive frequency only appeared from the 1970s onwards, with a peak at the beginning of the twenty-first century (Schmidt).

In view of these recurrences, Florian Schmidt suggests that there has indeed been a "reinvention of the crowd" (37),[1] yet its discursive and practical reappearance took different ideological and, as one might add, aesthetic forms: "Astonishingly," he writes, "in the early years of the twenty-first century, we see an almost total inversion of the negative connotations the term crowd previously had. The crowd suddenly started to appear as a source of knowledge, creativity, and productivity, not only in a metaphorical sense but also as a core element in business plans and value chains of countless companies" (42). Schmidt here refers to—and repeats—the (hi)story of what Tim O'Reilly famously labeled "Web 2.0," i.e., new forms of interactive and participatory channels and platforms in digital environments, which, at the turn of the twenty-first century, were heralded as forms of a basically democratic re-engagement of audiences, or consumers of media content, into the processes of production and distribution.

The crowd, then, signified an idea of collectivity that spoke to this promise of participation in and through digital media. It denoted an entity constituted by uncountable individuals, who, through networking and sharing, could contribute to and benefit from a joint endeavor of, e.g., producing knowledge in online encyclopedias or generating media content through the exchange of thoughts and ideas, images, and sounds among an otherwise assumedly heterogeneous constellation of people. The concept of the crowd, then, allowed for combining the notion of unruliness with an idea of collectivity that did not imply an all-too homogeneous, all-too

1 In the eponymous chapter of his book (37–64), Schmidt presents a thorough analysis of the "historic notions of the crowd in comparison with those defining the discourse today," arguing that "[c]ertain aspects of what a crowd was have remained remarkably stable over time, while others have changed substantially" (38).

organized way of collaborating and communicating (as is the case with the concept of "community").[2] Surely, for this "smart mob,", as Howard Rheingold called the online crowd of "produsers" (Bruns), there was no "physical confirmation through touch and a shared space, and thus the physical feedback of possessing strength in numbers" (Schmidt 47). Moreover, as Schnapp and Tiews argue, in postindustrial times, crowding was "channel[ed] [...] into certain domains of civic and electoral ritual, entertainment, and leisure" (xi).

Therefore, on the one hand, the crowd gradually changed into an "icon that circulates within a political economy characterized by the co-existence of media aggregation and bodily disintegration," becoming the "subject to a variety of uses and appropriations" (Schnapp and Tiews xi). "In this sense," as Francesco Bailo argues, "the use of the Internet, because of its decentralized and horizontal geography, assumed a symbolic relevance" (38). In the early 2000s, it represented an alternative to "the monopoly of institutions of professional experts," with the project of Wikipedia being perhaps the most prominent example of this "techno-utopian narrative" in which, as Bailo continues, "a self-reviewed crowd could compete with and potentially unseat the experts" (38). At the center of this narrative of the smart crowd, Bailo puts the "citizen user," i.e., the "technologically empowered networked individual" (36) who distrusts established political institutions (39). In social media, this user finds a media-technological framework that allows to both imagine and demand a more direct form of participation and deliberation in the political domain. Moreover, the "aggregative capabilities" of this framework's algorithmic operations contribute to "the formation of online crowds of like-minded individuals who, while sharing no prior associational link, hold similar opinions" (Gerbaudo 750). Meeting people that share, say, certain preferences, lifestyles, worldview, then, is not (or no longer) a coincidence, but the result of calculations that allow for the orchestration of the many at an unprecedented scope and scale.

At the same time, and on the other hand, the technological possibilities of communicating and interacting virtually provided a fruitful ground for the emergence of collectivities as visible political subjects in the early twenty-first century, which have frequently been referred to as crowds, too. Indeed, the rise of "social media platforms as crowd fora" (Dean 15) have significantly contributed to the proliferation of the crowd as an alternative form of conceptualizing collective organization, enabling

2 Indeed, the concept of the online community implies more binding relationships based on mutually shared interests. Though crowds might also follow the same overall goal, the motivations of members might be different from one another. For West and Sims, for instance, communities are constituted by "repeated peer-to-peer interactions" (70), so ties are much stronger than in crowds. At the same time, West and Sims argue that there are a number of "hybrid crowds" (70) with community-like features. This overlap can also be observed in crowd discourse.

people to network and connect over distances instantaneously in order to organize and display bodily co-presence. In this combination of online and offline mobilization, the Occupy movement's protest activities, for instance, have been framed as a crowd-based and -driven questioning of established orders of finance and politics; similarly, the idea of the "unruly crowd" speaking on behalf of democracy also entered the discourse on the so-called Arab Spring, during which physical and virtual collectivities articulated their revolutionary concerns.[3]

In view of the mobilizing potential ascribed to new media technologies, it perhaps does not come as a surprise that there is an "elective affinity between social media and populism," in that the former provides the latter with "a channel for the populist yearning to 'represent the underrepresented', providing a voice to a voiceless and unifying a divided people" (Gerbaudo 746). As Paulo Gerbaudo points out, social media are indeed used (and seem to function) as "gathering spaces where the 'lonely crowds' produced by the hyperindividualism of neoliberal society could coalesce, where the atoms of the dispersed social networks could be re-forged into a new political community, into an 'online crowd' of partisan supporters" (750). Similarly, Bailo, in his study on the populist Five Star Movement (M5S), argues that "[t]he political relevance of multitudes derives first from their capacity to synchronise and act in a coordinated fashion" (6). He concludes that, in the case of M5S, its "spectacular rise [...] was made possible by two concurrent trends: a decline in political trust and a Cambrian explosion of individual information and communication technologies" (9).

The notion of the crowd, in the discourse on these forms of collective organization on- and offline, remains highly ambivalent: As Dean notes, some "crowd observers claim the crowd for democracy," while others, in line with historical discourses specifically from the nineteenth century, see in it "the extraordinary rebellion of the masses," characterizing the crowd as "brutal, primitive, even criminal, mobs" (6–7). For some, the crowd storming the Capitol on January 6, 2021, for instance, which was also coordinated through social media networks, bore resemblance to the mob that invaded the National Assembly after the elections in France

3 It is worth noting that the perception of forms collective organization as crowds is always depending on the historical and geopolitical context: As Schnapp and Tiews critically remark, "the face of contemporary multitudes has increasingly become a foreign face associated with conflicts in Asia, the Middle East, and Africa relayed to first world living rooms and bedrooms via electronic media" and that "even in the developing world, contemporary mass actions appear to have become more 'citational'—they quote, sometimes in a nostalgic key, from a previous, now irrecuperable heroic era of crowds" (xii). What might have been an accurate diagnosis in 2006, needs an update now, though, considering the recent rise of populism in Europe and the U.S., which has contributed to a renewed (discursive) presence and relevance of crowds.

in 1848 (Harison). For most, this was an undemocratic act of violence; for others, a heroic deed in the name of democracy.

The Crowd in Digital Media

Even without the affective momentum of physical co-presence that bears the potential to disturb the public order, digital environments have been regarded as sites for the emergence of crowds, providing the possibility "to coordinate temporarily with those of the same mind" (Vehlken 52). I.e., the networking capabilities of digital infrastructures enable a form of interconnectedness that allow users to feel strongly tied to a "certain cause" (Vehlken 49). Just like offline activities of, say, protest movements such as Fridays for Future or the Occupy movement(s), virtual collectivities—conceived of or represented as crowds—might also help "uncouple political, economic and social behavior from the structures of entrenched systems and social organizations such as nations, political parties and labor unions" (Vehlken 49).

Specifically due to the promise of participation inherent in new media, which, I believe, sustains their "uncoupling potential" (at least rhetorically), crowd discourse and its normative ambiguities can best be observed in exactly these environments. Practices of crowd-sourcing and crowd-funding, for instance, quite frequently emphasize the amateur-based creation of content as opposed to professional media production. In so doing, they may be said to constitute what Andreas Reckwitz has called "aesthetic or hermeneutic voluntary communities" (3), consisting of online contributors who are eventually integrated into the joint endeavor of sourcing or funding in and for an individual(ized) collective project. At the same time, the suggestion of alternative means of participation and representation in online environments, more often than not, goes hand in hand with a sense of political empowerment of "the many," unfolding in a specific crowd aesthetics, which compensates for the absence of the physical body through symbolic practices that display "crowdness."

The crowd-sourced media production *Star Wars Uncut*, for instance, illustrates this dynamic of crowd discourse and its formation of collective subjectivities. It is a collective remake of the 1977 *Star Wars* movie from 2010, in which 15-second segments of user-made scenes (or parts of scenes) were recombined to reproduce the entire movie. Immediately after its publication, *Star Wars Uncut* was praised as an example of the democratic character of new media environments and celebrated the crowd's creativity: The online magazine *Vulture* called it "the greatest viral video ever," arguing that "*Star Wars Uncut* is a collectively made work of postmodern folk art," and reviewers did not get tired of stressing the project's potential to offer an alternative to the monopolist tendencies of Hollywood mainstream cinema (Seitz).

As I have outlined elsewhere,[4] the collective endeavor of *Star Wars Uncut* both afforded and was given shape by a discourse which, at the time, focused on the reconceptualization of the "crowd" as a creative team, which, as Surowiecki illustrates in his influential book on *The Wisdom of Crowds*, is imagined to "yield results [...] that are broadly superior to the performance of any individual member of the group" (qtd. in Rouzé 17). The promise of the superiority of the collective, understood as an act of claiming one's right to the story of *Star Wars*, was made particularly meaningful through the creation of the opposition between Casey Pugh, the curator of the remake who acted "on behalf of the crowd," on the one hand, and Lucasfilm, the production company of the *Star Wars* movies as a representative of corporate media on the other.

On an aesthetic level, "the crowd" as a voice of the many articulated itself (and thus came into being as a collective subject in the first place) through an aesthetics of intermedial remixing, through which individual subjectivity was sacrificed for the larger idea of producing one single movie remake. Whereas the 15-second segments uploaded on the project's website did not make sense on their own (just because they were much too short to render a meaningful part of the story), they were edited by the project's curator Casey Pugh—a step which revealed the actual hierarchy of the project and dismantled its egalitarian rhetoric. The crowd, then, did not become visible through bodies and their mediatization on the streets, but was constituted through an aesthetics of bricolage that communicated, or rather produced the heterogeneity usually connected to the notion of the crowd. At the same time, though, the project valued each contribution by acknowledging the choices for a specific media technology in the process of remaking (e.g., "flash animation, Claymation, 3-D animation, old- and new-school video-game graphics, stop-motion-animated action figures and Lego characters and paper dolls, masked performers, and sock puppets" [Seitz]), which were not altered in the process of connecting the pieces of the puzzle. Moreover, the project offered as an incentive for individual participation the chance of being named in the movie's credits as a revenue for the intellectual and creative investment into the crowd's endeavor (thus, through the backdoor of what seemed to be an alternative to established logics of media entrepreneurship, installing a cost-benefits-scheme which also entailed a competitive dimension).

Interestingly, then, though the project featured the crowd as a collectivity, the members of which largely remained invisible, it also provided options of stepping out of an unknown and heterogeneous group of people. Indeed, while users were able to enjoy what Elias Canetti has called the moment of "discharge," i.e. a complete disappearance of hierarchy and difference in a moment of (felt) egality in the constitution of a crowd (18, see also Schmidt 46), it also provided them with a framework

4 My analysis of *Star Wars Uncut* in this contribution is partially reproduced from Butler, "On the Ethics and Aesthetics" and Butler, "The Audience".

for the production of individuality through their very specific creative input and the option of becoming visible (and thus stand out) to different degrees.

Another new media constellation which featured both the collectivity of the crowd and the individuality of its members was *The Johnny Cash Project*, an online platform designed by director Chris Milk and digital entrepreneur Aaron Koblin to create a video clip to Johnny Cash's song "Ain't No Grave" through crowd sourcing. Its aim, it says on the platform's website, was to commemorate the American country singer and its oeuvre. The project was described, or described itself, as participatory, as it argued that it creates "a living, moving, ever changing portrait of the legendary man in black" by collecting individually designed video clip frames, which are then put together to generate one coherent audiovisual narrative. The "mission statement" of the project, which can be found on the website, elaborates on the participatory nature and effects of the endeavor, emphasizes both the collectivity of content creators and their individual contributions: "The Johnny Cash Project," it announces, "is a global collective art project, and we would love for you to participate [...] Your work will then be combined with art from participants around the world, and integrated into a collective whole: a music video for 'Ain't No Grave,' rising from a sea of one-of-a-kind portraits."[5] The simultaneity of wholeness and one-ness is also reproduced through the videoclip itself, as it contains a short "making of"-story preceding the visual rendering of Cash's song, which features statements of contributors from all over the world and emphasizes the collective dimension of the project by giving both countries of residence and the frame number in a caption. In so doing, the "making of" enhances the tale of collective empowerment both fueled by the project and its discourse. At the same time, the contributors' statements, which seem to be randomly selected, highlight their individual relationships to Cash and thus produce the idea of "one-of-a-kindness."

The mode of interaction between user and website was highly determined and framed by a commercial logic—indicated by the self-identification of the endeavor as a "project" in the first place, which, in turn, addressed members of the crowd as what Steve Sammartino (*The Great Fragmentation*; *The Lessons*) has called "projecteers". Moreover, besides producing a Johnny Cash video clip, the project also served as a "showcase for the HTML5-friendly Google Chrome" introduced in 2008 and subsequently established as the most popular browser (Proctor and Maher). Finally, and in accordance with project's architecture, there were "terms & conditions" defining the limits of the collective's creativity. In this vein, then, Carolin Guertin, in her study on digital prohibition, has pointed out that *The Johnny Cash Project* was indeed "severely

5 All quotes in this paragraph taken from the original website www.johnnycashproject.com, which has been partially redirected to https://www.radicalmedia.com/work/the-johnny-cas h-project.

restrictive, permitting only a single kind of illustration—created in the project's own interface—to be used" (135).

Yet, whereas Guertin calls the project a "nonreflexive 'reflexive remix'" (135), other scholars at least partially reproduce and perpetuate the tale of collective empowerment that the project itself contributes to stimulating. Apart from Koblin himself, who extensively elaborates on *The Johnny Cash Project* in a TED talk about the creative use of crowd-sourced data,[6] Leigh Edwards, for instance, in his study on the *Triumph of Reality TV*, calls it "one exciting and lively example" of Pierre Levy's "collective intelligence knowledge model" (36). It might well be due to this ambivalent perception of the project, being considered both part of a "new business model" and an alternative epistemology, that it is featured as "best practice" in David Alan Grier's *Crowdsourcing for Dummies* and, at the same time, canonized in the "Moments of Innovation" archive of the Massachusetts Institute of Technology, where it is described as "part art project, part memorial, and part collaborative storytelling project—it continues to evolve today [...] users can still submit their images to the music video, making it a dynamic and continuous memorial to the man and his music."

Whereas the collective subjectivity of the crowd in crowd-sourcing activities such as *Star Wars Uncut* or *The Johnny Cash Project* is produced within narratives of co-creation, collaboration, and participation (even if reproducing a commercial logic) that, more often than not, is driven by a libertarian ideology, the crowd also appears as agent in rightwing (online) activism. In these contexts, the idea of the unruliness of the crowd and its unfiltered articulation of the people's will forms the semantic framework for the mobilization of politically motivated action. The crowds that emerge, then, "disturb liberal critics because they challenge the composition of the liberal subject—as a political being who possesses reason, intent and individuality" (Hussain).

Digital media allow for the formation of these crowds (or the formation of a discourse on them) online, sometimes even before physical bodies are gathering in the streets. In this sense, they serve as "preparatory media" which help crowds come into being (discursively, and physically). Before Trump supporters stormed the Capitol on January 6, 2021, social media had provided a platform for the articulation of dissatisfaction and the need to overcome the status quo. They served as media to represent individual claims, which, through algorithmic calculations, were connected to each other despite of their heterogeneity. Indeed, as Luke Munn argues in his study of the ultra-conservative social media service Parler, "networked media had already been working to provide it with 'just enough' cohesion, transforming it into a more

6 In his TED-talk, Koblin also refers to Surowiecki's *The Wisdom of Crowds* to underline the idea of collective creativity articulated through *The Johnny Cash Project*.

dangerous political body [...] bringing together an array of pro-Trumpian voices to form an imagined collective" ("More than a Mob").[7]

On an aesthetic level, this process of producing the crowd as collective subjectivity finds expression through listing and (re)combining hashtags, which at once render the diversity of the people involved, while also making connections. As Munn observes, "if these hashtags work to surface the post to different communities, they also function to stitch those communities together, to construct a collective identity. These tags are bridges between camps, asserting that, despite their obvious differences, there are some common ideals and shared interests" ("More than a Mob"). Moreover, the crowd was constituted by the sharing and circulation of memes through which political positions could be articulated in a highly condensed form, and which worked as a shorthand iconography of Trump supporters whose digital shitstorming dramatically turned into a physical and overtly violent storming of the Capitol.[8] Collective meme-production and circulation, however, not only turns out to be an element of crowd aesthetics, but also, as Carolin Wiedemann has shown in her study on forms of collective organization in digital environments, also entail a specific affective, or affecting, momentum. In her analysis of meme creation and circulation on 4chan, she argues that "the single actors become part of something bigger that they can't perceive during its development. That is where processes of affection are occurring" (181).

Crowdification: On the Production and Productivity of a Social Figure

I have argued that the re-emergence of crowd discourse at the beginning of the twenty-first century could be considered an effect of the co-occurrence of a growing mistrust in the established political institutions (specifically, but not exclusively in Western liberal democracies), the ensuing rise of populism and the emergence of social media as platforms of digital communication serving as "crowd fora" that help render this form of collectivity visible. This revival of the crowd and its discourse draws on the ambiguities inscribed into the crowd as signifier, which adds to its affective potential and makes it adoptable to different ideological frameworks and their narratives. In other words, a specific constellation of political, socio-economic and technological developments has afforded crowd thinking and speaking and thus constituted the crowd as a collective subject assigned with agency through being addressed and acknowledged as such.

7 See also Munn's *Red Pilled* for a comprehensive analysis of what he calls "digital hate" on social media.

8 For an analysis of the significance of memes for the U.S. American alt-right, see Woods and Hahner.

Through this perspective, which centers on "the crowd" as a signifier producing a specific form of collective subjectivity, the crowd appears as what Sebastian Moser and Tobias Schlechtriemen have called a "social figure," i.e., a figure that emerges in different historical constellations, functioning as an emblematic type which represents contemporary debates, issues, and experiences of a society in a highly condensed way (165; 171–3, my translation). As such, as Schlechtriemen argues, social figures form the "avantgarde of [a society's] diagnosed problems" in and through which ambivalent, if not contradictory, trends and tendencies are articulated (151, my translation). Borch, in his semantic history of the crowd in sociological research, argues along similar lines, pointing out that "the crowd may be seen as a diagnostic category: it offers a lens or prism on how sociology has observed modern society and its social and political constitution at different times" (15).

Against this backdrop, and instead of asking for a definition of the crowd or its characteristics, then, it might be worth focusing on processes of "crowdification,'" i.e., on the ways of producing the crowd, which, as a social figure, both constitutes a collective subjectivity and articulates imaginaries of political participation and representation. Accordingly, one may ask how the crowd is created (through discourse and practices) in a specific sociocultural, political, and/or economic environment. Who is addressed and thus constituted as "the crowd," how, and by whom? What are the media-technological, social, etc. circumstances in which collectivities are framed and become visible as "crowds"? What are their affordances that enable or stimulate processes of "crowdification" in the first place? As hinted at above, there have already been a number of endeavors that have begun mapping this field of investigating the production and performativity of crowd discourse (see, e.g., Borch; Schnapp and Tiews). Yet, I believe that the most recent convergence of political concerns and media-technological developments, which added to the appropriation of crowd discourse and crowding practices in both left-wing and right-wing political circles, still needs to be explored in further detail. Starting from these questions, then, may open up a perspective that will contribute to a more nuanced understanding of both crowd discourse and the use of crowding strategies in processes of political mobilization.

Works Cited

Bailo, Francesco. *Online Communities and Crowds in the Rise of the Five Star Movement.* Palgrave Macmillan, 2020.

Borch, Christian. *The Politics of Crowds: An Alternative History of Sociology.* Cambridge University Press, 2012.

Bruns, Axel. "The Future is User-Led: The Path towards Widespread Produsage." *The Fibreculture Journal*, vol. 11, no. 11, 2008, https://fibreculturejournal.org/fcj-066-

the-future-is-user-led-the-path-towards-widespread-produsage/. Accessed 30 November, 2023.

Butler, Martin. "On the Ethics and Aesthetics of 'Remaking' in Web 2.0 Environments." *Remakes and Remaking Concepts—Media—Practices*, edited by Rüdiger Heinze and Lucia Krämer, transcript, 2015, pp. 171–180. https://doi.org/10.1436 1/transcript.9783839428948.171.

—. "The Audience Strikes Back... or does it? Formations of Participation and the Figure of the Amateur in New Media Environments." *Participation in American Culture and Society*, edited by Philipp Löffler, Margit Peterfy, Natalie Rauscher and Welf Werner, Winter, forthcoming.

Canetti, Elias. *Crowds and Power.* Gollancz, 1962.

Dean, Jodi. *Crowds and Party.* Verso, 2016.

Edwards, Leigh H. *The Triumph of Reality TV: The Revolution in American Television.* Praeger, 2013.

"Fact Check: Trump overstates Crowd Size at Inaugural." *Fox News*, 22 January 2017, https://www.foxnews.com/us/fact-check-trump-overstates-crowd-size-at-inaugural. Accessed 15 March, 2023.

Gerbaudo, Paolo. "Social Media and Populism: An Elective Affinity?" *Media, Culture & Society*, vol. 40, no. 5, 2018, pp. 745–53. *Sage Journals*, https://doi.org/10.1177/0163 443718772192.

Grier, David A. *Crowdsourcing for Dummies.* Wiley, 2013.

Guertin, Carolyn. *Digital Prohibition: Piracy and Authorship in New Media Art.* Continuum, 2012.

Harison, Casey. "The Crowd in History and the January 6 Attack on the U.S. Capitol." *Age of Revolutions*, 2 January 2023, https://ageofrevolutions.com/2023/01/02/the-crowd-in-history-and-the-january-6-2021-attack-on-the-us-capitol/. Accessed 17 March 2023.

Hussain, Salman. "What Does 'the Crowd' Want? Populism and the Origins of Democracy." *Critical Legal Thinking*, 21 July 2017, https://criticallegalthinking. com/2017/07/21/crowd-want-populism-origin-democracy/. Accessed 14 March 2023.

Koblin, Aaron. "Visualizing Ourselves ... With Crowd-Sourced Data." *TED*, May 2011, https://www.ted.com/talks/aaron_koblin_visualizing_ourselves_with_cr owd_sourced_data/transcript. Accessed 14 March 2023.

Le Bon, Gustave. *The Crowd: A Study of the Popular Mind.* McMillan, 1895.

Moser, Sebastian, and Tobias Schlechtriemen. "Sozialfiguren—zwischen gesellschaftlicher Erfahrung und soziologischer Diagnose." *Zeitschrift für Soziologie*, vol. 47, no. 3, 2018, pp. 164–180, https://doi.org/10.1515/zfsoz-2018-1011.

Munn, Luke. "More than a Mob: Parler as Preparatory Media for the Capitol Storming." *First Monday*, vol. 26, no. 3, 2021, https://firstmonday.org/ojs/index.php/fm /article/view/11574/10077. Accessed 25 June 2024.

—. *Red Pilled: The Allure of Digital Hate*. Bielefeld University Press, 2023.

Proctor, Jennifer, and Brigid Maher. "Emotional Multiplicities in Multi-Sourced Work." *Database / Narrative / Archive: Seven Interactive Essays on Digital Non-Linear Storytelling*, edited by Matt Soar and Monika Gagnon, Dnaanthology.com. Accessed 17 March 2023.

Reckwitz, Andreas. *The Society of Singularities*, translated by Valentine E. Pakis. Polity, 2020.

Rouzé, Vincent. *Cultural Crowdfunding: Platform Capitalism, Labour and Globalization*. University of Westminster Press, 2017. *Directory of Open Access Books*, http://doi.org/10.16997/book38.

Sammartino, Steve. *The Great Fragmentation: And Why the Future of Business is Small*. Wiley, 2014.

—. *The Lessons School Forgot: How to Hack your Way Through the Technology Revolution*. Wiley, 2017.

Schlechtriemen, Tobias. "Sozialfiguren in soziologischen Gegenwartsdiagnosen." *Gegenwartsdiagnosen: Kulturelle Formen gesellschaftlicher Selbstproblematisierung in der Moderne*, edited by Thomas Alkemeyer, Nikolaus Buschmann and Thomas Etzemüller, transcript, 2019, pp. 147–166.

Schmidt, Florian A. *Crowd Design: From Tools of Empowerment to Platform Capitalism*. Birkhäuser, 2017.

Schnapp, Jeffrey, and Matthew Tiews. "Introduction: A Book of Crowds." *Crowds*, edited by Jeffrey Schnapp and Matthew Tiews, Stanford University Press, 2006, pp. ix-xvi.

Seitz, Matt Z. "The Fan-Made Star Wars Uncut is the Greatest Viral Video Ever." *Vulture*, 24 January 2012, https://www.vulture.com/2012/01/fan-made-star-wars-recut-is-the-greatest-viral-video-ever.html. Accessed 17 March 2023.

Surowiecki, James. *The Wisdom of Crowds*. Doubleday, 2004.

Vehlken, Sebastian. "Multimodal Crowd Sensing." *Reclaiming Participation: Technology—Mediation—Collectivity*, edited by Mathias Denecke, Anne Ganzert, Isabell Otto and Robert Stock, transcript, 2016, pp. 51–66.

West, Joel, and Jonathan Sims. "How Firms Leverage Crowds and Communities for Open Innovation." *Creating and Capturing Value through Crowdsourcing*, edited by Christopher L. Tucci, Allan Afuah, and Gianluigi Viscusi, Oxford University Press, 2018, pp. 58–96.

Wiedemann, Carolin. *Kritische Kollektivität im Netz: Anonymous, Facebook und die Kraft der Affizierung in der Kontrollgesellschaft*, transcript, 2017.

Woods, Heather Suzanne, and Leslie Hahner. *Make America Meme Again: The Rhetoric of the Alt-Right*. Peter Lang, 2020.

Affordance

Alexander Starre

The critical term "affordance" comes with its own set of affordances these days—at least when used in the context of academic literary studies. The terminology of affordances has mostly been attached to one camp in a lively, sometimes even fierce debate on methodology in the humanities during the height of the Coronavirus pandemic.[1] From this conceptual angle, the connection of affordances and collective agency figures strongly as it concerns the projected relationship of art works and other cultural products with their audiences. There are pronounced differences, however, in the way critics inquire into the conjoined questions of which types of collective agency aesthetic objects afford and which aesthetic forms may rise as a result of collective action. Rita Felski, one of the protagonists of this recent skirmish, has productively deployed the language of affordances in her advocacy of a new brand of postcritique.[2] Yet, the partly polemical appeal of Felski's postcritical program is not inherently bound up with the explanatory reach of the idea of affordances. In a broader context, Caroline Levine's adaptation of the affordance concept has likely done the most to turn this term into a spreadable notion in literary studies.[3] So spreadable, indeed, that Levine's "affordance formalism" has already received significant blowback.[4] This short essay looks beyond current method

[1] See Brasch and Starre on what has been dubbed the "method wars" and on the broader conversation regarding methodology in literary studies.

[2] See especially her most recent book *Hooked: Art as Attachment* (2020).

[3] Winfried Fluck has usefully discussed both Felski's *Limits of Critique* and Levine's *Forms* in a review essay in *American Literary History*. As Fluck describes, Felski's call for postcritical literary studies resonates with Levine's work, even though Levine does not explicitly frame her work as a form of postcritique: "If one asks what book provides the most convincing countermodel to critique, Levine's is often the book mentioned first" (231).

[4] In *Life-Destroying Diagrams*, Eugenie Brinkema takes issue with Levine's practice of reading for forms only "insofar as they can be instrumentalized for the sake of something else, converted into confirming the logic of the political or social" (259). Stressing her own approach of "radical formalism," Brinkema holds, "all affordance formalisms write around the great potential of reading for form, which is precisely that it neutralizes and suspends and disimplicates critical oppositions, inserts irresponsible difficulties, unsteadies, unseats, works over yes and even wrecks" (260).

debates, first sketching a brief history of the affordance concept in the humanities and then testing out its critical potential using several suggestive medial artifacts and aesthetic forms that emerged in the context of Black Lives Matter activism in the United States.

The ur-text for today's critical affordance discourse is James Gibson's brief chapter "The Theory of Affordances," published originally in 1979 in Gibson's collection *The Ecological Approach to Visual Perception*. Gibson, a psychologist and expert on the mind's processing of visual information, wrote in quite a blunt way about his development of the term: "The verb to afford is in the dictionary, but the noun affordance is not. I have made it up" (Gibson 127).[5] He originally theorized about this notion with regard to animals and their cognitive and behavioral interactions with the environment. In this context, "[t]he affordances of the environment are what it offers the animal, what it provides or furnishes, either for good or ill" (127). Gibson stresses that while environmental affordances certainly derive from material properties, they are still tied to the specific experience of each individual animal species and therefore emerge in between animal and environment:

> An important fact about the affordances of the environment is that they are in a sense objective, real, and physical, unlike values and meanings, which are often supposed to be subjective, phenomenal, and mental. But, actually, an affordance is neither an objective property nor a subjective property; or it is both if you like. An affordance cuts across the dichotomy of subjective-objective and helps us to understand its inadequacy. It is equally a fact of the environment and a fact of behavior. It is both physical and psychical, yet neither. An affordance points both ways, to the environment and to the observer. (129)

In this formulation, the notion of affordances becomes somewhat of a media-theoretical concept. It probes the material-semiotic sphere between objects in the world and their perceivers or handlers. As such, it appears like a short intellectual path from Gibson's modeling of animals and their surrounding objects to the interaction of humans and the media that surround them.

Before the concept ever entered literary and cultural studies in any substantive way, however, a few more decades passed. Donald Norman's book *The Design of Everyday Things*, originally published in 1988 and then revised and expanded in 2013, modified Gibson's framework and zeroed in on the human-made environment and the ways in which it suggests or forecloses certain types of behavior. Norman adapted "affordances" for the field of design and simultaneously popularized the concept with his succinct definition of affordance as the "relationship between a physical

5 The *Oxford English Dictionary* indeed credits James Gibson with the original coinage of the term, citing a paper by Gibson from 1966 as the first recorded instance ("affordance, n.", def. 2).

object and a person (or for that matter, any interacting agent, whether animal or human, or even machines and robots). An affordance is a relationship between the properties of an object and the capabilities of the agent that determine just how the object could possibly be used" (Norman 11).[6] Hardly any critical modeling of the term these days fails to integrate Norman's work.[7] In his book, Norman recounts how he developed his approach in close intellectual (and personal) exchange with James Gibson, with whom he ultimately disagreed on the perceptual and mental processes that influence human agency vis à vis the use of objects.

The big bang for the spread of affordance-thinking in literary studies arrived with Caroline Levine's book *Forms: Whole, Rhythm, Hierarchy, Network* (2015), perhaps the most widely read, discussed, and cited book of literary theory from the 2010s. Levine's critical intervention merges an interest in literary forms with the relational impulse of Gibson's and Norman's thinking, seeing affordances as "the potential uses or actions latent in materials and designs" (*Forms* 6). For Levine, affordance thinking usefully and strategically extends across aesthetic and political registers. For one, this merger appears urgent to Levine because it can rearticulate the literary and the social reach of various forms:

> Every form constrains, but it also enables—it capacitates. If an enclosed space shuts in and excludes, it also affords security and shelter, a desirable space away from noise and cold. If the welfare state needs to tag everyone with an identification number to make sure they receive adequate nutrition and healthcare, or if the university needs to establish a timetable to make sure that all classes can find spaces to meet, these are not only structures of domination: they are forms that enable collective health and education. ("Not Against" 257)

One can see here how, rhetorically, Levine coordinates constraints and potentialities via the notion of affordance. For another, Levine claims that thinking in terms of affordances injects new energy into progressive political action *and* socially engaged literary criticism. Thereby, literary hermeneutics may become a tool translatable to the study of collective agency in non-literary domains: "To my mind, then, the value of literary studies lies not in our objects but in our methods, which we can bring to

6 For an up-to-date and comprehensive overview chronicling the rise of affordance thinking in design studies, see Davis's chapter "A Brief History of Affordances" in her book *How Artifacts Afford* (25–43).

7 While Levine pays her debts to Norman only in a brief footnote (Levine, *Forms* 152, fn. 15), studies by Serpell and Dahn, who expand on Levine's work, discuss Norman's influence more explicitly (see Dahn 9–10; Serpell 21–22). Serpell also notes that Eleanor Gibson, James Gibson's wife, published work that applied the theory of affordances to the psychology of reading and the formal features of text (Serpell 22; 315, fn. 85).

many urgent sites of injustice, from prison systems to climate change and from ur-
ban inequality to contemporary racism" ("Not Against" 257). The path outlined here
has recently taken Levine towards questions of ecological sustainability, leading to
suggestive revaluations of literary forms, e.g. novelistic happy endings, which sud-
denly appear to offer a viable aesthetic response to the biospheric pressures of the
Anthropocene. In the nonfiction narrative of Matthew Desmond's *Evicted*, a prize-
winning and widely read sociological account of poverty and homelessness in the
U.S., Levine locates a model of a "collective happy ending," arguing that this is "pre-
cisely the aesthetic form that we need most urgently now, in this age of mass pre-
carity" ("Not Against" 259).[8]

I would argue that it is no coincidence that Levine uses a sociological account as
one of her key examples for an agentic narrative form. In her book *Forms*, she had al-
ready resorted to the quasi-sociological vision of the television series *The Wire* as the
network-narrative that best represents her literary-theoretical investments. In the
concept of affordances and the operative term "to afford," scholars like Levine, Felski,
and Serpell have found a fitting rhetorical tool that can be used to tie together aes-
thetics and agency. Deployed in this form, the concept steers clear of several forms
of determinism: text determinism (i.e., the notion that the literary text implants its
meanings directly in the reader, often associated with the New Criticism); reader
determinism (i.e., the notion that active readers can bend textual meaning in sur-
prising ways, as reader-response criticism or British Cultural Studies stressed); or
finally technological or medial determinism (i.e., the paradigm of McLuhanite me-
dia studies, which sees the phenomenal form of carrier media trump their ideational
content). Affordance thinking thus complicates critical accounts that accord direct
political agency to texts just as much as it curtails conceptions of agency exclusively
attuned to anthropocentric understandings of social and cultural environments.

With regard to distinct twenty-first-century developments at the intersection of
aesthetics and collective agency, the evolving media constellations in the field of cul-
tural production and consumption appear as perhaps the most decisive sea change.
As I have written elsewhere, the affordances of print media have shifted consid-
erably—in Gibson's relational fashion—since screens have become the ubiquitous
medium of display and dispersion (see Starre, *Metamedia*). Where some forms of
printed communication, for example pamphlets and periodicals, have afforded
greater flexibility and spreadability across the nineteenth and twentieth century
than the codex book, the introduction of cell phones and tablets has mobilized
textual communication even further, such that a printed copy of a daily newspaper
today possesses wholly different medial affordances than one produced in the 1990s.
In turn, digitization has allowed scholars to see previous communication systems

8 For another consideration of Desmond's work and its relevance for literary and cultural stud-
 ies, see Starre, "Thick Description."

in a differential light, highlighting in a much clearer fashion the affordances of "old" media that can now be studied anew. Eurie Dahn's work on the magazine networks of the Jim Crow era is an excellent example of this trend in scholarship. Building on Norman's and Levine's affordance concepts, Dahn outlines the medial constraints and possibilities that periodicals embody: "Periodicals by their very form explicitly [...] afford [a] non-linear mode of reading and overall fluidity via tables of contents that offer the option to pick and choose what the reader might read and in what order. [...] Periodicals also afford non-linearity through the incorporation of calls to turn to certain pages to read the endings of various articles and insertions of advertisements that often interrupt articles, both visually and narratively" (11). As Dahn further explains, the network structures inherent in magazine production demand models of distributed agency on the part of critics.

As we have seen, affordance thinking has triggered renewed interest in the distribution of agency among various mediators (to use Bruno Latour's terminology) in the process of social (and aesthetic) communication. Yet how can we scale up this framework to the unprecedented levels of collective agency that became visible and readable in the digitally enhanced social movements of the twenty-first century, from Black Lives Matter to Fridays for Future?

For one, I would suggest, Dahn's historical insights into the network-building affordances of print magazines also apply in the age of social media. One of the most crystallizing and polarizing flashpoints of the recent reckoning with the legacies of slavery and racial domination in the United States took the form of a magazine: the hotly debated special issue of the *The New York Times* called the "1619 Project," published in 2019 to commemorate the 400th anniversary of the arrival of the first ship carrying enslaved Africans in the colony of Virginia. The whole project—spanning across the Sunday, August 18, 2019 edition of the *NYT* and including an extended, lavishly designed online feature on the newspaper's website—is an instructive case study in the affordances of medial objects in a multimedia ecology. Conceived by the journalist Nikole Hannah-Jones, the 1619 Project's core is a special issue of the *NYT Magazine*, which comprises a framing essay by Hannah-Jones, several historical and critical pieces by experts and columnists such as Matthew Desmond, Linda Villarosa, Kevin M. Kruse, Jamelle Bouie, and a "literary timeline" featuring creative works by contemporary Black artists and writers reacting to historical events or notable figures. In the age of printed mass magazines at the beginning of the twentieth century, the periodical form stood as the mobile, flexible, somewhat fleeting medial counterpart to the steady print culture of the book. Periodicals in the age of Jim Crow, as described by Dahn, were instrumental in creating and sustaining translocal networks of Black readers and Black activists. In today's hybrid social movements that pair "old" forms of public protest in the street with "new" forms of digital networking and hashtag activism, the form of the printed magazine carries a different set of affordances. The 1619 Project solidified and archived the public reckoning with

the legacy of race in the U.S. in the late 2010s. Then, in the aftermath of the George Floyd murder and the even more widespread Black Lives Matter protests in 2020, the 1619 Project became part of a national conversation and a fierce symbolic struggle surrounding the 2020 presidential election.

Approaching the 1619 Project as a literary scholar from the angle of affordances, one would neither exclusively seek to analyze individual essays, visual items, or poems in the magazine (though close readings remain important micro-level components). Nor would one solely attempt to measure the magazine's impact with relation to what it says about or does to some grand, abstract entity like "U.S. society." Rather, a critical account of the magazine's affordances would address the meso level (in Simone Murray's terms) or the midlevel scale (in Rita Felski's terms).[9] In its institutional and medial framing, the 1619 magazine certainly aims to foster collective agency. On its final pages, it features a message to educators, pointing them to a dedicated website at the Pulitzer Center that includes lesson plans, historical resources, suggestions for activities. Furthermore, the Pulitzer website contains a downloadable PDF of the entire magazine, suggesting that the contents can be spread free of charge and outside of the *New York Times* paywall. On the aesthetic side, another insert to the *NYT* special edition deserves notice: a sixteen-page insert formatted in the traditional broadsheet paper dimensions, featuring visual reproductions of items from the Smithsonian's National Museum of African American History and Culture. This expansive format is underscored by its front page, which features a reproduction of a broadside print from 1858, advertising a slave auction in New Orleans. Superimposed across this striking image is a slogan from the late historian John Hope Franklin reading "We've Got to Tell the Unvarnished Truth." The slogan is rendered in a glaring yellow font, replicating the slab-serif lettering of the slave auction broadside. In this aesthetic format, the magazine affords a reflexive confrontation with the print culture of the American slave system. The mediated historical forms of American racial subjection collide with a contemporary media product geared towards progressive historical revisionism and racial justice. The *NYT* 1619 Project, we may conclude, figured as a materialized node in the Black Lives Matter moment of contemporary US politics.[10] In triggering both progressive and reactionary responses, the mass-produced and widely circulated print object briefly syn-

9 See Felski, *Hooked* 144–45 as well as Murray, "Varieties".

10 In his ecological theory of political organization, Rodrigo Nunes holds that non-hierarchical collectives can benefit from "nodes or groups of nodes that animate an area or network, performing the function of concentrating the collective capacity to act in certain directions" (203). From the angle of media affordances, I would submit that it is not just groups of people or organizations which can fill this node position, as Nunes suggests, but also aesthetic objects. In her chapter in this volume, Simone Knewitz expands on the conceptual benefits of Nunes's work for modeling collective agency.

chronized the multifarious public conversations and offered a sustained attempt at shaping collective identity (e.g. in the emphatic "we" of Hannah-Jones's lead essay).

As a literary scholar with an interest in print culture and the institutional frameworks of American literary history, I find myself drawn towards similar moments during which we can observe the coalescing of collective agency (a really difficult phenomenon to track) into more ordered and recognizable communities and groups. Murray's description of the "mid-level" in the twenty-first-century literary field is on point in this regard: "[I]n the literary studies context, the various institutions of authorship, publishing, retailing, reviewing, and readership provide compelling 'mid-level' analytical frames for compiling thick descriptions of precisely how digital media are fundamentally reconceptualizing literary culture" (par. 8). There are multiple ways in which the Black Lives Matter moment has been reshaping the American literary field, running the gamut from a renewed interest in Black literary history, to increased diversity efforts at publishing houses, and to new bookselling strategies attuned to "books about race."[11] At the intersection of social activism and U.S. literary culture (or at least: reading culture), the past few years have seen the emergence of two closely related, crowd-driven forms that afford specific forms of aesthetic engagement and collective agency: the hashtag syllabus and the antiracist reading list.

In August 2014, the city of Ferguson, Missouri was reeling from the aftermath of the fatal shooting of Michael Brown by police officer Darren Wilson. The nightly unrest on the streets of Ferguson was met with a fierce response by local police, which employed military-style tactics and equipment. The scene became a media event and it sparked the Twitter campaign #FergusonSyllabus to pair direct forms of activism with a reading-centered approach, initiated by Marcia Chatelein, a history professor at Georgetown University.[12] After several more horrific instances of racialized violence in the years after Ferguson, the hashtag syllabus became a recognizable form, for example in the most formally ambitious hashtag syllabus: the Charleston Syllabus, conceived in 2015 by Chad Williams and Keisha N. Blain in response to the white supremacist terrorist attack at a Black church in Charleston, South Carolina. Since then, further U.S.-American hashtag syllabi emerged to address momentous concerns and events, such as the Black Lives Matter movement, the Trump presidency, and Indigenous resistance to a pipeline on native land (#StandingRockSyl-

11 On the peculiar marketing strategies regarding "books about race" in the U.S., see McGrath.

12 In an essay in *The Atlantic*, Chatelein remembers how she started this activity: "My idea was simple, but has resonated across the country: Reach out to the educators who use Twitter. Ask them to commit to talking about Ferguson on the first day of classes. Suggest a book, an article, a film, a song, a piece of artwork, or an assignment that speaks to some aspect of Ferguson. Use the hashtag: #FergusonSyllabus."

labus).[13] These digitally curated syllabi are not merely imitations of collegiate documents, as Alyssa P. Lyons summarizes:

> Unlike the syllabi found in your typical college classroom, hashtag syllabi are found on the internet and are user-generated, crowdsourced, and strive to be open-access. Hashtag syllabi are often compiled by people inside and outside of the academe, including activists and scholars and are often People of Color, women, and other minoritized peoples. Some associate the open access aspect of the hashtag syllabi to imply low quality or not peer-reviewed academic work. In reality, this allows users—members of the broader public—to read, access, sometimes modify, and contribute to the works contained within the syllabi. (17)

Lyons stresses the process-driven, somewhat messy quality of these born-digital syllabi, which sets them apart from the carefully worded and intricately structured documents distributed to students on the first day of class on campus.

In the aftermath of the George Floyd protests of 2020, a much tidier, but also often collectively authored format emerged alongside the hashtag syllabus: the antiracist reading list. The writer and activist Ibram X. Kendi had already published an antiracist reading list in the *New York Times* in May 2019. In 2020, a slew of American institutions followed Kendi's lead, with colleges, publishers, non-profits, and other cultural institutions offering up similar reading lists.[14] While many of these lists lean heavily on historical and sociological accounts, most of them also accord considerable space to poems, novels, or memoirs. While it would be a worthwhile undertaking to consider the *contents* of these syllabi and lists, I wish to briefly inquire into what it would mean to ask for the *affordances* of hashtag syllabi and antiracist reading lists in today's media culture.

As Eva von Contzen has usefully argued, lists have been a feature of script and print culture for a very long time. Yet despite the historical stability of this specific textual format, the affordances of lists have undergone considerable evolution, driven by the changing media environment in which lists are produced. A central affordance of the list format, according to von Contzen, lies in its practical familiarity to readers (322–23). Lists, as compared to more complex aesthetic forms, are mundane, everyday objects that permeate our lived routines (the shopping list, the to-do list, the invitation list ...). What is more, in the digital sphere, lists function as the antidote against the informational sprawl contained in the "feeds" of social media and

13 For further references and resources, see Caldwell.

14 The following lists appear somewhat representative of the proliferating antiracist reading lists in the United States: "Anti-Racist Books and Resources for Our Readers" by Penguin Random House; "Racial Justice, Racial Equity, and Anti-Racism Reading List" by the Harvard Kennedy School; "Schomburg Center's Black Liberation Reading List" by the New York Public Library.

news websites: compare the endlessly refreshing stream of Twitter to the brevity and precision of a list of top ten books or films. In this complexity-reducing precision, lists have a paradoxical effect on readers: on the one hand, they exude a seemingly democratic ethos ("you could write a list like this, too"); on the other, they inherently make a claim to authority ("this list of the best books is superior to all other lists").

The antiracist reading list, and by extension the hashtag syllabus, combine the practical affordances of the list with an ethos of reading. As Ibram X. Kendi described the goals of his reading list: "To build a nation of equal opportunity for everyone, we need to dismantle this spurious legacy of our common upbringing. One of the best ways to do this is by reading books." While Kendi and others carefully present their reading lists as provisional and limited, the formal affordances of the list point in another direction: a list with five, or ten, or fifteen books nudges the recipient of these recommendations to treat it like a checklist. In the form of the syllabus, this inherent affordance becomes even clearer: One cannot master a proposed course of study if one does not do the reading. The list carries another affordance: its itemized structure suggests to the list-user that the items on it will fulfil a unified purpose—in this case, further an antiracist education. By the same token, the list form conceals the divergent individual features of its items—and this is especially consequential with regard to aesthetic differences.

Lauren Michele Jackson has criticized antiracist reading lists for their pernicious genre blending:

> [E]ssays slide against memoir and folklore, poetry squeezed on either side by sociological tomes. This, maybe ironically but maybe not, reinforces an already pernicious literary divide that books written by or about minorities are for educational purposes, racism and homophobia and stuff, wholly segregated from matters of form and grammar, lyric and scene. Perhaps better to say that in the world of the anti-racist reading list genre disappears, replaced by the vacuity of self-reference, *the anti-racist book*, a gooey mass.

Jackson points out that the innovative formal features and the complex rendering of language and subjectivity in Toni Morrison's *The Bluest Eye*—a perennial favorite on such lists—may get completely lost in the checklist framing of antiracist reading. Conversely, the ubiquity of these reading lists and the urgency with which they have been circulated in recent years have opened up a broad segment of the market for Black authors and authors of color, propelling Claudia Rankine, Ta-Nehisi Coates, Michelle Alexander and others to the top of the bestseller list. As such, these lists have afforded considerable collective agency, although perhaps in a less explicitly political, than in a commercial way. Nevertheless, the sense of collective identity engendered by the idea of being part of a collective of "antiracist readers" cannot be completely dismissed, even if it overlaps with the market dynamics of U.S. publish-

ing. After all, the radical potential of suggesting or circulating reading materials has long been part of American civil rights movements, from abolitionist pamphlets in the nineteenth century to the bibliographies compiled for the NAACP magazine *The Crisis* under the editorship of W.E.B. Du Bois in the early twentieth century.

In a final twist, these contemporary syllabi and lists export their educational ethos outward from the academy into the public. On campus, the syllabus does not just guide student learning, it also fulfils the functions of a contract between instructor and student and of a permanent institutional record, as Jay Parkes and Mary B. Harris have argued. In the digital reading public, the hashtag syllabus is not contractual; yet it attempts to interpellate a wide array of readers as students. In the U.S. context, this projected expansion of the culture of the school coincides with dwindling numbers of humanities majors and with sustained attacks on humanities education by conservative state governments. Seen as a permanent record, the sprawling archive of reading lists provides a glimpse into the work of canonization under the dictates of a digital attention economy.[15] According to Jackson, the affordances of the reading list severely curtail the aesthetic potentials of Black literature. Nevertheless, these lists and syllabi can also be seen as a strategic attempt by academic readers to foster a para-academic culture of reading that transcends the walls of the neoliberal university. This would entail a much more inclusive sense of canon formation than the one incorporated in the traditional college curriculum. The "rhetorical agency" that allows one to write in an articulate form and effect change through participation in public discourse is of necessity an individualist entity, especially when tied to the legal status of authorship.[16] The act of reading, a likewise solitary endeavor often associated with passivity, has the potential to be reshaped by new forms of curation, aggregation, and medial dissemination into a crucial practice contributing to the formation of collective agency outside of traditional institutions.

Works Cited

"The 1619 Project," special issue of *The New York Times Magazine*, 18 August 2019.

Brasch, Ilka, and Alexander Starre. "Method as Practice." *Amerikastudien/American Studies*, vol. 67, no. 1, 2022, pp. 5–34, https://doi.org/10.33675/AMST/2022/1/4.

Brinkema, Eugenie. *Life-Destroying Diagrams*. Duke University Press, 2021.

15 As John Guillory has argued, a syllabus is never actually outside the logic of canonicity: "Changing the syllabus cannot mean in any historical context overthrowing the canon, because every construction of a syllabus institutes once again the process of canon formation" (31).

16 See Campbell for an influential rhetorical framing of agency that also stresses collective and participatory dimensions.

Caldwell, Ellen C. "Teaching Trump: The Rise of the Crowd-Sourced Syllabus." *JSTOR Daily*, 1 December 2016, https://daily.jstor.org/teaching-trump-rise-crowd-sou rced-syllabus/. Accessed 1 October 2023.

Campbell, Karlyn Kohrs. "Agency: Promiscuous and Protean." *Communication and Critical/Cultural Studies*, vol. 2, no. 1, 2005, pp.1-19, https://doi.org/10.1080/14791 42042000332134.

"#Charlestonsyllabus." *African American Intellectual History Society*, 19 June 2015, https ://www.aaihs.org/resources/charlestonsyllabus/. Accessed 1 October 2023.

Chatelain, Marcia. "How to Teach Kids About What's Happening in Ferguson." *The Atlantic*, 25 August 2014, https://www.theatlantic.com/education/archive/2014/ 08/how-to-teach-kids-about-whats-happening-in-ferguson/379049/. Accessed 1 October 2023.

Dahn, Eurie. *Jim Crow Networks: African American Periodical Cultures*. University of Massachusetts Press, 2021.

Davis, Jenny L. *How Artifacts Afford: The Power and Politics of Everyday Things*. MIT Press, 2020.

Felski, Rita. *Hooked: Art and Attachment*. University of Chicago Press, 2020.

Fluck, Winfried. "The Limits of Critique and the Affordances of Form: Literary Studies after the Hermeneutics of Suspicion." *American Literary History*, vol. 31, no. 2, 2019, pp. 229–48, https://doi.org/10.1093/alh/ajz003.

Gibson, James Jerome. "The Theory of Affordances." *The Ecological Approach to Visual Perception*, Lawrence Erlbaum, 1986, pp. 127–37.

Guillory, John. *Cultural Capital: The Problem of Literary Canon Formation*. University of Chicago Press, 1993.

Jackson, Lauren Michele. "What Is an Anti-Racist Reading List For?" *Vulture*, 4 June 2020, https://www.vulture.com/2020/06/anti-racist-reading-lists-what-a re-they-for.html. Accessed 1 October 2023.

Kendi, Ibram X. "Ibram X. Kendi's Antiracist Reading List." *The New York Times*, 29 May 2019, https://www.nytimes.com/2019/05/29/books/review/antiracist-read ing-list-ibram-x-kendi.html. Accessed 1 October 2023.

Levine, Caroline. *Forms: Whole, Rhythm, Hierarchy, Network*. Princeton University Press, 2015.

—. "Not Against Structure, but in Search of Better Structures." *American Literary History*, vol. 31, no. 2, 2019, pp. 255–59, https://doi.org/10.1093/alh/ajz005.

McGrath, Laura B. "'Books About Race': Commercial Publishing and Racial Formation in the 21st Century." *New Literary History*, vol. 54, no. 1, 2022, pp. 771–94, https://doi.org/10.1353/nlh.2022.a898329.

Murray, Simone. "Varieties of Digital Literary Studies: Micro, Macro, Meso." *Digital Humanities Quarterly*, vol. 16, no. 2, 2022, http://www.digitalhumanities.org/dh q/vol/16/2/000616/000616.html. Accessed 25 June 2024.

Norman, Donald A. *The Design of Everyday Things*. Basic Books, 2013.

Nunes, Rodrigo. *Neither Vertical nor Horizontal: A Theory of Political Organisation*. Verso, 2021.

Parkes, Jay, and Mary B. Harris. "The Purposes of a Syllabus." *College Teaching*, vol. 50, no. 2, 2002, pp. 55–61, https://doi.org/10.1080/87567550209595875.

Pulitzer Center: 1619 Project, https://1619education.org/. Accessed 1 October 2023.

Serpell, Namwali. *Seven Modes of Uncertainty*. Harvard University Press, 2014.

Starre, Alexander. *Metamedia: American Book Fictions and Literary Print Culture after Digitization*. University of Iowa Press, 2015.

—. "Thick Redescription: Narrating Sociocultural Forms with Matthew Desmond's *Evicted*." *Culture²: Theorizing Theory for the Twenty-First Century*, edited by Frank Kelleter and Alexander Starre, transcript, 2022, pp. 249–62.

von Contzen, Eva. "Die Affordanzen der Liste." *Zeitschrift für Literaturwissenschaft und Linguistik*, vol. 47, no. 3, 2017, pp. 317–26, https://doi.org/10.1007/s41244-017-0062-6.

Williams, Chad Louis, Kidada E. Williams, and Keisha N. Blain, editors. *Charleston Syllabus: Readings on Race, Racism, and Racial Violence*. University of Georgia Press, 2016.

Genre

James Dorson

This essay addresses the affordances of genre fiction for thinking the collective. Before I do so, however, let us first take a brief detour into the Mojave Desert. In Alexandra Kleeman's dystopian novel *Something New Under the Sun* (2021), a writer from New England goes to Hollywood to assist with the film adaptation of his first novel, but quickly discovers that things are off-kilter. For one, California seems to be caught in a perpetual cycle of drought and wildfires, the landscape everywhere "burning and burnt" (89). Moreover, in response to water scarcity, the real thing has been replaced by a privatized, synthetic substitute called WAT-R that monopolizes the state's water supplies. What really irks the writer, however, is neither the omnipresent fires nor that real water has become a luxury few can afford, but that his autobiographical novel, which he describes as "an exploration of how the memory of a person, which is like a ghost in its way, can live on in the present and the future" (34), has been turned into a literal ghost story by the screenwriter, replete with demons and "supernatural baddies" (58). And the writer himself fares no better than his work. Just as his earnest novel is transformed into mass market pulp, the literary writer also succumbs to a kind of horror, a mysterious dementia that appears to be a secret side effect of drinking WAT-R. At the end of Kleeman's novel, the author-protagonist is rendered speechless and near-catatonic by the new disease before disappearing into the Mojave Desert never to be heard from again.

The death of the literary author (not incidentally white, male, and middle-aged) as well as the displacement of his serious (or at least self-important) novel by genre fiction is an apt allegory of the contemporary literary marketplace. Since the turn to genre of highly acclaimed authors like Cormac McCarthy and Kazuo Ishiguro helped make popular genres newly respectable among the literary establishment, the literary field has been transformed by two developments: on the one hand, the rise to literary fame of a younger generation of writers from Colson Whitehead to Ling Ma (both innovators of the zombie apocalypse) renowned for their mixing of popular genre conventions (action-driven plots and futuristic or fantastic elements) with techniques more commonly associated with highbrow fiction (complex characters, figurative language, lyrical descriptions); and, on the other hand, the literary consecration of a number of unapologetic genre writers from Ursula K. Le Guin and

Octavia Butler to more recent authors like Paulo Bacigalupi and N. K. Jemisin, now embraced by cultural institutions that formerly shunned genre fiction.[1] While genre fiction for most of the twentieth century occupied a marginal position in the literary field as the commercial and formulaic Other to the more rarified products of modernism, this turn to popular genres has been yet another nail in the coffin of what Andreas Huyssen called "the Great Divide" between modernism and mass culture, whose boundaries had already been strained, if not abrogated, by postmodernism's playful appropriation of popular forms.[2] But unlike the postmodern use of genre conventions, the most recent turn to genre has been less about upending the hierarchies of high modernism than about challenging what counts as realism when the perceived regularities of everyday life are disrupted by the polycrisis of the present. The twenty-first-century return of geopolitical and financial instability, largescale protest movements, and rightwing populism in the wake of the relative stability of the 1990s, as well as the planetary threats of the climate emergency, the Sixth Mass Extinction, and the COVID-19 pandemic have replaced the manufactured sense of history's end with a new sense of dangerously accelerating change. And if the center cannot hold, nor can the literary strategies used to represent it. Writers today are turning to popular genres not in order to question positivistic attempts at grasping objective reality, as their postmodern predecessors did, but to represent an altered state of reality. Genre fiction no longer signifies the escapist delusions imposed on the masses by the culture industry (as it did for the modernists), nor a subversive potential for antirealism liberated from the hierarchies of elite culture (as it did for postmodernists), but "the realism of our times," as Kim Stanley Robinson says about sci-fi ("Realism"). If there is something new under the sun, as Kleeman's novel intimates, genre fiction is one of our culture's chosen ways of grappling with it.

1 By "unapologetic" genre writers, I mean genre fiction that is not marked or marketed as a literary adaptation of popular forms, in contrast, e.g., to the marketing of Whitehead's *Zone One* (2011) as a "zombie novel *with brains*" (my italics), as the tagline on the cover reads. For more on the much-noted "genre turn," see Lanzendörfer; Martin; Dorson; Hoberek, "Introduction" and "Literary Genre Fiction"; and Kelly. For a dissenting view on the genre turn that sees the divide between literary and popular fiction as still very much intact, see Rosen, "Literary Fiction". My point here is not to argue that all distinctions are gone—which clearly is not the case—but rather to address the affordances of popular genres for thinking the collective.

2 For an account of the difference between the postmodern use of genre fiction and the present turn to genre, see, e.g., Hoberek: "[T]here is a difference between the transitional but still self-consciously 'literary' appropriation of popular genres in the work of authors like Barth and Pynchon [...] and a newer tendency to confer literary status on popular genres themselves" ("Introduction" 237–238). While McGurl describes the use of popular genre conventions by postmodernist authors as "meta-genre fiction, where a popular genre—romance, western, science fiction, fantasy and detective fiction—is both instantiated and ironized to the point of becoming dysfunctional in the production of its conventional pleasures" (217), this is clearly not the case for the "unapologetic" genre writers I will be considering here.

As I argue here, the new respectability of popular genres is not only symptomatic of a dissatisfaction with established literary strategies for representing an altered state of reality, but also suggests new possibilities for imagining collective responses to the crises we face. In *The Great Derangement* (2016), Amitav Ghosh's influential censure of what he refers to as "serious" or "literary fiction," Ghosh calls the contemporary novel to task for ignoring the existential threats of climate change as well as for focusing on the individual psyche at the expense of the collective. "[W]hat is banished from the territory of the novel is precisely the collective" (78), he argues, with the consequence that "at exactly the time when it has become clear that global warming is in every sense a collective predicament, humanity finds itself in the thrall of a dominant culture in which the idea of the collective has been exiled from politics, economics and literature alike" (80). And yet Ghosh's own exiling of genre fiction as a viable alternative to literary fiction's limited range of tools for representing climate change and "the idea of the collective" required for mitigating it already seems positively dated.[3] Not only has the genre turn unsettled the rigid opposition that Ghosh sets up between literary and genre fiction, but Ghosh's desire to expand the repertoire of realism to include visions of the collective ignores how genre writing has always been more hospitable to collective imaginaries than its more reputable counterparts. By honing in on two critical aspects of genre fiction here—institutionality and different temporalities—the aim of the following is to sketch out some possibilities that render genre fiction particularly amenable to "the idea of the collective."

Institutionality

Mark McGurl has influentially described the institutionalization in postwar creative writing programs of a high modernist aesthetic centered around authorial self-expressivity, and therefore opposed to all generic forms, as the *"institutionalization of anti-institutionality"* (221; original italics). The challenge to this expressive model of writing by the genre turn in contemporary fiction consequently marks a cultural shift in our relation to institutional logics. Like the new formalism in literary criticism pioneered by Caroline Levine and others, which reconsiders the constraints of form as enabling rather than merely confining, genre theory also recognizes the productivity of constraints. Defining genre as "a set of conventional and highly organised constraints on the production and interpretation of meaning," John Frow observes how "[g]eneric structure both enables and restricts meaning, and is a basic condition for meaning to take place" (10). The reappraisal of popular generic conventions today thus signals a shift away from a Romantic-modernist view of formal constraints as inhibiting creative expression to one that views genre as gener-

3 See Bould on Ghosh's neglect of popular genres.

ative of new possibilities. Instead of searching for new expression outside of institutionalized forms, the genre turn acknowledges that expression can be innovated from within established patterns. Self-consciously drawing on generic conventions replaces the Romantic myth of artistic genius—traditionally coded as male (with women performing the passive role as muse) and famously likened by Harold Bloom to the oedipal struggle to break with the past—with a more collaborative model of literary production.[4] In contrast to the ingrained belief in post-Romantic Western culture that authentic expression comes from within the iconoclastic subject, genre fiction entails a model of literary production that by definition is relational. Readers make sense of a detective or science fiction story against a horizon of expectations defined by conventions particular to that genre. While this may be true of any text—after all, realism also only makes sense in relation to established conventions that shape reader expectations of what constitutes reality—genre fiction, through textual as well as paratextual markers, explicitly calls attention to its kinship with a group of similar texts. Unlike realist texts that refer to a probabilistic conception of reality, or modernist texts measured by their authorial authenticity, or even postmodernist texts that indiscriminately refer to other texts regardless of their genre, genre fiction first and foremost refers to other texts of the same genre. Signifying differently than the text-reality nexus of realism, the text-author nexus of modernism, and the text-text nexus of postmodernism, meaning in genre fiction is thus primarily generated in the relationship between the particular text and the general genre to which it belongs.[5]

This constitutive relationship of genre fiction between part and whole entails a cultural departure from the "society of singularities" (Reckwitz) that valorizes the particular over the general, the individual over the institution. This is not to say, of course, that individualism is not inscribed into particular genres. The adventure story and its generic mutations into the Western or hardboiled detective fiction are all characterized by the lone hero opposed to society. Jeremy Rosen observes that "the common features that constitute a genre's central conventions convey a shared social logic" (*Minor Characters* 7). In the case of the recent genre of "minor-character elaboration" that he identifies, where minor characters of canonical texts are made the protagonists of their own story, Rosen is no doubt right to argue that it contributes to the "liberal individualist project" (26). At the same time, the "social logic" of a particular genre always also coexists with the formal logic of genre as such, in which a text is never alone but always exists within a textual community held together by shared genre markers. Genres always point "outward, toward other gen-

4 On the gendering of high culture as male and popular culture as female, see chapter 3 of Huyssen, "Mass Culture as Woman."

5 For how genres are further rendered legible by their differential relationship with other genres, where the whole of one genre becomes a part of the larger genre system, see Cohen.

res, kindred practices" (42), as Rosen also notes. When it comes to genre not only is there no forest without trees, but there are no trees without a forest. If individuality is inscribed into particular genres, we might then say that collectivity is inscribed into the very concept of genre. And the kind of reading practices that genre fiction demands, where meaning is produced in the relationship between part and whole, models a very different social logic than, say, the survivalism of much dystopian YA fiction today.

A form of sociality in which the part is subsumed by the whole has for good reasons been rendered suspect by the twentieth century's traumatic experiments with totalitarian forms of collectivity. But the collectivist logic inscribed into the semantics of genre is not the kind of crushing conformity that modernists always suspected to be latent in mass culture. The production of meaning within a given genre does not simply reproduce a template on the model of standardized mass production. A particular text is not determined by the genre it belongs to. Since the 1980s, genre theory has moved away from the Aristotelian model of genre as a taxonomic category into which individual texts are placed to a more dynamic model of genre as a collaborative system in which individual texts actively transform their genres in the act of performing them. Genres do not hover authoritatively above or apart from their specific instantiations, but are produced and elaborated in the process of their articulation. As Rosen puts it, genre today is regarded "not as an ideal category with static rules or criteria but as a malleable, historically dynamic kind of literary and rhetorical practice that may be manipulated according to the needs and purposes of those who adopt it" (*Minor Characters* 10). This processual view of genre radically alters its symbolic significance from the modernist stigmatization of popular genres as a passive submission to fixed templates highly compatible with totalitarian rule to a democratic model of active participation.

Skepticism toward institutions as a way of organizing and amplifying collective agency is not only a result of neoliberal ideology but of what Rodrigo Nunes calls "the trauma of organization" (112), which is to say the abuse of organizational power in the twentieth century. Accounting for the potential danger of organization, Nunes explains how "in gathering and focusing the collective capacity to act in certain points, organisation opens that capacity to the risk of its appropriation by particular interests and the transformation of power to do things into power over others, *potentia* into *potestas*" (11). To avoid this latent danger, he shifts the focus from the noun "organization," a concept in which the whole subsumes the parts, to the gerund form of "organizing" in order to recognize the mutually constitutive relationship between part and whole (17). Genre fiction models such a process of assemblage. Each particular example of a genre renegotiates the terms of generic belonging; each text instantiates and simultaneously reconfigures the relationship between part and whole. Both rejecting the anti-institutional particularism of institutionalized high modernism and no longer seen as a mindless product predetermined by formulaic

conventions, genre fiction enacts the processual mediation between part and whole in aesthetic terms that organizational theorists like Nunes take as a viable model for collective action. And while the formal logic of genre obviously does not translate directly into political practice, as no literature does, it nevertheless shapes patterns of thought that are more amenable to thinking collectivity than forms of artistic production centered around the singularity of creative expression are.[6]

Temporalities

Apart from the institutional affordances of genre fiction vis-à-vis literary realism discussed above, the untethering of literature from a probabilistic universe—from Edward Bellamy's utopian *Looking Backward* (1888) to a cli-fi subgenre like solarpunk today—has long provided a space for alternative social visions to emerge that can inspire collective attempts to realize them. As the authors of a recent manifesto for the Green New Deal write, "fighting for a new world starts with imagining it viscerally" (Aronoff et al. 173). Kim Stanley Robinson's celebrated climate novel *The Ministry for the Future* (2020) is a good example of how a popular genre like sci-fi may be used to challenge what Mark Fisher influentially called "capitalist realism," which is not only the inability to imagine a different organization of society, but the inability to imagine how we get there. Robinson's novel opens in 2025 as a lethal heatwave sweeps over Northern India killing 20 million people in a matter of days. This extreme weather event has a mobilizing effect, catalyzing a chain of geopolitical actions that ultimately comprise a best-case scenario for energy transition to renewables. The novel is "pragmatopian" in the sense of combining a utopian vision of planetary decarbonization with a blueprint for achieving it.[7] Like its polyphonic structure comprised of multiple voices and styles, the novel does not imagine one single exit strategy from fossil fuels but a patchwork of initiatives ranging from permaculture and ecoterrorism to geoengineering and the titular ministry with the mandate to protect the rights of "all living creatures present and future" (16). These initiatives are from below as well as from above, represented contrapuntally in the novel as it alternates between institutional and everyday perspectives. By imagining not only a postcapitalist green future but the necessary steps to get there, *The Ministry for the Future* is what Gesa Mackenthun terms a "transition story" (1). If, as Simone Knewitz

6 The fan communities generated by—and in turn generating—genre fiction is a case in point. See, e.g., Jenkins on the "collective intelligence" of media fans.

7 The term "pragmatopia" is commonly used to describe Charlotte Perkins Gilman's feminist novels during the 1910s. Defined as a "realizable, possible, or achievable utopia" (Kessler 7), the term is well-suited to describe *The Ministry for the Future* as well.

argues in this volume, "[t]he challenge of collective agency in the twenty-first century is not the design of new visions of an alternative, more livable future, but how to create roadmaps that will guide us from our present situation to a more desirable and sustainable one" (33), then *The Ministry for the Future* is as lucid a roadmap as fiction has yet to produce.

Yet more than providing a vision of a different world or even a roadmap of how to get there, *The Ministry for the Future* uses sci-fi to model a form of temporality that "capitalist realism" has foreclosed. After all, the imagination of a better future does not necessarily provide a sense of its possibility. Political mobilization requires a sense that social change is possible through collective action, and not just something that occurs—if it occurs at all—independently from mass movements. As Fredric Jameson writes, the absence of a sense of historical agency "is betrayed by apathy and cynicism, paralysis and depression," while "a genuine historicity can be detected by its capacity to energize collective action" ("The Aesthetics" 119). In *Archaeologies of the Future*, he argues that such a "genuine historicity" can be kindled by the proleptic structure of sci-fi: Through its use of the future-past tense, sci-fi "transform[s] our own present into the determinate past of something yet to come" (288). This is how *The Ministry for the Future*, which not incidentally is dedicated to Jameson, is not merely a utopian thought experiment, but a way of countering the flattening of history that Jameson associates with postmodernism. As a historical narrative of the future, the proleptic structure of the novel works to unsettle a reified sense of the present as the end of history as well as to rekindle the radical notion that people make history happen. Events in the novel are arranged into a sweeping narrative of causal progression driven by multiple actors towards a decarbonized future, which fills events with intentionality and replaces what Walter Benjamin described as modernity's "homogenous, empty time" (261) with a historical sense of time as inherently meaningful. "That people can take their fate in their hands. That there is no such thing as fate" (563) is not just something that *The Ministry for the Future* explains didactically, but something it performs through its temporal structure.[8]

If the temporal organization of *The Ministry for the Future* produces a reinvigorating sense of historical agency, this is not a capacity exclusive to sci-fi. Genre fiction as such is organized by a kind of narrative temporality that makes it more open to historical change than literary fiction typically is. There are two kinds of temporality typical of literary fiction that popular genres dispense with. On the one

8 This mobilizing effect of the novel is widely attested to by the way it has been enthusiastically championed by climate activists and scholars like Bill McKibben and Andreas Malm, who describes its impact in visceral terms as "a punch in the belly of the reader." Far more than "literary" cli-fi, Robinson's novel has entered the climate activist media ecology in ways that both point to its agential capacity and to a feedback loop between fiction, science, and activism that may be crucial for collective action addressing climate change.

hand, Ghosh points out how the commitment of literary realism to a probabilistic worldview limits its capacity for representing the erratic patterns that not only define climate change but have always been a feature of a world subject to the whims of nature. Drawing on the geological distinction between "gradualism" and "catastrophism," he argues that literary realism represents a type of gradualism that rationalizes time as the orderly unfolding of predictable events through what Franco Moretti has called "fillers," which is to say descriptions of what happens between one turning point in the narrative and the next (17–20). Fillers thus not only tame the unexpected and improbable by subjecting it to rational explanation, but also significantly slow down narration. On the other hand, literature bound to representations of psychological depth is also organized by the time of individuals. In order to create the complex interiority of characters expected of literary fiction, the narrator has to flesh out the backstory and thought processes of individuals. Producing an effect of interiority therefore requires a backward-looking temporality. Through techniques like analepsis or interior monologue, readers are carried back into the memories of characters and granted privileged insight into their motivations. As the fictional novel of Kleeman's doomed author suggests, exploring "how the memory of a person, which is like a ghost in its way, can live on in the present and the future" (34), literary fiction is haunted by the past.

Restricted by neither of these temporalities typical of literary fiction—the gradualism of realistic representation and a retrospective temporality modeled on the individual psyche—genre fiction affords a much more expansive definition of time. From the evolutionary endgame of life on earth in H. G. Wells's *The Time Machine* (1895) to the interspecies futurism of Octavia Butler's *Bloodchild* (1995), genres like sci-fi and fantasy can range across temporal scales that exceed not just individual but human time. But beyond these speculative genres, genre fiction more broadly is oriented toward the future by the very fact that it is plot-driven. "Plots are not simply organizing structures," as Peter Brooks writes, "they are also intentional structures, goal-oriented and forward moving" (12). Even a historical romance, which by definition deals with the past, is propelled forward by the actions of its heroes. In this way, genre fiction harks back to the roots of mimetic narrative defined by Aristotle as the "representation not of persons but of action" (24). "The point is action," as he famously put it, "not character": The story does not exist "in order to portray moral character," but characters exist "for the sake of action" (24). While detached character description has been central to a realistic aesthetic ever since Flaubert famously dreamed of writing a book about nothing, which is to say a book without a plot, genre fiction derives from the older tradition of epic romance that revolves around the narration of exceptional deeds—the very tradition so mercilessly satirized in *Madame Bovary* (1856). For Georg Lukács, this distinction between description for its own sake and narration in which characters are not mere spectators but participants in events marks a distinction between a literature which, in accordance with scien-

tific positivism, objectifies the world as existing apart from social relations, and a literature that depicts human agency as constitutive of reality (see Lukács). In contrast to the mode of impersonal description pioneered by Flaubert, where the world exists as something to be contemplated by a detached observer, the epic mode of narration that Lukács favors depicts reality as inseparable from—and therefore malleable to—social actors. And unlike fashionable accounts of distributed agency today, which displace the onus of responsibility from powerful interests to a sprawling network of "actants," the centering of action through narrative form that Lukács describes provides a sense of relationality that does not diminish the agency of social actors for the change they bring about. Not standing apart from or above the world in a position of mastery does not entail a quasi-mystical interconnectedness of all things, but a historical relationship with the world shaped by our actions. "We are the change," as the galvanizing slogan of social movements aptly puts it.

By way of conclusion, consider two brief examples of how genre fiction can employ different action-driven temporalities in the service of a historical sense of how social actors drive change. N. K. Jemisin's Broken Earth trilogy (2015–2017) exemplifies the catastrophism that Ghosh calls for to help us grasp the predicaments of climate change. Set in the distant future on a continent ironically called "the Stillness"—ironic because the personified "Father Earth" has rippled angrily in seismic convulsions ever since a past civilization attempted to harness its energy—the novels use the generic hybrid of science fantasy to allegorize the interdependence of humans and their habitat in the throes of social and environmental change. Like Robinson's novel, much of the trilogy is narrated from the future after the collapse of the social order inhabited by its protagonist, a dark-skinned woman of a racialized caste of people with a special earth-moving power called "orogeny." Describing itself in the prologue as an account of "the way the world ends" (*The Fifth Season* 14), historical change is inscribed into the temporal form of the narrative. As with Robinson's novel, the trilogy uses prolepsis to transform events into the necessary steps towards the fulfillment of what has already come to pass. But if this sense of historicity in the trilogy is comparable to *The Ministry for the Future*, the allegorical work of fantasy functions on a more affective level to energize belief that another world is possible than Robinson's speculative pragmatism. If Robinson's novel is shot through with urgency, Jemisin's trilogy is charged with rage and the wish-fulfillment of dreams.[9] Apocalyptic as change in the Broken Earth trilogy is, it is not only necessary but deeply desired. As the narrator puts it: "[S]ome worlds are built on a fault line of pain, held up by nightmares. Don't lament when those worlds fall. Rage that they were built doomed in the first place" (*The Stone Sky* 7). Moreover, the power of orogeny that some possess not only makes them subject to racial oppression—which

9 Jemisin even claims that the trilogy's protagonist first came to her in a dream ("An Apocalypse" 476).

fuels the desire for change in the first place—but revolutionary subjects who precip-
itate the end of the world. True to genre fiction, the Broken Earth trilogy operates
"with a minimum of exposition and a maximum of action," as one reviewer writes
(O'Hehir). In contrast to literary fiction that moves backwards and inwards to pro-
duce character depth, the trilogy is driven by a mixture of fast-paced narration that
centers agency and characters with fantastical powers to make and break worlds.[10]
Reversing the apathy that Jameson attributes to a lack of historicity, Jemisin uses
epic fantasy to reimagine revolutionary agency. As Jemisin herself puts it: "The Bro-
ken Earth books are a Black female power fantasy" ("An Apocalypse" 470).

Finally, like Jemisin, Paolo Bacigalupi's hardboiled cli-fi thriller *The Water Knife*
(2015) uses genre fiction to depict a society on the brink of collapse. Only here the
apocalypse descends on the near-future Southwest as it deals with the catastrophic
effects of severe water shortage—a scenario extrapolated from the present unsus-
tainability of desert cities like Phoenix where much of the story takes place. Unlike
the classical detective story, which typically begins with a mystery and ends with
its neat resolution, the hardboiled thriller is characterized by a messy unfolding of
plot as bodies pile up and a world of corrupt interests is unveiled—in other words,
an apt genre for depicting the current rush against time as the climate crisis deep-
ens. Through its fast pace and suspenseful plot, *The Water Knife* uses the anticipatory
logic of the thriller, where readers are trained to anticipate its surprising twists and
turns, in order to produce a sense of urgency and hastening doom. If literary fiction
is typified by narrative deacceleration through its descriptive "fillers," as well as the
use of defamiliarizing language to slow down perception—techniques which per-
fectly align with the thriving cottage industry of attention enhancing technologies
today—*The Water Knife* in contrast ramps up the pace. While fantasy and cli-fi can be
used to open up history, the thriller may be used to accelerate it. Quipping on Rob
Nixon's notion of "slow violence," the narrator observes that "slow death didn't attract
attention" (136). Using the narrative acceleration characteristic of the suspense story
to bring the stakes of climate change into stark relief, the novel fosters the sense of
urgency required by any mass mobilization. Moreover, by forcing readers to expect
the unexpected, as double-dealing characters backstab each other throughout, the
novel further rejects the probabilism that Ghosh argues has blinded us to the climate
catastrophe in the first place.

The only reliable assumption in *The Water Knife* is that "everyone is out for them-
selves" (410), as one character remarks. Extrapolating from the worst tendencies of
the early twenty-first century, the dystopian world of the novel is driven by market

10 Ingeniously, the trilogy still builds character depth, not through psychological description or
analepsis, but by making the three main focalizers of the story the same character at different
stages of her life, which gives readers access to her past even as the story moves forward.

absolutism, dominated by cartel states and corporate interests, and defined by climate apartheid where the rich live in luxurious arcologies while the rest scavenge for a living. Yet qualifying the rampant individualism inherent in the hardboiled tradition, the ending of the novel also offers a glimmer of hope. While one of its three main characters, the journalist Lucy Monroe, acts out of empathy to save Phoenix by returning to it a long-lost document that would give Arizona water rights to what is left of the Colorado River, the character who in the end prevails, the young climate refugee Maria Villarosa, instead decides to bring the life-granting papers to a rival syndicate out of sheer self-interest: To live the decent life that her status as a refugee has denied her. Rejecting the well-intended idealism of Lucy in favor of the self-interested materialism of Maria, the novel not only centers power struggles over resources as the inalienable reality of a world defined by scarcity, but intimates a future solidarity based not on shared feelings but on shared interests. Empathy is often hailed as a key affordance of literary fiction, as it constructs complex characters readers can identify with through a retrospective narrative that burrows into their past. In contrast, the future orientation of the thriller, but also genre fiction more generally as it centers plot action, lends itself better to thinking the collective based on shared interests that point toward the future instead of the past. Like Jemisin's world brought down by the inequality that upholds it, Maria knows that Phoenix is irredeemable. "[T]hat place ain't never getting better, and I ain't going back" (447), as she says. Like genre fiction, Maria only moves forward. And whether the world can be built back better ultimately depends on whether its Marias, and not its Lucys, can find common ground to stand on, because, as the novel puts it: "Nobody survives on their own" (398).

Works Cited

Aristotle. *Poetics*, translated by Anthony Kenny, Oxford University Press, 2013.

Aronoff, Kate, Alyssa Battistoni, Daniel Aldana Cohen, and Thea Riofrancos. *A Planet to Win: Why We Need a Green New Deal*. Verso, 2019.

Bacigalupi, Paolo. *The Water Knife*. Orbit, 2015.

Benjamin, Walter. "Theses on the Philosophy of History." *Illuminations: Essays and Reflections*, translated by Harry Zorn, edited by Hannah Arendt, Schocken Books, 1968, pp. 253–64.

Bould, Mark. *The Anthropocene Unconscious: Climate Catastrophe Culture*. Verso, 2021.

Brooks, Peter. *Reading for the Plot. Design and Intention in Narrative*. Harvard University Press, 1984.

Cohen, Ralph. "History and Genre." *New Literary History*, vol. 17, no. 2, 1986, pp. 203–18, https://doi.org/10.2307/468885.

Dorson, James. "Cormac McCarthy and the Genre Turn in Contemporary Literary Fiction." *European Journal of American Studies*, vol. 12, no. 3, 2017, pp. 1–24, https://doi.org/10.4000/ejas.12291.

Fisher, Mark. *Capitalist Realism: Is There No Alternative?* Zero Books, 2009.

Frow, John. *Genre*. Routledge, 2006.

Ghosh, Amitav. *The Great Derangement: Climate Change and the Unthinkable*. University of Chicago Press, 2016.

Hoberek, Andrew. "Introduction: After Postmodernism." *Twentieth Century Literature*, vol. 53, no. 3, Fall 2007, pp. 233–47.

—. "Literary Genre Fiction." *American Literature in Transition, 2000–2010*, edited by Rachel Greenwald Smith, Cambridge University Press, 2018, pp. 61–75.

Huyssen, Andreas. *After the Great Divide: Modernism, Mass Culture, Postmodernism*. Indiana University Press, 1986.

Jameson, Fredric. *Archaeologies of the Future: The Desire Called Utopia and Other Science Fictions*. Verso, 2005.

—. "The Aesthetics of Singularity." *New Left Review*, vol. 92, 2015, pp. 101–32.

Jemisin, N. K. *The Fifth Season*, Orbit, 2015

— *The Stone Sky*, Orbit, 2017.

—. "An Apocalypse is a Relative Thing: An Interview with N. K. Jemisin." Interviewed by Jessica Hurley, *ASAP/Journal*, vol. 3, no. 3, 2018, pp. 467–77.

Jenkins, Henry. "Interactive Audiences? The 'Collective Intelligence' of Media Fans." *The New Media Book*, edited by Dan Harries, British Film Institute, 2002, pp. 157–70.

Kelley, Adam. "Jennifer Egan, New Sincerity, and the Genre Turn in Contemporary Fiction." *Contemporary Women's Writing*, vol. 15, no. 2, 2021, pp. 151–170, https://doi.org/10.1093/cww/vpab036.

Kessler, Carol Farley. *Charlotte Perkins Gilman: Her Progress Toward Utopia with Selected Writings*. Syracuse University Press, 1955.

Kleeman, Alexandra. *Something New Under the Sun*. Hogarth, 2021.

Lanzendörfer, Tim, editor. *The Poetics of Genre in the Contemporary Novel*. Lexington Books, 2016.

Levine, Caroline. *Forms: Whole, Rhythm, Hierarchy, Network*. Princeton University Press, 2015.

Lukács, Georg. "Narrate or Describe?" *Writer and Critic and Other Essays*, edited and translated by Arthur Kahn, Grosset & Dunlap, 1970, pp. 110–48.

Mackenthun, Gesa. "Sustainable Stories: Managing Climate Change with Literature." *Sustainability*, vol. 13, no. 7, 2021, https://www.mdpi.com/2071-1050/13/7/4049. Accessed 17 November 2023.

Malm, Andreas. "When Does the Fightback Begin?" *Verso Books*, 22 April 2021, https://www.versobooks.com/en-gb/blogs/news/5061-when-does-the-fightback-begin. Accessed 17 November 2023.

Martin, Theodore. *Contemporary Drift: Genre, Historicism, and the Problem of the Present*. Columbia University Press, 2017.

McGurl, Mark. *The Program Era: Postwar Fiction and the Rise of Creative Writing*. Harvard University Press, 2009.

McKibben, Bill. "It's Not Science Fiction." *The New York Review*, 17 December 2020, https://www.nybooks.com/articles/2020/12/17/kim-stanley-robinson-not-science-fiction/. Accessed 17 November 2023.

Nixon, Rob. *Slow Violence and the Environmentalism of the Poor*. Harvard University Press, 2011.

Nunes, Rodrigo. *Neither Vertical nor Horizontal: A Theory of Political Organization*. Verso, 2021.

O'Hehir, Andrew. "The 21st-Century Fantasy Trilogy That Changed the Game." *The New York Times*, 26 September 2017, https://www.nytimes.com/2017/09/26/books/review/nk-jemisin-stone-sky-broken-earth-trilogy.html. Accessed 17 November 2023.

Reckwitz, Andreas. *The Society of Singularities*, translated by Valentine A. Pakis, Polity Press, 2020.

Robinson, Kim Stanley. *The Ministry for the Future*, Orbit, 2020.

—. "The Realism of Our Times: Kim Stanley Robinson on How Science Fiction Works." Interviewed by John Plotz. *Public Books*, 23 September 2020, www.publicbooks.org/the-realism-of-our-times-kim-stanley-robinson-on-how-science-fiction-works/. Accessed 17 November 2023.

Rosen, Jeremy. "Literary Fiction and the Genres of Genre Fiction." *Post45*, vol. 7, 2018, https://post45.org/2018/08/literary-fiction-and-the-genres-of-genre-fiction/. Accessed 17 November 2023.

—. *Minor Characters Have Their Day: Genre in the Contemporary Literary Marketplace*. Columbia University Press, 2016.

Digital Affect

Regina Schober

The concept of "digital affect" may seem paradoxical due to our accustomed tendency to dissociate technology from emotion, abstract virtuality from embodiment, and the binary logic of data from the messy entanglements of feeling. This assumed split between technology and affect is rooted in an entrenched (and often gendered) Cartesian mind-body dualism that has effectively shaped our relationship with digital technology. This dissociation of technology and affect already came under pressure by George Simondon's 1964 conception of "transindividuality" in collective and affective technological relations (285) and, more recently, in the course of posthumanist re-conceptualizations of human-technology entanglements (Braidotti; Hayles). At the same time, a renewed theoretical interest in affect has urged us to recenter the body as well as non-cognitive dimensions of individual and collective experiences (Massumi; Ahmed; Ngai).

That posthumanism and affect theory emerged more or less simultaneously may be an indicator for their conflated interest: In the digital world, virtual extensions of experience that are perceived (often mistakenly) by many as disembodied prompt us to consider how our "being in the world" as humans is literally affected by technology. Thinking about digital affect, therefore, means to zoom in on posthumanist ideas especially through the prominence it places on *collective* structures and practices of world-making, and interaction, as it decenters human subjectivity and agency in its conception of relational, processual, and systemic processes of exchange and co-dependence. While much discussion has taken place concerning the difference between "affect" and "emotion," I will follow a widely accepted notion of affect as comprising a wider range of physical and non-cognitive responses, such as emotion, sensation, and habit. A perspective on digital affect foregrounds embodied experience in our use of and interaction with digital technology, more specifically, the media affordances, politics, and ethics of digital instrumentalization and circulation of affect, for example in the context of the attention economy, the viral dynamics of social media, and AI-generated and -retrievable affect. The category of digital affect thus highlights key components and requirements of collective agencies in technological arrangements in emphasizing what I will address as a) digital affects and network effects, b) invisible infrastructures and the "digital

banal," and c) artificial intelligence and black box affect. To conceptualize digital affects through the lens of network effects means to highlight the formation of collectivities through circulating network dynamics, as for example through dynamics of virality. Such collective transmission and exchange of affect often takes place in hidden infrastructures that, due to their abstraction, render individual interaction with digital media highly habitualized, thus running danger of obscuring and thus misrecognizing collective structures of self-forming. To focus on collective patterns of digital practices also entails thinking critically about the ways in which artificial intelligence reproduces affective posthumanist relationalities. By bringing into dialog the "affective turn" with theories of the digital I aim to confront the conspicuous absence of affect-related discourse of the liberal autonomous self in much tech discourse. I will do so by highlighting the aesthetics and politics of affect in human-machine relations of the digital era. It may be exactly the blind spots of digital affect that help to illuminate the correspondences and productive potentials of both approaches to future conceptualizations of digital collective agencies.

Digital Affects and Network Effects

Digital culture is largely organized in and through networks, from material server infrastructures to relational databases in semantic webs and "friendship" networks on social media platforms. "All networks afford connectivity" (114), Caroline Levine holds, thus regarding networks as specific forms and as "defined patterns of interaction and exchange that organize social and aesthetic experience" (113). Networks paradigmatically embody what Stephen Ahern calls "the most fundamental insight of affect theory: that no embodied being is independent, but rather is *affected by* and *affects* other bodies, profoundly and perpetually as a condition of being in the world" (4–5). This double logic of affect is prominently pronounced by Gilles Deleuze in his thoughts on Spinoza, according to which affect is expressed in the relationship between subject and object, as determined by the "capacity for being affected," which shows both in the "power of acting" and the "power of being acted upon" (27). Based on Aristotle's description of physical affect as an "accretion of force-relations," as it "arises in the midst of *in-between-ness*" (Seigworth and Gregg 1); affect is "what sticks, or what sustains or preserves the connection between ideas, values, and objects" (Ahmed 29). Especially in the case of mobile media practices, such relational forms of media use have become "tacit and embodied knowledge, which can be performed consistently until they become a routine and manifested in practice" (Ramella et al. 7). Wendy Chun's understanding of digital media as "habitual media" emphasizes their embodiment in collective network practices, defined as "imagined synchronous mass actions [that] create an imagined community in which the multiple 'I's are transformed every morning into a 'we' that moves together through time" (*Up-*

dating 26–27). Such a perspective on collective digital media practices can function as a corrective to the pervasive neoliberal narrative of individual choice, personalization, and strategic self-making through digital apps. Instead, what is brought to the fore are the affective affordances of digital media that powerfully engender collective patterns of experience and agency. These habitualized practices are inscribed into the user interfaces of digital media devices on the basis of datafying selves into "algorithmic identities" based on marketable categorization systems (Cheney-Lippold 5–6; also see Pasquale). This is the dystopian component of digital collective agencies, in the sense of corporate data "collections" to enable predictive monetization of habitualized affect in the attention economy.

This complex conflation of digital collective action and experience via habitual embodiment turns the digital into a specifically relevant field for studying affect. The complexity of circulating practices, ideas, and signs, of messy entanglements between objects and bodies renders digital network practices, which by definition consist of multiple cross-relations, highly affective practices. At the same time, the network seems to be a valid conceptual framework for describing affect as a semi-autonomous structure of circulating forces. It is this double perspective between *affects of networks* and the *network as a model for affect* that Kathleen Stewart brings together in her ethnographic description of "the net" as

> at once abstract and concrete, [...] both a distant, untouchable order of things and a claustrophobically close presence [...]. It's as if a net has grown around a mutating gelatinous substance. It's also as if the net is full of holes, so that little pieces or whole blobs of things are always falling out of it and starting up some new thing on their own. It harbors fantasies and fears. It spawns trajectories. It sets up a quick relay between things. It induces both rage and the softly positive sense of being connected and so somehow safe (or not, but at least "in it together"). There's a promise of losing oneself in the flow of things. But the promise jumps in a quick relay to the sobering threats of big business, global warming, the big-box corporate landscape, the master-planned community, the daily structural violence of in-equalities of all kinds, the lost potentials, the lives not lived, the hopes still quietly harbored or suddenly whipped into a frenzy. Either that, or the promise of losing yourself in the flow becomes a dull, empty drifting that you can't get yourself out of. (87–88)

Stewart's depiction of "the net" refers to commonly associated features of the network, such as the "untouchable order" of abstraction and randomness, the "close presence" of the small world, the postmodernist "promise of losing oneself" in rhizomatic diffusion, a reconfigurational logic of self-organization as the net "start[s] up some new thing on their own," the emergent properties of "spawn[ing] trajectories," the "sobering threats of big business" as concentrated power enabled by preferential attachment, and the idea of exclusion in the "net [as being] full of holes."

Yet, in Stewart's description, these network features are framed not as abstract, systemic properties but rather as *affective* structures, as they reflect ways of relating to, feeling about, and being affected by network affordances. While the relationality of networks encourages circulating affect, networks can also become objects with which we form affective relationships. Promises of connectivity themselves can become objects of desire as well as generating collective feelings of dread, pessimism, and despair, as Luke Fernandez and Susan Matt have shown with regard to the telegraph network in the late nineteenth and early twentieth century (258).

This affective ambivalence toward networks can be considered a form of "cruel optimism," when the desire for accelerated connectivity becomes "an obstacle to your flourishing" (Berlant 1), an attachment, or rather a web of attachments that proves stifling, overwhelming, and oddly dehumanizing. In fact, our affective relations with networks and, as a consequence, their cultural semantics, are anything but neutral, but often emotionally polarized. As Elisabeth Schäfer-Wünsche notes, networks "simultaneously invite narratives of utopia and of dystopia" (202). This observation is noteworthy since it suggests that networks "invite narratives," not only because they are cultural formations themselves, but because they induce a strong embodied response, despite, or because of, their abstract nature. "'Network'," Schäfer-Wünsche concludes, "thus emerges as a highly loaded structure—as quite the opposite of an 'innocent' formation" (219). Since networks always verge on the border between connect and disconnect, participation and hegemonic power, freedom and control, creation and destruction, they evoke and embody the very vulnerabilities of the relationship between individual and collective. Whether we are attached to "the promise of losing [ourselves] in the flow" or whether this promise "becomes a dull, empty drifting that you can't get yourself out of" (Stewart 88), the metaphoric opposition of "the chain of triumph" and "the web of ruin" (Galloway 281) in our conception of networks has been negotiated in a long history of narratives since antiquity (Gießmann; Schober).

As Galloway and Eugene Thacker describe the inherent contradiction of networks, "the self-regulating and self-organizing qualities of emergent networked phenomena appear to create and supplement the very thing that makes us human, yet one's ability to superimpose top-down control on that emergent structure evaporates in the blossoming of the network form, itself bent on eradicating the importance of any distinct or isolated node" (5). The ambivalence of networks is frequently discussed in relation to their virality, which can be, on the one hand, both empowering and mobilizing, as the remarkable power of social media grassroots activism such as #MeToo, #BlackLivesMatter, and #IchbinHanna have demonstrated. On the other hand, the ethical blindness of virality also makes the logic of exponential growth one of its most uncontrollable risks, most evident lately in online hate speech. As Simon Strick argues, right-wing online content has established itself as impressionist ordering principle ("Eindrucksortierer") and automatism (67),

especially because of the affective affordances of social networks, built on fleeting impressions/snapshots that are algorithmically connected in digital archives (167).

Virality connects the digital with affect both on a systemic and on a metaphorical level. Conceptual poet Kenneth Goldsmith writes in *Wasting Time on the Internet* that "our online lives are saturated with affect, our sensations amplified and projected by the network [...] Affect accounts for why things go viral on the networks. An invisible force, affect makes everything contagious" (38). The virality of networks concerns both the flow of information and the spread of affect. If the digital age is dominated by structures of spread and contagion, it makes sense to speak of "a kind of network virality that surpasses linguistic categories of disease and instead reaches out to explore new exploitable social assemblages of affective contagious encounter" (Sampson 3). As the Covid-19 pandemic has brought to full awareness, virality was never "just" a metaphor, not in the biological sense, nor in its implications of circulating fear, misinformation, and conspiracy theories. Virality, as Sampson argues, is "all about the forces or relational encounter" (4) in which the biopolitical mobilization of both positive and negative affect become mechanisms of control.

Invisible Infrastructures and the "Digital Banal"

The virality of affect makes digital networks particularly effective but at the same time strangely elusive. The multidirectional relational flows and cross-flows of digital affect render digital network infrastructure both powerful and also largely invisible. Consequently, the abstraction of power in decentralized structures leaves the network subject in a paradoxical state of indifferent vigilance. It is a grotesque combination of knowing, theoretically, that one is part of a wide-ranging "surveillance capitalism" (Zuboff), in which a large part of our daily interactions and practices are digitally traced, collected, and monetized, while simultaneously urging us to capitulate in view of both the pervasiveness and inevitability of digital technology. The unnamed protagonist in Lauren Oyler's 2021 novel *Fake Accounts* experiences this paradoxical sense of uneasiness while trying to research her ostensibly dead ex-boyfriend's social media accounts:

> Back in Brooklyn I mostly lay around in my bedroom, leaving only to pick up Thai food, reading quarters of books, and staying up late portaling from one social media account to the next. The frequency with which I would find myself back at @THIS_ACCOUNT_IS_BUGGED_ was natural but dizzying, and occasionally enraging: the account itself, if taken at face value, was boring, consisting of doctored photos and lengthy captions that hinged on one thing being not quite what it appeared but in fact a link in a chain of involvement of larger and larger entities, all the way to the very top. (122)

In tracing her ex-boyfriend's social media accounts for clues about his motivation to post conspiracy theories' never-ending "chain of involvement," the protagonist becomes aware of the hyper-relationality of fake information that comes out of this account. This relational conspiracy network, at the same time, entails an endless series of affective involvement, described as "natural but dizzying": Its habitual normalization of persistent attachment is described as only "occasionally enraging." Most often, the affective attachment goes unnoticed, as it is naturalized and, as Chun would argue, habitualized even to the extent of being perceived as "boring." Yet, affectively, this "boredom" is ambiguous, not despite but *because* of its invisibility. The protagonist's social media search is an explicit literary description of what Zara Dinnen calls the "digital banal," defined as "the condition by which we don't notice the affective novelty of becoming-with digital media" or, in other words, "the way we use media makes us unaware of the ways we are co-constituted as subjects with media" (1). The invisibility of "effac[ing] the affective stakes of life determined by algorithms" by way of naturalizing digital technology, according to Dinnen, is what literary fiction can counteract by "recover[ing] the novelty of living with digital media" (2). The paradox of the digital banal in this passage from Oyler's novel is framed by a binary of physical activity and passivity. The seeming inactivity of "lying around" is contrasted with the frenzy of account switching: The paradox of online lives (physically passive/still affected) contains an ambiguous affective relation in the posthuman subject, which suggests that behind the "visible," analog surface of embodiment there is another, invisible, layer of affective digitality.

The novel, written and published in the materiality of the printed book, does not manage to detach itself completely from this conflictedness, as it describes itself as part of and competing within the media ecology of distraction. The protagonist only reads "quarters of books" which become elements in the random streams of data that flow in and out of the digital subject's consciousness. These sequences of fragmented and discontinuous reading practices are supported by the literary style of the passage and of large parts of the novel, composed of predominantly paratactical syntax, enriched with additive gerund constructions. In that regard, the novel imitates that which it describes, in a form of digital ekphrasis. At the same time, it engages in denaturalizing the digital banal, as it reveals the logic of affective self-forming: This is a process that can no longer be integrated with traditional modes of subjectification through self-reflection in the tradition of the Enlightenment, but one which rather contains a complex interaction between affective self and algorithmic habitualization, while still retaining the narrating "I" who is seeking, at least, for spaces of self-reflection. That the space in which this self-forming takes place is shaped by the isolation of the bedroom points to the irony of the networked subject, who is surrounded by narratives of individualization but always algorithmically connected, and therefore always caught in affective collectivities—collectivities that can be simultaneously infectious and eerily isolating.

Artificial Intelligence and Black Box Affect

This doubleness of isolation and interconnectivity is also inscribed into the structures in which we interact with artificial intelligence. The rapidly advancing technology of AI-assisted chatbots, most prominently discussed recently in the case of ChatGPT3, has brought the posthuman entanglements between human body, language, technology, and digital data into full view. Our increasing interactions with artificial intelligence, whether in the case of voice assistants, chatbots, or algorithmically driven recommendation systems, prompt questions around our relationship with technology that, due to the abovementioned network implications, often evoke polarizing affective responses. Depictions of artificial intelligence as destructive robots have created uneasy feelings of fear vis-à-vis the loss of human control, while techno-utopian narratives have created euphoric feelings about the seemingly unlimited capacities for solving complex problems that these systems promise. The fact that especially with neural networks and deep learning algorithms, artificial intelligence has increasingly been perceived as an obscure "black box" has led not only to the naturalization, or banalization, of media practices addressed above, but also to the exact opposite, namely a mystification that hovers between a belief in the spiritual transcendence of artificial intelligence and its demonization in narratives of catastrophic loss of control that are fed by Frankensteinian modes of depicting AI as monstrosity (Finn; Birkle).

To counter the perceived powerlessness in our framing of AI as unknown and unknowable force, recent attempts to "deblackbox" artificial intelligence aim at revealing the often hidden material and political structures of discrimination (Chun, *Discriminating Data*; Crawford; Noble). By doing so, they channel the pervasive fear based on "human exceptionalism's insistent belief that humans naturally own all sorts of right to power" (Pitetti-Heil 288) into a posthumanist understanding of relational agency. This does not mean to deny human responsibility—on the contrary, it presses us to identify possibilities of intervening in, and designing individual and collective responsibility, towards algorithmically driven technologies. This can mean to develop a digital ethics of care that delineates the collective potentials of taking seriously different levels of interdependencies between societies, cultures, and digital media. Applying the demand formulated in the Care Collective's *Care Manifesto* of "put[ting] care at the very centre of life" (5) to digital media, for example, could help to imagine network infrastructures beyond capitalist profit based on the exploitation of invisible digital labor, natural resources, and political instrumentalization of digital affect. Within a digital ethics of care, posthumanist insights into the mutual affiliations of relational media can become a way of rethinking digital collectivities in terms of responsible and active community building rather than perpetuating an overdependence on "blind" habitualization created by an algorithmically driven attention economy.

To take collective action and "deblackbox" artificial intelligence in this context does not mean to disavow any affective responses to self-learning technology, but rather to make visible a range of multiple affects instead of perpetuating the dominant cultural narrative of fear. Whether this is the affect of empathy (Pitetti-Heil 295), that of expected "algorithmic authenticity" (Chun, *Discriminating* 114), or the technoliberal hopes connected with artificial intelligence providing "free" affective labor (Atanasoski and Vora 4), such affective ascriptions to artificial intelligence express heterogeneous and contradictory narratives of human-machine relations. Atanasoski and Vora emphasize that the technoliberal narrative of human freedom through algorithmic automation reflects humanity's "hierarchical if connected relationship to artificial intelligence" that often "obscur[es] the uneven racial and gendered relations of labor, power, and social relations that underlie the contemporary conditions of capitalist production" (4). Simultaneously, these technoliberal narratives, according to Atanasoski and Vora, are not the opposite of technodeterminist fears but rather the flipside of the coin, as both are based on prevalent social conceptions of human power relations. Rather, they claim, the fear of machines becoming more and more like humans often reproduces a universalizing "figuration of 'humanity' following the post- of postracial and postgender [...] that writes over an ongoing differential achievement of the status of the 'human'" (16). In other words, affective responses to human interactions with artificial intelligence often function as a mirror, reflecting social hierarchies, power relations, and structures of visibility in humanity itself. Or, as Sybille Krämer states, "what we have to fear is less artificial intelligence on the part of machines, but irrationality on the part of people" (28). In a posthumanist vein, Krämer deconstructs the supposed binary between human rationality and irrational artificial intelligence. Yet, implicitly, her statement reinforces a belief in the enlightened autonomous subject, albeit diagnosed as often absent.

Others critically approach the human-machine dualism from a different perspective, asking not whether humans are always rational but rather whether machines cannot also be able to detect, predict, and even generate emotions and affect. Within the most basic definition of affect as a body being affected by another body, it is possible to already consider any feedback structure of an algorithmically driven chatbot an affective relationship. Such a view, of course, challenges two properties that have often been exclusively ascribed to living beings, if not human beings: embodiment and emotions. As Elizabeth Wilson has shown in her historical study *Affect and Artificial Intelligence*, questions of intersubjective emotion and affectivity have played a role in research around artificial intelligence from the beginning. Interestingly, the truism that machines cannot have emotions is coded into and therefore reproduced by chatbots themselves. If we ask ChatGPT "How do you feel today?," it will most likely answer something like "As an AI language model, I don't have feelings like humans do." OpenAI seems to have a pre-installed template that instantly

replicates the humanist distinction between human (emotion) and non-human (no emotion), a view already problematized by Alan Turing in "Computing Machinery and Intelligence" (1950) as being part of an "other minds problem." We simply cannot know whether machines "feel" because we are humans.

However, the question of whether AI can be an affective agent should not be reduced to the question of whether the chatbot can "feel." Disregarding the difference between "feeling" and "affect," which is central to affect theory, such a reductive perspective would dismiss the relational dimensions of AI affect. Matthias Scheutz refers to different properties of affect in artificial intelligence, from "affective computing" (Picard) that explores possibilities for machines to be "affect-aware" to "affective" user interfaces to (seemingly) emotional robots (250). A specific case of affective computing concerns what is referred to as "emotion recognition," in which AI systems are trained to detect emotional patterns for example in human faces or voices. ChatGPT does not, like other AI systems, have the sensors and tracking capacities to detect the user's emotions, but it already actively provides a space of interaction, therefore prompting, itself, an affective relationship with "real" emotions. ChatGPT's affect, arguably, does not match our understanding of sentiment and subjective expression, as formulated in the tradition of the liberal autonomous self. Rather, we may need to reconceptualize AI affect as radically collective, as these automated systems are based on large-scale data models containing billions of data points, consisting of masses of individual "texts" to be recombined into newly generated content.

One of these data points is the individual user's affective response to the interaction—a data point that is also continuously fed into the system of machine learning. Affective responses to artificial intelligence can involve a wide range of emotions, including trust, frustration, excitement, pleasure, fear, boredom, expectation, and many other emotions and affects, as movies like *Her* (2013), *Ex Machina* (2014), and *I'm Your Man* (2021) have displayed. Human affective involvement with artificial intelligence, of course, works both ways. What can be regarded, from a technological perspective, as an important data set in reinforcement training data, involves vital ethical and political questions if artificial intelligence itself is considered an agent capable of producing and recognizing affect. "Can there be affect without the human?," Heather Houser asks in her reflection on the seeming paradox of a posthumanist reflection on the affective turn. While Houser connects this question to ecocritical reflections on affective transcorporeality, the question also gains relevance in the case of human-technology interaction, as this equally decenters human affect: "Affectivity does not mark human uniqueness," Houser writes. Such a decentering also necessitates an ethics of posthumanist relationality. Kate Crawford points to the problematic assumptions on which much automated affect recognition, for example in facial recognition technology, is based. She shows that many of the affect recognition tools found in education, security systems, and hiring contexts, employ

models rooted in universalizing and often racist practices of physiognomy, as for example in eighteenth- and nineteenth-century colonial pseudoscience of phrenology, the measuring of the skull to identify supposed links between physiognomic features and psychological states of mind. Crawford draws critical attention to the historically inscribed biases and assumptions of these artificial recognition tools, including, apart from the claims of affective universality, a biological determinism, an over-simplified definition of emotion (we may add, a lack of distinction between emotion and affect) as well as the question of machine-readability in an area that may be too complex to fall into neat categories necessary to the binary logic of code. So, "why, with so many critiques, has the approach of 'reading emotions' from the face endured?," Crawford asks (174). The answer she gives points to the politics of facial data, the "powerful institutional and corporate investments" (175) in this expanding industry, connected with economic and military control.

Besides these political and economic interests, human investment in digital affect seems to have been key to our interest in digital technology from the beginning. What sounds like a paradoxical pairing at first sight, the nexus between "digital" and "affect" becomes a multi-faceted field that is integral to posthumanist understandings of human-non human assemblages. From the radically relational perspective of decentering not only human agency but also human affect, digital technology becomes one (among many other) nodes in an entangled network of affective agents. To regard digital affect as collective network of relations implies its own ethics, as it makes visible and therefore enables us to recognize the often invisible dimensions of affective power, labor, and knowledge that are part of the digital infrastructures of affect.

Works Cited

Ahern, Stephen, "Introduction." *Affect Theory and Literary Critical Practice: A Feel for the Text*. Palgrave Macmillan, 2019, pp. 1–21.

Ahmed, Sara. *The Promise of Happiness*. Duke University Press, 2010.

Atanasoski, Neda, and Kalindi Vora. *Surrogate Humanity: Race, Robots, and the Politics of Technological Futures*. Duke University Press, 2019.

Berlant, Lauren. *Cruel Optimism*. Duke University Press, 2011.

Birkle, Carmen. "'I, Robot': Artificial Intelligence and Fears of the Posthuman." *Artificial Intelligence and Human Enhancement*, edited by Herta Nagl-Docekal and Waldemar Zacharasiewicz, De Gruyter, 2022, pp. 237–60.

Braidotti, Rosi. *The Posthuman*. Polity Press, 2013.

Care Collective, The [Andreas Chatzidakis, Jamie Hakim, Jo Littler, Catherine Rottenberg, and Lynne Segal]. *The Care Manifesto: The Politics of Interdependence*. Verso, 2020.

Cheney-Lippold, John. *We Are Date: Algorithms and the Making of Our Digital Selves.* New York University Press, 2017.

Chun, Wendy Hui Kyong. *Updating to Remain the Same: Habitual New Media.* First MIT Press new paperback edition, MIT Press, 2017.

—. *Discriminating Data: Correlation, Neighborhoods, and the New Politics of Recognition.* MIT Press, 2021.

Crawford, Kate. *Atlas of AI: Power, Politics, and the Planetary Costs of Artificial Intelligence.* Yale University Press, 2021.

Deleuze, Gilles. *Spinoza, Practical Philosophy.* City Lights Books, 1988.

Dinnen, Zara. *The Digital Banal: New Media and American Literature and Culture.* Columbia University Press, 2022.

Fernandez, Luke, and Susan Jipson Matt. *Bored, Lonely, Angry, Stupid: Changing Feelings about Technology, from the Telegraph to Twitter.* Harvard University Press, 2019.

Finn, Ed. *What Algorithms Want: Imagination in the Age of Computing.* MIT Press, 2017.

Galloway, Alexander R. "Networks." *Critical Terms for Media Studies,* edited by W.J.T. Mitchell and Mark B.N. Hansen, University of Chicago Press, 2010, pp. 280–296.

Galloway, Alexander R., and Eugene Thacker. *The Exploit. A Theory of Networks.* University of Minnesota Press, 2007.

Gießmann, Sebastian. *Die Verbundenheit der Dinge: Eine Kulturgeschichte der Netze und Netzwerke.* Kadmos, 2014.

Goldsmith, Kenneth. *Wasting Time on the Internet.* Harper Perennial, 2016.

Gregg, Melissa, and Gregory J. Seigworth. "An Inventory of Shimmers." *The Affect Theory Reader,* edited by Melissa Gregg and Gregory J. Seigworth, Duke University Press, 2020, pp. 1–26.

Hayles, Nancy Katherine. *How We Became Posthuman: Virtual Bodies in Cybernetics, Literature and Informatics.* University of Chicago Press, 1999.

Houser, Heather. "Affective Turn." *Posthuman Glossary.* Bloomsbury Academic, 2018, pp. 15–17.

Krämer, Sybille. "The Artificiality of the Human Mind: A Reflection on Natural and Artificial Intelligence." *Artificial Intelligence and Human Enhancement,* edited by Herta Nagl-Docekal and Waldemar Zacharasiewicz, De Gruyter, 2022, pp. 17–32.

Levine, Caroline. *Forms: Whole, Rhythm, Hierarchy, Network.* Princeton University Press, 2017.

Massumi, Brian. "The Autonomy of Affect." *Cultural Critique,* vol. 31, 1995, pp. 83–109, https://doi.org/10.2307/1354446.

Ngai, Sianne. *Ugly Feelings.* Harvard University Press, 2009.

Noble, Safiya Umoja. *Algorithms of Oppression: How Search Engines Reinforce Racism.* New York University Press, 2018.

Oyler, Lauren. *Fake Accounts.* Catapult, 2021.

Pasquale, Frank. "The Algorithmic Self." *The Hedgehog Review*, vol. 17, no. 1, 2015, https://hedgehogreview.com/issues/too-much-information/articles/the-algorithmic-self. Accessed 22 August 2024.

Picard, Rosalind W. *Affective Computing*. MIT Press, 1997.

Pitetti-Heil, Johanna. "Artificial Intelligence from Science Fiction to Soul Machines: (Re-)Configuring Empathy between Bodies, Knowledge, and Power." *Artificial Intelligence and Human Enhancement*, edited by Herta Nagl-Docekal and Waldemar Zacharasiewicz, De Gruyter, 2022, pp. 287–308.

Ramella, Anna Lisa, Asko Lehmuskallio, Tristan Thielmann, and Pablo Abend. "Introduction: Mobile Digital Practices. Situating People, Things, and Data." *Digital Culture & Society*, vol. 3, no. 2, 2017, pp. 5–18, https://doi.org/10.14361/dcs-2017-0 202.

Sampson, Tony D. *Virality: Contagion Theory in the Age of Networks*. University of Minnesota Press, 2012.

Schäfer-Wünsche, Elisabeth. "Work and Net-Work: Reflections on a Global Metaphor." *American Studies/Shifting Gears: A Publication of the DFG Research Network "The Futures of (European) American Studies,"* edited by Birte Christ, Christian Kloeckner, Elisabeth Schäfer-Wünsche and Michael Butter, Winter, 2010, pp. 201–21.

Scheutz, Matthias. "Artificial Emotions and Machine Consciousness." *The Cambridge Handbook of Artificial Intelligence*, edited by Keith Frankish and William M. Ramsey, Cambridge University Press, 2014, pp. 247–66.

Schober, Regina. *Spider Web, Labyrinth, Tightrope Walk: Networks in US-American Literature and Culture*. De Gruyter, 2023.

Simondon, Gilbert. *Individuation in Light of Notions of Form and Information*, translated by Taylor Adkins, University of Minnesota Press, 2020.

Stewart, Kathleen. *Ordinary Affects*. Duke University Press, 2007.

Strick, Simon. *Rechte Gefühle: Affekte und Strategien des digitalen Faschismus*. transcript, 2021.

Turing, A. M. "I.—Computing Machinery and Intelligence." *Mind*, vol. 59, no. 236, 1950, pp. 433–60.

Wilson, Elizabeth A. *Affect and Artificial Intelligence*. University of Washington Press, 2010.

Zuboff, Shoshana. *The Age of Surveillance Capitalism*. Profile Books, 2019.

II. Digital Environments

Digital Technology and the Promise of Decentralization: A Reconstruction of Popular Visions and Their Narrative Patterns

Jan-Felix Schrape

Introduction

Since its beginning, the social adoption of the Internet has been accompanied by the promise of technology-driven decentralization. Already in its earliest embodiment, the World Wide Web was considered to foster decentralized societal structures and new forms of collective agency (Negroponte). Web 2.0 allegedly triggered the replacement of mass media and one-to-many distribution with peer-to-peer exchange and many-to-many communication—ultimately leading to a ubiquitous form of "prosumer capitalism" (Ritzer 413). With the advent of the Internet of Things, 3D printing, and cyber-physical systems, we have been witnessing again the prospect of new forms of coordination and collaboration, sufficient to counteract existing asymmetries of economic power, this time in the production of goods (Rifkin, *The Zero Marginal Cost Society*; *The Green New Deal*). Recently, such narratives have extended to discussions of blockchain technologies that, according to several social scientists (see, e.g., Vergne; Davidson et al.) were to render contractual intermediaries obsolete: "With blockchain, for the first time in human history, people and organizations can trust each other directly, without intermediaries. Trust is not achieved by a middleman; it is achieved by cryptography, collaboration, and some clever code" (Tapscott and Euchner 13). Although none of these expectations have been fulfilled empirically, the belief that digital technologies will lead to decentralization and democratization has substantially shaped public debates and social science discourse.

Drawing on empirical material (e.g., web content, text and video documents, press reports) and social science research, this article begins with a problem-centered reconstruction (Héritier; Mayntz) of the discourse of technology-driven decentralization—from the Californian do-it-yourself subculture of the 1960s, the computer counterculture of the 1970s and 1980s, and debates on cyberspace and Web 2.0 in the 1990s and 2000s to present-day ideas of decentralized economic

systems. Subsequently, I will elucidate the shared patterns of complexity reduction of technology-centered promises of decentralization, which are a primary reason for their popularity despite repeated empirical disappointments. In light of their unambiguous formulation, these visions serve as easily recognizable landmarks in public debates and social science discourses, contributing to the channeling of public awareness and offering a basis for legitimacy in individual, collective, and corporate decision-making processes. They open up new fields of collective agency and make it possible to depict the societal status quo as both conditional and contingent and, therefore, open to criticism. Yet most visionary publications inherently give little consideration to the possibility of an expansion, conversion, or layering of existing socio-economic structures and instead focus on their radical displacement.[1]

The Whole Earth Catalog and DIY Culture

The *Whole Earth Catalog* (WEC) represents a fundamental point of origin for the vision of a decentralized do-it-yourself (DIY) culture. Regularly published from 1968 to 1971, it is considered one of the primary organs of the California counterculture movement of the late 1960s (Kirk; Roszak). The catalog defined itself as an "evaluation and access device" for technological tools. Reacting to a work culture defined by increasing division of labor and economic centralization, it propagated a return to practices of individual, distributed production:

> So far, remotely done power and glory—as via government, big business, formal education, church—has succeeded to the point where gross defects obscure actual gains. In response to this dilemma and to these gains a realm of intimate, personal power is developing—power of the individual to conduct his own education, find his own inspiration, shape his own environment, and share his adventure with whoever is interested. Tools that aid this process are sought and promoted by the Whole Earth Catalog. (Brand, *Whole Earth Catalog* 2)

Stewart Brand, founder of the WEC and of its successor, the popular science magazine *CoEvolution Quarterly*, was an entrepreneurial activist with parental financial reserves in the U.S. hippie subculture. In 1985, he co-launched *The WELL* ("The Whole Earth 'Lectronic Link"), one of the first virtual communities. Contrary to many of his contemporaries (e.g., Mumford), Brand viewed technological progress, social balance, and the conservation of nature not as being fundamentally in conflict. Instead,

1 This article builds on previous research on digital transformation and the architectures of digital utopianism, including Dolata and Schrape, "Platform Companies" and *Collectivity and Power*; Schrape, "Open-Source Projects"; and Dickel and Schrape, "The Logic."

he argued in 1974, the proper application of technology held the promise of a better future in each of these areas: "Man has still within him sufficient resources to alter the direction of modern civilization, for we then need no longer regard man as the passive victim of his own irreversible technological development" (Brand, "Comment on" 23). In this respect, Brand identified information, specifically practice-oriented knowledge of production and technology, which had often not been freely accessible in the past, as a key resource: "On the one hand [...] information [...] wants to be expensive because it's so valuable. [...] On the other hand, information almost wants to be free because the cost of getting it out in many respects is getting lower and lower all the time" (Brand in Getty Images Archive 0:38-1:09).

Accordingly, the basic idea of the WEC was to make technological know-how accessible to as many people as possible in order to empower them to produce material goods in a decentralized and collective manner: "At a time when the New Left was calling for grassroots political (i.e., referred) power, Whole Earth eschewed politics and pushed grassroots direct power—tools and skills" (Brand, "Whole Earth Catalog" 3). Thus, already in the early years of the modern DIY movement, the screwdriver-in-hand amateur was cast as a social figure standing in sharp contrast to the world of centralized production and private enterprise, one who, aided by the power of how-to knowledge and relying on collective means of self-organization, would prepare the way for a better era of human existence to come.

Brand touched the nerve of the times. While the first WEC was distributed in small numbers, by the time of the so-called *Last Whole Earth Catalog* was published in 1971, it had a print run of more than one million copies and was distributed by a major publisher. Kenner described publications like the WEC as "metaphors disguised as how-to-do-it and where-to-find-it manuals. The deepest need they satisfy is the need for such metaphors" (34). In addition to its unwavering belief in the primacy of technology as a solution to social problems, the early WEC stands out for the initial development of what is now a ubiquitous business model, "essentially encouraging customers to create the product, and then selling the customers and their work to each other and keeping the profits" (Worden 212). In Brand's subsequent publications (*CoEvolution Quarterly*, 1974–1984; *Whole Earth Review*, 1984–2003), ecological issues thus moved into the background, as they gave increasing attention to technological innovation and entrepreneurial decentralization.

In Europe, where self-sufficiency had previously mostly been a matter of necessity due to the constraints of the post-war period, politically motivated DIY practices gained prominence with the rise of the environmental movements in the 1970s. In addition to the then ubiquitous nature and wildlife documentaries on TV, with their increasing warnings about environmental sins, the 1972 report on "The Limits to Growth" by the *Club of Rome* questioned the widely held belief in the benefits of progress and imparted a fundamental awareness of the significance of ecological imbalances (Engels et al. 153–64). In alternative subcultures, one response to this

awareness was a change in personal lifestyle, with the desire to free oneself from the influence of market forces, which lead to a rediscovery of collective craft and small trade.

The conceptual basis behind this shift to decentralized production and consumption patterns could be found in numerous large-scale works critical of big industry, i.e., the studies by Jungk (1973), Ullrich (1977), and Schumacher (1973). Schumacher's notion of an "economics of permanence," in particular, had a substantial impact on the international environmental movement, and anticipated some essential ideas for a decentralized post-growth society. Like Brand, Schumacher saw the key to human survival in changing the way we approach existing and emerging technologies: "[...] a technology with a human face, is in fact possible [...]. It serves production by the masses instead of mass production" (117–18). Similarly, Burns foresaw an "inevitable [...] decline of the market economy" (14), and Harman predicted a social transformation that, as Marien summarized, would lead to "frugal technology [...] and more emphasis on social innovation" (422).

The Computer Counterculture and the Free Software Movement

However, by the early 1970s, the activist networks associated with the WEC were already taking a different direction—away from the idea of an all-encompassing anti-capitalistic lifestyle and toward the emerging computer hacking scene (Kirk; Turner). First, the few readers who aspired to really implement the WEC's proposals realized that it was impossible to decouple oneself from centralized economic structures overnight, due to the degree of technical competence this would require. Second, Brand and the activists around him recognized that a subsistence lifestyle went hand in hand with "mind-numbing labor and loneliness" (Baldwin and Brand 5). Third, through his observations on the video game *Spacewar!*, which was programmed by students from 1961 on, Brand developed an early fascination with computer counterculture: "The hackers made Spacewar, not the planners. When computers become available to everybody, the hackers take over. We are all Computer Bums, all more empowered as individuals and as co-operators" (Brand, "Spacewar" 50).

Although a closer look shows that *Spacewar!* can hardly be considered a typical example of a product developed in a hacker scene detached from the commercial market, given its development on university computing equipment donated by major corporations and its later adoption by the video arcade industry (Lowood), Brand had recognized early the potential for shifting WEC concepts of decentralization and collective empowerment through access to technological knowledge to the world of intangible information networks. The free and open circulation of technological knowledge and information was, in fact, formative for many computer-

centered project groups that were established at universities in North America in the 1960s. Their work served as the breeding ground for the broader amateur computer scene in the 1970s, which has been described as "an avid, eager-beaver breed, anxious to share technological insights and applications with other chip fanatics" ("The Computer Society" 49).

As this niche gradually expanded in the 1980s into a full-fledged microcomputer industry serving the mass market, knowledge sharing became increasingly hampered by technical hurdles such as the distribution of software in binary format and changes to copyright law (Menell). In response, in 1983, MIT employee Richard Stallman announced the development of a freely usable, open-sourced operating system (GNU) as an alternative to proprietary software distributions. With Stallman's "Free Unix!" manifesto, the *Free Software Movement* was born, promoting open and self-organized software development ever since. Moreover, with the establishment of legally recognized licensing models for open-source software, the movement eventually became the basis for open-source projects such as the *Linux* kernel, which became fundamental for the industry (Schrape, "Open-Source Projects").

Brand was associated with the *Free Software Movement* from its very beginning. In 1983, publisher *Quantum Press/Doubleday* gave him an advance of 1.3 million U.S. dollars to create a *Whole Earth Software Catalog* "[that] would do for computing what the original had done for the counterculture" (Turner 129). The catalog came out in 1984, but was a commercial disappointment. Yet the subversive impetus of the original WEC becomes apparent in the introduction to the *Software Catalog*: "Computers and their programs are tools. They empower. They estrange. [...] Their power grew with governmental and commercial institutions after the war [...]. With the coming of personal computers came a shift in the power balance" (Brand, *Whole Earth Software Catalog* 2).

Brand, with Kevin Kelly (who later became the editor of the tech periodical *Wired*), also organized the first *Hackers Conference* in Sausalito (San Francisco Bay Area) in 1984, bringing together the hacker scene and the burgeoning IT industry. The event further advanced the development of a hacker ethic (Levy) as well as of new business models—and it was at this conference, too, that Brand made his famous statement—which was later frequently misquoted: "Information *almost* wants to be free" (Brand in Getty Images Archive 0:38-1:09). Kelly, along with Brand, was furthermore involved in the launch of the online community *The WELL* in 1985, which was based solely on user-generated content and, unlike social networking sites of today, funded by membership fees, with no advertising: "By contrast to ponderous commercial systems [...], the WELL offers little beyond what its users bring to the system. [...] Despite its state-of-the-art veneer, WELL habitués argue that the medium is as much a step backward to the 19th-century literary salon as a step into the future" ("Sausalito Journal" A14).

Taken together, the *Whole Earth Software Catalog*, the *Hackers Conference*, and *The WELL* visibly accomplished the transformation in California "from counterculture to cyberculture" (Turner): No longer was the focus on the decentralized production of material goods, but rather on the collective appropriation of the world of digital information. For one thing, the belief in the decentralizing power of the network—resulting in a dissolution of the social roles between producers and consumers, a loss of relevance of formal organizations, and an extended scope for collectivity—became a defining influence on the subsequent discourse on cyberspace and Web 2.0. At the same time, the WEC and *The WELL*, with their early implementation of intermediary platforms for distributing and exploiting user-generated content, put to the test a concept that was to become influential for the development of the platform-based Internet economy (Dolata and Schrape, "Platform Companies").

Cyberspace, Web 2.0, and Digital Prosumerism

Beginning in the early 1970s, but widely unrelated to the Californian countercultural movement, several expectations related to technology-induced decentralization began to circulate in the German-speaking countries. Given the influence of Bertolt Brecht's radio theory and Hans-Magnus Enzensberger's "Constituents of a Theory of the Media," those were linked to the then-new media. The videocassette system was seen as the antithesis of a hierarchically constituted society (Baumgart); videotext systems heralded the end of the traditional mass media and the advent of novel options for the public to participate directly in political decisions (Haefner 286–96.). Cable television, with its richness of information and intended "open" channels allowing citizens to co-create the program, was expected to offer media recipients new opportunities of choice and expression (Modick and Fischer).

With Berners-Lee's invention of the World Wide Web as a user-friendly interface of the Internet, the American and European lines of discourse and other tech-related visions (e.g., Haraway) converged, and, from the early 1990s on, the Web quickly became known as an essentially open medium, one that would promote greater public democracy and flatten the hierarchies between producers and recipients. Negroponte, for instance, attested to the Internet—at the time termed "cyberspace" (Barlow)—the capability to advance the shift "of some intelligence, from the transmitter to the receiver" (19): "It has four very powerful qualities that will result in its ultimate triumph: decentralizing, globalizing, harmonizing, and empowering. [...] The traditional centralist view of life will become a thing of the past" (239f.). In a similar sense, Steven McGeady diagnosed a "shift back towards decentralized management models and decentralized work models" (147). More moderate voices like Neil Postman, who noted that it was no longer the dissemination of information that was

the pivotal problem, but rather how to use it to generate knowledge, received little attention at this time.

After a brief period of disillusionment as a result of the implosion of the "dot-com bubble" in 2000, discussions about the reformative power of online technologies picked up again in 2002 in the social sciences: Drawing on the open-source movement's own narratives (Raymond), Yochai Benkler pointed to the increasing relevance of open-source software projects as evidence for a new, more effective production model that, being based on equitable and decentralized forms of collaboration, would eventually gain advantage over the classic forms of socio-economic coordination:

> Commons-based peer production is [...] emerging in the digitally networked environment. Facilitated by the technical infrastructure of the Internet, the hallmark of this socio-technical system is collaboration among large groups of individuals [...] without relying on either market pricing or managerial hierarchies [...]. (Benkler and Nissenbaum 394)

A related influential concept was the paradigm of "open innovation": Drawing on the success of open-source projects, Henry Chesbrough coined the term in 2003 to characterize how previously closed and intra-organizational research and development (R&D) processes were opened up, decentralizing the dynamics of innovation and presumably improving competitiveness as well as cost-effectiveness (Bogers and West).

In 2005, the Internet again moved to the forefront of public discourse with Tim O'Reilly's widely noticed essay "What is Web 2.0?" At its core, O'Reilly's text addressed the unprecedented bundling of data in the business world: "Database management is a core competency of Web 2.0 companies [...]. This fact leads to a key question: Who owns the data?" (O'Reilly 3). This aspect, however, quickly faded into the background during this phase of public discourse, as Web 2.0 quickly became a synonym for an overall spirit of optimism about the enabling possibilities of the Internet. In this context, three expectations can be distinguished that together amount to a vision of technology-induced decentralization and dismantling of established socio-economic distribution of roles (Schrape, *Digitale Transformation* 70):

- *End of the mass media*: Gillmor referred to Web 2.0 as the first "many-to-many" medium and the first step toward a general loss of relevance of the classic, "one-to-many" mass media: "Grassroots journalists are dismantling Big Media's monopoly on the news, transforming it from a lecture to a conversation" (I, IV).
- *Dissolution of producer and consumer roles*: Rheingold resumed the discussion on the expansion of collective intelligence through the Internet, and Surowiecki coined

the idea of the "wisdom of the crowds," followed by Kelly, who postulated in 2005 that by 2015 "everyone alive will (on average) write a song, author a book, make a video, craft a weblog, and code a program."

- *Democratization of societal decision-making*: The assumption that all Web users would become prosumers also led to the idea of a general democratization of decision-making throughout society due to new tech-induced options for collective agency (Castells) and "the power of organizing without organizations" (Shirky I).

In the Web 2.0 debates, again, critical voices were initially rarely heard. This is certainly true with regard to Habermas's comments in 2006, which noted the ambivalent political consequences of a fragmented public sphere ("Political Communication"; see also Habermas, "Reflections," 2022), as well as for Lanier, who warned of the unpredictable consequences of self-governing collectives.

Although it soon became apparent that sheer technological possibility would not lead to shifts in social roles and that the dynamics of the information age are shaped to a much lesser extent by individual users and user collectives than by a small number of IT corporations (Dolata and Schrape, "Platform Companies"), the affirmative theses listed became sententious points of reference in the ongoing discourse, eventually culminating in the proclamation of an entirely new age—"the age of the prosumer" (Ritzer et al. 380). This "prosumer society" (Ritzer 413) allegedly would be characterized by the newfound power of the consumer and the decentralization of media production and diffusion (Ritzer and Jurgenson; Anderson).

In this context and under the immediate influence of the "Arab Spring" (2010/2011) and Occupy Wall Street (2011), the well-received concept of "connective action" has furthermore been worked out by W. Lance Bennett and Alexandra Segerberg. They characterized online technologies as "organizing agents" that would assume the coordination tasks of traditional movement organizations and enable decentralized and distributed forms of "peer organization in the crowd" (Bennett et al. 239).

A closer look at the attention and coordination dynamics of the cases mentioned and more recent movement phenomena (e.g., Mouvement des Gilets Jaunes, Fridays for Future), however, reveals that the impression that technology can override or substitute formerly essential organizational processes is primarily the result of a temporally limited, or situational, point of view. As Anastasia Kavada has pointed out, crowd protest dynamics and organized movements have always been closely intertwined. As soon as it comes to establishing collective agency and public visibility beyond the moment, protest movements, even in the digital age, cannot do without genuinely social and complex processes of internal organization, identity formation, and collective goal-setting (Dolata and Schrape, *Collectivity and Power*).

The Notion of a Post-Capitalist Maker Economy

With the popularization of 3D printing, from the mid-2000s onwards, tech utopianism again took a "material turn"—away from the world of immaterial information and toward the distributed production of material goods. Drawing on additive manufacturing technologies already in use in industry since the 1980s and using open-sourced design data, Adrian Boyer, in 2004, initiated the project Replicating Rapid-Prototyper to develop a 3D printer assembled entirely from 3D-printer-produced parts. In his manifesto "Wealth without Money," he characterized 3D printing as the next step in socio-technological development that would decentralize economic processes and return the control of the means of production to the people. MIT employee Neil Gershenfeld's FabLabs pursued similar objectives: open workshops equipped with modern machinery offering all participants the opportunity to manufacture their own material goods. Chris Anderson, already an influential voice in Web 2.0 discourse, described 3D printing as the harbinger of a "new industrial revolution" that would lead to the emergence of a "maker economy" in which anybody could actualize their product ideas anywhere (51).

The basic idea from 1960s Californian counterculture that "grassroots direct power" (both in an economic and political sense) could be achieved by making tools and knowledge available to everybody had thus undergone a comprehensive update: New technologies were now expected to tackle the DIY scene's inherent problems, as many of the tools and resources needed could now be manufactured by amateurs themselves. In this manner, central dilemmas of open-source and maker movements (e.g., exploitation by corporations) would be resolved through a decoupling from traditional capitalist market structures. Modern means of communication would help to ensure that self-sufficiency was no longer accompanied by social deprivation (Anderson; Gershenfeld).

Taken together, contributors to the discourse suggested, 3D printers, online technologies, and the Internet of Things opened up opportunities for social transformation that previously could not be realized:

> The Makers Movement [...] has been driven by four principles: the open-source sharing of new inventions, the promotion of a collaborative learning culture, a belief in community self-sufficiency, and a commitment to sustainable production practices. [...] If we were to put all the disparate pieces of the 3D printing culture together, what we begin to see is a powerful new narrative arising that could change the way civilization is organized in the twenty-first century. (Rifkin, *The Zero Marginal Cost Society* 99)

In other words, visions of technology-driven decentralization no longer solely pertained to commons-based peer production or an adhocracy among equals

in cyberspace, but— under the umbrella term of the "collaborative commons" (Rifkin)—now projected that the decentralized production of material goods would help overcome real-world socio-economic imbalances (Papadimitropoulos; Kostakis et al.; Stalder).

Propositions for a socially and ecologically balanced post-capitalist economy also draw on such narratives. They offer the prospect of an upturn for the individual and self-organized collectives and a loss of relevance for classic economic authorities due to "the rise of non-market production, of unownable information, of peer networks and unmanaged enterprises" (Mason 244). Thanks to new forms of technologically mediated collective coordination, communities such as FabLabs or Makerspaces can now exchange knowledge at all stages of production and development regardless of time or location. Such communities, it is suggested, will thus pave the way for a sustainable economic order, as decentralized production not only reduces the need for the transport of goods, but also promotes a more environmentally friendly form of existence (Pansera and Fressoli; Hankammer and Kleer).

Much like their forerunners, "resilient communities, the degrowth movement and peer production" are described as complementary components of a comprehensive paradigm shift—"away from an economic system based on the irrational exploitation [...], towards one characterized by a radically different definition of the content of human well-being" (Kostakis et al. 133). In a similar sense some evangelists consider Blockchain technology, the principle of decentralized accounting based on cryptographically secured chains of distributed data ledgers managed by peer-to-peer networks, to be the stepping stone to an emerging period of post-capitalism in which intermediary organizations allegedly become increasingly obsolete (Vergne; Waters; Tapscott and Tapscott; Cohen): "The ultimate purpose of blockchain is to abolish, or at least reduce the power of monopolies, and according to its proponents this will eventually happen using decentralized structures allowing creators to interact directly with users [...]" (Makridakis and Christodoulou 8).

From the countercultural message of the Whole Earth Catalog to the computer hacking scene and the debates about the Web and Web 2.0, to the discourses on a presumed maker economy and post-capitalism, new technologies have been and continue to be characterized as the stimulus for fundamental processes of societal transformation. By enabling comprehensive processes of decentralization and novel forms of collective agency, they are seen to open up the possibility of surmounting current societal conditions. Yet, technological innovation alone is incapable of pushing society into a particular direction; it is necessarily embedded in multi-layered social appropriation processes, as the history of the Gutenberg printing press clearly showed us already centuries ago: The modern letterpress was only able to achieve its transformative power in an interplay with major societal developments, including the European Reformation and the Industrial Revolution (Stöber).

Narrative Patterns of the Promises
of Technology-Driven Decentralization

The promises of technology-driven decentralization outlined above are characterized by three basic assumptions: (1) Technological innovations or the repurposing of already existing technologies are expected to enable the replacement of centrally coordinated communication and transaction procedures with collaborative processes in peer-to-peer networks. (2) As a result, intermediary organizations, established market structures, and classic forms of hierarchical decision-making are expected to decline in significance. (3) Taken together, these dynamics are expected to lead to reduced socio-economic power asymmetries, the disintermediation of social roles, and a democratization of society.

However, although the Internet, at a purely technical level, is still based on the principle of distributed control and decentralization, empirical developments point in a direction opposite to these expectations:

- The DIY counterculture that arose with the WEC did by no means lead to an erosion of centralized production. Instead, by exploring intermediary structures for the aggregation of user-generated content, it contributed to the genesis of a core business model of the platform-based Internet economy (Worden).
- The present-day relationships between open-source communities, hardware and software companies, and the commercial IT sector in general are not characterized by competition but complementarity, as open-source development projects nowadays serve as essential incubators for industry-fundamental infrastructures and standards (Schrape, "Open-Source Projects").
- Although the Web (2.0) has made communication more flexible and contributed to the emergence of new hybrid forms of private and public spheres as well as new forms of collectivity and collective agency, this has not eroded the significance of big media providers, nor has it led to a general dissolution of producer-consumer roles. Instead, the present Internet economy is characterized by an almost worldwide hegemony of a few technology companies and a historically unique bundling of private sector power over infrastructures and data (Dolata and Schrape, "Platform Companies").

Against these findings, it seems implausible that further technological innovations or new technology-mediated forms of co-production, co-consumption, and collectivity will lead to an end of mass production or an immediate loss of relevance for intermediary organizations. Nonetheless, corresponding expectations continue to circulate in public and social science discourse, especially in the early days of any new technology. One reason for the popularity of technology-driven promises of decentralization despite repeated empirical disappointments—other than their compati-

bility with utopian ideals (Sargent)—can be found in their patterns of factual, social, and temporal complexity reduction (*Tab. 1*).

Table 1: Simplification patterns of technology-based decentralization promises

Factual Dimension	Social Dimension	Temporal Dimension
Decontextualization Decoupling from socio-economic contexts; bridging social problems through technology	*Overgeneralization* Transference of technological practices from specific user milieus to the population at large	*Detachment* Dissociation from past empirical disappointments; marginalization of professionalization dynamics

Source: Dickel and Schrape (54).

In the *factual dimension* of meaning, technological innovations are framed as solutions to overcome or bypass long-term solidified social problems. The discourse here tends to detach application-specific technologies from their original frame of reference, as the processes of technology adaption become decoupled from their socio-economic contexts and characterized as universal alternatives. In the Web 2.0 discourse and debates on a presumably emerging post-capitalistic economy, context-dependent application areas of new technologies such as 3D printing or social media have been depicted as a catalyst for generating comprehensive decentralized substitution structures for fully-fledged organizational contexts and functional systems of society (e.g., economy, law, politics).

From a *social viewpoint*, the early adopters of new technologies are formatted as agents of socio-technical change. Their individual and collective practices are projected onto the future population as a whole without considering their milieu-specific sociocultural backgrounds. The activists in the early DIY movement, for example, were forced to realize early on that the ideal of a distributed subsistence economy was not an option for most people. Likewise, the preferences of the young, educated, and tech-savvy early adopters of Web 2.0 were not easily transferred to later users (seminal: Rogers); the users of open workshops such as *FabLabs* or *Makerspaces* are as well conspicuous for their specific motivations and socio-economic backgrounds (Hepp and Schmitz; Schrape; Lange and Bürkner).

From a *temporal perspective*, current visions of decentralization are readily dissociated from previous developmental stages, failed expectations, and foreseeable professionalization dynamics. Contemporary discussions of a post-capitalist economy often fail to consider empirical caveats regarding former expectations about the

reformative power of the Internet. These discussions reflect the very same ignorance found in the Web 2.0 discourse that ignored the failed visions of the 1970s. The gradual appropriation of niche developments by established economic actors in earlier periods is likewise overlooked in current debates or regarded as the consequence of afore insufficiently defined technological infrastructures.

Communicative Functions of Visions of Technology-Centered Decentralization

Based on such patterns of simplification and arising out of diverse individual and collective interests, far-reaching promises of technologically-enabled decentralization are regularly reformulated—often by professional "visioneers" (McCray; Sand)—not least as they are easily integrated into a variety of ongoing political, cultural as well as economic discourses and fulfill elementary communicative functions in the areas addressed (Zhan; Schrape, *Digitale Transformation*; Tutton; Beckert; Konrad).

Table 2: Communicative functions of technology-centered decentralization visions

Channeling	Alignment due to the necessity of either consent or disagreement; semantic coordination of collective and corporate activities
Motivation	Motivation of volunteers in civil society, of freelancers and employees in economic contexts, or of early adopters in innovation processes
Distinction	Supporting the construction of collective identities, simplifying differentiation from other social domains or groups in early user milieus
Legitimization	Plausible basis for validation and legitimization in entrepreneurial or organizational, political, and personal decision-making processes
Attention	Public awareness of potential new socio-technological development paths; marketing of commercial products and content; individual self-marketing
Criticism	Critical assessment of given social conditions through the construction of utopian alternatives alongside new technological possibilities

With their unambiguousness and thus insistence on either agreement or rejection, such propositions of technological decentralization considerably contribute to the alignment and channeling of socio-political communication processes, the semantic coordination of collective or corporate activities, and the motivation of employees, freelancers, consumers, volunteers, or activists. Moreover, they facilitate the construction of collective identity and goal-setting in social movements, tech-related communities, and further interest groups and allow a distinction from other social domains in early-adopter milieus (*Tab. 2*).

In light of a fundamentally unpredictable future (Schneider et al.), the expectations and visions outlined above also offer a plausible basis for validation and legitimization in organizational, collective and personal decision-making processes as they substantially contribute to the coping with contingencies and uncertainties (Dickel and Schrape 54): Business enterprises may see in these utopias (or dystopias) a confirmation of their previous course or derive from them a need for realignment. Early adopters may align their preferences with them and consider themselves as "innovative." Academia may declare a need for further research. Established politicians or social movement activists may call for reorientation. Mass media and publicist channels on the Social Web may mount a series of follow-up reports after the emergence of a (recurring) radical vision of the future.

Furthermore, as can be seen in the history of the discourse since the 1960s and, more recently, in the example of blockchain technologies, radical visions and expectations of technology-driven decentralization serve to create public awareness of potential socio-technological development paths that private-sector organizations or science and politics at some point will have to confront. They open up new fields of experimentation and collective agency, both in the political and economic sense, and promote the emergence of accordingly oriented communities or movements. Finally, utopian expectations and visions of the future associated with new technological lines of development make it possible to depict the societal status quo as both conditional and contingent and, therefore, changeable and open to criticism. Thus, the recourse to technology-based promises of decentralization can serve as an instrument for reducing situational complexity in a plethora of communication contexts.

Conclusion

Notions and visions of technology-driven decentralization and democratization continue to circulate with increasing ubiquity—from the Californian counterculture of the 1960s, the computer hacking scenes of the 1970s and 1980s, and the debates on the disruptive potential of the World Wide Web and Web 2.0 in the 1990s and 2000s to more recent visions of a post-capitalist economy. The specific

expectations range from the user-centered creation and distribution of digital information to the decentralized production of material goods. Yet, they all share the prospect of overcoming existing social power configurations, the belief that new technological solutions will enable the transfer of hitherto centrally coordinated socio-economic activities to distributed peer-to-peer networks, and the conviction that technologies foster self-organized collectives and new, more potent forms of collective agency.

The unambiguous formulation of these visions allows them to serve as easily recognizable landmarks in public debates and social science discourses, contributing to the channeling of public awareness and offering a basis for legitimacy in individual, collective, and corporate decision-making processes. Yet most visionary publications inherently give little consideration to the possibility of an expansion, conversion, or layering of existing socio-economic structures and instead focus on their radical displacement.

However, even though new technologies from the 1960s onward have led to considerably greater flexibility in communication, collective coordination, and collaborative production of content or goods, this has by no means caused a radical erosion of fundamental socio-political resource and power asymmetries, nor a general replacement of established forms of socio-economic organization. Open-source projects, for example, have contributed significantly to the reorganization of software production. Today, though, they are, above all, an integral part of the development activities of large IT companies. On the one hand, Web 2.0 has significantly expanded the scope for collective formations and enables new forms of collective agency, but, on the other hand, it has also led to the emergence of highly profitable multi-sided market structures and centrally controlled platform ecosystems for almost all activities society has to offer.

Promises of decentralization, or even democratization, of socio-economic structures primarily through technology thus remain a well-honed delusion, one that, in the worst case, obscures contradictory empirical developments such as oligopolistic configurations or dynamics of re-centralization in the Internet economy. At their best, technological infrastructures can serve to enhance existing trends in social, political, or economic areas, which already show a tendency toward decentralization. However, these potentials will not be realized automatically within the horizon of technological innovation, or within a short period of time, but become part of long-term and gradual socio-technical reconfiguration dynamics, as they are in all cases embedded in complex and multi-layered processes of social appropriation and deliberative negotiation.

Works Cited

Anderson, Chris. *The Long Tail*. Hyperion, 2006.

—. *Makers: The New Industrial Revolution*. Random House, 2013.

Baldwin, James T., and Stewart Brand. *Soft-Tech*. Penguin, 1978.

Barlow, John Perry. "A Declaration of the Independence of Cyberspace." *Electronic Frontier Foundation*, 8 February 1996, https://projects.eff.org/~barlow/Declarati on-Final.html. Accessed 1 October 2023.

Baumgart, Reinhard. "Die schmutzigen Medien: Reinhard Baumgart über Enzensbergers 'Kursbuch 20.'" *Der Spiegel*, no. 18, 26 April 1970, https://www.spiegel.de /kultur/die-schmutzigen-medien-a-86610b12-0002-0001-0000-000045439835 ?context=issue. Accessed 1 October 2023.

Beckert, Jens. *Imagined Futures: Fictional Expectations and Capitalist Dynamics*. Harvard University Press, 2016.

Benkler, Yochai. "Coase's Penguin, or, Linux and 'The Nature of the Firm.'" *The Yale Law Journal*, vol. 112, no. 4, 2002, pp. 369–446, https://doi.org/10.2307/1562247.

Benkler, Yochai, and Helen Nissenbaum. "Commons-based Peer Production and Virtue." *Journal of Political Philosophy*, vol. 14, no. 4, 2006, pp. 394–419.

Bennett, W. Lance, and Alexandra Segerberg. "Organization in the Crowd: Peer Production in Large-Scale Networked Protests." *Information, Communication & Society*, vol. 17, no. 2, 2012, pp. 232–260, https://doi.org/10.1080/1369118X.2013.8703 79.

Bennett, W. Lance, Alexandra Segerberg, and Shawn Walker. "The Logic of Connective Action. Digital Media and the Personalization of Contentious Politics." *Information, Communication & Society*, vol. 15, no. 5, 2014, pp. 739–768, https://doi.o rg/10.1080/1369118X.2012.670661.

Berners-Lee, Tim. *Information Management: A Proposal*. Working Paper. CERN, 1989.

Bogers, Marcel, and Joel West. "Managing Distributed Innovation: Strategic Utilization of Open and User Innovation." *Creativity and Innovation Management*, vol. 21, no. 1, 2012, pp. 61–75, https://doi.org/10.1111/j.1467-8691.2011.00622.x.

Boyer, Adrian. "Wealth Without Money." *Reprap.org*, 2 February 2004, http://reprap. org/wiki/Wealth_Without_Money. Accessed 1 October 2023.

Brand, Stewart. "Spacewar. Fanatic Life and Symbolic Death Among the Computer Bums." *Rolling Stone*, 12 July 1972, http://wheels.org/spacewar/stone/rolling_sto ne.html. Accessed 1 August 2023.

—. "Comment On: Lewis Mumford: *The Next Transformation of Man*." *CoEvolution Quarterly*, vol. 1, no. 4, 1974, p. 23.

—, editor. *Whole Earth Catalog*. Whole Earth, 1968, https://monoskop.org/images/ 0/09/Brand_Stewart_Whole_Earth_Catalog_Fall_1968.pdf. Accessed 1 October 2023.

—. *Whole Earth Software Catalog*. Doubleday, 1984.

—. *Whole Earth Catalog: 30th Anniversary Celebration*. Whole Earth, 1998.

Brecht, Bertolt. "Der Rundfunk als Kommunikationsapparat." *Gesammelte Werke*, vol. 18, Suhrkamp, 1967, pp. 127–134.

Burns, Scott. *The Household Economy: Its Shape, Origins, and Future*. Beacon, 1977.

Castells, Manuel. *Communication Power*. Oxford University Press, 2009.

Chesbrough, Henry W. *Open Innovation: The New Imperative for Creating and Profiting from Technology*. Harvard Business Press, 2003.

Cohen, Boyd. *Post-Capitalist Entrepreneurship*. Productive Press, 2017.

Davidson, Sinclair, Primavera De Filippi, and Jason Potts. "Blockchains and the Economic Institutions of Capitalism." *Journal of Institutional Economics*, vol. 14, no. 4, 2018, pp. 639–658, https://doi.org/10.1017/S1744137417000200.

Dickel, Sascha, and Jan-Felix Schrape. "The Logic of Digital Utopianism." *Nano Ethics*, vol. 11, no. 1, 2017, pp. 47–58, https://doi.org/10.1007/s11569-017-0285-6.

Dolata, Ulrich, and Jan-Felix Schrape. *Collectivity and Power on the Internet*. Springer, 2018.

—. "Platform Companies on the Internet as a New Organizational Form: A Sociological Perspective." *Innovation*, March 2023, https://doi.org/10.1080/13511610.2023.2182217.

Engels, Jens, Tamara Withed, Richard Hoffmann, Hilde Ibsen, and Wybren Verstegen. *Northern Europe: An Environmental History*. Abc-Clio, 2005.

Enzensberger, Hans M. "Constituents of a Theory of Media." *New Left Review*, vol. 64, no. 1, 1970, pp. 13–40.

Gershenfeld, Neil A. *Fab. The Coming Revolution on your Desktop*. Basic Books, 2005.

—. "How to Make Almost Anything: The Digital Fabrication Revolution." *Foreign Affairs*, vol. 91, no. 6, 2012, pp. 43–57.

Getty Images Archive. "Stewart Brand States Information Wants to Be Free." *gettyimages.in*, 1 November 1984, https://www.gettyimages.in/detail/video/at-the-first-hackers-conference-in-1984-steve-wozniak-and-news-footage/146496695. Accessed 1 October 2023.

Gillmor, Dan. *We the Media*. O'Reilly, 2006.

Habermas, Jürgen. "Political Communication in Media Society: Does Democracy Still Enjoy an Epistemic Dimension?" *Communication Theory*, vol. 16, no. 4, 2006, pp. 411–426, https://doi.org/10.1111/j.1468-2885.2006.00280.x.

—. "Reflections and Hypotheses on a Further Structural Transformation of the Political Public Sphere." *Theory, Culture & Society*, vol. 39, no. 4, 2022, pp. 145–171, https://doi.org/10.1177/02632764221112341.

Haefner, Klaus. *Mensch und Computer im Jahre 2000*. Birkhäuser, 1984.

Hankammer, Stephan, and Robin Kleer. "Degrowth and Collaborative Value Creation: Reflections on Concepts and Technologies." *Journal of Cleaner Production*, vol. 197, no. 2, 2018, pp. 1711–1718, https://doi.org/10.1016/j.jclepro.2017.03.046.

Haraway, Donna. "Manifesto for Cyborgs: Science, Technology, and Socialist Feminism in the 1980s." *Socialist Review*, vol. 80, 1985, pp. 65–108.

Harman, Willis W. "The Coming Transformation." *The Futurist*, vol. 9, no. 1, 1974, pp. 15–24.

Hepp, Andreas, and Anne Schmitz. "Afterlives of the California Ideology| Local Ambivalences Toward the Maker Ideology: Makerspaces, the Maker Mindset, and the Maker Movement." *International Journal of Communication*, vol. 17, 2023, pp. 4196–4216.

Héritier, Adrienne. "Causal Explanation." *Approaches and Methodologies in the Social Sciences*, edited by Donatella Della Porta and Michael Keating, Cambridge University Press, 2008, pp. 61–79.

Jungk, Robert. *Der Jahrtausendmensch: Bericht aus den Werkstätten der neuen Gesellschaft.* Bertelsmann, 1973.

Kavada, Anastasia. "Creating the Collective: Social Media, the Occupy Movement and Its Constitution as a Collective Actor." *Information, Communication & Society*, vol. 18, no. 8, 2015, pp. 872–886, https://doi.org/10.1080/1369118X.2015.1043318.

Kelly, Kevin. "We Are the Web." *Wired*, 8 January 2005, http://www.wired.com/wired/archive/13.08/tech.html. Accessed 1 September 2023.

Kenner, Hugh. "The Last Whole Earth Catalog." *The New York Times* 14 November 1971, pp. 7, 34.

Kirk, Andrew G. "Appropriating Technology: The Whole Earth Catalog and Counterculture Environmental Politics." *Environmental History*, vol. 6, no. 3, 2001, pp. 374–394, https://doi.org/10.2307/3985660.

—. *Counterculture Green.* University of Kansas Press, 2007.

Konrad, Kornelia. "The Social Dynamics of Expectations: The Interaction of Collective and Actor-Specific Expectations on Electronic Commerce and Interactive Television." *Technology Analysis & Strategic Management*, vol. 18, no. 3–4, 2006, pp. 429–444, https://doi.org/10.1080/09537320600777192.

Kostakis, Vasilis, Latoufis Kostas, Minar Liarokapis, and Michael Bauwens. "The Convergence of Digital Commons with Local Manufacturing from a Degrowth Perspective." *Journal of Cleaner Production*, vol. 197, no. 2, 2018, pp. 1684–1693, https://doi.org/10.1016/j.jclepro.2016.09.077.

Kostakis, Vasilis, Vasilis Niaros, George Dafermos, and Michael Bauwens. "Design Global, Manufacture Local: Exploring the Contours of an Emerging Productive Model." *Futures*, vol. 73, 2015, pp. 126–135, https://doi.org/10.1016/j.futures.2015.09.001.

Lange, Bastian, and Hans-Joachim Bürkner. "Flexible Value Creation: Conceptual Prerequisites and Empirical Explorations in Open Workshops." *Geoforum*, vol. 88, 2018, pp. 96–104, https://doi.org/10.1016/j.geoforum.2017.11.020.

Lanier, Jaron. "Digital Maoism: The Hazards of the New Online Collectivism." *Edge*, May 2006, https://www.edge.org/conversation/digital-maoism-the-hazards-of-the-new-online-collectivism. Accessed 1 October 2023.

Levy, Steven. *Hackers: Heroes of the Computer Revolution*. Anchor, 1984.

Lowood, Henry. "Videogames in Computer Space: The Complex History of Pong." *IEEE Annals of the History of Computing*, vol. 31, no. 3, 2009, pp. 5–19, https://doi.org/10.1109/MAHC.2009.53.

Makridakis, Spyros, and Klitos Christodoulou. "Blockchain: Current Challenges and Future Prospects/Applications." *Future Internet*, vol. 11, no. 12, 2019, 258, https://doi.org/10.3390/fi11120258.

Marien, Michael. "The Two Visions of Post-Industrial Society." *Futures*, vol. 9, no. 5, 1977, pp. 415–431, https://doi.org/10.1016/0016-3287(77)90022-2.

Mason, Paul. *Post-Capitalism: A Guide to Our Future*. Allen Lane, 2015.

Mayntz, Renate. "Mechanisms in the Analysis of Social Macro-Phenomena." *Philosophy of the Social Sciences*, vol. 34, no. 2, 2004, pp. 237–259, https://doi.org/10.1177/0048393103262552.

McCray, W. Patrick. *The Visioneers: How a Group of Elite Scientists Pursued Space Colonies, Nanotechnologies, and a Limitless Future*. Princeton University Press, 2013.

McGeady, Steven. "The Digital Reformation: Total Freedom, Risk, and Responsibility." *Harvard Journal of Law and Technology*, vol. 10, 1996, pp. 137–147.

Menell, Peter S. "Envisioning Copyright Law's Digital Future." *New York Law School Review*, vol. 46, 2002, pp. 63–199.

Modick, Klaus, and Matthias J. Fischer, editors. *Kabelhafte Perspektiven*. Nautilus, 1984.

Mumford, Lewis. *The Myth of the Machine I: Technics and Human Development*. Harcourt, 1967.

Negroponte, Nicholas. *Being Digital*. Knopf, 1995.

O'Reilly, Tim. "What is Web 2.0?" *O'Reilly Network*, 30 September 2005, http://oreilly.com/pub/a/web2/archive/what-is-web-20.html. Accessed 1 September 2023.

Pansera, Mario, and Mariano Fressoli. "Innovation without Growth: Frameworks for Understanding Technological Change in a Post-growth Era." *Organization*, vol. 28, no. 3, 2021, pp. 380–404, https://doi.org/10.1177/1350508420973631.

Papadimitropoulos, Vangelis. "The Digital Commons, Cosmolocalism, and Open Cooperativism." *Organization*, March 2023, https://doi.org/10.1177/13505084231156268.

Postman, Neil. *Building a Bridge to the 18th Century: How the Past Can Improve Our Future*. Vintage, 2000.

Raymond, Eric S. *The Cathedral and the Bazaar*. O'Reilly, 1999.

Rheingold, Howard. *Smart Mobs: The Next Social Revolution*. Basic Books, 2003.

Rifkin, Jeremy. *The Zero Marginal Cost Society*. St. Martin's Press, 2014.

—. *The Green New Deal*. St. Martin's Press, 2019.

Ritzer, George. "Prosumer Capitalism." *The Sociological Quarterly*, vol. 56, no. 3, 2015, pp. 413–445, https://doi.org/10.1111/tsq.12105.

Ritzer, George, Paul Dean, and Nathan Jurgenson. "The Coming of Age of the Prosumer." *American Behavioral Scientist*, vol. 56, no. 4, 2012, pp. 379–398, https://doi.org/10.1177/0002764211429368.

Ritzer, George, and Nathan Jurgenson. "Production, Consumption, Prosumption: The Nature of Capitalism in the Age of the Digital 'Prosumer.'" *Journal of Consumer Culture*, vol. 10, no. 1, 2010, pp. 13–36, http://dx.doi.org/10.1177/1469540509354673.

Rogers, Everett M. *Diffusion of Innovations*. Free Press, 2003.

Roszak, Theodore. *From Satori to Silicon Valley: San Francisco and the American Counterculture*. Don't Call It Frisco Press, 1986.

Sand, Martin. *Futures, Visions, and Responsibility*. Springer VS, 2018.

Sargent, Lyman T. *Utopianism: A Very Short Introduction*. Oxford University Press, 2010.

"Sausalito Journal." *The New York Times* 15 August 1989, p. A14.

Schneider, Christoph, Maximilian Roßmann, Andreas Lösch, and Armin Grunwald. "Transformative Vision Assessment and 3-D Printing Futures: A New Approach of Technology Assessment to Address Grand Societal Challenges." *IEEE Transactions on Engineering Management*, vol. 70, no. 3, 2023, pp. 1089–1098, https://doi.org/10.1109/TEM.2021.3129834.

Schrape, Jan-Felix. "Open-Source Projects as Incubators of Innovation: From Niche Phenomenon to Integral Part of the Industry." *Convergence*, vol. 25, no. 3, 2019, pp. 409–427, https://doi.org/10.1177/1354856517735795.

—. "The Promise of Technological Decentralization: A Brief Reconstruction." *Society*, vol. 56, no. 1, 2019, pp. 31–37, https://doi.org/10.1007/s12115-018-00321-w.

—. "Kollaborative Labs und offene Werkstätten." *Ökologisches Wirtschaften*, vol. 35, no. 1, 2020, pp. 22–24.

—. *Digitale Transformation*. transcript/UTB, 2021.

Schumacher, Ernst F. *Small Is Beautiful: A Study of Economics As If People Mattered*. Blond and Briggs, 1973.

Shapiro, Andrew. *The Control Revolution*. Public Affairs, 1999.

Shirky, Clay. *Here Comes Everybody: The Power of Organizing Without Organizations*. Penguin, 2008.

Stalder, Felix. *The Digital Condition*. Polity Press, 2018.

Stallman, Richard. *New UNIX Implementation*. Usenet, 27 September 1983, https://groups.google.com/g/net.unix-wizards/c/8twfRPM79uo/m/1xlglzrWrUoJ. Accessed 1 October 2023.

Stöber, Rudolf. "What Media Evolution Is: A Theoretical Approach to the History of New Media." *European Journal of Communication*, vol. 19, no. 4, 2014, pp. 483–505, https://doi.org/10.1177/0267323104049461.

Surowiecki, James. *The Wisdom of Crowds*. Anchor, 2004.

Tapscott, Don, and Jim Euchner. "Blockchain and the Internet of Value. An Interview with Don Tapscott." *Research-Technology Management*, vol. 62, no. 1, pp. 12–19, https://doi.org/10.1080/08956308.2019.1541711.

Tapscott, Don, and Alex Tapscott. "How Blockchain Is Changing Finance." *Harvard Business Review*, 1 March 2017, https://hbr.org/2017/03/how-blockchain-is-changing-finance. Accessed 1 Oct. 2023.

"The Computer Society: Pushbutton Power". *TIME Magazine* no. 2, 1978, pp. 46–49.

Turner, Fred. *From Counterculture to Cyberculture*. University of Chicago Press, 2006.

Tutton, Richard. "Wicked Futures: Meaning, Matter and the Sociology of the Future." *The Sociological Review*, vol. 65, no. 3, 2017, pp. 478–492, https://doi.org/10.1111/1467-954X.12443.

Ullrich, Otto. *Technik und Herrschaft*. Suhrkamp, 1977.

Vergne, Jean-Philippe. "Decentralized vs. Distributed Organization: Blockchain, Machine Learning and the Future of the Digital Plat-Form." *Organization Theory*, vol. 1, no. 4, 2020, https://doi.org/10.1177/2631787720977052.

Waters, Ben. "Decentralizing Technology, Society, and Thought." *Medium (Hacker Noon)*, 8 October 2018, https://hackernoon.com/decentralizing-technology-society-and-thought-c59318a8aef9. 1 October 2023.

Worden, Lee. "Counterculture, Cyberculture, and the Third Culture: Reinventing Civilization, Then and Now." *West of Eden: Communes and Utopia in Northern California*, edited by Iain Boal, Janferie Stone, Michael Watts, and Cal Winslow, PM Press, 2012, pp. 199–221.

Zhan, Chuyue. *Framing Utopia in Emerging Technology*. Media@LSE MSc Dissertation Series, London School of Economics and Political Science, 2023.

What About Knowledge?
Agency and Proletarianization in Digital Environments

Matti Kangaskoski

The aim of this article is to investigate the affordances and aesthetics of collective agency in the contemporary digital environment with respect to the concepts of *knowledge* and *automation* in Bernard Stiegler's philosophy. Digital environments, and more specifically *digital cultural interfaces*, such as social media, news apps, streaming services, have a *form*, and, contrary to what the interfaces promote, this form is far from neutral or "natural" (Kangaskoski, "Logic of Selection"). The form encourages certain kinds of actions and modes of engagement while discouraging others and is driven with the energy of a specific business model. What is more, interfaces aim to automatically predict users' behavior and desire. I take this form, *the form of the environment*, to be aesthetic in the sense that it governs its users' senses, experience, and intellect—their sensibility. Viewed thus, aesthetics is also politics, a question of the sensibility of the "we," of a collection of actors. To what extent, then, does this aesthetic afford the time and processes that foster knowledge? To what extent does it enable agency, individual and collective? What kind of agency might that be? Are there better alternatives to the current forms of the digital environment? These are the questions I probe in this essay.

In doing so, I take the view that the possibility of knowledge is a necessary component of agency and that knowledge is essential in enabling participation—participation viewed generally, but also as participating in the aesthetic, in what Stiegler calls the "production of symbols" (*Symbolic Misery*, vol. 1 10).[1] Moreover, knowledge is intimately connected to retaining a past and projecting a future, being in a process of becoming, which can also be called *individuation*. I have previously argued that for a collective to form, it needs to be able to co-individuate, by which I mean that there should be a possibility of becoming something together, which requires time and space for that very becoming, whatever shape it may take, as well as the chance

[1] "By symbolic misery I mean, therefore, the loss of individuation which results from the *loss of participation* in the *production of symbols*" (10). The symbols Stiegler refers to are both the symbols of intellectual life (concepts, ideas, theorems, knowledge) and sensible life (arts, know-how, mores).

of recognizing, processing and integrating (not erasing) differences or disparities (Kangaskoski, "Algorithmic We"). Here, in connection with knowledge, I parse the integration of disparities as tensions looking to be resolved. This resolve is always only temporary, a metastable equilibrium. This tension can be created by dissensus, complexity, obscurity—anything that is unfinished, disconnected, unclear—and for which there is desire to be resolved. Knowledge and individuation result from being able to *hold this tension unresolved* for a period of time in order to test its components, to understand and feel more about it, instead of collapsing the tension into predetermined, *automatic* categories. Automation tends to result in a loss of knowledge, which I here discuss as "proletarianization." Predetermination, calculation, and automation are important background concepts in their inverse relation to openness, fundamental noncalculability, and the possibility of knowledge.

I explore the possibility of collective agency, within these processes of knowledge and co-individuation and set in contrast with being *algorithmically interpellated*—automatically "hailed" (as in "Hey! Look at this artefact!") into an amorphous group in which the tension tends to collapse in preset, and often binary categories of like/dislike, for/against, us/them, and so on. Finally, the aspect of time is relevant as the automatic interpellation and the collapse of tension happen in an ever-renewing present moment, removed from the need of retaining a past or projecting a future, and collective agency, insofar as it is a process of individuation, necessarily has a past (as retained memories and traces) and a future (as the collective desire to imagine something beyond the present moment).

Knowledge and Automation

Let us begin small and investigate an exemplary site of knowledge, a tiny moment of writing. For now, this tiny moment serves as the theatre for the tension we are interested in. We shall then elaborate from the example of writing to the example of reading, eventually reaching collective measures. So, while I write this article, *these words*, one by one, letter by letter, on my computer in Microsoft Word, the program keeps automatically filling in predictions for words when I start to type. I can accept the prediction or I can continue typing letter by letter. This is the *present moment* of the example. But what happens within this moment of *my* writing and the *program's anticipation* of what I might write? The word I am typing is, evidently, connected to a broader structure—a sentence, a paragraph, and a section already written, *in the past*, as well as grammar and conventions. Some of it is, as of yet, unwritten, *in the future*. When I write, I hold this past and this future in a tension within the present moment, in the tension between what is written and what I want to still write. This tension, within the flow of consciousness, is conditioned by the past and by cultural and academic conventions, but it is not fully determined by them. The tension keeps

the future open to my knowledge and desire—my singularity as a writer as well as to the contingencies of the location and the situation of the writing. In other words, this moment is open to my knowledge and skill as well to chance, and as long as I am still thinking, it has not collapsed into any concrete result. The prediction of the program, on the contrary, has no tension, and no openness beyond what I bring to it by beginning to type. The offered word is a calculated probability, and it is offered as an automatic filling—to help me write. As a calculated probability it is a standardization, and as standardization, it has, by definition, nothing to do with my desire and singularity as a writer (and a being) nor with the local, specific context of the writing. The prediction draws from what John Cayley names the "orthotext": a cleaned-up version of language, purified from the noise of, say, raw Internet files as well as from embodied and situated practices of language. So, when I choose to accept the suggested word, I collapse the possibilities open to me into the orthotext and let the program resolve the tension *for me*: In this moment of accepting the automation I surrender holding (as attention) the past of the article in my mind (as retention) and I surrender the anticipation (as protention) of the future of the article in my mind; and, for this moment, I surrender the factual grammatical knowledge to the prewritten form as well as the creative skill of writing. This is a small, momentary surrender, and I have to again summon my desire and knowledge, the past and the future, when deciding what to type as the beginning of the next word.

This tension and its temporary resolve, therefore, is where and when knowledge may take place. The idea of tension in the present moment is strongly related to the idea of the flow of consciousness consisting of retentions and protentions (Stiegler, *Technics and Time*, vol. 3). Primary retention designates the present moment, including the "just past" of, for example, a melody. We retain the previous notes while listening to the present ones, and the melody only makes sense within this extended present. Secondary retentions are primary retentions faded into memory—the melody I heard yesterday. But we do not remember as such, instead we retain certain aspects of our present moment experience. Stiegler's addition to this phenomenological description of perception, stemming from Edmund Husserl, is tertiary retention, which is done by external artefacts, such as books, tools, and technology in more general terms. Retentions are coupled with corresponding protentions as anticipations of what may come next, either in the near future (we anticipate the next notes of the melody) or further on as predictions, hopes, dreams, desires. Also, tertiary retentions, as for example the program of Microsoft Word, may be able to have protentions, such as predicting the next suitable token.

Let us return to the moment of writing. In that moment, to be able to think and remember the past of the writing, and to be able to think and anticipate its future, and to know what I want to write, which words can be used to express it, beyond what is typical, expected, or correct; how to construct a sentence, beyond, again, what may be expected or governed by convention—this is knowledge beyond calcu-

lation, and writing beyond standardization. Knowledge, crucially, is not then just factual knowledge, the *knowing what*; I treat it, following Stiegler, differently to the "justified true belief" or propositional knowledge of "X knows that Y" from analytical philosophy (see Ichikawa; Jenkins; Steup). Knowledge includes *being able to do* and *knowing how*, and it is therefore also connected to skill. Stiegler typically speaks of knowledge of how to do (*savoir-faire*), how to live (*savoir-vivre*), and how to think (*savoir conceptualiser*) (e.g., *States of Shock* 15), which can be granulated further into practically infinite applications of artisanal, artistic, scientific, parenting etc. knowledges. This present moment, insofar as the tension is retained open to non-predetermined possibilities, is, of course, also the site of creative possibilities.

The collapse to and with automation, that *may* happen in that moment of writing, *may* lead to a loss of knowledge. For Stiegler, automation, as technology in general, is a *pharmakon*, both poison and remedy.[2] The auto-prediction of my writing is therefore neither good nor bad as such. It may be useful and constructive, but it may also be detrimental and destructive. The latter becomes the case when I begin to rely on the prediction, thus collapsing the field of possibilities into the calculated prediction, and thereby, moment to moment, lose my knowledge, for example, as ability to hold the tension of the possibilities open and to think about them. I may lose the know-how related to the possible words I would choose to write—including hearing the acoustic elements of language, its "evocalizations" (Stewart qtd. in Cayley)—and as the practical grammatical knowledge of what letters go into the word, which, in itself requires a past and a future as the preceding and succeeding words will determine its grammatical number and congruence.

Let us continue for one brief moment longer with this small example and note that the loss of knowledge results in *proletarianization* (Stiegler, *For a New Critique* 37–38). Proletarianization, of course, evokes a history of work and Marx's well-known formulations, but it is Stiegler's invention to re-emphasize that beyond alienation and class struggle, proletarianization is the process of losing knowledge through automation. In this way, a writer using automation with writing, irrespective of class and position, can lose their knowledge connected to writing, and become thus proletarianized. The same applies in other arenas of knowledge.

Broadening the small example of predicting and auto-filling words, Microsoft Word's writing assistant can give me an overall grade and granulate the text into, for example, correctness, grammar, clarity, problematic geopolitical references, and discriminating language. This is another facet of the orthotext: a tacitly normative version of language relying on norms considered neutral or neutrally good (as well

2 The pharmacology of technology is an over-arching theme in Stiegler's work, used in most of his writings. For a short explanation as a keyword in Ars Industrialis' website, see https://arsindustrialis.org/pharmakon. Ars industrialis is an "International association for the industrial politics of the spirit", founded in 2005 according to Stiegler's initiative.

as standards and conventions). The assistant may be useful for me in pointing out unintentional aspects of my writing, but in the same way as letting the individual word resolve automatically, relying on the assistant may also erode my ability to assess and decide for myself. I lose the knowledge of my own text to the point that I lose the sense of what is good, what may be good, or what I want it to be like; I surrender my *singularity* and *desire* with respect to this text. By "singularity" I mean—far from attempting to construct a mythical individual who acts independently from their environment—differentiation and individuation in the sense of becoming someone and not anyone. Becoming someone (but not someone *special*) is shown in a new light with respect to the digital environment, which tends to standardize into homogenous groups, while advertising individual choices. And by desire, I mean my will insofar as it *extends to the infinite and is never complete*, or to put it in an upper register, contrasted with my will as *drive* as it grabs a *finite object that can be fulfilled*. Daniel Ross uses an example that I find illuminating:

> [T]he satisfaction of the animal drive which we call hunger ends with the consumption of food, even if this drive is of course perpetually renewed. In the case of human desire, however, the object of my desire is always something singular, a singular process of individuation, whether that process is another human being, or a kind of knowledge or art, or way of living, and as a process of individuation it is necessarily and inevitably in-complete, and therefore infinite, endless. (6)

To summarize, desire is singular, because it is created through my past experiences and present knowledge (as ability, know-how, factual knowing, and sensibility), through which I project future possibilities that I wish to attend to.

Nevertheless, the case of Microsoft Word with its predictions and assistant may appear innocent. Is it really all that much? Let us then broaden the view into artificial intelligence, such as ChatGPT or other large language models (LLMs). These are only a step further in the automatic prediction and filling of the next token. I can ask the program to write entire texts, surrendering the whole broader picture of thinking and crafting to an automatic, standardized program, and first, lose the opportunity to learn, and then, gradually, lose the ability, know how, and desire to do so. In this way, I do not individuate, because I do not learn, and if I read what ChatGPT writes for me, I attend to the orthotext. It is not nothing, but it is, at least in my view, less. Letting an LLM craft a text for me from start to finish is a blunt example of potentially losing both theoretical knowledge and the ability to formulate it into writing. LLMs themselves do not have knowledge, they have data and protocols. They are modelling pre-existing texts token by token (one token may be just a part of a word) without singularity or desire, without past or future, based on statistical calculations and programmed norms. It is a model of the output of knowledge and

as such very impressive, but it is not knowledge itself in the sense I am construing here.

Of course, automation saves our time, and a long-lasting dream has been that this time can then be used for something else. Freed from work, we can become creative. This automation is, however, a pharmakon. Stiegler et al. suggest that the time and energy thus saved should be reinvested in new dis-automatisations and *noodiversity*, i.e. a diversity of new knowledges, or it may lead to proletarianization (Montévil et al.). I will come back to this thought at the end, but if we remain with the tension of potentially losing knowledge of how to write, conceptualize, and research, it is possible to see already here, preliminarily, how knowledge is connected to agency as the ability to act on one's own intentions. Without the knowledge and skill of writing, I do not have access to the practice of writing and everything connected to it and enabled by it.

Let us shift from the small moment of writing into a broader moment of reading and look at reading as an example case of the aesthetics of contemporary digital environments. The aesthetics of the digital environment govern the distribution of the sensible in a specific way, guiding its users to engage and create through its logic; a logic which attempts to appear neutral, and affordances, which attempt to pose as self-evidently good.

Reading and the Proletarianization of Sensibility

As I have tried to show, knowledge and individuation requires tension, and this tension is held unresolved, at least for some time, before it is resolved *by the knower*. Within this tension there is probing, investigation, analysis, synthesis, deliberation, weighing, gathering more evidence—anything that helps us understand what it is that we are probing. This tension is crucial also for reading. As Maryanne Wolf writes,

> [w]e seem to be moving as a society from a group of expert readers with uniquely personal, internal platforms of background knowledge to a group of expert readers who are increasingly dependent on similar, external servers of knowledge. I want to understand the consequences and costs of losing these uniquely formed internal sources of knowledge without losing sight of the extraordinary gifts of the abundant information now at our fingertips. (55)

Wolf describes the loss of singular and internal knowledge of reading due to dependency on external servers. Much of her concern stems from the pharmakon of the abundance of information which causes us to read with simplification, speed, and triage (75–76). It seems evident that in this environment the slower act of interpreta-

tion is left with less attention. I wish to connect interpretation here with the process of knowledge, as both advance through holding open the tension described in the first section, a tension resolved by understanding. Similarly to knowledge, interpretation is almost by definition open-ended, and interpretability, in literary works, is one of the most cherished features. Interpretation is the act of making sense of what a text says and connecting it to one's own experience as well as a broader context in the world. Interpretation deals with questions such as: what does it mean? What is it about? What did I feel when reading and why? Wolf describes the act of reading and interpretation in the following way: "[T]he information harvested from the text; the connections to our best thoughts and feelings; the critical conclusions gained; and then the uncharted leap into a cognitive space where we may upon occasion glimpse whole new thoughts" (64–65). Wolf parses the uncharted leap and the whole new thoughts further as the Heideggerian disclosing, as an aha-moment, or the moment when "an arms-wide expanse in the reader's mind opens up" (64–67). Analogously to knowledge, in literary interpretation the reader draws from their own past experience as well as the past (and after reading, the totality) of the poem, story or drama they are reading to draw singular insights—singular, but shareable.

For example, in Mallarmé's classic poem "A Roll of the Dice Will Never Abolish Chance" we begin by reading the following lines: "A roll of the dice / will never / even when thrown under eternal / circumstances / from the depths of a shipwreck" (3–5), and we continue coursing through the subsequent pages and lines set with various sizes and rhythms, reading from page to page and sometimes across the whole spread, piecing together possible connections among many. For example, the title line of the poem is pieced together from words that are highlighted by larger size throughout the poem: "a roll of the dice / will never / abolish / chance" (3–19). Mallarmé's text is notoriously "open." But open to what, exactly? Open to the possibility of understanding what is said in a singular way, i.e. one's own interpretation. For example, I might try to persuade the reader of this text to look at the roll of the dice from the perspective of the tension described in this essay. In the poem, we find a figure (the Master) who shuffles the dice in their fist, hesitating to roll them. Why hesitate? Because, in my interpretation, when the dice are not rolled, the potential of possibilities remains open. This is the space of the tension discussed here, the space for probing, testing, investigating, but not yet deciding. When the dice are rolled, we collapse the potential into something concrete, a word and a text in our example case of writing. However, as the poem suggests, even if the dice are rolled, the roll will never, even when thrown under eternal circumstances, abolish chance. We could read this non-abolishment of chance as the ensuing metastability which is never a real end but enables new potentials. The last line of the poem comes close to my reading, as it says that *all thought is a roll of the dice*, which in my interpretation would mean that all thought, and even more precisely in the writing example of

this essay, all words, when they are written, constitute a collapse of all the potential thoughts or words into one. *This*, for example. But then it begins again.

In other words, reading Mallarmé's poem we see how the act of reading also has the potential of holding open the tension of possible meanings, probing, investigating, gathering evidence, trying to connect them with each other into a possible cohesion. If we care to do this, we may learn something, provided we have the ability and knowledge to do so. Indeed, this kind of reading resembles what is sometimes called critical thought, and "[f]rom the standpoint of the reading brain," Wolf writes, "critical thought represents the full sum of the scientific-method processes" (62). Critical thought "synthesizes the text's content with our background knowledge, analogies, deductions, inductions, and inferences and then uses this synthesis to evaluate the author's underlying assumptions, interpretations, and conclusions" (62). What is more, Wolf sees critical reasoning as crucial in "inoculating" the next generation "against manipulative and superficial information" (62). However, "in a culture that rewards immediacy, ease, and efficiency, the demanding time and effort involved in developing all the aspects of critical thought make it an increasingly embattled entity" (62). Critical thought, as Wolf eloquently describes it, is of course knowledge as the knowing what and the knowing how. And if it is not developed or sustained, it may be lost. We are edging from the knowledge of the individual towards a more collective measure, as Wolf reports the thoughts of the literary scholar and teacher Mark Edmundson, who speaks of an absence of "any developed belief system" in young people. Edmundson thinks this is due to simply not knowing enough about the systems and not having the patience to find out and examine them (Wolf 63). In other words, from the perspective of the community of Edmundson's "young people" there is an intergenerational loss of knowledge. They have been proletarianized, which means that they do not have access into this area of society and life, nor do they have agency related to it. They cannot participate, let alone contribute.

But what have they been proletarianized by? Already mentioned in passing above, Wolf and many others see the attention span chopping, information overloading, and too fast-paced digital environment as the problem. I have myself argued elsewhere that the digital environment, as it is established now, has normalized and subsequently normativized certain aesthetic features for its artefacts. They include quick recognizability, discrete affectivity, and high compression, which are created through the pressure of the dominating business model, the number of available artefacts, and the material, processual, cognitive, and cultural affordances of the interfaces (see Kangaskoski, "Logic of Selection"; "Affordances of Reading"). These features cater to speed and a quick collapse of tension, i.e. the information-overloading fast pace. Moreover, the drive-based business model of contemporary digital interfaces is geared towards finite objects and immediate satisfaction in an ever-renewing present moment with less cultivation of infinite goals that draw from the past and imagine a future. There is no business model for infinite goals in

the current digital ecology. We do not need to dive deep into the question here—it is enough to say that within what has variously been parsed as the economy of attention,[3] surveillance capitalism (Zuboff), or platform capitalism (Srnicek); the logic is to try to make the user quickly select an offered artefact through algorithmic interpellation. The interpellation's motivation is to sell a product, maximize eyeballs for advertisers or make the user stay on the subscription-based interface.

How to make the user select the artefact? By capturing their sensibility with whatever drives them, and what drives them is predicted through the tracking, collecting, analyzing, and profiling of traces and other data provided, in aggregation with the same of their reference groups. Importantly, from the perspective of knowledge, I have argued elsewhere that insofar as the user is interpellated in this quick, affective, and compressed mode and insofar as the user engages in the same mode, the user also is acting and reacting automatically ("Logic of Selection"). In other words, the user is interpellated as an automaton whose reaction of like/dislike, love/hate, lust/disgust, sympathy/outrage is predicted through calculation.

The tentative answer to the question of what "young people" have been proletarianized by is therefore the logic and form of the digital interfaces whose aim it is to interpellate them as eyeballs for advertisers, thus normalizing a mode of attendance that makes it difficult to switch into the more patient and slowly rewarding mode of close reading and critical thought, i.e. practices of knowledge. And I think it is warranted to extend the analysis beyond Edmundson's "young people" to concern a broader group, at least those whose usage of digital interfaces constitute a major share of their waking life. In the world there are a little over five billion Internet users and a little under five billion social media users. The average daily time spent online in 2022 was six and a half hours (Kemp). The exact measure in which different segments of the world's population is influenced by the digital environment is beyond this article to establish, but these figures suggest that it is not an insignificant amount.

The Aesthetics of Collective Agency Governed by Digital Cultural Interfaces

So far, I have connected the logic and form of the digital environment to its aesthetics in two ways. First, its logic and form create a tacitly normative aesthetic, governing

3 As for the connection between attention and economy, I refer to the ideas of Georg Franck (see also Krieken) as well as Crogan and Kinsley. In the information overload attention becomes the rare resource. Andreas Hefti and Steve Heinke as well as Agnès Festré and Pierre Garrouste make a through interrogation on the issue between economy and attention.

what is suitable within its interfaces. This concerns how the interfaces present arte-
facts to us and their action potentials. Second, I have referred to aesthetics as sen-
sibility and a mode of engagement with the interfaces. This concerns how we attend
to them. *Aisthēsis*, following Stiegler, in its widest sense means sensory perception
(*Symbolic Misery*, vol. 1 1), and therefore the question of aesthetics is "that of feeling
and sensibility in general" (1). Digital interfaces govern the distribution of the sensi-
ble (*sensu* Ranciére), which can here be interpreted as tacitly teaching users, through
habituation, what kinds of modes of attendance and types of artefacts *make sense*, are
reasonable and pleasurable on the interfaces.[4] My aim in this section is to investi-
gate how this sensibility relates to knowledge, automation, and agency. The hypoth-
esis to be discussed is that sensibility, like knowledge, may also be proletarianized.
This may happen through the reduction of the users' singularity into predictable pro-
files and through the attempt of bypassing their aesthetic, knowledgeable attention
and favoring programmed reactions. Following this hypothesis, I argue that the user
is interpellated as an *aesthetic automaton*, one whose selection and reactions should
collapse automatically and quickly into preselected options. This interpellation is at
once both individual and collective; I am interpellated as an individual, but at the
same time I am hailed into a group of people "like me". Finally, I discuss what kind
of agency is offered for an aesthetic automaton.

To think about the individual and the collective as they are automatically inter-
pellated by the interfaces, I wish to bring in an analogy. The keyword for this analogy
is *Gestell*, the Heideggerian term both for something that has been *enframed*, put in its
place and treated as a standing reserve as well as a mode of ordering the world, and a
mode of attending to it. *Gestell*, specifically, is the essence of technology (Heidegger,
The Question). The analogy I wish to set up is the treatment of nature as something
out there to be used; to treat, for instance, a natural forest as a standing reserve for
construction, paper, firewood, recreation, and so on. In attending to it in this way,
we put it in its place, separate it from its surroundings and its history, and we treat it
as something calculable (how much is left) and something we can extract value from
(how much it costs). Anything can, and has been, treated like this from animals to
human animals, from the oceans to other planets and space. This is, arguably, the
logic of the *Anthropocene*, where the planet has become a *Gestell*, and has led us to the
downward spiral of the current ecosystems collapse.

When a digital application, such as Instagram, pops a notification on my mo-
bile screen, it interpellates me as a calculable reserve from which value can be ex-

4 As David Panagia summarizes, "[k]ey to Rancière's understanding of a *partage du sensible* is
the tension between a specific act of perception and its implicit reliance on preconstituted
objects deemed worthy of perception." In my argument, digital interfaces, through their tacit
normativity, influence precisely the *preconstitution of the objects deemed worthy of perception*
that we then implicitly rely on.

tracted. The reserve here is attention which the application can turn into revenue. So, I have been *gestellt*, put in my place as "eyeballs," as consumer, user, viewer, customer, a market. I am also enframed by a group and put in my place within it, as I am interpellated based on the tracking, analysis, profiling, and prediction of my behavior. This profile is shared by everyone "like me," and so it is also a collective appeal, a grouping *Gestell*. Myself and people like me are addressed as a collection of calculable automatons.

Gestell is a mode of engagement and a reduction, a cutting off. A reductive compression of complexity and interconnectivity, and a reductive compression of time and space. This compression is very concrete in the case of mobile interfaces. A typical smart phone—which is the arena for the aesthetic experience in question, the *world at my fingertips*—presents its art and practice in small increments, one *screenful* at a time. Anything that hopes to catch the eye of the user must be similarly reduced, not only in sheer size but also in terms of the duration and depth of the tension it presumes.

Let us then recall that knowledge has a past, a present, and a future within the mind of the knower. The logic of the interface, however, is to reduce the time of the user into as close to the present moment as possible, and within that present moment, the user should become "your experience now," designating a momentary affective tone. We select this tone from preassembled menus or just by tapping the screen, making it as effortless as possible. In fact, we are constantly asked to like and select by touching, clicking and pushing buttons and icons. This isolated affect as *your experience* is what the market wants to predict and once actualized, use to offer more artefacts (see Kangaskoski, "Logic of Selection"). This quasi-automatic affective reaction is more predictable than the slower, deliberate choices, and thus easier to predict and govern—*quasi-automatic*, because it is automatic only insofar as the user acts as the interface prompts to act; there is always the potential to do otherwise. Interesting for our exploration is that this "experience," although it is often expressed as "your experience *today*," means *right now*, at this very present moment, unconnected with the past and the future. The aspect of experience meant here is unconnected from what *I think* as well as what might be *good* or *valuable* beyond my experience and beyond this moment. Connecting with the past and the future as well as with good or bad would require time to think about broader connections, holding the tension unresolved for a moment longer. But, as for the distribution of the sensible on the interfaces, this behavior does not make sense.

The logic of capture and *Gestell*, with its reduction of space and time required for knowledge, amount to the proletarianization of *sensibility* as the collapse of aesthetic attention into standardized and programmed responses (Stiegler, *Symbolic Misery*, vol. 1, e.g. 1–13; 46–48). It is *symbolic misery* to not be able to take part in the production of symbols and to lose the knowledge of how to attend to them. I lose access to a certain mode of aesthetic experience, just like the "young people" in Edmundson's

testimony. Crucially, it is not about being "informed" or not. What is lost is both the knowledge and the desire to know. Parsing it further, the aesthetic experience in question requires knowledge related to searching for, familiarizing with, and investigating an artefact, holding the interpretative tension open, which may result in understanding something about it, and this *something* would be both about the artefact and myself, since knowledge is the result of the tension between the artefact and my singular way of knowing. Lost with the singular ways of knowing, the diversity of knowledges, *noodiversity*, is also lost (Stiegler et al., *Bifurcate*). Stiegler and others (e.g., the Internation Collective, more of which below) sees this diversity of knowledges as a necessity for a society to function, analogous to the *biodiversity* that ecosystems need for functioning. Without knowledge, and through standard artefacts reacted to in predictable and discrete ways, there is no becoming diverse, but instead becoming the same. With regards to knowledge and automation, where automation collapses the potentials of the tension of possibilities into standardized options (e.g. the orthotext), we could call the capture of sensibility the *collapse* of sensibility into automated reactions. What kind of agency does the standing reserve, interpellated as an aesthetic automaton, have? What kind of chances are there for collective agency when the individuals composing the group do not know of each other and have no space nor time for becoming something together?

Experience shows that volumes of people can be mobilized through digital interfaces for a cause or even for a revolution, and these causes and revolutions may achieve their goal—to topple the government or to make a certain change. My example in "Algorithmic We" is the so-called social media revolution in Egypt, in which the group was successful at amassing a large volume of people to overthrow the government, but after the fallen government, another autocrat took power. I argue that in order for a collective to form, it needs to be able to co-individuate. In the case of collectives, it means becoming something together in a way that is specific to them and through being open to the tensions within the group as well as to the tensions brought about by the complexity of the issue at hand, overcoming those tensions in a metastable resolve. This means also the possibility of imagining the infinite, i.e. a future beyond the finite satisfaction of the immediate goal. I recently attended a mass demonstration, and in the capacity of a poet, also performed in the gathering. Over ten thousand people were mobilized against racism, specifically the racism in the current Finnish government parties. The demand of the demonstration was that the government take antiracist policies as an integral part of their government program. But, as it so happened that a few days before the demonstration the government in power published a program in which it committed itself to antiracist policies of its own making. Therefore, the immediate, finite goal of the demonstration was already fulfilled *before* the demonstration took place, however partially and unsatisfactorily. This did not stop the momentum of the demonstration, which by Finnish standards was a big gathering, but it did, again in my view, dissipate the finite demand.

For a collection of people to work together beyond this kind of finite end, it would need a past and a *future*. It requires a process where the past is the retained trace of becoming the collective. This already entails collective knowledge. The present is the process itself and the future is what it is able to project—what it *desires* based on its knowledge and singularity. This is in stark contrast with the affective reactions garnered on the interfaces as they are responses to what is offered in the present, served as personalized experience, but they are not reflective of *desires* of future outcomes. *Agency* comes from the ability to participate in and contribute to this future, which is the feeling that we *as a* collective are able and know how to create it. In Stiegler's thought, agency comes from the ability to participate, and participation is "a *passage from potential to act*, while the loss of participation is a *regression from act to potential*" (*Symbolic Misery*, vol. 2 25). Knowledge as ability and desire as will towards an infinite goal enable this passage to act. In contrast, an automaton cannot have agency, because an automaton has no desire as the will to imagine something that is not yet there or predicted, precisely as the writer, suspended between words, has the possibility to imagine the future of the text beyond the orthotext. Or the reader, who can hold the past of the text in their mind, and be able to think and feel in the space afforded by the open tension, and thereby able to project potential futures and meanings.

Conclusion: Absence of Epoch, Troubled Guardrails, and a Vision for the Role of Knowledge

Stiegler's concept of *epoch* designates a historical and societal situation where the shock of technological innovation, of which history knows many, is settled through learning to use the new technology and through understanding how it works (*Age of Disruption*). The shock of technological innovation creates the tension, which is resolved through learning and adjusting. This tension needs and takes time, and with this time, a metastable equilibrium is reached, after which something new can again come. Now, in the twenty-first century, we are still adjusting, are still within the shock caused by the commercial Internet from the 1990s, Web 2.0, and social media. New inventions, such as Open AI's ChatGPT, which, as the company announced in September 2023, is now able to use the Internet in real time for its recommendations and answers. In other words, with new inventions pouring in there is no time for adjustment on the individual or the collective scale, and thus Stiegler speaks of the *epoch of the absence of epoch* (10–18). The collective scale includes institutions, laws, education systems and practices, even public spaces and parenting. The societal scale of knowledge is rooted in institutions and practices, which are rooted in common policies, culture and history. This knowledge, too, is disrupted by the current technologies. On this note, António Guterres, the secretary-general of the UN, suggests

that we must replace the "move fast and break things" idea of Silicon Valley—the very ideology of disruption—with "move fast and mend things" (United Nations).

Within the same frame of thought, Stiegler calls our current situation "more than tragic" ("Machines of the Technosphere"). It is tragic because of the downward spiral of ecosystems, but it is more than tragic because, although we are aware of it and know what we should do to stop it, we seem to be unable to act to do so. The digital interfaces, amplifying mis- and disinformation, are no small part of this inability. Replacing the mantra of disruption with mending, caring, or knowledge has to push through the logic of the digital environment, which itself, having become "atmospheric" (Hansen) or "infrastructural" (Paasonen), is an integral part of the more than tragic situation.

To address this problem, the United Nations recently (in June 2023) published a policy brief aimed at formulating common guidelines or "guardrails" for what it terms *information integrity* on digital platforms.

> The danger cannot be overstated. Social media enabled hate speech and disinformation can lead to violence and death. The ability to disseminate large-scale disinformation to undermine scientifically established facts poses an existential risk to humanity (A/75/982, para. 26) and endangers democratic institutions and fundamental human rights. (3)

In more detail, hate speech "has been a precursor to atrocity crimes, including genocide" (9). Mis- and disinformation pose serious threats to the "global public" impacting health and mental health, climate action, democracy, elections, gender equality, security and humanitarian response. It has "severe implications for trust, safety, democracy and sustainable development" (11). Therefore, the policy brief proposes a regulatory model that highlights commitment to information integrity, respect for human rights, support for independent media, increased transparency, user empowerment, strengthened research and data access, scaled up responses, stronger disincentives (regarding the business model), and enhanced trust and safety (21).

In my view, this is a welcome proposal. However, when Guterres tweeted about the proposal, the more than tragic situation of conversation could not have become more starkly into view. In the comments, the proposal was met with disdain and construed as a ban for the freedom of speech, a conspiracy plot for suppressing the people and of the powerful elites imposing laws on free citizens. Hate speech in the form of ad hominem attacks was abundant. Many commentators professed the view that it is the individual's responsibility to not be affected by hate speech or disinformation, not the platform's problem. I am not convinced many of them read the policy brief (and why would they, since this is not part of the sensible on the interface). What the commentators seemed to share was the conviction that the digital environment, and here specifically social media, was "free" at present. Even if many

agreed that there is a lot of disinformation and hate speech, none of the comments I saw (there were over 4,000 comments as of 28 September 2023 and I have not performed a serious analysis of all of them) questioned the platform itself as a controlling agent, thus verifying the success of its tacit normativity. And this is, indeed, a feature of any normative environment, to fade from sight as a site of control. At the same time, the erosion of trust and information pollution that the policy brief wishes to address were abundantly performed in the comments of the Tweet. Digital cultural interfaces are a big part of the environment where knowledge and collective agency should take place, but at the moment, I think it is safe to say that this environment does not support a "deliberative ecology" that would make cooperation likely (Danisch).

I wish, however, to end on a positive note. In 2020, the Internation Collective, a group of some sixty scholars, artists, engineers and activists, published a volume called *Bifurcate: "There is no Alternative"* which was handed over to the UN as an urgent plea for an alternative view into contemporary society, including outlines and the theoretical and practical background for a *contributory economy, contributory research* and *contributory design*. In terms of the design of digital interfaces and taking the cue from urban studies (Sennett), the group promotes an "ethics of cooperation" as the creation of spaces where people can come together to meet each other and to discuss "the difficulties of everyday life" (Alombert et al. 181). Crucially, the cities within which such cooperative spaces may occur, should be open localities, "capable of being transformed over time and of hosting improbable events" (181–182). Speaking specifically about digital design, they point out that the design of digital platforms (here called interfaces) should be made adjustable according to local needs and knowledge, as contributory design, in stark contrast with the current model of fairly uniform and black-boxed platforms. For this end, they suggest "the design and development of contributory digital technologies, allowing individuals to express themselves and to stage confrontations between points of view, thus generating processes of discussion, debate and collective deliberation, which are constitutive of collective intelligence" (181).

This necessitates designs that take the singularity and locality of knowledges into account and contribute to designs that may be incomplete and unfinished, but, crucially, take into account the needs of the inhabitants and can be modified by the inhabitants themselves (182). In this way, the local inhabitants could participate in the design, use their knowledge and have agency in relation to their digital environment, resulting in a diversity of designs and a diversity of new kinds of knowledges.

Let us, then, conclude with a thought experiment involving such a design, even if only to a minimal degree. Let us imagine a web page, an app, a shop, or any service, that, instead of trying to extract the affective momentary tone of "your experience now" expressed as selections from preset emoticons, asks: "What are your thoughts on this? Is this good?" Implied in the latter question would be good for the individual

and good for the collective. In this fantasy there would be time, space, and desire to answer. Taking this kind of feedback into account, be it writing or, say, a voice message, would be laborious because it cannot be automated; someone would have to think about it. However, the argument could be made that investing in caring for this kind of feedback might have good returns in the long run, due to the diversity of knowledges of the customers, based on which products, services and design could be developed. This would, of course, already presuppose that the business goal is to make the goods *good*, and this would practically be possible in a society that valorizes contribution instead of extraction. The valorization of contribution through knowledge would also be the reason why the customer would take their time to give that feedback.

Is this pure fantasy? The Internation Collective argues that these kinds of contributory acts are in fact not only a choice between X or Y models, but that the extractive model simply does not work and effectively ruins its own conditions, of which the Anthropocene and the destructive aspects of the digital environment are evidence. The collective argues that for a system such as a human society to function, it needs to be able to *bifurcate*, that is, to invent new, improbable means of work, art, practices, politics, and so on. This is, again, the diversity of knowledges, tied to localities. This kind of system is open to outside influence and able to integrate it into its workings through invention, whereas a closed system, which all automated systems are, is doomed to perform its own entropy towards disintegration. The extractive logic works only if it is possible to move on to the next resource after depleting the existing one, as if nothing had happened. We know now that this is not possible.

I hope to have shown that knowledge cannot be automated, but can be lost through automation. And when lost, it results in proletarianization and the loss of participation, not to mention contribution. Digital interfaces, as they are currently set, favor automation and do not foster knowledge practices in their design. These have negative implications for agency in the individual and collective levels. However, the sheer example of the Internation Collective, a group capable of imagining, researching, discussing, agreeing and arguing for an alternative vision with highly developed theory and concrete suggestions, is evidence of strong collective agency and the possibility of change. One of the main features in their suggestion is that knowledge, in all its many possible forms from practical to artisanal, and from theoretical to artistic, sporting, juridical and spiritual, is necessary for communities, and part of the diversity of these knowledges comes from their being singular and local. This example, to me, among many others, shows that there certainly is thinking and imagining beyond standardization. And that however ubiquitous, the effect of automation is not predetermined, which is something I have tried to emphasize in this essay by consistently using the word "may" instead of "will" when speaking of the effects of automation. The future, by the same token, is not set, and therefore it may also be one of diversity of knowledges.

Works Cited

Alombert, Anne, Vincent Puig, and Bernard Stiegler. "Contributory Design and Deliberative Digital Technologies: Towards Social Generativity." *Bifurcate: "There is no Alternative,"* edited by Bernard Stiegler with the Internation Collective, translated by Daniel Ross, Open Humanities Press, 2021, pp. 178–94.

Ars Industrialis. "Pharmakon (pharmacologie)." *Ars Industrialis*, https://arsindustrialis.org/pharmakon. Accessed 7 March 2024.

Cayley, John. "Modelit: eliterature à la (language) mode(l)." *Electronic Book Review*, 2 July 2023, https://doi.org/10.7273/2bdk-ng31.

Crogan, Patrick, and Samuel Kinsley. "Paying Attention: Towards a Critique of the Attention Economy." *Culture Machine*, vol. 13, 2012, pp. 1–29.

Danisch, Robert. "Rhetorical Structures, Deliberative Ecologies, and the Conditions for Democratic Argumentation." *Argumentation*, vol. 34, 2020, pp. 339–353, https://doi.org/10.1007/s10503-019-09496-w.

Festré, Agnès, and Pierre Garrouste. "The 'Economics of Attention': A History of Economic Thought Perspective." *OEconomia: History, Methodology, Philosophy*, vol. 5, no. 1, 2015, pp. 3–36, https://doi.org/10.4000/oeconomia.1139.

Franck, Georg. "The Economy of Attention." *Journal of Sociology*, vol. 55, no 1, 2019, pp. 8–19, https://doi.org/10.1177/1440783318811778.

Hansen, Mark B.N. *Feed Forward: On the Future of Twenty-First-Century Media*. University of Chicago Press, 2015.

Hefti, Andreas, and Steve Heinke. "On the Economics of Superabundant Information and Scarce Attention." *OEconomia: History, Methodology, Philosophy*, vol. 5, no.1, 2015, pp. 37–76, https://doi.org/10.4000/oeconomia.1104.

Heidegger, Martin. *The Question Concerning Technology and Other Essays*, translated and with an introduction by William Lovitt, Garland Publishing, 1977.

Ichikawa, Jonathan Jenkins, and Matthias Steup. "The Analysis of Knowledge." *The Stanford Encyclopedia of Philosophy* (Summer 2018 Edition), edited by Edward N. Zalta, https://plato.stanford.edu/archives/sum2018/entries/knowledge-analysis/. Accessed 29 November 2023.

Kangaskoski, Matti. *Reading Digital Poetry: Interface, Interaction, and Interpretation*. Unigrafia, 2017.

—. "Affordances of Reading Poetry on Digital and Print Platforms—Logic of Selection vs. Close Reading in Stephanie Strickland's 'V-Project'." *Image [&] Narrative*, vol. 20, no. 2, 2019, pp. 35–50.

—. "Algorithmic We: Belonging in the Age of Digital Media." *Style*, vol. 54, no. 1, 2020, pp. 36–47.

—. "Logic of Selection and Poetics of Cultural Interfaces: A Literature of Full Automation?" *The Ethos of Digital Environments: Technology, Literary Theory and Philoso-*

phy, edited by Susanna Lindberg and Hanna-Riikka Roine, Routledge, 2021, pp. 77–97.

—. "Digitaalisten kulttuurikäyttöliittymien piilevä normatiivisuus. Kirjallisuuden muuttuva poetiikka." *AVAIN – Kirjallisuudentutkimuksen Aikakauslehti*, vol. 18, no. 2, 2021, pp. 28–49. https://doi.org/10.30665/av.107876.

Kemp, Simon. "Digital 2023: Global Overview Report." *Datareportal*, 26 January 2023, https://datareportal.com/reports/digital-2023-global-overview-report. Accessed 29 November 2023.

Krieken, Robert van. "Georg Franck's 'The Economy of Attention': Mental Capitalism and the Struggle for Attention." *Journal of Sociology*, vol. 55, no. 1, 2019, pp. 3–7, https://doi.org/10.1177/1440783318812111.

Mallarmé, Stéphane. *A Roll of the Dice Will Never Abolish Chance*, translated by Robert Bononno and Jeff Clark. Wave Books, 2015.

Montévil, Maël, Bernard Stiegler, Giuseppe Longo, Ana Soto, and Carlos Sonnenschein. "Anthropocene, Exosomatization and Negentropy." *Bifurcate: "There is no Alternative*," edited by Bernard Stiegler with the Internation Collective, translated by Daniel Ross, Open Humanities Press, 2021, pp. 45–62.

Paasonen, Susanna. *Dependent, Distracted, Bored: Affective Formations in Networked Media*, MIT Press, 2021.

Panagia, David. "'Partage du Sensible': The Distribution of the Sensible." *Jacques Ranciere: Key Concepts*, edited by Jean-Philippe Deranty, Routledge, 2014, pp. 95–103.

Ross, Daniel. "Introduction." *The Neganthropocene*, edited, translated, and with an introduction by Daniel Ross. Open Humanities Press, 2018, pp. 7–32.

—. "Politics and Aesthetics, or, Transformations of Aristotle in Bernard Stiegler." *Transformations: Journal of Media & Culture*, no. 17, 2009, http://www.transformationsjournal.org/wp-content/uploads/2017/01/Ross_Trans17.pdf. Accessed 29 November 2023.

Srnicek, Nick. *Platform Capitalism*. Polity Press, 2016.

Stiegler, Bernard. *Technics and Time, 1: The Fault of Epimetheus*, translated by Richard Beardsworth and George Collins, Stanford University Press, 1998.

—. *Technics and Time, 2: Disorientation*, translated by Stephen Barker, Stanford University Press, 2009.

—. *Technics and Time, 3: Cinematic Time and the Question of Malaise*, translated by Stephen Baker. Stanford University Press, 2011.

—. *For a New Critique of Political Economy*. Polity Press, 2010.

—. *Symbolic Misery, Volume 1: The Hyperindustrial Epoch*, translated by Barnaby Norman, Polity Press, 2014.

—. *Symbolic Misery, Volume 2: The Katasprophē of the Sensible*, translated by Barnaby Norman, Polity Press, 2015.

—. *States of Shock: Stupidity and Knowledge in the 21st Century*. Polity Press, 2015.

—. *The Neganthropocene*, edited, translated, and with an introduction by Daniel Ross, Open Humanities Press, 2018.

—. *The Age of Disruption: Technology and Madness in Computational Capitalism*. Polity Press, 2019.

—. "Machines of the Technosphere: The Role of Morality in the Biosphere According to Arnold Toynbee and the New Genealogy of Morality." Lecture, 7 March 2019, Helsinki, translated by Daniel Ross, https://www.academia.edu/45187207 /Bernard_Stiegler_Machines_of_the_Technosphere_2019. Accessed 29 November 2023.

—, with the Internation Collective, editors. *Bifurcate: "There is no Alternative,"* translated by Daniel Ross, Open Humanities Press, 2021.

United Nations. *Our Common Agenda: Policy Brief 8. Information Integrity on Digital Platforms*. United Nations, 2023, https://indonesia.un.org/en/236014-our-com mon-agenda-policy-brief-8-information-integrity-digital-platforms. Accessed 29 November 2023

Wolf, Maryanne. *Reader, Come Home: The Reading Brain in a Digital World*. Harper-Collins, 2019.

Zuboff, Shoshana. *The Age of Surveillance Capitalism: The Fight for a Human Future at the New Frontier of Power*. Public Affairs, 2019.

Algorithmically Together: Platform Collectivity and the Memetic Politics of TikTok

Heather Suzanne Woods

Finding Each Other Online

In the summer of 2022, millions of Americans watched as the Supreme Court announced its decision on *Dobbs v. Jackson Women's Health Organization*. The decision was monumental, as the Court indicated it was reversing *Roe v. Wade*, the historic ruling cementing the constitutional right to abortion for citizens of the United States of America. The decision was not quite a *surprise*: Reproductive justice advocates had been planning for its fall for many years and a leaked document from May 2022 appeared to reveal the will of the increasingly conservative Court almost two months before the official ruling. For some of the most committed members of the "pro-life" movement, the decision (and its leak some months prior) represented a culmination of decades of advocacy, politicking, and strategy. And yet, the reversal of *Roe* could be categorized as a *shock* for the majority of Americans who support abortion access "in all or most cases" (Hartig).

The *Dobbs* decision leak instigated ongoing public discourse regarding the political effects of abortion rights restrictions. After the circulation of the draft opinion, advocates on both sides of the debate flocked in droves to the Supreme Court (Bravin and Kendall). Op-eds and think pieces flooded American newspapers and blogs. Politicians braced for fallout or sought to capitalize on the national frenzy. On social media, users across platforms participated in the national conversation by sharing news articles, offering analysis and commentary, and circulating now ubiquitous Internet memes. Memes—digital and/or cultural shorthands that reference and iterate upon existing discourse or context—translate political discourse into easily sharable and remixable content that circulates within and across social media platforms. In the context of the *Dobbs* controversy, memes offered a particularly potent form of public commentary on social media platforms. Stitching together both advocacy and Internet culture, these memes mobilized the political power of shared, algorithmically-amplified aesthetics to reflect on *Roe*, imagine alternate realities, and organize collective action.

One of the most prolific sites of memetic discourse on the *Dobbs* decision and the fall of *Roe* was TikTok. TikTok is a short form, video- and audio-based platform that is tailor-made to support aesthetic remixing and cultural iteration on issues of public relevance. Using TikTok's built-in content creation tools and short-form video culture, users quickly launched a bevy of TikToks (short videos) related to abortion access and reproductive care. Some of these videos depicted protests and mobilizations in the nation's capital and in politically significant areas around the country. Others offered point-by-point explainers highlighting the textual significance of different parts of the leaked document (and, eventually, the final opinion of the court). Still other videos showed people calling their elected representatives to express their opinions on the decision. One TikToker, user @SarahBellumsn (later @sarahbellumcalls), went so far as to film her daily phone call to the office of U.S. Senator Mike Lee with "a daily uterus update." TikTok users, in turn, "dueted" the video to provide their live, side-by-side reactions to the series. The tone, tenor, and content of these videos was often distinct, depending on the user and their perspective. However, these TikToks were also often referential, sharing (or creating) collective imagery, sound, and aesthetic structure in service of consciousness-raising and political mobilization. In short, TikTok became a vehicle for aesthetic commentary on reproductive rights in America. Users' interests and agency were central to architecting this constellation of media. But so, too, were TikTok's platform affordances, which helped to circulate and amplify aesthetic messages. Indeed, TikTok's social and technical features fueled both the development of the memetic media and its widespread circulation, on and off the platform.

While popular media often describes it as an application for frivolity—think dancing, challenges, and other light-hearted trends—TikTok has become an important space for collective action on social and political issues, often through shared creation and re-creation of aesthetic content related to pop culture. After the death of George Floyd in 2020, for instance, TikTok became an important site for organizing and activating young people through the rallying cry and hashtag #BlackLivesMatter. In 2021, users engaged in political protest against unfair labor laws across Southeast Asia. Their actions were so widespread that it prompted one scholar to suggest that "TikTok has proven itself as the current platform for political activism in the region, at least for the younger generations, especially among Gen Z" (Jalli, "How TikTok"). Scholars have also noted that TikTok can shape politics by drawing together experts and everyday users around important issues, such as climate change (Hautea et al.; Zhao and Abidin 5).

In this theoretical essay, I contribute to this burgeoning field of scholarship on TikTok and political action. I argue that TikTok's socio-political platform affordances invite users to engage in collective action via the collaborative co-creation of memetic content. More particularly, I suggest that TikTok's multi-mediated platform creates conditions of possibility for activating and organizing collective

action through networked, memetic, aesthetic action on the app. Scholarship on memes has convincingly shown that they can be used to participate in politics (Greenwalt and McVey; Hawkins and Saleem; Silvestri). Scholars have also noted how memes have evolved and adapted over time, shifting from relatively simplistic image macros to complex, culturally-nuanced, multi-media artifacts (Woods and Hahner 4–5, 9–11; Sieffer-Brockmann et al.; Milner; Zulli and Zulli). Memetic adaptation results from changes in digital communication norms, user interests and engagement, and structural changes in the platforms on which memes are created, remixed, shared, and discussed. Indeed, the aesthetic and technical features of a particular platform shape the types of memetic expression distributed on it. As such, this article explores the intersection between social media platforms and meme culture to understand better how collective, political aesthetics emerge through political memes. TikTok, a platform that prioritizes aesthetic creation and remixing, is an ideal site to investigate the possibilities for collective action through memes.

Like many other social media platforms, TikTok allows users to connect with one another through creating, remixing, and reworking visual, audio, and written media. However, TikTok is unique in the crowded landscape of social media apps because its socio-technical infrastructure helps its users to architect aesthetically unbounded, infinitely remixable memetic content within the app (and frequently, off the app). Moreover, TikTok's video- and sound-based frameworks draw in (and upon) existing aesthetic features in the cultural zeitgeist, infusing memetic media with multiple layers of meaning. These features have prompted scholars to suggest that meme production is primary to social interaction on the platform. Zulli and Zulli, for instance, note that "imitation and replication are digitally and socially encouraged by the TikTok platform, positioning mimesis as the basis of sociality on the site" (1873). Further, while other platforms seek to hide the algorithmic curation of their social media interfaces, TikTok encourages users to partner with the app as an agent in producing memetic culture. Ultimately, the platform mobilizes algorithmic logics to draw together both the individual and collective through a carefully calibrated experience with a particular, intertextual, hypermobile, and circulatory form of memetic communication organized through the technical infrastructure of the platform as a socio-cultural infrastructure.

This essay will unfold in three parts. First, I will describe key features of platforms and how users can activate individual platforms' social, technical, and aesthetic affordances to create forms of digital collectivity. Second, I will introduce TikTok and briefly describe its capacity for fomenting collective political action through contingent, iteratively created collective aesthetics. Finally, I will analyze how TikTok's socio-technical and geopolitical affordances can also limit the capacity for sustained democratic action.

Platforms as Aesthetic Intermediaries for Collectivity

Platforms are technopolitical infrastructures that dominate the modern experience of the digital sphere. Platforms function socially and technically as intermediaries between users, developers, corporations, and the larger digital economy (Srnicek 43–48; Gillespie 349–239). More conceptually, platforms serve as nodal points between multiple collectives, stitching together people, processes, content, and technical logics in a bounded but ultimately participatory way. Liang, Aroles, and Brandl contend that "the main feature of platforms is the provision of an online interactive community, which facilitates interactions between users" (318). For example, social media platforms orient user engagement and creativity by constructing user tools and interfaces that support the generation of content or interaction on existing content. Although platforms frequently position themselves as *neutral* intermediaries, they shift our political, social, and economic futures in their image (Gillespie 348–9; Rodgers 404–12).

In the modern moment, platforms predominate as a primary organizational schema for relation. We can call this form of relationality *platform collectivity*, or the social condition of contingent, bounded togetherness characterized by shared affiliation in digital spaces. As I characterize it, platform collectivity operates in relationship to platforms as both a generalized organizing feature of digital life and as specific, discrete formations that cohere within particular social platforms. *Platform collectivity* manifests as an ongoing set of practices, experiences, activities, and infrastructures that mediate how humans experience the digital sphere and each other.

Platform collectivity organizes the technical and the social affordances of a platform to produce conditions of possibility for organized action in the digital sphere that can spill over into material contexts. Indeed, on certain social media sites, these discourses unfold memetically, through iteration, (re)creation, and circulation of ideas, content, images, and other shared vernaculars. Memes, Internet shorthands that are highly legible while also bounding communication to/within a particular digital culture, can serve as a communicative vehicle within and across platforms (Milner 159; Shifman). Yet, scholars also note that "different 'platform cultures' [...] exist within social media; that is [...] diverse vernaculars [...] arise from a combination of the user practices and technical affordances at play with any given digital medium" (Pearce et al. 3). While some research on social movements in the digital sphere treats social media as a singular unit, focusing on individual platforms is necessary to understand how these platform cultures emerge relative to the technical affordances of the platform and how users take it up collectively (Pearce et al. 3). Memetic content—mediated, iterative, and collectively authored discourse—is both constitutive and reflective of these platform collectivities.

On their own, memes are collective communication artifacts, inventing and (re)creating novel discourses through iteration/circulation (Woods and Hahner 4–5, 138–142). While they often appear nonsensical or trivial, memes can characterize shared affect and aesthetics of communities and "invite broader discussion" among potential participants (Milner 159; Shifman). Memes are the result of networked communication from multiple human and non-human agents. As such, memes shape, define, bound, narrativize collectivities through their movement within and across platforms: slingshotting between individuals and the collective. Equally important, memes move ideas, concepts, and aesthetics from center to margin and back again. This communicative movement and memetic circulation help constitute both broad and narrow aesthetically-organized communities.

Elsewhere I have argued that individual social media platforms are networked with online collectives, institutions, news outlets, media outfits, and more. Memes transverse and connect these nodal points on the network (Woods and Hahner). However, TikTok's particular technical capacities foreground memetic action not as an *option* for engagement but as an *entrypoint* to the application, forming what Zulli and Zulli have called a "meme at the level of platform infrastructure" (1883). In the case of TikTok, platform collectivity forms in response to the aesthetic cultures and participatory affordances of the platform. In the following section, I examine in detail the communicative facets of TikTok's platform infrastructure that facilitate memetic remixing and platform collectivity.

Collective Aesthetics and the Technical Features of TikTok

TikTok is a widely used social media app that boasts over two billion users across the globe (Tidy and Smith Galer). TikTok's parent company, ByteDance, was founded in 2012, some eight years after the social media platform Facebook. Harnessing the power of artificial intelligence for curating content based on user engagement and related data, ByteDance produced a number of earlier platforms before it developed TikTok. In 2017, the company released TikTok as a stand-alone platform. Despite an initially sluggish uptake by audiences in the global West, TikTok's userbase grew exponentially and in rapid order. By 2020, TikTok was the most downloaded app, beating out social media hegemons like Facebook, Twitter, and Instagram ("As Tik-Tok Grows"). By 2021, TikTok had replaced Google.com as the most popular Internet domain (Tomé and Cardita). While some industry commentators have suggested that TikTok's growth has slowed in 2022, in 2023 TikTok reported having 150 million monthly active users (Shepardson).

Together, Apart: The Feed For Strangers to Find Each Other

Most generally, TikTok is a short-form, video-based platform with an emphasis on the creation of sharable, often self-referential, multi-media content. TikToks tend to be less than a minute in length, and some are even just a few seconds long. This shortness encourages brevity and topical focus. Because audiences experience the app in a steady stream of videos, content creators are encouraged to capture viewers' attention early. While TikTok as a company has been encouraging its users to experiment with longer videos, including several minutes in length, the majority of content circulating on the app remains quite temporally limited. In comparison to earlier video-based social media platforms, like YouTube or Vine, TikTok seems to operate in a sweet spot—long enough to develop an idea or build a connection, but not so long that it risks losing audiences' attention.

For our purposes, we might aptly say that TikTok is a meme factory, supporting the development of short, interconnected media that spreads rapidly across the platform and Internet culture writ large. Like other platforms, TikTok is part of a broader ecosystem of apps, devices, algorithms, media outlets, search engines, and more. People work in tandem with the socio-technical logics of the app to create highly memetic content that moves across audiences and, indeed, platforms. In turn, TikTok's algorithmic logics collaborate in creating temporally bounded communities by providing individual recommendations but help individuals find one another.

Users produce *TikToks*, or discrete video-based posts, that are then aggregated and placed in one of two feeds. Each feed is labeled at the top of the platforms' interface. The first feed is labeled "For You" and is the default for users opening the app. Like in other social media, media content on this feed is determined based on complex algorithms. Based on their engagement and other information, these algorithms offer users media content in anticipation of what will align with their interests. The "For You" feed (also known as the "For You Page" or #fyp) theoretically curates the seemingly infinite stream of TikToks for individual users. The other feed is labeled "Following." This feed comprises TikToks made by others that an individual user "follows." Users may follow other users on TikTok by clicking on a small "plus" icon underneath their profile picture, signifying that this action will "add" TikToks from this profile to the users' "Following" feed. Unlike other platforms that predominantly organize social media by privileging existing connections (e.g. "friends" on Facebook or "followers" on Instagram), TikTok's "For You" page prioritizes stranger relationality. Users need not have a large following to go viral on the app; users also do not need to "know" other users to encounter or engage with their content. Whereas other social media may orient users to find others they know "in real life," on TikTok, connections are not bound by these relationships. Instead, users *may find one another* through memetic co-creation and algorithmically-amplified connections.

TikTok's technical and cultural affordances incite the formation of communities of affiliation or interest, often through the memetic making and remaking of content-in-common. Colloquially known as reaching "[blank]Tok," virtual communities form through shared memetic content. Users can expect to find themselves on "free speechTok," "prolifeTok," "vinylTok," or "reproductive justiceTok." These communities are goaded into existence by an algorithmic infrastructure trained on finding and aggregating sameness and difference amongst demographic communities. Indeed, algorithms orient the formation and performance of collective aesthetics on TikTok in ways similar to and different from other social media platforms. TikTok employs certain technological features such as hashtags, a feed curated by a discovery engine, and an algorithm.

By virtue of its networked nature, platform collectivity orients the socio-technological affordances of a particular platform into a unique but interconnected and ongoing process of drawing together (and pulling apart) individuals into temporally limited but discursively powerful online collectives (McVey and Woods). Samantha Hautea and colleagues note that "[n]ew media such as social platforms have led to a variety of avenues for collective action [...]. Although they lack the centralized organization of traditional activism, networked social movements can challenge the dominant gatekeeping of traditional media [...] and are changing social discourse on an unprecedented level [...]." In other words, TikTok creates conditions of possibility for a collective agency organized by and oriented through humans, socio-technical infrastructures, and the multi-mediated communication that moves between them.

TikTok's popularity as a tool for collective action may be attributed to the platform culture that forms alongside and through its technical features, including its powerful discovery engine and its easy-to-create content interface. Zhao and Abidin note that TikTok's "audiovisual affordances—including its technical and social capacity" (3) can create chains of discursive connection among users that can then be oriented toward collective action. For these scholars, the socio-technical affordances of TikToks as a multi-mediated platform "invite the production of personal narratives, connect them with each other in a dialogue, and collectively speak back against injustice" (3). Here, collective agency is characterized as shared aesthetic expression, facilitated by both human interaction and the platform logics of TikTok itself. This expression has a creative, communicative force: As Lee and Abidin argue, "[t]he participatory affordances of TikTok invite more users to perform and showcase their creativity in their participation of social movements [...]. This everyday use of TikTok becomes a powerful weapon for social advocacy and political messages, formidable enough to make a 'real action' in the world through the platform's networkedness" (3). To be clear, it is not that TikTok itself generates the collective agency of users who create media on the app. Rather, the platform's mediated and participatory features help shape both collective discourse and the formation of communities of aesthetic

affiliation in short temporal order, facilitating the formation of collectivities based on algorithmically-assessed affiliation or interest.

Although other social media sites use algorithms to construct the user experience of their platforms, TikTok is distinct in that it invites the algorithm front and center. Bhandari and Bimo call this "the forefronted algorithm" (2). They remark that "of the major social media platforms on the market, TikTok is the only one to position its algorithm at the center of the social experience it engenders; the algorithm determines the type of video content the user is exposed to, and viewing this content makes up the majority of the experience on the platform" (2). TikTok prompts users to interact with the algorithm as a matter of practice, even encouraging users to see it as a helpful guide in finding the best communities on TikTok.

In many cases, users treat the algorithm as an invisible but very present agent shaping their experience on TikTok. In much the same way actors break "the fourth wall," users may break the "platform wall," recognizing the power and importance of an algorithm as an agent of creation and directing attention to it. It is not uncommon for users to "speak" directly to the algorithm in the comments section of a TikTok, thanking it for showing a user a particular video or helping them "find" a coveted TikTok community. When users find themselves algorithmically directed to a type of TikTok content with which they do not resonate, they may in turn chastise the algorithm (or otherwise question it for "putting them" there.) So visible is the forefronted algorithm that there are instructional TikToks for users to "train" the algorithm to access particular "parts" of TikTok—and particular collectives with shared interests. On TikTok, users may experience a sense of pride or privilege when they have sufficiently refined their algorithm to "find" a particular collective such as "bookTok," "bmxTok" "makeupTok" and more. Users may feel a sense of accomplishment at engaging with the algorithm in such a way that it helps them find communities of interest as an expression of their individual or collective identity. The elevated visibility and the forefronted nature of the algorithm contributes to the formation of collective aesthetic imaginaries in part by delivering users to communities with which they may share (or form) interest and affiliation. In turn, the TikTok community and the forefronted algorithm orients user towards particular aesthetic norms for collective action.

Multi-Media as Participatory, Memetic Media

TikTok's ability to draw people together across difference is based in large part on its multi-mediated, intertextual nature. That is, although TikTok is often described as a video app, it is not only that. Instead, TikTok is a multifaceted app that occurs through the repeated condensation of text, image, sound, and technical media such as hashtags. From a scholarly perspective, we might call each of these discrete elements *texts* that operate in relationship with each other, resulting in a richly intertex-

tual experience for both creators and viewers. Importantly, each of these individual textual formats is subject to creative engagement by App users. Changing one element of a TikTok video can dramatically alter the meaning or context of the video. In this way, TikTok draws upon iteration as a dominant framework for content creation in a way that supports memetic remixing of content.

TikTok's visual elements are partnered with sound, text, and technical features like hashtags. One feature that makes TikTok stand out among social media apps is that it allows users to playfully modify each of these media either individually or in combination to suit a user's vision for a video. Most generally, users can determine what is depicted in a post and easily capture it using a personal device. Even more than that, users can play with (and within) the images, ideas, and symbols depicted by the video by adjusting other aesthetic elements of TikTok.

For instance, TikTok videos might have diegetic sound, or sound that comes from and is directly related to what is happening in the video. In a video demonstrating protests, a TikTok might feature the sounds of marchers' feet on pavements, their protest chants, or the sounds of the police's armored bodies clashing with the crowd. But TikTok also makes it very easy to overlay this text with another, non-diegetic sound as background. In many cases, users deploy this secondary background set of sounds to complement (or contrast) the scenes depicted in the videos (Zhao and Abidin 9–10). More than that, a TikTok's audio component is inherently layered, meaning that each layer creates an opportunity for connection and creation. In a TikTok focusing on protests, a content creator might choose to deploy over diegetic sounds a background sound that captures the intensity of the moments shown in the video. Or, they may choose to take a well-known pop song to garner attention from those familiar with the music (if not the subject matter depicted). Users can choose from a wide variety of pre-existing sounds from well-known artists or they can borrow the sounds of content creators. The background sound against which videos are set is also subject to remaking. On TikTok, there is an entire genre of users who create viral sounds for others to use; these often exist in the form of music mashups, commentary overlayed on music, or funny soundbites. On other occasions, unintentional sounds can become memes themselves. In going viral, they are subject to further iteration and recreation as users make and remake content with them. Sound matches the importance of video on the visual app, such that each individual TikTok becomes a richly textured experience for both creators and users.

While both sound and moving image is foregrounded on TikTok, many users also choose to use written text to produce a multi-media post. Text can be deployed in many ways on TikTok. For instance, each TikTok can be captioned. These captions appear underneath the TikTok creators' user name, often flanked by a host of hashtags related to the caption or the video. Given the brevity of the TikTok genre, most of these captions are quite short. On the platform, captions may or may not be immediately descriptive of what is depicted in the video. In some instances, these captions

may provide additional context about the post, or they may only be anecdotally related. Text may also appear in the video itself. Here, the text may be used to move the internal structure of the video along (particularly necessary to establish context given short videos) or it can flag content for a scrolling user, letting them know in the first few seconds what the rest of the video will be about. Finally, text can be used by creators for closed captioning; this makes sound-based content accessible to those with hearing disabilities or those who are watching videos without sound. As with video and sound, textual usage on TikTok is another avenue to create new content (or iterate on existing ones.)

Often, TikTok communities lead in developing Internet culture, directing the ideas and conversations that occur off-site and even offline. It is not uncommon to see images, ideas, language, and aesthetics that first occurred on TikTok elsewhere on social media, the news, or in popular culture. This is remarkable insofar as it highlights the networked capacity of the platform and the aesthetic content that help architect it. In the case of memetic content, TikTok's affordances empower users to not only rework existing media, but actively participate in developing an evolving meme culture. This meme culture helps shape the norms and strategies used by users when making, remaking, or circulating memetic content.

Collective Iteration Built In

TikToks condense these discrete media (or texts) into a singular cohesive and coherent format. As the visual register is paired with other multimedia features, each element serves as a building block that can be made and remade iteratively. Indeed, remaking is built into the very structure of TikTok as a platform. The ease of use for filming, editing, and sharing content affords users the ability to craft content at a rapid rate with very few additional tools needed. The short format of the digital media added onto those accessible editing tools supports the circulation of media from the moment of its creation to its consumption.

Even after the initial moment of creation, TikToks are set up for persistent, consistent iteration. The platform organizes users through shared aesthetics; users may use the platform's built-in "duet" or "stitch" function to integrate other users' video in whole or in part to produce shared aesthetics anew. The duet and stitch functions effectively mean that users can provide additional commentary for an original video, incorporate new ideas or sounds, or build on the content within the video. For instance, a particular genre of TikToks on "musicTok" uses the duet feature to add additional instruments or singing to an existing musical performance. Such duets tend to occur within a chain: An original video of someone playing a song on guitar may be joined by someone on bass, then drums, then saxophone, then voice. In some instances, the duets are so complex that they feature multi-part harmonies and com-

prise a virtual multi-piece orchestra. Indeed, users have used this and other functions to write an entire musical (based on a meme).

Such features are not simply tools for distributing existing content across TikTok or the broader ecosystem. Rather, TikTok's particular brand identity and functionality are determined in large part by its droves of what it calls content creators, its social and technical infrastructure, which encourages participation in media creation, and relative ease of use for ordinary users. TikTok's multi-media audiovisual platform leads users to take up or curate both individual and shared aesthetics such that TikToks become "inherently intertextual in that the meanings of the content and style depend on those in other contexts" (Zhao and Abidin 11). In other words, TikTok operates at the intersection of user-made content, collective aesthetics, temporally-limited media, mixing and remixing of trendy images and sound from the cultural zeitgeist. In what remains of this article, I offer a brief example of platform collectivity architected through memetic relation on TikTok.

Memetic TikTok on *Dobbs* and *Roe*

The summer of 2022 was punctuated by the leak and subsequent announcement of the *Dobbs* decision. To be clear, the leak did not instigate deep partisan division over reproductive healthcare in America, but it shined a light on those divisions and made them (even more) public. Reproductive health care, particularly the right to an abortion, has increasingly become a dividing issue in the United States (Kretschmer 893–894). But abortion access was not a public conversation from the start. Sociologist Kelsy Kretschmer has argued that before the Supreme Court's initial ruling on *Roe* in 1973, abortion was largely considered a private, family matter (893–894). Indeed, part of the work of feminist groups in the middle of the twentieth century was to relocate reproductive health issues as political, subject to public deliberation. Doing so also meant reframing the stakes of discourse and deliberative action to focus less on individuals in positions of power and more on the power of the *collective*. Rhetorical scholars highlight such a communication strategy as "consciousness-raising discourse" or "collective rhetoric"—a collaborative form of discourse that can spur social change through collective meaning-making, aesthetics, and narrative action (Dubriwny 396–397).

Some fifty years later, the communicative power of collectivity through consciousness-raising persists in newly mediated forms. In the aftermath of the *Dobbs* decision and the fall of *Roe*, citizens turned to social media platforms to react to the criminalization of abortion in real-time. TikTok became an important hub for collective action on reproductive justice. Journalist Lindsay Dodgson noted, for instance, that "[i]n the hours after an initial draft majority opinion written by Justice Samuel Alito was leaked to Politico [...] TikTok immediately became a

place for people to share their sorrow, commiserate, and call allies to action." Posts with hashtags like #reproductivehealth, #bansoffourbodies, #roevwade, #feminist, and #birthcontrol created a chain of interconnecting videos documenting users' reactions to the leak.

By the time the Court issued its controversial ruling on *Dobbs*, demonstrations across the nation (and the world) were well underway. Many users took to TikTok to plan, execute, and document public protests, including a number at the Supreme Court. One such TikTok video, viewed over 800,000 times, showed protesters with signs riding public transit in the nations' capital. After following several unidentified, unnamed people with signs walking to the protest, the video shows images of a growing crowd near the Washington Monument, various museums, and the Supreme Court Building. The video was set to a sound remixing a speech by Congresswoman Alexandria Ocasio Cortez and the song "Humble" by Kendrick Lamar. Underneath the video, the caption reads "hands off. #roevwade #DC #washingtondc #abortionban #womensmarch #bansoffourbodies #supremecourt #protest" ("Em on TikTok"). Other users deployed the app to crowdfund for health care or legal funds or share resources related to reproductive health (Dodgson).

A related TikTok video posted by @OMGasho after the *Dobbs* decision relies on the aesthetic features of platform collectivity afforded by iterative remixing. The video shows a series of video and still shots of protesters against the decision, set to a remix of "This is America" by Childish Gambino and "Congratulations" by Post Malone. Some protest signs feature primarily written word (e.g., "Stop This War on Women") and others contain evocative imagery (red handprints on the curvy figure of a body, a hanger, images of recently deceased justice Ruth Bader Ginsburg and so forth). Still others are dressed in imagery, wearing red cloaks and white hats, gesturing towards the dystopian novel *The Handmaid's Tale*. While any one of these sounds, images, referents, or ideas can create an entry point for understanding the persuasive communication contained in the video, and while it is fairly easy to discern the position of the poster, what is most interesting is the memetic intertextuality of this video. By pairing an upbeat but equally dystopian Childish Gambino's warning about a racist, sexist, and oppressive America with a sardonic play on Post Malone's congratulations, the discursive context deepens. Through self-referential incongruity, posts such as these demonstrate dual communicative impact of memetic media: First, these examples elevate the overt persuasive messaging regarding the dystopian nature of reproductive healthcare in the United States, and second, they highlight the creation of bounded, temporary communities formed when users understand or apply one of the TikTok's many referents.

Here, platform collectivity is socially and technically incentivized by choices in shared mediated context. Iterative remixing is made easily possible (if not probable) by the myriad textual threads available to creators. The author of the video, for instance, has strategically aligned imagery with sound, such that Gambino's line "guns

in my area" narrates a protest sign held by a protester lamenting that guns are less regulated than healthcare. In so doing, the intertextuality serves as a multi-media invitation for viewers, whether or not they know @omgasho. The invitation is multiplicitous—one can duet or stitch the video, use the sound to make one's own video, engage in conversation in comments, feel a sense of solidarity and collectivity in a time of shared loss, and even join a local protest to participate in the action in real life. Given the TikTok's nearly 862,000 likes, 21,000 "shares" and thousands of comments, users have taken up this invitation in earnest.

Similar videos exist with different audios attached, including a viral sound from the latest season of the Netflix streaming series *Stranger Things*. Here, protesters are depicted as the featured song notes "Chrissy wake up, I don't like this." Although abortion rights, and protests, may not have anything in particular in common with *Stranger Things*, and although *Stranger Things* might not take a particular political stance as pertains *Roe v. Wade* or the *Dobbs* decision, memetic context stitches together these two distinct elements forming a new whole. By condensing shared aesthetics into a singular video, people who watch *Stranger Things* are invited into conversation around abortion care, and the viral nature of the sound helps to slingshot the imagery to nearly 2 million likes and 52 million shares.

Other videos offer similar yet distinct, but related aesthetic experiences for viewers. Some feature influencers reacting live to experts discussing the structural problems underlying healthcare (and, frankly, patriarchal violence) in the United States. Using a memetic format typical to TikTok, their heads float in the bottom third of the camera as they silently but visibly represent depicted narratives, express their dissent through placid but emotionally charged facial expressions. This video features no commentary in the description, simply the hashtags #RoeVWade and #WomensRights. Clicking through these hashtags—which is another pathway towards engagement of these ideas—shows young people reacting to the news of the overturn of *Roe v. Wade*, explaining possible effects, and even sharing "hypothetical" situations of imaginary.

These brief examples show how TikTok's technical and social tools draw users into active engagement with both content creation and the communities or movements founded through collective creation. These memetic media are exemplars of platform collectivity constituted through both individual actions of videomakers and algorithmic sorting of users into communities who may come into contact with the material. Through platform collectivity, online collectives cohere both algorithmically and autopoetically, meaning that they form autonomously of any individual actor or agent. From a techno-discursive perspective, what draws people together is the circulation of a shared text to which users direct their attention (Warner 49–50). Yet, what matters more than the individual text in itself is the fact that it exists, that it resonates with a certain group of people. More than that, the text must be shared, such that it can be "picked up at different times and in different places by

otherwise unrelated people" (Warner 51). Like the platform, platform collectivity is (1) distributed across any one individual, community, or technical location; (2) systemic and connected (that is to say, networked) and (3) engaged/participatory. Taken together, platform collectivity both evidences and facilitates the power of individuals working together across difference, facilitated by the affordances of platforms, often for a limited and unspecified amount of time.

The Future of Platform Collectivity

In this theoretical essay, I have examined how aesthetic forms of platform collectivity cohere on (or within) a particular social media platform: TikTok. While it is often dismissed in academic and popular culture as a space for irreverent performance (e.g., dancing), the application influences cultural landscapes on and off the platform. Tik-Tok is a distinct communicative channel that mobilizes algorithmic logics to draw together both the individual and collective through a carefully calibrated experience with a particular, intertextual, hypermobile, and circulatory medium: memetic, iterative content.

From a cultural perspective, social media platforms hold a number of communicative affordances that make them useful for collective action. TikTok's invitational ethos, partnered with accessible tools for making and sharing media, creates conditions of possibility for building shared meaning online. In turn, the iterative, creative processes particular to platform culture foreground creation and participation on these networked platforms. The social and technological affordances endemic to the platforms subsequently encourage the transmission of both information and—whether intentionally or not—the creation of communities of affiliation or interest (McVey and Woods 1). By virtue of its particular mediation on/through platforms, this *platform collectivity* is distributed, connected, and participatory, spanning across individual media or any one platform. It thus exists as a portable social formation. At the same time, expressions of platform collectivity are discrete, architected by the unique social and technical affordances of the platform. This paradox is activated through memetic content that moves between and among particular communities and platforms.

As a technical logic of relation, platform collectivity gestures towards the power of interconnected subunits of community that form in response to internal and external algorithmic and social forces. Rather than forming *"the* public," a social relation that is defined in part by its omnipotence of "social totality" (Warner 49), platform collectivity provides a name to the non-random, often algorithmically-oriented organization of people, networks, platforms, news media, search engines, and media content that can flash in and out of existence with a certain quickness, or huddle together a little longer after the fact. Platform collectivity is neither

permanent nor entirely temporally liminal. Its transformative potential exists from the collectives that take it up together neither autonomously or through the direct actions of a single actor.

While social and other emerging media often appear to make communication easier fairly straightforwardly, in reality, many social media platforms significantly rework the structure of communicative action, necessitating new models for tracing and evaluating communication processes (van Dijck 4). Platforms support the sense of connectivity that seems to describe the online space since the rise of Web 2.0. As we look toward the formation of Web 3.0, it makes sense to reevaluate what connectivity is and can look like. Given the economic imperatives associated with platform culture, connectivity (or any social function) supported by individual platforms constrains social relations to the direct benefit of platforms.

While I endeavored to trace ways in which TikTok engenders platform collectivity, the platform's cultural and technical situatedness as a private platform in a politicized, racialized, gendered and surveillance-oriented economy of data certainly limits activist action. For example, TikTok has repeatedly been subject to complaint that it suppresses, deprioritizes, or otherwise limits certain topics and creators, including those related to the #BlackLivesMatter movements (Shead). More generally, for-profit platforms are obligated to shareholders and owners over their users. Liang and colleagues have argued that "the platform's neoliberalism is not just a set of economic policies; platform participants are forced to become 'homo economicus', and their behaviour is configured by the platform's sophisticated algorithms relying on market rationality" (318). Moreover, they suggest that "the themes of connectivity and exchange, central to platforms, obscure the neoliberalism ideology that runs free at the heart of platform capitalism" (Liang et al. 323). The neoliberalization of the public sphere is not specific to TikTok, platforms, or even the twenty-first century. Rather, mass consumption has been central to the political process and model of civic engagement and citizenship since at least World War II (Cohen 7).

As with other social media, TikTok's significance in popular culture has bled into geopolitical life. Because a foreign entity owns TikTok, it has faced significant—perhaps outsized—criticism for its data collection processes. In general, politicians critical of the app's impact focus in large part on bolstering national security in a fraught, digitally-mediated geopolitical sphere. That is, policymakers have repeatedly stated their concern about the implications of allowing ByteDance, a company based in China, to collect significant amounts of data on American citizens. This rhetorical framing highlighted how platforms could be politically advantageous for other countries, meaning TikTok would become a form of surveillance—"a Chinese spy tool" (Allyn). Such discourse has been particularly persistent, infiltrating the United States' local, regional, and national politics for several years. However, much of this rhetoric has been toothless, even at the uppermost echelons of American political infrastructure.

In July 2020, President Donald Trump advocated banning the platform, apparently for its connections to China, with which his administration had a strained relationship (Wong et al.). On August 6, Trump signed an executive order prohibiting economic transactions between TikTok's parent companies and U.S. entities (Lerman). The move encouraged TikTok to court American corporate entities to acquire or otherwise manage its U.S.-based operations (Lerman). Ultimately, attempts to ban the app were unsuccessful. Federal courts responding to complaints from both TikTok and TikTok users ruled that the Trump administration had been "arbitrary and capricious" in its attempt to ban the app. In addition to highlighting the potential political motivation against TikTok (and China), courts also ruled that Trumps' executive order could infringe upon freedom of speech (Allyn).

The platform continues to be plagued by its geopolitical associations and, more particularly, by political posturing about China. In 2022, FCC Commissioner Brendan Carr called on Google and Apple to remove the social media application from their app stores, a move that the *Washington Post* calls the latest "chapter in TikTok's complicated dance with the U.S. government" (Gregg). In March 2023, lawmakers in the USA introduced a bipartisan bill (the RESTRICT ACT) that would give the executive branch significant powers to curtail platforms like TikTok. The Electronic Frontier Foundation strongly opposes the bill, which they note would undermine federal statutes that "protec[t] the free flow of information in and out of the United States and supports the fundamental freedom of expression and human rights concerns" (Kelley and Greene). Of particular interest, the RESTRICT Act is predicated on potentially limiting or controlling technologies based on the popularity, distribution, and widespread use of possible communication platforms.

While TikTok as a platform has an economic investment in creating and forming collective cultures on the app, users have demonstrated that the app can be used to generate collective affect despite technical or cultural fragmentation. Whether we call them crowds or affiliative publics, TikTok's communicative capacities allow users to find one another—to overcome the individualizing and individuating effects of the platform's algorithms in a way that might support resistance or at least the imagining of politics otherwise.

TikTok represents a fascinating case study in platformed collective action—one that is indeed complicated, not only because of its associations with particular geopolitical actors, but because it represents the further inculcation of democratic action in the privatized digital sphere. Moreover, this case study can reveal key elements of the future of collective agency in digital media, particularly when we study the platform's functionality relative to aesthetic creation in communities and subcommunities. In other words, TikTok's private but public, geopolitical and localized, collective and individualized features highlight the paradox of organizing in the twenty-first century.

Works Cited

Allyn, Bobby. "U.S. Judge Halts Trump's TikTok Ban, The 2nd Court To Fully Block The Action." *NPR*, 7 December 2020, https://www.npr.org/2020/12/07/9440390 53/u-s-judge-halts-trumps-tiktok-ban-the-2nd-court-to-fully-block-the-actio n. Accessed 10 April 2023.

"As TikTok Grows, so Does Suspicion." *The Economist*, 9 July 2022, https://www.ec onomist.com/interactive/briefing/2022/07/09/the-all-conquering-quaver. Accessed 13 April 2023.

Bhandari, Aparajita, and Sara Bimo. "Why's Everyone on TikTok Now? The Algorithmized Self and the Future of Self-Making on Social Media." *Social Media + Society*, vol. 8, no. 1, 2022, https://doi.org/10.1177/20563051221086241.

Bravin, Jess, and Brent Kendall. "Court Leak Stokes Abortion Fight—Chief Justice Confirms Authenticity of Draft Opinion; Both Sides Get Ready for Possible Shift." *Wall Street Journal*, 4 May 2022, https://www.proquest.com/usnews/docvi ew/2659017767/citation/48720BCE4ECA41EAPQ/1. Accessed 25 September 2023.

Bucher, Taina, and Anne Helmond. "The Affordances of Social Media Platforms." *The SAGE Handbook of Social Media*, edited by Jean Burgess, Alice Marwick, and Thomas Poell, SAGE 2018, pp. 233–53, https://doi.org/10.4135/9781473984066.

Cohen, Lizabeth. *A Consumers' Republic: The Politics of Mass Consumption in Postwar America*. Vintage Books, 2003.

Dodgson, Lindsay. "TikTok Turned into a Guide to Attending Protests and Donating to Abortion Funds Overnight after the Roe Leak." *Insider*, 4 May 2022, https://www.insider.com/where-to-donate-how-to-protest-overturn-ro e-v-wade-abortion-tiktok. Accessed 10 April 2023.

Dubriwny, Tasha N. "Consciousness-Raising as Collective Rhetoric: The Articulation of Experience in the Redstockings' Abortion Speak-Out of 1969." *Quarterly Journal of Speech*, vol. 91, no. 4, 2005, pp. 395–422, https://doi.org/10.1080/00335630500 488275.

Greenwalt, Dustin A., and James Alexander McVey. "Get Gritty with It: Memetic Icons and the Visual Ethos of Antifascism." *Communication and Critical/Cultural Studies*, vol. 19, no. 2, 2022, pp. 158–79, https://doi.org/10.1080/14791420.2022.2 066145.

Gregg, Aaron. "FCC Commissioner Calls on Google and Apple to Ban TikTok App." *Washington Post*, 2 July 2022, https://www.washingtonpost.com/business/2022/ 06/29/fcc-tiktok-ban-apple-google/. Accessed 19 April 2023.

Hartig, Hannah. "About Six-in-Ten Americans Say Abortion Should Be Legal in All or Most Cases." *Pew Research Center*, 13 July 2022, https://www.pewresearch.org/ short-reads/2022/06/13/about-six-in-ten-americans-say-abortion-should-be-l egal-in-all-or-most-cases-2/. Accessed 19 April 2023.

Hautea, Samantha, Perry Parks, Bruno Takahashi, and Jing Zeng. "Showing They Care (Or Don't): Affective Publics and Ambivalent Climate Activism on TikTok." *Social Media + Society*, vol. 7, no. 2, 2021, p. 1–14, https://doi.org/10.1177/20563051 211012344.

Hawkins, Ian, and Muniba Saleem. "Rise UP!: A Content Analytic Study of How Collective Action Is Discussed within White Nationalist Videos on YouTube." *New Media & Society*, 2021, pp. 1–20, https://doi.org/10.1177/14614448211040520.

Kelley, Jason, and David Greene. "The Broad, Vague RESTRICT Act Is a Dangerous Substitute for Comprehensive Data Privacy Legislation," Electronic Frontier Foundation, 4 April 2023, https://www.eff.org/deeplinks/2023/04/broad-vagu e-restrict-act-dangerous-substitute-comprehensive-data-privacy. Accessed 19 April 2023.

Kretschmer, Kelsy. "Shifting Boundaries and Splintering Movements: Abortion Rights in the Feminist and New Right Movements." *Sociological Forum*, vol. 29, no. 4, 2014, pp. 893–915, https://doi.org/10.1111/socf.12125.

Lerman, Rachel. "'45 Days of Ambiguity': What a U.S. TikTok Ban Could Mean for Users and Employees." *The Washington Post*, 17 August 2020, https://www.was hingtonpost.com/technology/2020/08/17/tiktok-ban-us-faq/. Accessed 7 March 2024.

Liang, Yin, Jeremy Aroles, and Bernd Brandl. "Charting Platform Capitalism: Definitions, Concepts and Ideologies." *New Technology, Work and Employment*, vol. 37, no. 2, 2022, pp. 308–27, https://doi.org/10.1111/ntwe.12234.

Manyika, James. "An Overview of Bard: An Early Experiment with Generative AI." Google AI, https://ai.google/static/documents/google-about-bard.pdf. Accessed 19 April 2023.

McVey, James Alexander, and Heather Suzanne Woods. "Anti-Racist Activism and the Transformational Principles of Hashtag Publics: From #HandsUp-DontShoot to #PantsUpDontLoot—Present Tense." *Present Tense: A Journal of Rhetoric in Society*, vol. 5, no. 3, http://www.presenttensejournal.org/volume-5/a nti-racist-activism-and-the-transformational-principles-of-hashtag-publics-f rom-handsupdontshoot-to-pantsupdontloot/. 19 September 2018.

Milner, Ryan M. *The World Made Meme: Public Conversations and Participatory Media.* MIT Press, 2016.

Pearce, Warren, Sabine Niederer, Suay Melisa Özkula, and Natalia Sánchez Querubín. "The Social Media Life of Climate Change: Platforms, Publics, and Future Imaginaries." *WIREs Climate Change*, vol. 10, no. 2, 2019, p. e569, https://do i.org/10.1002/wcc.569.

Plantin, Jean-Christophe, Carl Lagoze, Paul N. Edwards, and Christian Sandvig. "Infrastructure Studies Meet Platform Studies in the Age of Google and Facebook." *New Media & Society*, vol. 20, no. 1, 2018, pp. 293–310, https://doi.org/10.1177/1461 444816661553.

Rodgers, Scott. "The Duality of Platforms as Infrastructures for Urban Politics." *Communication and Critical/Cultural Studies*, vol. 18, no. 4, 2021, pp. 404–12, https://doi.org/10.1080/14791420.2021.1995616.

Seiffert-Brockmann, Jens, Trevor Diehl, and Leonhard Dobusch. "Memes as Games: The Evolution of a Digital Discourse Online." *New Media & Society*, vol. 20, no. 8, 2018, pp. 2862–79, https://doi.org/10.1177/1461444817735334.

Shead, Sam. "TikTok Apologizes after Being Accused of Censoring #BlackLivesMatter Posts." *CNBC*, 2 June 2020, https://www.cnbc.com/2020/06/02/tiktok-black livesmatter-censorship.html. Accessed 19 April 2023.

Shepardson, David. "TikTok Hits 150 Mln U.S. Monthly Users, up from 100 Million in 2020." *Reuters*, 20 March 2023. https://www.reuters.com/technology/tikt ok-tell-congress-it-has-150-million-monthly-active-us-users-2023-03-20/. Accessed 13 April 2023.

Shifman, Limor. *Memes in Digital Culture*. MIT Press, 2014.

Silvestri, Lisa Ellen. "Memeingful Memories and the Art of Resistance." *New Media & Society*, vol. 20, no. 11, 2018, pp. 3997–4016, https://doi.org/10.1177/146144481876 6092.

Tidy, and Sophia Smith Galer. "TikTok: The Story of a Social Media Giant." *BBC News*, 4 August 2020, https://www.bbc.com/news/technology-53640724. Accessed 19 April 2023.

Tomé, João, and Sofia Cardita. "In 2021, the Internet Went for TikTok, Space and Beyond." The Cloudflare Blog, 20 December 2021, http://blog.cloudflare.com/p opular-domains-year-in-review-2021/. Accessed 19 April 2023.

Warner, Michael. "Publics and Counterpublics." *Public Culture*, vol. 14, no. 1, 2002, pp. 49–90, muse.jhu.edu/article/26277.

Wong, Queenie, Laura Hautala, and Andrew Morse. "The TikTok Saga: Everything You Need to Know." *CNET*, 18 September 2020, https://www.cnet.com/news/po litics/the-tiktok-saga-everything-you-need-to-know/. Accessed 19 April 2023.

Woods, Heather Suzanne, and Leslie A. Hahner. *Make America Meme Again: The Rhetoric of the Alt-Right*. Peter Lang. 2019.

Zhao, Xinyu, and Crystal Abidin. "The 'Fox Eye' Challenge Trend: Anti-Racism Work, Platform Affordances, and the Vernacular of Gesticular Activism on TikTok." *Social Media + Society*, vol. 9, no. 1, 2023, pp. 1–16, https://doi.org/10.1177/205630512 31157590.

Zulli, Diana, and David James Zulli. "Extending the Internet Meme: Conceptualizing Technological Mimesis and Imitation Publics on the TikTok Platform." *New Media & Society*, vol. 24, no. 8, 2022, pp. 1872–90, https://doi.org/10.1177/1461444 820983603.

III. Narrating Collectivity Beyond the Human

Constraints and Community
in Multiplayer Video Games

Marco Caracciolo

Digital media and the Internet raise new challenges for the definition and practice of the collective.[1] Political discourse and activism rely on the distributed network of social media, creating unprecedented possibilities for collective organization on a national and transnational level (Postmes and Brunsting). For audiences of artistic or entertainment practices, the forms of the collective are changing as well. Readers of fiction are increasingly using services such as Goodreads.com to share impressions of the books they read, on social media-like platforms that are easily monetized by corporations such as Amazon (which owns Goodreads).[2] This article focuses on a mode of collectivity that is even more fundamentally bound up with digital media and the Internet: namely, the practices of online or "multiplayer" gaming. Combining play and narrative engagement in a shared, intersubjective context, online games are a microcosm illustrating many of the dilemmas that underlie digital communities—the promise of decentralized cooperation but also the ever-present threat of irresponsible or predatory behavior.

My approach to video games is inspired by New Formalist work in literary studies. As argued by Caroline Levine, the forms found in creative practices are never merely formal in a narrow sense: On the contrary, forms such as hierarchies or networks of collaboration abound in social processes and play an important part in cultural meaning making. Therefore, New Formalism is sensitive to the ways in which the forms of cultural artifacts (such as novels, films, or video games) resonate and engage with the forms inherent in social practices at large. While the New Formalist framework and the language of form originate in literary studies, this approach can be readily extended to video games. In this medium, the concept of "form" spans a

1 This article is a revised and expanded version of chapter 4 of my book *On Soulsring Worlds: Complexity, Digital Communities, and Interpretation in Dark Souls and Elden Ring* (Routledge, 2024). Reprinted with permission.
2 See Milota for an empirical study of online commentaries on Goodreads, among other similar platforms.

broad range of devices, from the basic rules and objectives of the game to the rep-resentational and narrative strategies implemented by the developers. In the case of multiplayer games specifically, the possibilities of interaction created by the de-velopers through formal devices can shape players' intersubjective experiences both during gameplay and in other Internet-based practices that revolve around games (for instance, discussion groups, Reddit threads, and so on).

On the level of basic gameplay, games can create multiplayer experiences in pro-foundly different ways. Players can share a physical space, at a LAN party or when a game allows for "split-screen" multiplayer on the same computer or console sys-tem. More frequently today, though, multiplayer gaming involves sharing a virtual environment remotely, through an Internet connection. Multiplayer gaming spans a broad spectrum from pure competition (a free-for-all "deathmatch," in which ev-ery player is fighting for themselves) to purely cooperative experiences (in which all players work together to achieve a certain goal). Team-based multiplayer games fall halfway on this spectrum: They combine competition (against the opposing team or teams) and cooperation (within the team). In most of these games, players act within the same simulated environment through the mediation of the player-character or "avatar" (see Vella, "'It's A-Me/Mario'"): A representation that players control directly and that allows them to interact with the game world—for example, by collecting resources or fighting other players (or computer-controlled enemies).

Across this range of multiplayer experiences, two features tend to remain con-stant. The first is that players have to be connected simultaneously to play together: As in real-life interaction, their avatars need to occupy the same digital environment synchronously to compete or collaborate. Second, players are allowed and even en-couraged to communicate directly, either through in-game chat or by using exter-nal voice chat services such as Discord to coordinate their actions. However, some games challenge these conventions, either by allowing for asynchronous multiplayer or by placing considerable constraints on communication. This article focuses on how these innovative ways of bringing players together can create uniquely reward-ing experiences and also overturn some of the stereotypes and assumptions sur-rounding gaming culture. I will argue that asynchronous gameplay and constrained communication are instrumental in cultivating more responsible and critical prac-tices in online communities, not only during active gameplay but also outside of gameplay proper, when players discuss gameplay strategies or interpret the games' narrative and atmosphere. Of course, correlating a certain form (in this case, two game mechanics) to an effect is always tricky: Many factors shape the community surrounding a certain game, and it is difficult to both generalize about a certain community and trace all of its features to the developers' formal choices. Yet asyn-chronous multiplayer and constrained communication appear to have a significant defamiliarizing potential: By encouraging players to reconsider what they took for granted about multiplayer experiences, they open up spaces for reflection that lead

to more profound or meaningful forms of online collectivity than are typically found in mainstream gaming.[3]

Inevitably, this focus on asynchronous and constrained-communication multiplayer leads me to privilege certain kinds of games in my discussion. Astrid Ensslin introduced the term "literary games" for video games whose complexity is comparable to literary works, particularly (in Ensslin's discussion) at the level of their creative or unconventional use of verbal language. I propose extending this concept to any game that displays the complexity typical of literature, not only in the verbal domain but also in narrative, emotional, and ethical terms.[4] My examples of asynchronous and constrained-communication multiplayer in the next section, *Death Stranding* (Kojima Productions 2019) and *Journey* (thatgamecompany 2012), are literary in this extended sense, but they also belong to very different strands of the gaming industry—the former being a major production by famed Japanese game creator Hideo Kojima, while the latter is an "indie" game with a distinct arthouse feel.[5] Despite these differences in positioning within the landscape of contemporary gaming, *Death Stranding* and *Journey* converge in adopting an innovative approach to multiplayer experiences: They create unusual forms of online togetherness that challenge the dominant culture of "hardcore" gaming, which is defined by shallow interactions and potentially toxic behavior.

After discussing work on uncooperative behavior in online gaming, I turn to my main case study, *Elden Ring* (FromSoftware 2022), a critically acclaimed game that builds on FromSoftware's earlier *Dark Souls* series (2011–2018) while presenting the player with a vaster, more open world and more nonlinear progression. Like the three *Dark Souls* games, *Elden Ring* features a sophisticated multiplayer system, combining both synchronous and asynchronous elements. My discussion will focus on how each playthrough is shaped by asynchronous and constrained interactions with other players. This is another literary game that rewards careful excavation of its universe and backstories: I argue that, together with the game's narrative complexity and signature difficulty, the multiplayer mechanics in *Elden Ring* contribute to more thoughtful practices in online communities. Moreover, I show how FromSoftware

3 Of course, this difference may also reflect a difference in the demographics (social background, education, etc.) of the audiences addressed by these games. While I cannot rule out this possibility in the article, it seems to me that the wide appeal and impressive sales figures of FromSoftware games suggest that they are not only catering to a niche of "arthouse" players (who may be less inclined to toxic behavior than mainstream gamers). However, the issue of audiences is certainly worth exploring further from an empirical perspective.

4 Relevant in this respect is work in film and media studies on narrative complexity, which involves nonlinear or multilinear strategies that challenge storytelling conventions (see, e.g., Buckland). That kind of complexity is an aspect of what I am calling literary gaming here, although of course games realize it in different ways from film.

5 For a comprehensive study of the aesthetics and rhetoric of independent games, see Juul.

games create unique integration between two experiences of community that are, in many games, distinct from one another: interactions with other players during active gameplay and the post-hoc discussions that surround games on various Internet platforms. The narrative and gameplay difficulty of these games contributes to bringing these typically separate experiences into close alignment.

Introducing Asynchronous and Constrained-Communication Multiplayer

At first glance, it would not be unusual for players of Hideo Kojima's *Death Stranding* (Kojima Productions) to think they are playing a single-player game. The player-controlled character, a deliveryman named Sam Porter Bridges, is asked to traverse a postapocalyptic wasteland where only few pockets of human society survive. The core gameplay involves building or rebuilding infrastructure to connect these settlements while Sam makes his way across the United States. If infrastructure is a visible manifestation of the collective, then *Death Stranding* centers on the problem of rebuilding community in a postapocalyptic world destabilized by supernatural forces—a set-up that resonates with contemporary anxieties of climate disaster and supply chain disruptions.[6] Yet, despite this focus on community, the world of *Death Stranding* feels vast and empty when I traverse it. The sense of loneliness is increased by the fact that negotiating this visually striking landscape is never smooth or self-evident, because I need to juggle multiple bulky packages while crossing difficult terrain, climbing mountains, and fighting off bandits. When visiting the urban centers or in cutscenes, the player encounters a large cast of computer-controlled, non-player characters (NPCs), but they never cross paths with other players' avatars.[7]

Nevertheless, when I play *Death Stranding* in the "online" mode my world is pre-filled with structures such as bridges and ladders built by other players. These structures are clearly marked as different from those I have built: They appear in each area after I restore the Internet-like "chiral network"; their presence makes the task of navigating the landscape significantly easier. In fact, playing *Death Stranding* offline greatly increases the difficulty level, because I have to start from scratch instead of benefiting from community-built infrastructure. Algorithmically (and to some extent randomly), the game selects some structures built by other players and includes them in my game world, along with the builder's username. In turn, some of the

6 For more on this reading of *Death Stranding*, see Caracciolo, *Contemporary Narrative*, chapter 8. Rubenstein, Robbins, and Beal discuss the literary relevance of infrastructural thinking, adopting a New Formalist method that ties in with my approach here.

7 Throughout this article, I use the "we" form or "the player" to refer to basic in-game experiences that are likely to be widely shared across players, whereas I switch to the first-person singular when the emphasis lies on my own experiences and responses to the games.

bridges or roads I build may show up in another player's world, although I have no direct control over that process. This is an excellent example of what video game theorist Ian Bogost calls "procedurality," "the computer's special efficiency for formalizing the configuration and behavior of various representative elements" (13). In the case of *Death Stranding*, the system was designed to procedurally distribute player-built structures, with a limit of structures per game area (so as not to make the gameplay too easy). The algorithm also seems to take into account the "like" system, which allows players to show appreciation for particularly useful structures.[8] The result is a unique form of asynchronous, algorithmically driven cooperation between players: I cannot intervene in other players' worlds directly, but the infrastructure built by others serves as a trace or echo of their gameplay, evoking community even in the impossibility of direct interaction. Emotionally, this strategy complicates the loneliness of gameplay, because we realize that the game's central problem—rebuilding community—demands teamwork, but we are ultimately unable to share the landscape with other players: Whatever interaction we can have with them is filtered by an abstract infrastructure-sharing algorithm. The combination of impressive vistas, postapocalyptic setting, and asynchronous multiplayer is responsible for the game's melancholy atmosphere, which is its main claim to literary complexity—much more so, in fact, than the convoluted plot and the characters' heavy-handed rhetoric.

If verbosity is, as noted by many critics and commentators (e.g., Frushtick), one of the factors making the experience of Kojima's game less enjoyable, the same cannot be said about *Journey*, my example of constrained multiplayer communication. In fact, this is a completely wordless game. The player's goal is to navigate a series of interconnected spaces while solving puzzles: Like *Death Stranding*, this is a game of landscape traversal, but the atmosphere of this vast desert is very different from Kojima's postapocalyptic game. A poster child for "indie" and arthouse games, *Journey* uses pastel colors and delicate textures to evoke a vaguely Orientalist world, with ruins of a mysterious civilization strewn across a deserted landscape. Contributing to this atmosphere is the fact that this world is mostly devoid of anthropomorphic presences; the creatures we encounter repeatedly in the course of our playthrough are made of fabric even when they resemble animals (for example, a jellyfish).

Yet, occasionally, we can sight in the distance another traveler wearing clothes similar to our own avatar. Initially the player will wonder whether this is a multiplayer situation—that is, whether these characters are controlled by the computer or by other players, but there is no way to know for sure. No name is displayed, and communication is extremely limited: There is no voice chat here, and while the travelers can exchange sounds known as "chirps," the other's responses could easily be procedurally generated. In fact, the only in-game confirmation that these figures are player avatars (and that this is a multiplayer game) comes after the end credits, when

8 See Reynolds for a detailed description of the game's multiplayer systems.

the game's paratext reveals the name of the other users we shared part of our *Journey* with. Because these players are randomly selected by the game and their usernames not displayed until the end, it is difficult to make contact with them outside of the game. Instead, players have devised creative ways of communicating, for example by tracing messages in the sand. Sharing the landscape with a player who remains completely anonymous is a unique experience afforded by *Journey*'s asynchronous multiplayer system. The constraints on communication contribute to the metaphysical qualities of *Journey*'s gameplay: somewhat counterintuitively, the sense of intersubjective sharing is intensified by the impossibility of direct verbal communication.[9] While *Journey*'s arthouse approach will not cater to all players' tastes, its silent multiplayer helps create a distinctively contemplative atmosphere.

Toxic Behavior and "Grief" in Online Communities

Any generalization about a place as divided as the Internet is of course bound to invite disagreement, but it seems safe to suggest that gaming communities, in general, have a rather poor track record when it comes to respectful behavior. The culture of hardcore gaming is strongly (if stereotypically) aligned with notions of hypercompetitive masculinity. Even if gaming audiences (and games themselves) have become far more inclusive and diverse over the last decade, the controversies surrounding "GamerGate" in 2014–2015 demonstrate that sexist assumptions are still entrenched in at least some gaming communities.[10] GamerGate was a harassment campaign launched by online commentators who targeted female developers, particularly well-known figures in the indie gaming industry whose games engage with issues of social justice or contemporary politics. Writing before GamerGate, Mia Consalvo already noted "a pattern of a misogynistic gamer culture and patriarchal privilege attempting to (re)assert its position " (1). While it would be unfair to see GamerGate supporters as representative of the "average" gamer, their response is symptomatic of larger rifts within the world of gaming, which can easily spiral into irresponsible or toxic behavior.

If we focus more narrowly on multiplayer interactions, problematic behavior is not hard to come by. A longitudinal study by Jesse Fox and Wai Yen Tang offers a comprehensive picture of players' experiences with the online game *Team Fortress 2*. Their point of departure is that "several studies have found negative social interaction to be common within online games [...] and more broadly in gamer culture" (4058). The results, based on diary observations by a relatively small number of participants (n =

9 For more on how this kind of implicitness can enhance empathy and "sharing" in engaging
 with fictional characters, see Caracciolo, "Fictional Characters."
10 For more on the GamerGate, I refer to Melissa Kagen's helpful discussion.

38), broadly confirm this idea. Verbal aggression—in the form of teasing "trash-talk" or downright harassment—is frequent, with around 76 percent of players reporting that they have experienced or practiced such behavior.[11] A player's perceived lack of skill is one of the main reasons for this kind of harassment. Toxic masculinity and sexism are two more themes emerging from the qualitative data.

A study by Jonas Heide Smith highlights two patterns that contribute to uncooperative behavior in multiplayer games even in the absence of direct verbal harassment: cheating and grief. The former means interacting with the game in a way that was not intended by the developers, usually by exploiting a coding error in a way that gives the player an unfair advantage in competing against others. "Grief," by contrast, is gaming jargon for destructive behavior targeted at other players that does not result in any strategic advantage for the player performing it. In a survival game, for example, grief could involve destroying or damaging a structure built by another player just for the sake of bullying them. For Smith, the frequency of cheating and grief in online gameplay places severe limitations on multiplayer collaboration. These behavioral patterns introduce intersubjective tensions and dilemmas that potentially destabilize online communities. Smith understands these destabilizing forces through the lens of the concept of the "tragedy of the commons," first introduced by ecologist Garrett Hardin and later picked up by many economists. In essence, the tragedy has to do with how, if left unregulated, shared resources are bound to be exploited by one individual or group acting out of self-interest. In the case of multiplayer games, of course, resources are rarely finite in an absolute sense: Even if an online world runs out of a particular material, it is always possible to reset or restart the game.[12] The "tragedy" of online gaming thus has more to do with social capital than with resource usage, with harassment, cheating, and grief being the most significant challenges to cooperation and fair competition in multiplayer contexts.

The answer, as Smith highlights, is more regulation—and indeed that is what asynchronous and constrained-communication multiplayer provide. Before I expand on those elements in *Elden Ring*, it is worth stressing that toxic or uncooperative behavior during gameplay frequently translates into unsupportive or hypercompetitive online communities: the "trash talk" that defines multiplayer game experiences spills over into Reddit threads, YouTube comments, and so on. Obviously, the link between in-game behavior and the larger collectives built around games is not always straightforward; but in my case study, *Elden Ring*, there is a clear connection between the two, as we will see in the next section.

11 Another study by Ballard and Welch, also with a focus on massively multiplayer online games and a larger sample size (n = 151), found that 52 percent of the participants experienced cyberbullying.

12 See Alenda Chang's insightful discussion of ecological collapse in video games (chap. 5).

Forms of Community Building in *Elden Ring*

Developed by Japanese company FromSoftware, *Elden Ring* came out in early 2022 to virtually universal acclaim. The continuities between *Elden Ring* and FromSoftware's earlier games, particularly the *Dark Souls* series, are hard to miss. Most of the game's core mechanics are shared with *Dark Souls III*, and while *Elden Ring* takes place in a different universe from the earlier games, players familiar with the series will notice numerous parallels between the two. In both *Dark Souls* games and *Elden Ring*, the player starts out as a lowly everyman condemned to cycles of death and rebirth, a "hollow" (*Dark Souls*) or "tarnished" (*Elden Ring*) creature. The fantasy landscape is desolate and punctuated by impressive cathedrals and castles modeled on European medieval architecture—but often in ruin, as if to signify past glory. We are faced with a world in a grave crisis: In *Dark Souls*, the fire keeping the land alive is about to go out; in *Elden Ring*, the godlike "Greater Will" has been upended by a catastrophic event known as the "Shattering." By advancing through the story and defeating some of the most powerful creatures (known informally as "bosses") of this land, the player-character slowly gains influence.

The narrative of these games is frequently obscure, and the intricate backstories of the main characters are contained in item descriptions, making up a vast body of "lore" that players can ignore or spend a great amount of time dissecting, depending on their inclinations.[13] Environmental storytelling, in Henry Jenkins's phrase, plays an important role, too: In FromSoftware games, stories frequently emerge from the physical layout of the locations explored by the players or from other spatial elements that provide information on the game world and its inhabitants. In any case, reconstructing the games' lore requires significant gap-filling and even speculation, with active members of the FromSoftware community frequently sharing lore "theories" in online settings such as Reddit or YouTube. I will return to these online communities: For now, suffice it to say that, by the end of the game, the player is asked to make a choice whose implications (due to the obscurity of the game world) are not always explicit or easy to follow. What is clear, though, is that the player's final decision shapes the fate of the whole universe: Should the fire or the Greater Will be restored, or should the player's actions usher in a different age, with new gods and ideologies?

Advancing the game to this turning point is not straightforward, either. The gameplay of both the *Dark Souls* series and *Elden Ring* is defined by an unusually high difficulty level. Progressing through the games' areas requires careful planning and repeated attempts, because every enemy can be deadly and knock down the player-character in a few hits. Every time the player dies, they are returned to the

13 "Lore" refers to the backstories of a game world and its characters, as opposed to the narrative that is told by or entangled with the player's actions; see Krzywinska for discussion.

nearest save point, but most of the regular enemies (including those just defeated) are also revived: Effectively, every time the player dies, they must clear an area from scratch. The bosses tend to have large amounts of hit points and can also deal substantial damage, requiring the players to study their attack patterns and chip away at their health pool in extended, nerve-racking encounters. Controversially, FromSoftware games have no difficulty setting, so that players need to put in the time and effort to master the difficulty level intended by the designers. The result is that death is an extremely common event in FromSoftware games, much more so than in comparable action games.

Needless to say, this can prove to be a deeply frustrating experience: YouTube is full of "rage quit" videos with players abandoning a FromSoftware game after failing to beat a boss by just a handful of health points, after countless attempts. In part, the frustration is relieved by the games' focus on community building, which is realized through a number of sophisticated multiplayer systems. While my focus is on asynchronous multiplayer here, it is important to note that *Dark Souls* games and *Elden Ring* feature synchronous multiplayer as well, in which players can share the game world with other players. Like everything else in FromSoftware games, this synchronous multiplayer does not follow the conventions of most multiplayer games. There is no "match-making" menu where we can easily find co-players here, no way of simply inviting a friend to our game world with one mouse click. Instead, synchronous multiplayer involves using a complicated series of in-game items. For example, in *Elden Ring*, an object called "Small Golden Effigy" is required for cooperative multiplayer, whereas the red equivalent is for player-versus-player (PvP). These items can be used anywhere in-game, but activating an effigy near a statue called "Effigy of the Martyr" will increase the chances of summoning another player. If we want to enlist another player to help us fight against a tough boss, we need to consume another item, called "Furlcalling Finger Remedy." None of these items is available from the start of the game: We need to find them through single-player gameplay.

Given these complicated subsystems, one would expect a clear explanation of which item does what, but this is a game that steers away from any form of handholding: Instead, players are left to figure out how the multiplayer mechanics work by themselves—or, more likely, they will need to look up a guide on the Internet.[14] This is the first way in which *Elden Ring* builds a strong connection between in-game experience and a larger community of players: Its gameplay workings and narrative arc so murky that the player is essentially required to use Internet resources to make

14 See also Daniel Vella's ("No Mastery") reading of the first *Dark Souls* game (FromSoftware 2011): "[F]or the majority of time she spends engaging with *Dark Souls*, the player will be acutely aware of the limits of her knowledge in the face of elements or behaviours in the game that the cosmos she has established cannot account for."

the most of the game—and indeed one can find extremely detailed information not just on how multiplayer systems work but also on the location of special items, secret doors or passageways, and so on. Of course, discussion fora and online guides exist for many if not most games; but in the vast majority of these games, a reasonably competent player can get away without using those resources systematically: In *Elden Ring*, by contrast, one is likely to miss a significant number of in-game encounters and experiences without engaging with the community, during gameplay (for instance, through the messaging system discussed below) and on external websites.

Note that the game's inherent difficulty plays a central role in the community. Difficulty here covers every single aspect of the game, from the extreme challenge posed by the boss fights to the intricate narrative universe, where very little is spelled out for the player, and the arcane gameplay mechanics. Virtually all of these dimensions of the game require paying attention to what other players are saying or writing. The result, as I mentioned, is close integration between gameplay and resources that are external to game experience. This integration also leads to a collaborative culture that is unparalleled in other areas of contemporary gaming. In an informal survey I ran on Reddit in September 2022, 42 players were asked: "How would you characterize the Internet community surrounding *Dark Souls* games and *Elden Ring*? Include one or more keywords." Words such as "helpful" or "supportive" were used by twenty of the respondents. Only seven respondents expressed more negative feelings, with some of them complaining about the "elitism" of those who routinely disparage other players' lack of skill.[15] Of course, it is important not to idealize the FromSoftware community, which is afflicted by many of the problems noted in the previous section. But the atmosphere does seem comparatively more supportive than in other games, and that is in no small part due to the complexity of the games' storytelling and ludic mechanics. Moreover, the integration between gameplay and community is deepened by the games' unique asynchronous multiplayer and messaging system, to which I turn in the next two sections, with *Elden Ring* as my main example.

Bloodstains and Ghosts: Asynchronous Play

Elden Ring is unlike most other games in that it does not draw a clear distinction between single-player and multiplayer mode at the level of the interface. Instead, a multiplayer session can only be started within the world of a "solo" playthrough. But the boundary between game modes is also blurred by a number of asynchronous elements, traces or echoes of other players' worlds that are visible, as long as the player is connected to the Internet, even if they are not actively seeking multiplayer

15 I distributed this survey on the subreddits for the three *Dark Souls* games and *Elden Ring*.

experiences. These asynchronous elements fall into two categories: bloodstains and white ghosts. When I enter a new area and notice a large number of bloodstains on the ground, I know that I am about to face a difficult boss or group of enemies. Interacting with the bloodstains shows me how a fellow player died: The player enters my world as a red ghost, immortalized for just a few seconds at the time of their death. Similar to the community-built infrastructure of *Death Stranding*, the process that governs the appearance of bloodstains is algorithmic and inscrutable, but it can provide me with valuable information on how to survive the next encounter. When I find numerous bloodstains near a drop, for example, I know that the fall cannot be survived, and I look for another spot to climb down. More importantly, though, the bloodstains are a tangible trace of the difficulty of the game, they suggest that my struggle with the game's infuriatingly hard bosses is not an exception—not merely the result of my lack of skill—but rather a shared experience.

In addition to these bloodstains, while I am exploring the sprawling world of *Elden Ring* I come across ghostly shapes that move, jump, and fight much in the same way as I do. I am unable to interact with these ghosts directly; in fact, they vanish after a few seconds. It is unclear whether these ghostly sequences are prerecorded from other players' playthroughs or live snippets from another user's gameplay. But the difference is inconsequential, because no direct interaction is possible: I can see the other player, but they cannot see me. As a player on Reddit puts it, "I honestly love the Ghosts, even if it's not in real-time, it makes such a deadly world feel less depressing knowing there are others adventuring alongside you."[16] Another player on the same subreddit explains the ghosts in terms of overlapping temporalities: "you may have failed and someone else took your place in a different instance in the future, as well as those who did it in the past." Just as the game's backstories are arranged in a multitude of temporal planes, these ghosts—the red ones accessed through bloodstains and the white ones that appear on my screen from time to time—evoke a long history of struggles against the game's difficulty: They involve me in a community that, while not physically present while I play, supports my efforts by showing that many others have tried, failed, and presumably succeeded in the end. Even when I am not engaged in online gameplay, the *Elden Ring* community maintains a ghostly, benign presence in my game world. Also important in this respect is that the appearance of other players' ghosts is randomized: Much like the community-built infrastructure of *Death Stranding* or *Journey*'s companions, the ghosts are controlled by an algorithm that remains, largely, inscrutable to the player. This algorithmic unpredictability makes chance encounters even more meaningful and poignant, because it resonates with the game's mysterious atmosphere.[17]

16 See u/Jokerchyld for the entire thread.

17 On the topic of algorithmic unpredictability, see Ed Finn's insightful discussion.

"Praise the Message": Constrained Communication

The messages left by other players on the ground go even further. In *Dark Souls II* (2014), which implemented a similar mechanic, a character asks the avatar early on in the game: "Did you notice any letters on the ground on the way here? These are messages that have jumped the fissures between worlds. [...] If your will to soldier on falters, try leaving a message. Somebody out there is sure to listen." In *Elden Ring*, too, my game world is strewn with glowing markers on the ground or floor of the locations I visit: When I interact with them, a message pops up on my screen. I can rate these messages as "good" or "poor" depending on their usefulness or emotional value. I can leave a message for other players, too, and my health bar is topped up every time another player likes one of my messages. This is asynchronous communication, since there is always a delay between the creation of a message and its appearance in another player's world; whether that happens or not depends (like the ghosts discussed in the previous section) on the game's algorithms. But the messages are also a constrained form of communication, since I cannot type any text but I have to pick from a word list and arrange the terms within a fixed syntax. The templates include "Praise the ...," "Why is it always ...?", or "... ahead," while the word list covers basic actions (attacking, healing, etc.), situations (battle, hiding place, danger, etc.), places (cave, river, etc.), and so on. These constraints ensure full interoperability of the messages across languages, because my text in English will appear in (for example) German or Japanese to those who are playing the German or Japanese version of the game. The constrained nature of the messages limits questionable behavior including hate speech or trash talk directed at other players; but it also poses a creative challenge, in that players are asked to work with the fixed syntax and word list to convey meaning.

Some of these meanings are practical and serve as in-game advice: Just before entering a room, for example, I may come across the message "Group ahead," which tells me that I have to heal up and prepare for a tough fight. Other messages provide clues for some of the game's most difficult puzzles, which would otherwise be difficult to solve without using an online guide or walkthrough (unless the player has hours to spend on trials and errors).[18] Thanks to the messages, I do not need to quit the game and consult Internet resources; I can simply follow the advice provided by other players in-game. Due to the constrained nature of the messages, solving the puzzle will still require some guesswork, because the other players cannot tell me what to do in plain language. Thus, the messages are unlike a step-by-step walkthrough in that they do not completely spoil the pleasure of discovery, they just gently nudge the players towards the solution. Effectively, this system builds into the

18 For an example of how messages can assist with puzzle-solving, see Rebekah Valentine's discussion of a puzzle that requires players to use the "Erudition" gesture.

game world the community advice one would normally find outside of the game it-self, on specialized websites or discussion groups. But it does so in a way that pre-serves immersion and also does not completely take agency away from the player.

Importantly, the messages are not purely utilitarian. On an emotional level, the messaging system contributes to a focused experience in that it makes certain emo-tional evaluations or expressions more likely than others. When I emerge from a difficult boss fight at the end of Stormveil Castle, for instance, I find myself on a hill overlooking a new area called "Liurnia of the Lakes." The view from this clifftop is striking, with rocky outcrops dotting the lakes and the spires of a far-off town shrouded in mist. It would not be far-fetched to see this panorama as a reference to Caspar David Friedrich's quintessentially Romantic painting, *Wanderer above the Sea of Fog*: After all, this game brims with allusions to European art history. While I admire the sublime landscape of Liurnia, I notice a message on the ground which tells me in simple words: "Gorgeous view." This, of course, does not add anything to my technical understanding of the game, but it does enhance my experience of *Elden Ring* through a sense of sharing this sublime feeling with the community—and that is only possible because "gorgeous" is one of the adjectives made available by the developers. In other instances, the intersubjective sharing enabled by the mes-saging system relates to the more grueling aspects of the game. A comment on a YouTube video essay on *Dark Souls* games reads as follows: "You know what makes me happy about these games? When I defeat a boss after hours of trying and I read the messages on the floor saying 'I did it' or 'good job' it makes me feel like I am part of a group that struggled together and made it through."[19] The messages build com-munity in the absence of direct interaction; the loneliness of "solo" gameplay—the countless hours spent learning the patterns of a single enemy—amplifies the emo-tional resonance of these words.

Of course, not all messages are meant in earnest: Some are deliberately mislead-ing ("hidden passage here" where there is no hidden passage), some are humorously self-referential ("by the way, praise the message"). After a boss fight in which we confront our own doppelganger (a "mimic tear"), a player reportedly came across the following message: "didn't expect weak foe, therefore time for introspection."[20] With some experience of the game, even the most bizarre or misleading of these messages become an in-joke, a quip that creates bridges across worlds and players' experiences. Through asynchronous gameplay and constrained communication, *Elden Ring* succeeds in building a community that is supportive both practically and emotionally. Perhaps the conclusion of an *IGN* journalist, Rebekah Valentine, is not too idealized, then: "With a community dedicated to earnest, altruistic information exchange, a lack of feedback for misinformation and trolling, and no real direct way

19 See "How Souls Games Save You."

20 See the subreddit by u/Fabrimuch for this and a number of other examples.

to bother other players who don't want to be bothered, *Elden Ring* has established an information system that can, by and large, be trusted. What other social network can say that in 2022?" (Valentine). In no small part, that success is due to the game's combination of three factors: the complexity of its multiplayer, which weaves together single-player experience and community building; the unpredictability of the algorithms controlling the players' asynchronous interactions, which makes these interactions more meaningful because there is no simple way of knowing when or where we will encounter the ghost of another player; and the game's unusually high difficulty level, which can only be mastered through intersubjective sharing of both information and emotional resources.

Conclusion

In today's digital world, the definition of community straddles real-life intersubjectivity and the possibilities offered by Internet-based communication. This article has offered a case study on community building in the context of multiplayer gameplay, focusing on the affordances of two mechanics that defamiliarize the conventions of online gaming: asynchronous multiplayer, which enables interaction across a spatio-temporal gap, and constrained communication. As Smith argues, multiplayer games are afflicted by a version of the "tragedy of the commons" first theorized by ecologist Garrett Hardin: Selfish behavior is the norm unless there are checks and balances in place that make such behavior costly. In online gameplay, players frequently engage in irresponsible or antisocial actions such as cheating or harassing other players—a trend that mirrors the toxicity of hardcore gaming culture. *Elden Ring* and other games (such as *Death Stranding* and *Journey*) implement mechanics that are aimed at reducing this toxicity and creating a supportive gaming environment. This feat becomes even more remarkable if we consider the inherent difficulty and complexity of *Elden Ring* and other FromSoftware games, which do not spoon-feed the player but rather present them with worlds full of mystery and intricate systems. These are literary games that reward patience and attention to detail.[21]

The more complex the game, the more the community is asked to fill in the gaps by explicating basic mechanics, reconstructing the narrative and its implications and elaborating on the rich mythology or "lore" of these universes. FromSoftware games are thus an example of how a literary level of nuance and sophistication can make it into a popular medium, become highly successful, and create a dedicated player base. This success is due to many factors, of course, but important among

21 In Caracciolo, "Materiality," I capture these features under the rubric of "archaeological" gameplay, with *Elden Ring* as an example.

them are the formal devices that steer players towards certain kinds of interaction: Both the asynchronous multiplayer elements (the ghosts) and the messaging system immerse gamers in an intersubjective world of shared joys and frustrations—a system that tends to discourage irresponsible behavior. It could be argued that From-Software games such as *Elden Ring* provide a "sanitized" experience of collectivity by disrupting direct interaction with other players. However, this reading does not take into account the fact that these games do include a more direct form of multiplayer, in the form of competitive "invasions" or of collaborative, "co-op" gameplay. These interactions contribute to opening up the player's experiences to less constrained forms of collectivity, but they are still oriented (emotionally and ethically) by the devices I highlighted in this article. Further, the player's experience is enriched by the close integration between gameplay and participation in the online practices that surround these games: More than in most other games, the community builds itself around the difficulty and depth of in-game experience, leading to a sense of sharing and belonging that transcends direct engagement with the games. The takeaway here, also beyond the world of gaming, is that more responsible forms of online togetherness can be cultivated through innovative formal design: that is, by adopting strategies that reward collective problem solving rather than individual (and potentially selfish or solipsistic) responses.

Works Cited

Ballard, Mary Elizabeth, and Kelly Marie Welch. "Virtual Warfare: Cyberbullying and Cyber-Victimization in MMOG Play." *Games and Culture*, vol. 12, no. 5, 2017, pp. 466–91, https://doi.org/10.1177/1555412015592473.

Bogost, Ian. *Unit Operations: An Approach to Videogame Criticism*. MIT Press, 2006.

Buckland, Warren, editor. *Puzzle Films: Complex Storytelling in Contemporary Cinema*. Wiley-Blackwell, 2009.

Caracciolo, Marco. *Contemporary Narrative and the Spectrum of Materiality*. De Gruyter, 2023.

—. "Fictional Characters, Transparency, and Experiential Sharing." *Topoi*, vol. 39, 2020, pp. 811–17, https://doi.org/10.1007/s11245-018-9593-x.

—. "Materiality, Nonlinearity, and Interpretive Openness in Contemporary Archaeogames." *Eludamos: Journal for Computer Game Culture*, vol. 13, no. 1, 2022, pp. 29–47, https://doi.org/10.7557/23.6618.

Chang, Alenda Y. *Playing Nature: Ecology in Video Games*. University of Minnesota Press, 2019.

Consalvo, Mia. "Confronting Toxic Gamer Culture: A Challenge for Feminist Game Studies Scholars." *Ada: A Journal of Gender, New Media, and Technology*, vol. 1, 2012, https://www.scinapse.io/papers/130989119. Accessed 15 November 2023.

Ensslin, Astrid. *Literary Gaming*. MIT Press, 2014.

Finn, Ed. *What Algorithms Want: Imagination in the Age of Computing*. MIT Press, 2017.

Fox, Jesse, Michael Gilbert, and Wai Yen Tang. "Player Experiences in a Massively Multiplayer Online Game: A Diary Study of Performance, Motivation, and Social Interaction." *New Media & Society*, vol. 20, no. 11, 2018, pp. 4056–73, https://doi.o rg/10.1177/1461444818767102.

FromSoftware. *Dark Souls II*. Microsoft Windows, 2014.

—. *Dark Souls III*. Microsoft Windows, 2016.

—. *Elden Ring*. Microsoft Windows, 2022.

Frushtick, Russ. "*Death Stranding* Review: Hideo Kojima Tries to Make Fetch Happen." *Polygon*, 1 November 2019, https://www.polygon.com/reviews/2019/11/1 /20942070/death-stranding-review-hideo-kojima-ps4. Accessed 15 November 2023.

Hardin, Garrett. "The Tragedy of the Commons." *Science*, vol. 162, no. 3859, 1968, pp. 1243–48.

"How Souls Games Save You." *Youtube*, uploaded by Daryl Talks Games, 12 March 2022, https://www.youtube.com/watch?v=keIWG6hSD7Q.

Jenkins, Henry. "Game Design as Narrative Architecture." *First Person: New Media as Story, Performance, and Game*, edited by Noah Wardrip-Fruin and Pat Harrigan, MIT Press, 2004, pp. 118–30.

Juul, Jesper. *Handmade Pixels: Independent Video Games and the Quest for Authenticity*. MIT Press, 2019.

Kagen, Melissa. "Walking Simulators, #GamerGate, and the Gender of Wandering." *The Year's Work in Nerds, Wonks, and Neocons*, edited by Jonathan P. Eburne and Benjamin Schreier, Indiana University Press, 2017, pp. 275–300.

Kojima Productions. *Death Stranding*. Microsoft Windows, 2019.

Krzywinska, Tanya. "World Creation and Lore: *World of Warcraft* as Rich Text." *Digital Culture, Play, and Identity: A* World of Warcraft *Reader*, edited by Hilde Corneliussen and Jill Walker Rettberg, MIT Press, 2008, pp. 123–41.

Levine, Caroline. *Forms: Whole, Rhythm, Hierarchy, Network*. Princeton University Press, 2015.

Milota, Megan. "From 'Compelling and Mystical' to 'Makes You Want to Commit Suicide': Quantifying the Spectrum of Online Reader Responses." *Scientific Study of Literature*, vol. 4, no. 2, 2014, pp. 178–95, https://doi.org/10.1075/ssol.4.2.03mil.

Postmes, Tom, and Suzanne Brunsting. "Collective Action in the Age of the Internet: Mass Communication and Online Mobilization." *Social Science Computer Review*, vol. 20, no. 3, 2002, pp. 290–301, https://doi.org/10.1177/089443930202000306.

Reynolds, Matthew. "*Death Stranding* Multiplayer Explained: How Online Structures, Bridge Links, Strand Contracts and Other Connected Features Work." *Eurogamer*, 24 September 2021, https://www.eurogamer.net/death-stranding-mu ltiplayer-6027. Accessed March 12, 2024.

Rubenstein, Michael, Bruce Robbins, and Sophia Beal. "Infrastructuralism: An Introduction." *Modern Fiction Studies*, vol. 61, no. 4, 2015, pp. 575–86, https://doi.or g/10.1353/mfs.2015.0049.

Smith, Jonas Heide. "Tragedies of the Ludic Commons: Understanding Cooperation in Multiplayer Games." *Game Studies*, vol. 7, no. 1, 2007, http://gamestudies.org/ 0701/articles/smith. Accessed 15 November 2023.

thatgamecompany. *Journey*. Microsoft Windows, 2012.

u/Fabrimuch, "Funniest Message." *Reddit*, 2022, https://www.reddit.com/r/Eldenri ng/comments/t581gr/funniest_message/. Accessed 12 March 2024.

u/Jokerchyld, "What Exactly Are Those White Ghosts Running Around." *Reddit*, 2022, https://www.reddit.com/r/Eldenring/comments/t3xk48/what_exactly_a re_those_white_ghosts_running_around/. Accessed 11 March 2024.

Valentine, Rebekah. "*Elden Ring*'s Player Messages Are the Most Fascinating Social Media Platform of 2022." *IGN*, 15 April 2022, https://www.ign.com/artic les/elden-rings-player-messages-fascinating-social-media-platform-2022. Accessed 15 November 2023.

Vella, Daniel. "'It's A-Me/Mario': Playing as a Ludic Character." *Foundations of Digital Games Conference Proceedings*, 2013, pp. 31–38, http://www.fdg2013.org/program /papers/paper05_vella.pdf. Accessed 15 November 2023.

—. "No Mastery Without Mystery: *Dark Souls* and the Ludic Sublime." *Game Studies*, vol. 15, no. 1, 2015, http://gamestudies.org/1501/articles/vella. Accessed 15 November 2023.

Bureaucratic Form and the Future We in Kim Stanley Robinson's *The Ministry for the Future*

Stefanie Mueller

Two protest movements have emerged in Germany in the last few years that raise a central problem when it comes to the politics of climate change: *Fridays for Future* (which originally started in Sweden as *Skolstrejk för klimatet*) and *Die Letzte Generation* (The Last Generation) have taken to the streets because climate change will affect them (the humans currently below the age of 26) and future generations significantly more than those humans currently in power. This conundrum—that those whose future is most immediately concerned by present decisions are excluded from the decision- and policy-making process—is not new, of course, and it begs the question, at least in democratic societies, at what age citizens are mature enough to vote, if maturity is even the right variable. It also draws attention to the fact that political decisions are often geared towards more immediate concerns and goals, rarely going beyond the duration of legislative terms.

In 2005, in an interview with David Brancaccio from PBS, Kurt Vonnegut showed himself desperate about climate change and the U.S. public's apparent state of denial. "The game is over," he vehemently declared and pointed out that the catastrophe had been long in the making. He said, "Look, I'll tell you [...] [o]ne thing that no cabinet has ever had, is a Secretary Of The Future. And there are no plans at all for my grandchildren and my great grandchildren." What Vonnegut was suggesting, in other words, was an institution (a secretary or department) that would propose ideas for issues that required long-term attention and planning, such as climate change. It is precisely this idea that animates Kim Stanley Robinson's novel *The Ministry for the Future* (2020). The novel presents a near-future world in which an international body has been created that is to organize the struggle against climate change more effectively and to represent the interests of future generations. One of its goals is to achieve "legal standing" (35) for unborn citizens so as to afford lawyers the opportunity to represent their interests in courts. From there, the novel quickly opens a wide vista of additional possibilities and tools that governments have at their disposal to combat climate change: from technological and ecological to fiscal and financial. In the course of the novel, the ministry and the head of the ministry, Mary Murphy, pur-

sue many of those possibilities and nudge (indeed, occasionally push) governments to do the same.

But the novel is far from a straight-forward tale of ministerial agendas, let alone a political thriller à la Michael Crichton. Instead, Robinson's novel seems to attempt to tell the stories of as many of the agents involved in climate change as possible, including the elites making decisions as well as the wildlife impacted by them. Indeed, as critics and scholars have noted, the novel is particularly interested in the representation of the many and for this purpose draws on narrative modes that are uncharacteristic of the (realist) novel: "The novel is [...] largely dominated by collective and/or anonymous voices [...], and by non-narrative discourses of knowledge [...], leaving comparatively little room for the everyday life or heroic actions of individuals, for their emotions, ruminations and discussions, that have occupied a large part of the modern novel" (Patoine 147). Building on those observations, I argue that it is precisely through such "non-narrative discourses of knowledge" that the novel represents collectives and seeks to build collective agency. It does so by drawing on a type of discourse that is representative of the organizational form which is at the center of the novel's plot: a bureaucracy. Indeed, I want to suggest that the novel seeks to perform the ministry of which it tells: to provide literary standing for the many, including future generations, and pathways for solutions to the challenges posed by climate change. What I analyze is the way in which the novel achieves this goal: I discuss the specific aesthetic and narrative strategies through which it represents collectives and collective agency, and I argue that a primary and most significant strategy is its use of a bureaucratic register. In the first part of this article, I therefore discuss the various bureaucratic forms employed in the novel and how they afford narrating collectivity as well as how they may build collective agency. In the second part, I briefly consider the effects of drawing on bureaucratic forms to narrate collectivity in the Anthropocene and I come to the conclusion that these forms afford the communication of knowledge about climate change and allow Robinson to create a "transtextual" network that seeks to build extratextual collectives (Johns-Putra 283).

Representing Collectives in the "Anthropocene": Genre, Form, and Bureaucracy

The Ministry for the Future covers about thirty years, from the ministry's creation at the annual Conference of the Parties to the Paris Agreement in 2025 (from COP 29 to COP 58), at which point the novel documents the successes of the vast shift not only in international environmental policies and practices, but truly of what can only be called a series of political and environmental revolutions around the globe. The novel's 106 chapters present different stories, places, groups and individual entities,

with only a few recurrent characters and plot lines. Among the recurrent characters are Mary Murphy, the head of the ministry, and Frank, a U.S. citizen who survives a catastrophic heat wave in India in the novel's first chapter. Their stories soon intertwine and provide the novel with a more traditional narrative and plot, the story of an unlikely friendship. The majority of the novel, however, strives to represent a planetary multitude—humans as well as non-human entities that register and indeed contribute to the political, economic and environmental changes that follow the initial cataclysmic events in India and the creation of the ministry.

The types of collectives that the novel represents range broadly. There are familiar forms of organized collectives, such as the ministry itself as well as states (Sikkim, 231–233), cities (L.A., 275–279, and Hongkong, 513–517), and international bodies such as the COP or the World Economic Forum at Davos, for example. The smaller collectives include refugee camps, teams of scientists, environmental activists, and terrorist groups such as the Children of Kali (see 230). In addition, there are collective and *non-human* entities such as the market (191–192). The novel clearly tries to represent all the spatial scales of planetary existence, from atoms to the sun, and to impress upon its readers the need to abandon the distinction between humans and non-humans in an effort to narrate the full scope of agents involved in the planet's climate system. In a chapter that diagnoses the decrease of the human population around the globe, for example, the reader also learns that birds and other animals are now legally considered subject of rights and possess citizenship status (world citizenship was introduced earlier). In addition to the spatial scales that the novel pays attention to, it also seeks to represent temporal scales as it acknowledges time and again the needs of unborn generations. This is mainly done through the ministry's agenda, of course (i.e., the efforts to achieve legal standing in court), as well as through the comparatively long time span that the novel covers. To put it differently, the novel provides literary standing to a number of entities –individual and collective—some of whom (including refugees and unborn children) presently still lack legal and political standing.

Collectivity is a key issue in the discourse on climate change. Climate change is often framed as a phenomenon that concerns all of humanity because there is only one planet on which humans can thrive, only one planet that they can call home. Hence, the discourse frequently employs the first-person plural pronoun, such as in this passage from the introduction to *The Climate Book* by Greta Thunberg:

> The climate and ecological crisis is the greatest threat that humanity has ever faced. It will no doubt be the issue that will define and shape *our* future everyday life like no other. This is painfully clear. In the last few years, the way *we* see and talk about the crisis has started to shift. But since *we* have wasted so many decades ignoring and downplaying this escalating emergency, *our* societies are still in a state of denial. (my emphasis)

Such claims to collective identity and specifically collective agency have been challenged, however, specifically in the course of the debates over the concept of the "Anthropocene." In particular when it comes to questions of accountability and reparation, critics point out that not all of humankind has contributed nor is contributing equally to carbon emissions and the loss of biodiversity. Much depends on income, as Thunberg notes: "The richest 1 per cent of the world's population are responsible for more than twice as much carbon pollution as the people who make up the poorest half of humanity." While historically, it is industrial Western countries whose carbon emissions have begun to impact the planetary climate long before countries such as India and China started on an accelerated path to catch up. Finally, and perhaps even more crucially, there is the term "human" itself which is problematic. Not only because for much of the twentieth century and in some cases until today, "human" was a category that excluded persons of color or Indigenous ancestry. Similarly, the category has come under some attack from scholars who point out that climate change concerns not only the human species and that non-human actors need to be taken into account. Yet even scholars and critics who acknowledge that there is no unified, homogenous human *we* argue that there is a need for such a collective entity in order for meaningful action to occur. As Dipesh Chakrabarty concludes, "climate change poses for us a question of a human collectivity, an us, pointing to a figure of the universal that escapes our capacity to experience the world. It is more like a universal that arises from a shared sense of a catastrophe. It calls for a global approach to politics without the myth of a global identity, for, unlike a Hegelian universal, it cannot subsume particularities" (222).

Scholars of climate change have often turned to literature as a means to convey knowledge about as well as to move and motivate readers to act against it. The significance of the former becomes apparent when one considers, as does Rob Nixon in the following passage, the example of Michael Crichton's novel *State of Fear*:

> How can environmental activists and storytellers work to counter the potent political, corporate, and even scientific forces invested in immediate self-interest, procrastination, and dissembling? We see such dissembling at work, for instance, in the afterword to Michael Crichton's 2004 environmental conspiracy novel, State of Fear, wherein he argued that we needed twenty more years of data gathering on climate change before any policy decisions could be ventured. Although the National Academy of Sciences had assured former president George W. Bush that humans were indeed causing the earth to warm, Bush shopped around for views that accorded with his own skepticism and found them in a private meeting with Crichton, whom he described as "an expert scientist." (9)

While spreading knowledge and information are still crucial, more recently, scholars and activists have also turned to literature to understand why knowledge and in-

formation, which are readily available today, may not be enough. They have looked to the narratives and other aesthetic forms that afford the representation of climate change's scales, in particular its planetary scope, its long durée and incremental pace, as well as its distributed multitude of agents. Some scholars have made the argument that the contemporary novel, and in particular the contemporary realist novel, is ill-equipped for the representation of climate change's scales. With respect to the representation of the collectives involved in and impacted by climate change, Amitav Ghosh makes the most thought-provoking argument. Acknowledging the writers in the Euro-American realist tradition that have represented collectives, or "'men in the aggregate,'" Ghosh nonetheless maintains that "[i]t is a fact that the contemporary novel has become ever more radically centered on the individual psyche while the collective [...] has receded, both in the cultural and the fictional imagination" (78). For Ghosh, this moment in which novelists abandon narratives and forms of collectivity and collective agency coincides with the Great Acceleration: It is the moment in which modernist writers—animated by ideas of "progress" abandon the writing style of novelists such as John Steinbeck and the moment in which liberalism and post-war politics rigorously focus on the individual in U.S. culture (79).

To some extent, therefore, the representation of collectives and collective agency in a novel such as Kim Stanley Robinson's *The Ministry for the Future* is a question of generic conventions and aesthetic forms. While Robinson has long figured as a writer of science fiction, his recent work, such as *New York 2140* (2017), has been received as realist, and similar claims can be made for *Ministry*. Adeline Johns-Putra, for example, has argued that,

> Robinson's novels, as examples of what Jameson calls the "Science-Fictional" phase of the historical novel, make their political and ethical points through the interplay between *récit* and roman: the morally worthwhile, vividly described actions of empathetic and believable actors are shown to achieve morally desirable and politically effective consequences. (290)

Other critics, such as Patoine, have pointed out the novel's strong reliance on "non-narrative discourses of knowledge" and what may therefore be called its generic hybridity (147). As examples Patoine lists "chapters, that give voice to non-human entities (riddles formulated by the sun, the Earth, a photon, CO_2, history, the market, herd animals, code), or that explain (directly, or through debates in the form of anonymous dialogues) different theories from the humanities and social sciences" (146). Moreover, as the essays in this volume, indeed, the volume in its entirety, try to demonstrate, aesthetic forms do not exist in a realm that is separate from social and cultural issues, but intersect and carry over into the social. This is a position that is most prominently taken by New Formalists such as Caroline Levine and Anna Kornbluh. As Levine explains, "[t]he idea of affordances is valuable for understanding the

aesthetic object as imposing its order among a vast array of designed things, from prison cells to doorknobs. Literary form does not operate outside of the social but works among many organizing principles, all circulating in a world jam-packed with other arrangements" (7).[1] In this sense, I would argue that Robinson's novel demonstrates the potential of narrative forms to afford collectivity and collective agency in an effort to explore and add to our understanding of the potential of social forms to afford them.

If collective agency is understood as a form of concerted action by a group of agents, then the novel actually begins at a moment at which the established procedures and protocols for concerted action on a global level have demonstrably failed. Readers learn that the recent global stocktaking of carbon emissions "didn't go well" (15) and that the subsequent creation of the ministry is a direct response to this failure to reduce carbon emissions. It is a creative interpretation of the Article in the Paris Agreement that allows the creation of new "'Subsidiary Bodies for Implementation of the Agreement.' These subsidiary bodies had previously been understood to mean committees that met only during the annual COP gatherings, but now some delegates argued that given the general failure of the Agreement so far, a new subsidiary body with permanent duties, and the resources to pursue them, was clearly needed to help push the process forward" (15). The lethal heat waves in India, with which the novel begins, add urgency to this sober diagnosis.

On the level of narrative (story), collectives take shape and take action mostly through networks and hierarchies. When the city of Los Angeles is flooded, for ex-

1 For a more detailed discussion of the criticism that the New Formalists and in particular Caroline Levine have received, such as by Eugenie Brinkema, see Alexander Starre's discussion of "Affordance" in this volume. While I agree with Brinkema's view that there is a certain risk in reading form with an eye to its social and political relevance (the handmaid's fate, if not worse), I am ultimately convinced that form is always political. More than Brinkema's critique, it is Dorothy Wang's approach to New Formalism that I find pertinent and indeed political. In "The Future of Poetry Studies," Wang criticizes Levine for her exclusion of writers that have long theorized the relationship between the formal and the social: "[T]here has been a long and substantial tradition of black intellectuals and cultural critics and practitioners who have thought hard and at great length about the inseparability of the formal and the social in the 'real world': Stuart Hall, C. L. R. James, Aimé Césaire, Amiri Baraka, Édouard Glissant, and, more recently, Fred Moten and the Afropessimists, among others. Many of these thinkers did not or do not work inside English departments. By occluding an entire tradition of black thought that has engaged with the problem of form and larger sociopolitical structures, such as those of colonialism and white supremacist racial hierarchies, the 'New Formalism' betrays the telling and endemic provinciality of Anglo-American literary studies" (223). Considering not only Levine but also Brinkema in the light of this observation, the entire debate over the social significance of aesthetics appears as a field struggle (in the sense in which Pierre Bourdieu has coined this term in his work on the literary field) and hence as one that is representative of a white avant-garde position.

ample, a network of citizens with boats emerges that help one another: "Lots of little boats but nothing big and nothing organized" (278). The narrative repeatedly emphasizes the small scale of the impromptu collective: "People shared knowledge," but without working phones, this sharing of knowledge occurs on an individual basis and in part based on people's "local knowledge" (278, 279). It is a crowd, occurring spontaneously, existing for a limited time, and animated by the desire to help and to survive. This network is therefore clearly distinct from the social networks characteristic of pre-flood L.A., and as such they are also characterized as more real. For example, the chapter's homodiegetic narrator exclaims, "I kept thinking This is real, this feels good, why again are you trying to be a fucking actress?" (278). Indeed, at the end, the narrator (a former actress) rejoices at the sight of the destruction of Hollywood's dream factory. The entire episode suggests that local and unmediated connections are more valuable and more beneficial for everyone, and that L.A. would be rebuilt at a much smaller scale.

But the novel does not only value such spontaneous figurations of the multitude, it is also quite invested in more permanent collective structures. The ministry itself is a textbook example of hierarchical organization, with Mary Murphy as its head and primary representative. In the chapters beginning with "Notes for Badim," the reader gets to witness the organization's bureaucratic structures in action. Although some of them record her diplomatic efforts, the notes mostly cover meetings between Mary and experts, department heads and teams, in which Mary seeks information, deliberates with her team, ultimately makes or postpones decisions. The meetings are characteristic of public but also of private organizations, and they are overall characterized by ideal-typical features of bureaucracy, such as neutrality, transparency, and regularity. Which is to say Mary listens to everyone at the table equally, whether she agrees with them or not. Those at the table are frequently experts in their fields, they have no personal stakes in the business at hand, and deliberation processes in the ministry have clear rules which everyone follows. Or do they? Badim is also the person associated with the ministry's black wing, a network of agents (or "friends," as Badim calls them, 110) pursuing the organization's agenda by illegitimate means. Badim explains to Mary that black wings are a common feature of large organization and that she must remain unaware of the details of their doings: "'[P]eople might resign if they knew that their actions were known to higher-ups. Anyway, you might not even know these people, I'm not sure how acquainted you are with your whole staff'" (112). In the case of the ministry for the future, hierarchy and network ultimately support one another as they strive for the same goals albeit by different means and vastly different forms of legitimation. Importantly, however, even though they support one another, their actions are ul-

timately not concerted: Mary remains largely unaware of the black agency's activities.[2]

Given the narrative's staging of the heat waves and the stocktaking as cesurae and its emphasis on the need to find new forms of acting cooperatively and more effectively, readers may be expecting *novel* forms of collective agents. Surprisingly, the two dominant forms in the novel are rather old-school: the ministry and the nation state. In the case of the ministry, the novel demonstrates the efficiency of (albeit ideal-typical) classic bureaucratic and managerial forms working in tandem with a black wing. The ministry is therefore a combination of the most rational and efficient structure for the evaluation and management of information on climate change, enabling its agents to work to the best of their abilities. While the black wing increases the ministry's power through its use of physical violence and thus expands its reach beyond legality.[3]

A similar pattern characterizes the novel's presentation of nation states, in particular in the case of India, which occupies a central role in the novel. Following the heat wave, India's government actually decides that cooperative action on an international policy level is not to their benefit. They decide to break the Paris Agreement and to pursue "solar radiation management action" (18), i.e., the distribution of sulfur dioxide in the atmosphere above India to cloud the sky and thus to lower temperatures. While it is a classic case of unilateralism that is initially presented as potentially endangering global weather patterns, it ultimately proves part of the solution. Even more importantly, India soon witnesses a social and cultural revolution that appears to be initiated by the horror of the heat waves: "Elections were held and the nationalist nativist BJP party was thrown out of office as insufficient to the task, and partly responsible for the disaster, having sold the country to outside interests and

2 While she is therefore not portrayed as the head of the black agency, she does eventually change her mind about violence. Compare her response to Tatiana's assassination.

3 In their conversation, Badim tells Mary that black wings are a frequent element of organizations in general. In fact, indeed, where it pertains to bureaucracy, the element of secrecy is noted by Max Weber: "Every bureaucracy seeks to increase the superiority of the professionally informed by keeping their knowledge and intentions secret. Bureaucratic administration always tends to be an administration of 'secret sessions': in so far as it can, it hides its knowledge and action from criticism [...]" (qtd. in Graeber 195). Largely, however, the operations of the black wing in *Ministry* are not so much due to the bureaucratic subject as they are due to what has been described as a grim turn in Robinson's oeuvre. In *The LA Review of Books*, Gerry Canavan points out that both U.S. pop culture and Robinson's prior works prioritize non-violent solutions to political problems and that Robinson's latest work suggests that those solutions might not suffice this time. "*The Ministry for the Future* takes us to the other side of that surety, asking a question that has typically been forbidden to ask in anything but deeply coded, allegorical, and sublimated terms: What if political violence has a role to play in saving the future? What if you actually can't beat the bastards playing by their rules in the institutions they buy and sell?"

burned coal and trashed the landscape in the pursuit of ever-growing inequality" (25). The novel presents the successes of "[t]he world's biggest democracy, taking a new way," including the abolition of the caste system (25). But as with the ministry, there is a black wing to the nation state, a political faction that calls itself the Children of Kali, that is quite open in its use of physical force to guarantee the well-being of the Indian nation. They "sent a message out to the world: change with us, change now, or suffer the wrath of Kali" (25–26). In both cases, the narrative demonstrates how network and hierarchy support one another, even as the network ultimately dislodges the hierarchy's centralizing effects. That is to say, while Mary is the head of the ministry and thus stands for hierarchical organization, the actions of the network are not controlled by her. The same appears to be true for the relationship between the Indian government and the Children of Kali. As ministry and nation state thus formally become more decentralized, they also appear to become more democratic.

While nation state and ministry may therefore appear as rather old-school than novel forms of collective entities, what is significant is the novel's prioritization of structural over individual agency. As Simone Knewitz points out in her discussion of collective agency in this volume, "Both [Wendy] Brown and Jodi Dean relate the emphasis on individual responsibility to 'neoliberalism's dismantling of social institutions' (Dean, 'Critique or Collectivity?' 173) and see in it not an enhancement, but a squashing of political forms of agency" (25). The novel's emphasis on political and social institutions, whether the ministry, the nation state, or farming cooperatives, is therefore not just a necessity for representation but a nod towards the need for such institutions for the formal affordance of collective agency in the first place.

With institutions and crowds, and multitudinous others in place, how does the novel narrate collective agency itself? I argue that the narration of collective agency in *Ministry for the Future* is achieved by indirection.[4] To put it more bluntly: Readers know that collective agency occurs because the novel reports that stuff happens and there is significant change towards a healthier planet over time. This change includes not only change in terms of increased biodiversity or other environmental factors, but also social change. However, this collective agency is not necessarily *concerted* action. Indeed, as the example of India and Los Angeles show, occasionally the novel suggests that collective agency cannot be scaled up indefinitely. Instead of the concerted action afforded by international protocols and agreements, the novel's broad panorama and polyphonic scope suggest that there are various collectives, some organized and some not, simply acting to the best of their abilities towards remediating the effects of climate change. In this regard, *Ministry*'s organizational landscape is similar to what Rodrigo Nunez has described as a principle of distributed action, which calls for a greater diversity of organizational forms, whether horizontally or

4 See my chapter on James Fenimore Cooper's novel *The Bravo* for a discussion of corporate
 agency as collective agency that is narrated as indirect agency (Mueller 2023).

vertically.[5] Indeed, the novel's point seems to be that there needs to be action in the first place.

In addition to the formal affordances on the level of story (narrative), there are formal affordances on the level of discourse (narration). As I mentioned at the beginning of this article, *The Ministry of the Future* is noteworthy for its generic hybridity: the fact that it draws on narrative registers that are more dominant in factual than fictional narration.[6] In this respect, one of the central, if not the central strategy defining the novel is to represent a broad scope of agents involved in and/or impacted by climate change. On the one hand, the novel attempts to realize this goal through personification and polyphony. In addition to the basic narrative that follows Mary and Frank, the novel therefore presents a great variety of different voices, from refugees to actresses, from millionaires to farmers.[7] In some cases, it uses personification to give voice to non-human (the sun) as well as non-individual agents (the market). In addition to the multiplicity of perspectives, the homodiegetic narrative vignettes often fluctuate between I and We narration, which is to say that an unidentified speaker refers to themselves collectively as well as individually. The Hong Kong chapter, for example, begins, "What did we teach Beijing, you ask? We

5 "Nunes proposes that we move beyond stifling oppositions and recognize that we need different, concurrent forms of organization that mediate between qualities of horizontality and verticality, diversity and unity, centralization and decentralization" (Knewitz 33).

6 I find the distinction between fictional and factual narratives analytically useful, even if these are the poles at each end of a spectrum. The distinction was introduced by Christian Klein and Matías Martinez in *Wirklichkeitserzählungen*, a collection of articles that (as the subtitle explains) focus on areas, forms, and functions of non-literary narratives and narrations. The distinction serves to highlight the fact that non-literary texts, too, draw on aesthetic forms and narrative modes as they represent the extra-textual world.

7 While this variety is impressive, it is also not quite as diverse as critics writing about the novel's "planetary polyphony" are perhaps implying (Patoine 141). The novel focuses on characters and areas in North America and Europe, with people of color mostly in the roles of refugees and climate-change victims. There is a notable absence of Indigenous characters, an absence that seems to be rather typical for cli-fi, as the research of Nicole Seymour and Briggetta Pierrot suggests. In their discussion of Kim Stanley Robinson's *New York 2140*, as well as three other prominent works of cli-fi, Seymour and Pierrot write that "[a]ll but one text explicitly invoke Indigenous peoples only to absent and sometimes even appropriate their experiences and traditions. We argue that these tendencies are neither coincidental nor benign. First, they contribute to a larger status quo wherein 'concepts and narratives of crises, dystopia, and apocalypse obscure and erase [past and] ongoing oppression against Indigenous peoples and other groups.' Further, these erasures suggest that contemporary Indigenous peoples have little to contribute to the processes of confronting or adapting to climate change—which is demonstrably false. Finally, such erasures prevent these cli-fi texts from fully capturing 'the massive temporal and spatial scales on which climatic changes play out,' [...] even as they purport to do exactly that" (95).

taught them a police state doesn't work!" (513).[8] Eventually, the speaker refers to their own perspective and position: "You have to be part of a wave in history. [...] It's a feeling—how can I say it? It's as if everyone in your city becomes a family member [...]" (515). Through such first-hand accounts, as they could be called, the novel seeks to acknowledge and represent the complexity and large scale of the phenomenon of as well as the remedies for climate change. To give an example, chapters 71 to 73 sequentially present notes for Badim that record a meeting about the creation of a new earth-centered religion, an account of the creation of a new habitat corridor in eastern North America, and a summary of modern monetary theory. The chapters are not directly connected, except for the fact that they speak to the costs of climate change as well as to successful remedies. This places a significant burden on readers, who must make these connections themselves and have to become, in a sense, climate-change literate.

This is no coincidence, of course, and indeed is in many ways in tune with the fact that a significant portion of the narrative forms that the novel employs can be considered bureaucratic forms. This includes the meeting notes as well as theoretical introductions and overviews (such as the chapter on monetary theory and a chapter on "Jevons Paradox," for example (165–166) and chapters consisting of testimonies and histories, such as the one providing an account of the state of the Arctic Ocean's ice cover in 2032 (147–149). While Patoine calls those "non-narrative discourses of knowledge," it is more accurate to stress that they are discursive forms that are more characteristic of factual than fictional literatures and that, in addition, they are characteristic of bureaucratic management (Patoine 147). In addition, there are the bureaucratic-managerial practices that dominate the novel: Characters are frequently in meetings and conferences or engaged in (diplomatic) phone calls or correspondences. All of those forms share an emphasis on the ordered communication of knowledge and information, of course; they are frequently used in organizations to make sure that all levels and dimensions of a phenomenon at hand is represented before deliberation begins, whether it is testimonies, historical accounts, or reviews. But bureaucratic forms also tend towards impersonality. After all, the point of a bureaucratic regime is to apply its rules and regulations equally to everyone. This "formalistic impersonality" is one of the central aspects distinguishing bureaucracies from aristocracies (Fry and Raadschelders 40). This tendency towards the impersonal encoded in bureaucratic forms also translates into the novel's frequent use of summary (rather than scene): Many of the chapters present events in summary and hence highly mediated, and even chapters such as the ministry meetings which would lend themselves to scenic presentation and thus to more immedi-

8 Some chapters also employ an unidentified addressee which creates a dialogic form that is very much in keeping with Adeline Johns-Putra's argument that the novel affords a "discursive collective" that includes readers (293).

ate narration are presented in the form of meeting minutes, which is inarguably a rather mediated and diegetic genre.

Ultimately, the argument has been made that the novel's form connects the text to a larger textual universe, specifically, to Kim Stanley Robinson's non-novelistic oeuvre. Johns-Putra even makes the case that the novel's transtextual realism includes the readers as another collective impacted by but also in a position to act against climate change:

> While some of these non-fictional communications provide publicity for the novels, they are not strictly promotional pieces or events, for they are also instalments in an extended Robinsonian philosophy. All Robinson's work in the twenty-first century, when taken as a transtextual whole, resembles a coherent ideological infrastructure. Moreover, readers are incorporated into this structure, to form part of the collective, utopian enterprise that Robinson depicts in his fiction and elaborates on in his media and public appearances. (290)

In a sense, therefore, the novel can be understood to perform the ministry of which it tells: It acknowledges the claims of diverse actors that are often not taken into account in debates over climate change—from slave laborers to refugees, from unborn children to non-human agents—and presents their perspectives to the readers. In this way, it can be said to give literary standing where legal standing is still lacking. Moreover, this polyphony also adds to the novels effort to provide a broad array of paths for action, from the controversial (such as solar radiation management and carbon capture) to the mundane (replacing fossil fuels with renewable energy sources). That it draws in large parts on a bureaucratic register and its impersonal tone makes sense precisely because the collectivities that are represented as well as their strategies are occasionally at odds with one another, and yet the novel seeks to represents them all equally. To do so it requires the bureaucratic register's commitment to neutrality and impersonality. Yet, the side effect of such impersonality is a great degree of narrative distance that not even the novel's sentimental ending can remedy. As ecocritic Nicole Seymour has argued, sentimentality is one of the stereotypical affects on which mainstream environmentalism draws, alongside earnestness, reverence and wonder, for example (see 4–5). Yet, such affects, as research by sociologists and anthropologists such as Kari Norgaard have shown, do not motivate people to act against climate change.[9]

9 Nicole Seymour's *Strange Natures: Futurity, Empathy, and the Queer Ecological Imagination* (2013) also demonstrates to what degree such mainstream environmentalist affective registers are rooted in heteronormative ideas. This is also true for *The Ministry for the Future*, which consistently celebrates heteronormative family values, and concludes with an odd interpretation of the Ganymede myth.

Knowing the Facts, Feeling Collectively

Bureaucracy is not a phenomenon solely of state and state administration, but one also of market capitalism. As Frye and Raadschelders explain, "capitalism and bureaucracy share an emphasis on formalistic impersonality in their relationships. In the market, acts of exchange are oriented toward the commodity, and those acts, Weber asserts, constitute the most impersonal relationship into which humans can enter" (41). The ubiquity of bureaucratic-managerial structures, settings, and indeed practices (accounting, for example) may partly explain the fact that the bureaucratic register has long found its way into Western pop culture. Take film and television, for example: TV series such as *The Office* (2005–2013), *Parks and Recreation* (2009–2015) or *The Good Place* (2016–2020) do not simply employ the workplace-as-family topos but engage explicitly with their bureaucratic-administrative settings; while animated movies such as *Inside Out* (2015) and *Storks* (2016) draw on the bureaucratic register to imagine decidedly non-bureaucratic phenomena, such as a child's emotional life. As scholars have pointed out, such stories offer viewers the pleasure of recognition and inside jokes as they bring their own workplace and consumer experiences to the viewing. In addition, there's actual pleasure to bureaucracies—at least as ideal types. In *The Utopia of Rules*, David Graeber observes that "the experience of operating within a system of formalized rules and regulations, under hierarchies of impersonal officials, actually does hold—for many of us much of the time, for all of us at least some of the time—a kind of covert appeal" (149). To understand this appeal better, but also to better understand the ramifications of Kim Stanley Robinson's use of the bureaucratic register to narrate collective agency in the Anthropocene, let us briefly revisit Max Weber's basic characterization of bureaucratic organizations.

Weber's discussion of bureaucracies in *Economy and Society* is part of his larger work on the question of authority: what types of authority exist and ultimately, why people accept authority in the first place. According to Weber, bureaucracy accompanies mass democracy and is an attempt at levelling the playing field. It is rule by office, rather than by blood, and hence, to some extent, shares with the law the idea of blind-folded neutrality—albeit, in both cases, ideal-typically. According to Weber, the characteristic principles of bureaucracies are that they are rule-bound (whether these rules are administrative rules or laws) and this rule-boundedness defines everything from administrative procedures to the selection of new agents; that they are hierarchical; that those who hold offices separate their professional from their private persona, that they are selected on merit, and that they have received a professional education that qualifies them for their office.

Impersonality is therefore the combined effect of the structural effort to separate position from person that we call bureaucracy. As David Graeber notes, it is this impersonality that has gained bureaucracies the reputation of being "soulless," but as he also points out, soullessness, too, has its appeal.

> In fact, if one really ponders the matter, it's hard to imagine how, even if we do achieve some utopian communal society, some impersonal (dare I say, bureaucratic?) institutions would not still be necessary, and for just this reason. To take one obvious example: languishing on some impersonal lottery system or waiting list for a desperately needed organ transplant might be alienating and distressing, but it's difficult to envision any less impersonal way of allocating a limited pool of hearts or kidneys that would not be immeasurably worse. (152)

Impersonality can therefore be said to be the price we pay for a system that is at least structurally geared towards treating everyone and everything equally. As I noted earlier, however, in the case of *The Ministry for the Future*, this impersonality that is an effect of the bureaucratic forms that dominate the novel's discourse and the effort to represent collectives and collective agency may have disadvantages. Because recent research suggests that acting against climate change is not so much a problem of knowledge as of motivation.

Writing in 2011, Kari Norgaard sums up the widespread assessment at the time that the public needed more information about climate change and that—once informed—they would do something about it:

> Environmental and social scientific communities alike have identified the failure of public response to global warming as a significant quandary. Most existing explanations emphasize lack of information (people don't know enough information; climate science is too complex to follow; or corporate media and climate skeptic campaigns have misled them) or lack of concern (people are just greedy and self-interested or focused on more immediate problems). [...] There is the sense that "if people only knew," they would act differently: that is, drive less, "rise up," and put pressure on the government. (1)

But as Norgaard and other researchers have pointed out, neither is information about climate change hard to come by nor is it—at its base—too complex to understand. Yet, there is a clear failure to "integrate this knowledge into everyday life" (4). Based on her extensive field work in Norway and to some extent in the U.S., Norgaard comes to the conclusion that information about climate change evokes three key emotions in the people she studied in these countries. These emotions are fear, helplessness, and guilt, and evidently none of these are likely to motivate people to act, quite the contrary. Talking to her U.S. students, Norgaard sums up their predicament: "We are overwhelmed because we recognize the enormity of the problem but have no clear sense of what can be done and do not know whether other people also really care, whether the political system is up for the task, and whether their attempt to respond will generate even further problems!" (193) Today, more

than ten years after Norgaard presented her research, *climate anxiety* has become a widely recognized phenomenon.[10]

Whether one feels capable and empowered to do something against the effects of climate change is also a question of whether one feels alone or in solidarity with others. It is, as I pointed out at the beginning of this article, to some extent a question of collective agency. The literary critic Min Song observes that "[w]henever I think about climate change, which is often, I struggle to make sense of its enormity. So much seems to be at stake. Maybe everything" (1). Song describes the feeling of being overwhelmed, of preferring to deal with the mundane everyday instead, and he suggests that it is a problem of collective agency:

> Maybe you feel this way too. [...] If so, why do you and I feel this way? So much of it comes down to the fact that you and I lack strong models of a *shared agency*. Your ability to act in ways that have the intended effects is in doubt. You don't know how to connect with others and find ways to expand what you can do alone, so that you can act in a way that makes a difference. (1–2)

For Song, it is clear that literature can help remedy this problem: It can provide models of "shared agency" and help its readers to develop the skills necessary to enter and contribute to forms of collectivity and collective agency, in particular attention,[11] which is necessary to counter the forms of culturally supported denial that both Song and Norgaard have identified as part of the problem when it comes to effectively addressing climate change. In addition, scholars such as Seymour have argued that the positive emotions elicited by humor, for example, may be much more effective in motivating people. Analyzing works that pursue ironic and irreverent aesthetic strategies to represent climate change, she maintains that

> the works in my archive undercut public negativity toward activism while also questioning basic environmentalist assumptions: that reverence is required for ethical relations to the nonhuman, that knowledge is key to fighting problems like climate change. They suggest that it is possible to 'do' environmentalism

10 Climate anxiety and eco-anxiety are scientifically recognized medical phenomena that are primarily associated with children and young adults. "Although painful and distressing, climate anxiety is rational and does not imply mental illness" (Hickman et al.). Ecocritic Sarah Jaquette Ray describes her experience with her students: "The generation growing up in this age of global warming is not lazy or feigning powerlessness. Instead, they are asking why they should work hard, and to what end. [They are] so frozen by their fears that they are unable to desire—or, yes, even imagine—the future" (2).

11 Norgaard makes this point as well when she defines her use of "denial," and she stresses the cultural patterns of attention to which we are trained.

without the aforementioned affects [i.e. guilt, shame, didactism, prescriptive-
ness, sentimentality, reverence, etc.], and perhaps even without knowledge.
(4)

Kim Stanley Robinson's novel *The Ministry for the Future* contains many models of col-
lectives and many examples of successful collective action. But while it is certainly a
hopeful novel in that it provides clear avenues for action, it is not necessarily a novel
that can address readers affectively, nor address them in ways that makes them *feel*
solidarity as well as a sense of collective agency. The bureaucratic register's tendency
towards impersonality forecloses this important aspect of climate change fiction.
Instead, the novel's strength lies in its suggestion that social institutions such as
bureaucratic organizations, have an important part to play in the struggle against
climate change. By drawing on the bureaucratic register, it prioritizes knowledge
and information about climate change and its attendant effects, such as loss of bio-
diversity, in an effort not only to inform its readers about the complexity of the prob-
lem and possible remedies, but also to portray the heterogenous multitudes that are
impacted by it. As I hope to have shown, the novel thereby provides literary stand-
ing to agents that frequently still lack legal standing and thus to expand its readers
understanding of the persons involved in climate change, of the different pathways
for action that are available to them, as well as the diversity of challenges faced by
different groups.

Works Cited

Canavan, Gerry. "Of Course They Would: On Kim Stanley Robinson's 'The Ministry
 for the Future.'" *The LA Review of Books*, 27 October 2020, https://lareviewofbook
 s.org/article/of-course-they-would-on-kim-stanley-robinsons-the-ministry-f
 or-the-future/. Accessed 25 October 2023.
Chakrabarty, Dipesh. "The Climate of History: Four Theses." *Critical Inquiry*, vol. 35,
 no. 2, 2009, pp. 197–222, https://doi.org/10.1086/596640.
Fry, Brian R., and Jos C.N. Raadschelders. *Mastering Public Administration: From Max
 Weber to Dwight Waldo*. Sage, 2014.
Ghosh, Amitav. *The Great Derangement: Climate Change and the Unthinkable*. University
 of Chicago Press, 2016.
Graeber, David. *The Utopia of Rules: On Technology, Stupidity, and the Secret Joys of Bureau-
 cracy*. Tantor Media, 2018.
Hickman, Caroline, Elizabeth Marks, Panu Pihkala, Susan Clayton, R. Eric
 Lewandowski, and Elouise E. Mayall. "Climate Anxiety in Children and Young
 People and Their Beliefs about Government Responses to Climate Change: A

Global Survey." *Lancet Planet Health*, 2021, no. 5, pp. e863-73, https://doi.org/10.1016/S2542-5196(21)00278-3.

Johns-Putra, Adeline. "Transtextual Realism for the Climatological Collective." *The Cambridge Companion to Literature and Climate*, edited by Adeline Johns-Putra and Kelly Sultzbach, Cambridge University Press, 2022, pp. 283–295.

Klein, Christian, and Matías Martinez, editors. *Wirklichkeitserzählungen: Felder, Formen und Funktionen nicht-literarischen Erzählens*. J.B. Metzler, 2009.

Kornbluh, Anna. *The Order of Forms: Realism, Formalism, and Social Space*. University of Chicago Press, 2019.

Levine, Caroline. *Forms: Whole, Rhythm, Hierarchy, Network*. Princeton University Press, 2015.

Mueller, Stefanie. *The Corporation in the Nineteenth-Century Imagination*. Edinburgh University Press, 2023.

Nixon, Rob. *Slow Violence and the Environmentalism of the Poor*. Harvard University Press, 2013.

Norgaard, Kari. *Living in Denial: Climate Change, Emotions, and Everyday Life*. MIT Press, 2011.

Patoine, Pierre-Louis. "The Realism of Speculative Fiction: Planetary Polyphony and Scale in Kim Stanley Robinson's *The Ministry for the Future*." *Représentations dans le monde anglophone*, vol. 2, 2022, pp. 141–157.

Ray, Sarah Jaquette. *A Field Guide to Climate Anxiety: How to Keep Your Cool on a Warming Planet*. University of California Press, 2020.

Robinson, Kim Stanley. *The Ministry for the Future*. Orbit, 2020.

Seymour, Nicole. *Strange Natures: Futurity, Empathy, and the Queer Ecological Imagination*. University of Illinois Press, 2013.

—. *Bad Environmentalism: Irony and Irreverence in the Ecological Age*. University of Minnesota Press, 2018.

Seymour, Nicole, and Briggeta Pierrot. "Contemporary Cli-Fi and Indigenous Futurisms." *Departures in Critical Qualitative Research*, 15 December 2020, vol. 9, no. 4, pp. 92–113, https://doi.org/10.1525/dcqr.2020.9.4.92.

Song, Min Hyoung. *Climate Lyricism*. Duke University Press, 2022.

Thunberg, Greta, editor. *The Climate Book*. E-book edition, Penguin, 2022.

Vonnegut, Kurt. "Interview with David Brancaccio." *Now on PBS*. Oct. 7, 2005.

Wang, Dorothy. "The Future of Poetry Studies." *The Cambridge Companion to Twenty-First-Century American Poetry*, edited by Timothy Yu, Cambridge University Press, Cambridge, 2021, pp. 220–233.

Weber, Max. *Readings and Commentary on Modernity*, edited by Stephen Kalberg, Blackwell, 2005.

IV. New Forms of Collective Activism

A Re-Invention of Language: War, National Community and a Poetics of the First-Person Plural

Natalya Bekhta

In this essay I explore how, in times of crisis, literary discourse constructs, maintains, and questions the fraught "we" of a nation across a variety of genres. In a well-known argument Benedict Anderson defines nations, these relatively young social formations, as imagined communities and suggests that the two genres particularly adept in the task of imagining such communities have been the novel and the newspaper. For example, when a novel addresses its readers with a "we," it implies an expectation that there exists a (linguistic, ethnic or other) community that can partake in this address.[1] The novel "with its 'prosaics' turned the idea of society based on a common language, traditions, habits, and space into something natural, everyday, and real" (Juvan 383; see also Anderson 27). The link between issues of national definition and literature wanes with the "progressive separation between the literary and political orders" (Casanova 133), but at times of great crisis we can again see it very clearly. Recently, Pascale Casanova has put forward a distinction between "combative literatures" and "pacified or non-engaged ones" (133) to describe the enmeshment of the political and national struggles and the literary-aesthetic concerns in certain historical conditions. In what follows, I rely on her idea of "combative literature" in a narrow sense, to refer to a national literature in times of war.

War obviously changes literary production—as well as the role of the writer in society—and it does so in many ways. One specific aspect, in which I am interested here, is the reactivation of the manifold quest for language: the ability to use pre-war structures and words, the need for new forms of expression that would at least approximately convey the new reality, horrific and incomprehensible at first, and, importantly, the possibility of referring to the imagined and contradictory national community as "we." "Nation" becomes a prominent—actively lived—category of collective identification in times of war. It is, however, difficult to bring this category

1 At the same time, as Jernej Habjan elaborates, the novel has become a global genre with transnational circulation so that the ties between the novel and nation rely on extratexual reality to clarify the meaning of the "we" reference (464).

into literary theory without invoking also the much more suspicious notion of "nationalism." But, as Etienne Balibar reminds us in relation to the Russian-Ukrainian war, "there is no such thing as a 'nation' without nationalism, hence an absolute rejection of nationalism as a reactionary ideology per se is meaningless, unless we decide that the nation-form itself should be rejected." Rather than avoiding these categories, or pretending that world literature and its theory exist only in cosmopolitan circulation (usually in English) and in a world without nation-states, scholars of literature must find ways of coming to terms with the continuing significance of the idea of "nation" in many literatures today, especially those in a combative state.

War is also a more general characteristic of the twenty-first century and a global structuring influence on the aesthetics of literary forms, as, for example, Debjani Ganguly explores. Ganguly singles out three global developments significant for the world-literary aesthetics that occurred after the end of the Cold War and the collapse of the Soviet Union: the global proliferation of war and violence, developments in information technologies, which make distant suffering a feature of everyday life, and, as a consequence, a new humanitarian sensibility (10). These conditions, according to Ganguly, give rise to "a new kind of novel as a global literary form" (1). Selecting representative examples of the new genre, Ganguly, however, omits anything written in "Eastern Europe or the erstwhile Soviet Union" (6) and focuses on an Anglophone context—metropolitan or postcolonial—which, in turn, leads to an omission of distinctive socio-aesthetic questions preoccupying the newly independent postcommunist states, including concerns of national (self)definition.[2] But, as Hrvoje Tutek demonstrates, if the Soviet Union were to be approached as an integral part of our global historical system, then this would reveal the formative influences on the cultural forms, caused by its dissolution, also in literatures outside the socialist bloc (5). This trajectory of influence is usually left unexplored and the literary cultures of what was formerly known as the "Second World" are assumed to follow the patterns visible from the world-literary core—such as those of the global novel. With this in mind, I intend this article to contribute to a larger project of the reconstruction of the "second-world" literatures within the current investigations of collective agency and, more generally, within the world-literary geographies at large.

The "combative" state of the literary field in post-1990s Eastern Europe, arguably, continuously challenges the novel for its cultural authority—even if its international prestige remains undeniable—and makes it compete with other, non-novelised literary forms (Bekhta, "Literatures"). When it comes to genres, in times of a particu-

2 Ganguly's rationale for the omission is that the end of the Cold War has had a lot more repercussions beyond the habitually discussed ones of the capitalist unification of the world and the end of Soviet communism (6). This is a valid point and yet a comparative study including examples from all of the former "Three Worlds" would most likely cast the global novel in a new light.

larly dramatic crisis, the stable narrative structures and the established conventions of the novel arguably start to feel too static; they cannot capture the reality at a break-ing point, in the immediacy of this process. The novelistic representation needs tem-poral distance to its object and the novel's narrative form also imposes a particular set of possibilities and limitations on its material. Narrative, at its most basic, is a form of sense-making and thought that constructs a temporal whole, providing a closure that causally relates its various elements and thus endows them with mean-ing (Walsh 14). This is not to say that the object of narrative interest is necessarily complete, temporally rounded, or finite. But these are features—and side effects—of a specifically narrative mode of comprehension (Walsh). In times of war, the future of any kind of temporal progression is in jeopardy and the social time is radically open-ended in a way that resists narrative closure ("Will there be the next day?"). In times of war, it would seem, poetry, drama, essay and non-narrative genres come to the forefront as more fitting forms of speaking about reality.[3]

In what follows, I will rely on the work of two Ukrainian writers, Serhiy Zhadan and Kateryna Kalytko, and explore the variety of genres in which they write, in order to trace the shape and meaning of the communal "we" of the nation in times of crisis. I construct my argument based on their recent poetry collections, dramas, essays, and interviews. This combination of literary and non-literary discourses will allow me to stay close to how Ukrainian society "thinks itself" (following the method from Alain Badiou, *The Century*), in an attempt to avoid a premature imposition of a certain designation that would arrest the movement of the we-discourse into a static notion (such as a particular notion of "nation"). I approach the problem of communal self-definition—and the overarching theme of this collected volume—via the pronoun "we" since to me it seems that, in contemporary philosophy and political thought, precisely this pronoun offers a form of expression of a utopian desire for an egal-itarian future and formal placeholder for a collective agent that could bring about such a future (see Bekhta, "The Promise").

Absent Pronouns

Before the early morning of the February 24, 2022, when Russia invaded Ukraine in the open (as opposed to, e.g., its unmarked troops in Crimea in 2014), the war had already been going on for eight years in a localized and hybrid mode. Eight years meant, amongst other things, a lot of reflection on how long this war would still continue and what kind of future was in store for Ukraine and its people. Serhiy Zhadan, in his 2020 essay in the collection *The Future We Want* (Kebuladze), asked

3 See also the WReC on the "irrealist" aesthetic of the (semi-)peripheral novel and its anti-nar-rative tendencies.

precisely this question: "What will come after?" (Zhadan, «Що буде потім?» 66). He did not have any ready answers and, in any case, answers from 2020 would hold less validity now. But what is of interest in the context of my article is Zhadan's language:

> We often talk about how everything will be after the war. Except, who do I mean when I say, "we often talk"? Most likely, it's a very subjective and distorted echo of those, with whom you speak. In other words, this phrase doesn't lay claims to objectivity, to being an analysis of social trends and of societal rhetoric. When it comes to this war, what kind of rhetoric does the society have? Does such a joint rhetoric even exist? I don't have a clue. But from time to time, I face this question: How will everything be after the war? [...]
> How would we all (yes, yes, again with the "we") like to see the future of [our] children? (69–70; my translation)

A striking feature of this passage is uncertainty: Seemingly speaking about a widely discussed topic, Zhadan qualifies his every sentence. This uncertainty reflects a new social situation for language: the uncertainty or even suspension of the future in times of an indefinite war. Zhadan is struggling to find the right language not only to speak about the future–a futile speculation, it seems—but to speak on behalf of a national community as community, as a society with a consolidated position on the issues that are vital to its survival. Being a well-known poet, performer, and activist, Zhadan's social standing is an important one and thus there is a lot of weight to his "we," which leads to self-reflection on whether he can indeed speak on behalf of the national community. His "we," Zhadan qualifies, is a reverberation of his interlocutors. It is his interpretation that they share his position and, as with any interpretation, you cannot be absolutely sure how much of it is your own projection.

Normally, any social group contains various internal contradictions but these do not prevent the group members from identifying themselves as members of this particular group.[4] What matters for the cohesion of a social group is a certain baseline of agreement. Where does this baseline lie? Zhadan's uncertainty about the "we"-reference, similarly to other authors in the collection of essays *The Future We Want*,[5] put together by the Ukrainian philosopher Vakhtang Kebuladze, illuminates the tensions gripping Ukrainian society in 2020, in the sixth year of the "small" Russian-Ukrainian war. Zhadan, a native of the Luhansk region himself, has been aware of

4 For my discussion of this issue, on the basis of Cohen, see Bekhta, *We-Narratives*, 30-35.

5 For example, Andrei Kurkov, several pages into his essay, suddenly checks himself: "I have just allowed myself to say 'we', 'us', 'ourselves'. But it would be more honest to switch into singular—'I', 'me', 'myself'. As I said, we are a commonwealth/brotherhood [співдружність] and an 'rival-hood' [співворожість] of all possible and impossible figures-identities of our society, of our state" (109; my translation).

the painful contradictions within Donbas, partly occupied since 2014, where the al-
legiances to Ukraine or Russia or, beyond any nationality, to a local community or
even to local "extralegal" business groups[6] would even divide families, and people
closest to each other would fight on the different sides of the trenches.

But the large-scale Russian attack on Ukraine in 2022 has dramatically redrawn
the way Ukrainians see themselves in terms of group belonging. Judging by the pub-
lic and literary discourse in the tragic year that followed, the new war consolidated
the Ukrainian society to an extent unseen since 1991, the year of independence. While
it is too soon to make any generalizations about the emergence of the new social
agency and a new political identity in Ukraine, in the next section of the article I
consider in more detail the first traces of this change and the possible trajectories
for the development of Ukraine as a collective subject. In this section I stay with the
pre-2022 state of affairs and briefly elaborate the causes of the delayed consolida-
tion. (While my explorations are discourse-based, any discursive operations of the
construction of the national "we" are underpinned by the material conditions of bod-
ies "acting in concert," as Simone Knewitz, referencing Judith Butler, outlines in her
essay in this volume (27). These collective acts range from demonstrations and up-
risings to the physical defence of what is perceived as one's land).

Yulia Yurchenko, dissecting the socio-economic and political transformations
in Ukraine between 1991 and 2014, notes that "the Ukrainian nation as an imag-
ined community was weak when the country became independent and remained as
such until the insurrection of 2013–2014" (20). In their struggle for political power,

6 That allegiance to a certain business fraction would constitute an identity element for a so-
 cial group is significant. Large parts of Luhansk and Dontesk oblasts in Eastern Ukraine lie
 on the Donets Coal Basin (popular shortening: "Donbas"), with coal miners being the largest
 social group in this region. In their 1993 study of the transformations in the working class
 and the miner's movement after the dissolution of the Soviet Union, Vadim Borisov and Si-
 mon Clark make several observations that help contextualize the difficulty of assessing social
 identities in this region. Coal mining in the Ukrainian Donbas begun already within the bor-
 ders of the Russian empire and attracted large numbers of peasant migrants from the central
 governorates of the empire so that in 1993, according to Borisov and Clark, 54 percent of the
 population in Donbas identified themselves as Russian. At the same time, social identity of
 coal miners (the privileged and most numerous fraction of the working class in the region un-
 til the collapse of the Soviet Union) was constructed not so much in national or ethnic terms
 as in opposition to the official ideology of the Soviet Union (39). After the Union's dissolution,
 new categories of the capitalist alternative became defining, such as entrepreneur or busi-
 ness owner (39, 43). This, I should add, would lead to people's allegiances being tied to var-
 ious competing business fractions. The economic and political instability that followed 1991
 created a fruitful ground for criminal businesses and the rise of the so-called "mafia", which
 started to compete with—or even substitute—weakened state institutions. In other words,
 the "nation state" (держава) in Donbas would, in some cases, be a maximally abstract and
 distant phenomenon.

the newly formed capitalist blocs of Dnipropetrovsk and Donetsk business elites re-
lied chiefly on antagonistic methods that would manufacture simplified and ho-
mogenised identity narratives, subsuming various social, religious and linguistic
groups in post-Soviet Ukraine, and pit them against each other (15). The political in-
fluence of the Dnipropetrovsk bloc clearly dominated the period of 1991–1998/1999,
while in 1998/1999-2004 the Donetsk bloc acquired noticeable political leverage. Af-
ter the "short interregnum of 2004–2007" (16), the Donetsk bloc has usurped state
power in 2007–2013/2014. Without any meaningful ideological differences between
the two rival blocs, their competition for political influence had to rely on the in-
creasing "compartmentalization of society, the myths of 'two Ukraines' and each of
them being the other's 'Other'" (17; see also 59). Often framed as ethnic or linguistic
(chiefly, between Ukrainians and Russians), various conflicts in Ukraine have been
"ideational/political, effective and manipulated rather than causal, and [they] can
be interpreted as structural ruptures necessitated by shifts in the balance of power
within and between social blocs, classes and their fractions [...]. The true conflicts are
class formation and accumulation struggles between foreign and domestic capital"
(18), including Russian business stakes in Ukraine.[7]

In short, as a newly independent nation-state with a Soviet legacy, Ukraine's
social, and political contradictions have been inextricably tied to the economic
imperatives of neoliberal capitalism and the accompanying fundamental transfor-
mation of society's foundational institutions. These contradictions, going hand-in-
hand with the manufacturing of the social reality by (domestic and foreign) political
technologists (128–151), preclude any simplified analyses of the social problems
within post-1991 Ukraine as well as of the reasons behind the Russian invasion
(including the Kremlin tale of the "persecution of the Russian speakers").[8] While
the dominant political narratives, both within Ukraine and outside, rely on antag-
onistic simplifications, Ukrainian society itself is multi-ethnic, multi-cultural, and
multi-religious (17; see also Bojcun). And trying to speak on behalf of the Ukrainian
society, as Zhadan attempts to do in 2020, is always a challenging task. As in any
contemporary society.

At the same time, social contradictions notwithstanding, Zhadan's work repeat-
edly makes clear that there's no escaping the "we," however fraught it may seem ("yes,
yes, again with the 'we'"). Moreover, in the circumstances of a "combative" culture,

7 Yurchenko cites a striking example of the continuing imperial ambitions of the post-So-
 viet Russia towards former Soviet republics. When in 2013 the Ukrainian business elites
 started leaning towards the liberalisation of trade with the EU, this aggravated Russia and
 exposed its views on Ukraine as Russian property: "Putin referred to Ukraine's DCFTA ambi-
 tions—among others—as the EU attempt to 'choke' whole sectors of Russian economy that
 he would not accept" (157).

8 For several simultaneously possible ways of defining the current Russian-Ukrainian war, see
 Etienne Balibar.

the work of the poet is to find a fitting modality of expression for the stance of society; to find a suitable language. Themes of silence or of a false "we" of the public debate, which is rather an "I" multiplied by its own reflection, run through all of Zhadan's post-2014 work. Elsewhere I have traced some of the nuances of collective address in his 2018 poetry collection *Антена* [*Antenna*] (Bekhta, "'We'"), which juxtaposed falsities of the public language about society at war with the desired discursive situation, in which there will have to be "difficult questions" and "awkward replies." In other words, the "we proper" will have to be capable of negotiating differences, while remaining consolidated—while remaining a "we." Zhadan's work consistently engages with the problem of togetherness and of the related ability to rely on a common, mutually understandable language for a negotiation of such togetherness.[9]

Besides his poetry, Zhadan's drama *Хлібне перемир'я* [*A Harvest Truce*] offers the most poignant consideration of this problem. Here I will not read the drama in detail, only focus on my central question: What is a Ukrainian "we" in times of war? Published in 2020, *A Harvest Truce* is arranged, significantly, as a conversation amongst people who have known each other their whole lives. For the most part, it is a dialogue but, as Orysia Hrudka aptly describes, "the main thing happens here between the lines: Between a joke and a line full of tragedy, separated in the text only by one full stop; between a line about the trivial and about the vital." Two brothers are the central characters of the drama, a thirty-something Tolik and his older brother Anton. Anton learns about the death of their mother, who lived together with Tolik in their childhood house, and comes back home to help with the funeral. But it is Eastern Ukraine in the summer of 2014 and their house is on the front lines of the bloodiest battles between the Russian and Russian-backed forces and the Ukrainian army. The bridge across the river, connecting their tiny town with the main roads and administrative services in the nearby oblast centre, has been blown-up, phone connection is intermittent and there is no electricity nor running water. Anton manages to get through to the mayor to ask for help with the funeral but, when neighbors come by later, he learns that the mayor has been killed and so there is no more state authority left anywhere in the vicinity. (In a symbolically significant ambiguity, it is not clear whether the mayor has already been dead for a long time.) Several of the female neighbors come to stay for an overnight vigil and one of them, a local activist referred to as Aunt Shura, assumes control over the funeral rituals.

This is the background for the two brothers to try and talk about what has happened—with their lives, with the mother, with the war. But talk they cannot, having been estranged for years. Especially now, when no one is quite certain what is happening and who is fighting on whose side. Anton finds a hidden sniper rifle in the house and confronts Tolik about it but he just shrugs it off. The brothers try reminiscing but the uncomfortable and abusive family past becomes too unbearable, so

9 On togetherness, see Kangaskoski in this volume.

they fight, or drink, or hug and cry. The character interactions and the very form of *A Harvest Truce* dramatize an almost physical inability to talk about the most personal experiences and life choices, as well as the lack of an adequate, socially accepted language for the new, war-torn reality. Let us consider a few excerpts from the drama:

> *Anton*: We'll fix this. What's with the priest?
> *Aunt Shura*: Our priest went to war. Two months ago.
> *Anton*: Who is he fighting for?
> *Aunt Shura*: For the Christian faith. (*Turns to one of the women.*) Let's go!
> *Tolik*: Some Knights of the Crusades you are, fucking hell…
> (Zhadan, *Хлібне перемир'я*, 46)[10]

The short, curt conversations are punctuated by bitter humor and sarcasm so that it is easy to miss the silent unfolding of a heart-breaking tragedy. The drama, very symbolically, locks up all its characters, so familiar to each other and simultaneously so estranged, in one house, with no bridge that would allow them to leave and with wheat fields burning closer and closer. Unwilling to engage with the "difficult questions" and "awkward answers" (dramatized in Zhadan's 2018 poetry collection), they have no escape from their situation; the physical conditions force them to start talking and to look for ways out, for some kind of future and yet—they cannot talk. This is the case, for example, with an extremely difficult question of allegiances:

> *Tolik*: […] Aunt Shura.
> *Aunt Shura*: Yes?
> *Tolik*: So, on whose side you're on?
> *Anton*: Tolik!
> *Tolik*: I'm just curious.
> *Anton*: Tolik, that's enough.
> *Tolik*: What, I'm just asking.
> *Aunt Shura*: I am, Tolik, on the side of stopping these rivers of blood. And so that the church is open again.
> *Tolik*. I see.
> *Everyone sits in silence.* (59)

Much like in 2022, peace becomes an awkward answer—a non-answer—to the straightforward question. With the majority of expert discourse on the future of the Russian-Ukrainian war revolving around the static opposition of "peace"/indefinite

10 All translations from the Ukrainian into English are mine. However, an English translation by Nina Murray of *A Harvest Truce* is forthcoming with the Harvard Library of Ukrainian Literature.

military aid,[11] Balibar provides a much-needed meta-reflection: "I must confess that I have no ready answer. Even worse: in many cases, I fear that these answers do not exist. However, this cannot prevent us from seeking these answers, and before that *finding the correct formulation for the questions themselves*" (my emphasis). It is an anachronistic move to equate the meanings of the word "peace" in 2022 to what it may have meant in 2020. But what unites them is the socio-linguistic situation of the realities of war, when the very conditions for common discourse need to be carefully taken into account and the formulations most fitting the complexity of the dimensions of this war found.

When answers are not available—full or partial, however awkward—and even individual words, such as "peace," require painstaking redefinition, one could start with pronouns. They are also an uncomfortable part of speech in times of war but, as *A Harvest Truce* shows, they contain potential solutions to discursive dead-ends. In Zhadan's drama Tolik, Anton, Shura and others only very reluctantly come to say "us" or "them" as the content of neither of these collective references is clear, in Donbas in the summer of 2014.[12] News are mostly delivered in sentences without sentence subjects, where only the sentence predicate bears a person ending. Significantly, in Ukrainian plural conjugations of the verb do not make it clear, whether the verb without a (pro)noun refers to the first-person plural (we) or to the third (they):

Anton: So here you say: [we/they] went [to fight], then came back. But as far as I can tell, half of ours left, [they] didn't want to stay here, with these ones.[13] (77)

Rinat: [...] (*Addressing Tolik.*) Anyway. One can't go that way. There these ones left, others came. Changed the flags on the commandant's office.
Anton: Changed? And the post office, phone office, train station — whose are they now?
Rinat: Post office? [They] burnt *my* post office. (107; my emphasis)

Pronouns, linguistically speaking, are semantically empty: The meaning of "I" depends on who says it, the meaning of "this" depends on the situation in which it is said. Pronouns, in other words, do not carry semantic meaning but acquire it by

11 How will the large-scale Russian-Ukrainian war end? With peace, since individual wars do not last forever. But how will it be achieved, on what conditions and when? These are the questions that are still not being properly considered, two years into the new war, beyond two unsatisfactory answers: Either Ukraine surrenders to Russia (so that there is "peace"), nor Ukraine is continuously armed to a certain degree so that the war is endless but contained within Ukraine's borders at all costs.

12 For a novel-length consideration of the problem of allegiances, see Tamara Duda's novel *Daughter* [Доця, 2019].

13 «Ось ти кажеш: пішли, потім назад прийшли. А у мене половина наших виїхало, не захотіли тут лишатись, із цими» (Zhadan, *Хлібне перемир'я* 77).

directing attention to the object of reference in a given context (see Bekhta, *We-Narratives* 56, for elaboration). In *A Harvest Truce* this pronominal lack of meaning is particularly visible: Pronouns are the only designation for the warring parties in the drama, so that it is up to the reader to piece together Ukrainian or Russian allegiances of the characters. Which is also part of the point: It is often very difficult, even for the characters themselves, to figure out these allegiances. Working-class people, they often express anger and confusion at having to live in the midst of war, which none of them seems to actively support but, at the same time, in which each of them is somehow implicated. For example, Kolia, a local farmer, whose wife is about to give birth and who allegedly helped the Russian invaders build fortifications, bursts out in desperation: "We're stuck here as if in a mousetrap, and can't leave anywhere. What, is this what I wanted? My harvest is burning, I don't need your politics at all. I don't need to hide, I've done nothing wrong. It's you lot who are being silent, hiding something" (109). The striking directness of the second person address in this passage suddenly breaks through the round-about conversation and confronts the group in the house. It also marks a slow re-surfacing of personal pronouns towards the end of the play. For example, it turns out that Tolik and Rinat, local postman, went to the same school. They look through the school photo album and enumerate all those who haven't survived:

> *Tolik:* [...] Denys. See? Wearing gloves. Goalkeeper. He was killed in the park.
> *Rinat:* Yeah, I know.
> *Tolik:* And do you know, by whom?
> *Rinat:* No, I don't.
> *Tolik:* Yeah you do.
> *Rinat:* How would I know?
> *Tolik:* Everyone knows. Our own killed him. (117–118)

> *Aunt Shura:* You know, Rinat, there were other things you weren't taught at school. Like blowing up bridges. Burning the fields. But you are burning them.
> *Rinat:* Who, me?
> *Aunt Shura:* You, who else.
> *Rinat:* Me?
> *Tolik:* You. We... Us, who else?
> *Rinat:* What's up with you, Tokh?
> *Tolik:* What's up, what's up. You know everything yourself. We all know everything. Just won't say it. [...] (122)

The appearance of personal pronouns of collective reference in character speech towards the end of the drama is stylistically marked—these lines stick out from the character's idiom and are clearly the author's own voice, a certain deus-ex-machina move that introduces a hopeful note into an otherwise desperate discursive situa-

tion. This move may break literary conventions but, within the larger socio-linguistic situation of a stalled public debate and the lack of appropriate language for devising a collective future, Zhadan's intervention into his characters' speech shows how a strikingly small adjustment—a straightforward use of personal pronouns—can create a big shift towards mutual understanding. This linguistic experiment, if I may call it so, shows an opening for a difficult conversation about which collective identity mobilizes this group—and which identity mobilized Donbas in 2014 and why—and this is also an opening onto a collective site of overcoming of the divisive social myths, manufactured by the political technologists in the course of Ukraine's independence, amplified by the scandal-hunting media and reinforced on social media. In *A Harvest Truce*, however, there are no easy answers. Zhadan offers a brief glimpse of how a change in pronominal reference makes it possible for a group of alienated people to find an agreement—all of the characters, except Tolik, decide to leave the house. But they come back almost immediately and lock the doors, first locking themselves in the house in the middle of burning fields, and then locking themselves in the room with the dead mother. A grim finale.

Pronouns That Became Verbs

Russia's large-scale invasion of Ukraine started at 3:40 a.m. on February 24, 2022 across all of the 1,974 kilometers of the joint land border and through the 1,084 kilometers of the Belarus border, not to mention attacks from the sea and air. This invasion changed things swiftly and dramatically within the Ukrainian society and, in the year that followed, it also increased social consolidation.[14] Coming back to the category of "nation," it is now possible, together with Balibar, to envisage "an 'optimistic' scenario linked to the character of the current patriotic resistance, which suggests that Ukraine and its *ideal identity* is moving from an 'ethnic nation' in the direction of a 'civic nation', or a prevalence of the *demos* over the *ethnos*" (Balibar; emphasis in original). The primary sign of optimism for Balibar is "the remarkable fact that—contrary to the expectations of the invader the two 'linguistic communities' existing in Ukraine […] have joined forces in the patriotic resistance and identified with the idea of an independent Ukrainian nation-state." This joint resistance has indeed been multicultural and *multilingual*—more so than the implied reference only to the Russian-speaking Ukrainians would suggest (see, e.g., Aliev). And, while civic national transformation is far from complete or certain, at this point it registers also

14 Registered, e.g., by the surveys of the Ukrainian NGO "Centre for Society Research" (Bobrova et al.), conducted soon after the Russian invasion, then at three, six and at nine months of the ongoing war.

on the level of language. In this section of the article, I will focus on the same question as above, what a Ukrainian "we" is in times of war, but in the new, post-2022 context.

Kateryna Kalytko's poetry collection *Люди з дієсловами* [*People with Verbs*] was already in production when the large-scale war broke out and her finished manuscript fell apart—a sign of very tangible ties between literature and its social context. As Kalytko describes in her interviews, the collection was subsequently stitched together with new texts, some of them raw, impulsive and "skinless," and published in this updated shape («Люди»). Kalytko shares her understanding of poetry with Zhadan: According to Kalytko, the important work of the poet in times of war is to speak despite the feelings of being helpless and lost for words. The poems in *People with Verbs* are punctuated by uncertainty and meta-poetic questions ("I do not know how to speak. And what for these poems are," 24; "I asked you if it was prudent to write poetry now," 24; "Wherefrom do these poems come?," 30). But the poet continues speaking: It is an important service to the rest of the society, which needs new language to come to terms with the new reality ("We are to re-invent the words, later," 25). In Kalytko's own words, poetry comes to the forefront of language, crippled by war, as "the space of ultimate honesty and humanness, where one refuses to accept the utter helplessness of language" («Люди»).

If we compare the distribution of pronouns in Zhadan's 2020 *A Harvest Truce*, with the linguistic situation Kalytko observes in the immediate aftermath of the 2022 war, the changes are striking. What Zhadan's work registered in the public discourse was the vagueness of demonstrative pronouns used in place of personal ones, the sematic emptiness of the personal pronouns and, finally their absence. Kalytko's poems clearly mark the change that 2022 has brought about: There is no future and no certain answers still, but there is an absolute clarity about the meaning that fills the national "we" and there is a refusal to speak only in private, with the mirror, refusal to compromise and accept comfortable but false answers. One of Kalytko's poems in the collection, «Особистий займенник» ["Personal Pronoun," 15–16], offers an elaboration on the new linguistic and, specifically, pronominal situation.

Nouns are worthless without verbs, says Kalytko in the description of *People with Verbs*. One has to think that pronouns are right there with the nouns, worthless on their own. They need verbs—which is to say, they are defined through action (rather than through context, as linguistic theories would have it). The poem "Personal Pronoun" is divided into eleven stanzas, with the shortest ones comprising only one or two lines. Pronouns and their meanings change with each stanza, as each stanza also brings about a shift in spatio-temporal coordinates. I shall quote the poem in full, having numbered the stanzas, alongside my own rough translation:

Особовий займенник

[1]

Прийде час подякувати, що сталася доля така
і що ми віддавали одне одному більше,
ніж насправді могли. Що тримали землю в
руках
серед попелу і гнилого м'яса, дати і дні згу-
бивши.

[2]

Я любила Європу наприпочатку весни,
цей залитий сонцем порядок, шляхетний
присмак усталеності.

[3]

Я могла би приїхати і лишитися.

[4]

Ось тільки залізна нитка,
що за мною тягнеться, на шматки розітне
міста.

[5]

Я й скучаю за часом, коли не любила його,
не відгадувала модуляцій голосу, не думала
взагалі,
не ходила туди, де щем і високий вогонь.
Та велика історія шкіриться, і зуби у неї гнилі,
і різець її — у вузлуватих пальцях.
А у нього потріскані губи і довгі вії.
Він сміється.
Різець здіймається, опускається.
Отже, це зі мною, ще раз.

[6]

Тепер ніде не спокійно.

[7]

Вже за місяць війни забувається, як раніше
було.
Я тепер не поетка, я глина у печі горя.

Personal Pronoun

[1]

Time will come to thank for the fate that
happened
and that we gave each other more
than we actually could. That [we] held this
soil in hands amidst ashes and rotting meat,
having lost dates and days.

[2]

I used to love Europe at the very beginning
of spring,
this sun-drenched order, this noble after-
taste of stability.

[3]

I could have come here and stayed.

[4]

Except the iron thread,
which unravels behind me, will slice the
cities into pieces.

[5]

I even miss the time when I didn't love him,
when I didn't guess the modulations of the
voice, didn't think at all,
didn't go there, where there is anguish and
tall fire.
But big history is sneering, and her teeth are
rotten,
and the cutting tool bit of hers is in the
arthritic fingers.
And his lips are cracked and eyelashes are
long.
He is laughing.
The cutting tool lifts, it lowers down.
So, this is happening to me, once more.

[6]

Now nowhere is calm.

[7]

Already one month into a war one forgets
how it used to be.
I am not a poet anymore, I am clay in the
oven of grief.

І не вірш це, а коридор, пробитий крізь безго-
лосся,
це ось, чуєте, він сміється у коридорі.

[8]
Прийде час подякувати, що все сталося саме
так,
що була безладна ніжність розмов
між сиренами, попід градами.

[9]
Уві сні він стріпується, як накритий хусткою
птах, —
я не вмію більше молитися, тому отаке прига-
дую.

[10]
Очі наших двохсотих. Обвуглені прапори.
Дикі гуси вертаються з вирію.
Річки у кривавій піні.

[11]
Ні минулого, ні майбутнього поки ще.
І я прошу лише: говори,
хай ця мова не зникне.
Хай вона буде
спільною.

And this is not a poem, it's a corridor, broken
through voicelessness,
and this here, listen [pl.], it's him laughing in
the corridor.

[8]
Time will come to thank that everything
happened exactly this way,
that there was a disorderly tenderness of
conversations
in-between the sirens, under the Grad rock-
ets.

[9]
In his sleep he twitches, like a bird covered
by a cloth, -
I don't know how to pray any longer, that's
why I recall such things.

[10]
Eyes of our KIAs. Charred flags.
Wild geese are coming back after winter.
Rivers foam with blood.

[11]
No past and no future, not yet.
And I ask only: speak [sing.],
may this language not disappear.
May it be
communal.

The contemporary poem, Alain Badiou observes, is "the opposite of mimesis" (*The Age* 51). It identifies itself as an "experience of thought" (29). How do we then approach the metaphorical language of Kalytko's poem? When the poet says, for example, that "[we] held this soil in hands amidst ashes and rotting meat, having lost dates and days" («тримали землю в руках серед попелу і гнилого м'яса, дати і дні згубивши»), it is not merely a loftier way of saying that we were defending our land selflessly. To "defend selflessly" is a phrase that does not mean much to anyone outside that situation. The notions it evokes become too abstract too quickly: Do you ever think of the soil underneath your feet, your house, your city and so on as your country? Saying "to defend the land selflessly" does not carry a matching meaning for those outside and those inside the situation, where there is the need to actually, physically defend what used to be a symbolic idea ("one's land"), not to yield, not to move away under the pressure of deadly force from the soil on which you stand. And, more than that, to experience this resistance on a scale of the whole national community, on a collective rather than individual level. National community, as the

reader will remember, is an *imagined* community,[15] which, in the midst of war, suddenly becomes material and physical. This is why the poem offers the concrete language of "holding the soil in hands," in which the material embodiment of the action of defense is strengthened by an evocation of senses: ashes from the burning cities in your throat and eyes, and in the nose—the stench of corpses rotting in the yards, in the bomb shelters you are in, in the trenches, which you are still holding. The numbness of the mind in the situation where the past life is already destroyed but the future one cannot be thought of or imagined (yet?). The result of the poem's thought process is a renewal of language so that this language can speak truthfully in the new, war-torn reality.

Against the background of the first stanza, concerned with the real, the next stanza offers a seemingly out-of-place, idealized image of Europe: "this sun-drenched order, this noble aftertaste of stability." This is Europe in the eyes of a traveler going on a spring vacation. The image further defines the contrast between the old and new realities, when neither order nor vacations are possible. Not even movement as a refugee, as stanzas [3]-[4] clarify, because the imperceptible but iron-strong ties to one's own land, to its people will make an absence physically felt, both in the one who leaves and in the place left behind ("the iron thread, // which unravels behind me, will slice the cities into pieces").[16] Significantly, the deictic coordinates of the stanza [3] places the "I" of the poem right within Europe. Europe is not a distant, promised land—it also contains a war-ravaged country, so unfitting into its idealized (self-)image.

But to come back to pronouns: The first stanza [1] is defined by "we" and by time-lessness («дати і дні згубивши», "having lost dates and days"). Mentioned only once, "we" is present in this stanza through the verbs, conjugated in the first-person plural. The next three stanzas are marked by "I," in the past [2], in a hypothetical present [3], and in the actual present [4] which transfers to stanza [5], where the "I" unites with "him". Who is "he"? Someone "I" loves and someone emblematic of the new time, this perpetual present. Consider the stark contrast with which "he," youthful, laughing, weary, is positioned against the old "big history," with her rotten teeth, arthritic fingers and a sneer. This is the past, which repeats itself ("So, this is happening to me, once more") and which makes a sharp cut between the previous life and the current one. But this repetition of the past is not the abstract phrase of "history repeats

15 As Benedict Anderson put it, "the members of even the smallest nation will never know most of their fellow-members, meet them, or even hear of them, yet in the minds of each lives the image of their communion" (6).

16 This line captures the need for many Ukrainians, who lived abroad before February 2022, to go back home and to take up arms (see, e.g., the story of the Ukrainian dental surgeon in Austria, Natalia Fauscher [Ivanov and Zhykalova]).

itself." It is happening to the "I," something she has lived through already once before (the 2014 war?) and thus, again, a concrete, material experience born by a living person.

Stanza [5] also marks the biggest intensity of feeling in the poem. It is the poem's personal center, the so-called zero-point in the deictic system of coordinates, which the personal pronoun "I" (as well as "now" and "here") occupies and against which the other pronouns and deictic elements of language acquire their meaning. «Отже, це зі мною, ще раз», "So, this is happening to me, once more." After this statement, the "I" is not alone anymore, implicitly relying on the "we"-community, whose presence is coded even into the impersonal sentence structures. (Stanza [8], for example, repeats the formulation of the opening stanza [1], defined by the first-person plural.) What is striking about the "we"-address here—and what exemplifies particularly well the new, consolidated collective identification of the Ukrainian society as a clearly defined group—is, paradoxically, its occasional appearance, its mostly implied and unspoken presence. Mentioned only once directly, the "we" of this poem marks the conjugation of the verbs, marks the structure of address (as in the plural "listen [first-p. pl.], it's him laughing in the corridor"), it appears as a possessive pronoun in the tragic and tender phrase, "Eyes of *our* KIAs." The "we" of Kalytko's "Personal Pronoun" does not need to rely on constant repetitions (that only foreground the absence of "we proper"). This new "we" is certain of its existence. While Zhadan registers a self-dissociation in the Ukrainian "we," before 2022, in Kalytko's work we begin to find a near-equivalence[17] between the "I" and the "we," their mutual certainty.

My intuition about the change in the social meaning of the we-reference in Ukraine after February 2022 can be confirmed by briefly turning to a meta-linguistic reflection again. The excerpt cited below comes from Zhadan's speech at the 2022 Frankfurt Book Fair, where he received the prestigious German Book Trade Peace Prize. Talking about Ukraine's future now, Zhadan's words do not have any uncertainty of his 2020 essay. Compare the following passage with the one quoted at the beginning of this article:

> One way or another, we will need to again reconstruct a sense of time, a sense of prospects, a sense of continuity. We are doomed to have a future, moreover—we are responsible for it. The future is being formed right now from our visions, from our opinions, from our readiness to take responsibility. [...] We are all joined by our language. And even if at some points its possibilities seem limited to us and insufficient, one way or another we will be forced to return to these possibilities of language, which give us hope that in the future there will be nothing unsaid

17 I borrow this phrase from Badiou's analysis of the relationship between the "I" and the "we" in another poetic context (*The Century* 90).

and no misunderstandings between us. [...] For as long as we have our language we also have at least an ephemeral chance to explain ourselves, to talk through our truth, to bring order into our memory. So let's talk, let us talk.

Kalytko's poem culminates in the same imperative: "No past and no future, not yet. / And I ask only: speak [sing.], / may this language not disappear. / May it be / communal" (16). This gradual arrival at the communal language in "Personal Pronoun" is in line with Kalytko's more general observation, present throughout her collection, of how one of the immediate effects of war on language is an inability to simply speak, caused by the break-down in the usual sense- and meaning-making mechanisms. So to start uttering words again is the first step towards regaining the communal ability to use language, again. The concluding word of Kalytko's poem, «спільний» (which can be rendered into English most closely as "communal," "common," "joint") leaves no doubts about the newly found togetherness. To fully understand its significance, let us in conclusion consider the temporality that develops throughout the poem. Stanza [7] is key in this respect, offering a direct comment on the linguistic situation, in which the poem was written: «не вірш це, а коридор, пробитий крізь безголосся, // це ось, чуєте, він сміється у коридорі» ("this is not a poem, it's a corridor, broken through voicelessness, // and this here, listen [pl.], it's him laughing in the corridor"). This poem is to be understood as a break through the lack of voice, the lack of language, but where to? It would seem that the poem offers an escapist timespace, alternative to the present, or even a nostalgic longing for the past, when it was possible for "him" to laugh. But this would be a misreading: What is significant is that the poem should function as a corridor (a passage leading from and towards) rather than a static spatial image. This poem is thus an opening onto a trajectory towards a communal future, a possibility parallel to the present and capable of actualization. And the way forward is through speech, through a thorough attention to language and through a painstaking work of finding the correct formulations for our problems first, before looking for their answers.

Works Cited

Aliev, Alim. "National Communities of Ukraine in the War against Russia." *Ukraïner*, 26 December 2022. https://ukrainer.net/national-communities-in-the-war/. Accessed 21 November 2023.

Anderson, Benedict. *Imagined Communities: Reflections on the Origin and Spread of Nationalism*. Revised edition, Verso, 2016.

Badiou, Alain. *The Age of the Poets and Other Writings on Twentieth-Century Poetry and Prose*. Verso, 2014.

—. *The Century*, translated, with a commentary and notes, by Albeto Toscano, Polity, 2008.

Balibar, Etienne. "In the War: Nationalism, Imperialism, Cosmopolitics." *Спільне / Commons*, 29 June 2022, https://commons.com.ua/en/etienne-balibar-on-russo -ukrainian-war/. Accessed 21 November 2023.

Bekhta, Natalya. *We-Narratives: Collective Storytelling in Contemporary Fiction*. Ohio State University Press, 2020.

—. "'We' and the Language of War: On the Poetry of Serhiy Zhadan." *Style*, vol. 54, no. 1, 2020, pp. 62–73, https://doi.org/10.5325/style.54.1.0062.

—. "The Promise and Challenges of 'We': First-Person Plural Discourses across Genres." *Style*, vol. 54, no. 1, 2020, pp. 1–6, https://doi.org/10.5325/style.54.1.0001.

—. "Literatures of the Former 'Second World' and the Current Theories of World Literature: A Conceptual Challenge." *New Conjunctures and Directions in Literary and Cultural Studies*, edited by Ansgar Nünning and Magdalena Pfalzgraf, Narr, forthcoming.

Bobrova, Anastasia, Yulia Nazarenko, Natalia Lomonosova, Olena Sybru, and Yelyzaveta Hassai. «Дев'ять місяців повномасштабної війни в Україні: думки, переживання, дії» ["Nine Months of Full-scale War in Ukraine: Thoughts, Concerns, Actions"]. *Cedos*, 16 March 202,. https://cedos.org.ua/rese arches/devyat-misyacziv-povnomasshtabnoyi-vijny-v-ukrayini-dumky-perez hyvannya-diyi/. Accessed 14 March 2024.

Bojcun, Marko. "Where is Ukraine?: Civilization and Ukraine's Identity." *Problems of Post-Communism*, vol. 48, no. 5, 2001, pp. 42–51.

Borisov, Vadim and Simon Clark. «Реформа і революція в комуністичному заповіднику» ["Reform and Revolution in the Communist Reservation"]. *20 років капіталізму в Україні. Історія однієї ілюзії* [*20 Years of Capitalism in Ukraine: A History of One Illusion*], edited by Kyrylo Tkachenko, Art Knyha, 2015, pp. 26–33.

Casanova, Pascale. "Combative Literatures." *New Left Review*, vol. 72, 2011, pp. 123–134.

Cohen, Anthony P. *Symbolic Construction of Community*. Routledge, 1985.

Duda, Tamara. *Daughter*, translated by Daisy Gibbons, Mosaic Press, 2021.

Ganguly, Debjani. *This Thing Called the World: The Contemporary Novel as Global Form*. Duke University Press, 2016.

Habjan, Jernej. "Novel Fiction, Newspaper Reality." *Neohelicon*, vol. 43, no. 2, 2016, pp. 461–471. https://doi.org/10.1007/s11059-016-0356-7.

Hrudka, Orysia. «Хлібне перемир'я: п'єса» [*"A Harvest Truce: A Play"*]. *Krytyka*, October 2021, pp. 7–8, https://krytyka.com/ua/reviews/xlibne-peremyria-piesa. Accessed 21 November 2023.

Ivanov, Pavlo and Olena Zhykalova. «Загиблій парамедикині з Кропивницького присвятили автобус для евакуації поранених» ["An Evacuation Bus for the Wounded is Named after the Deceased Paramedic from Kropyvnytskyi"].

Suspilne: Novyny, 26 December 2022, https://suspilne.media/346688-zagiblij-pa ramedikini-z-kropivnickogo-prisvatili-avtobus-dla-evakuacii-poranenih/. Accessed 21 November 2023.

Juvan, Marko. "The Nation between the Epic and the Novel: France Prešeren's The Baptism on the Savica as a Compromise 'World Text.'" *Canadian Review of Comparative Literature/Revue Canadienne de Littérature Comparée*, vol. 42, no. 4, 2015, pp. 382–395.

Kalytko, Kateryna. *Люди з дієсловами [People with Verbs]*. Meridian Chernowitz, 2022.

Kebuladze, Vakhtang, editor. *Майбутнє, Якого Ми Прагнемо [The Future We Want]*. Tempora, 2020.

Kurkov, Andriy. «Про майбутнє і користь англійської граматики» ["About the Future and Usefulness of the English Grammar"]. *Майбутнє, Якого Ми Прагнемо [The Future We Want]*, edited by Vakhtang Kebuladze, Tempora, 2020, pp. 103–20.

«Люди з дієсловами»: виходить нова збірка віршів Катерини Калитко—про війну, довіру і пам'ять» ["'People with Verbs': Kalytko's New Poetry Collection Is Out—On War, Trust and Memory"]. *Meridian Czernowitz*, August 2022. https://www.meridiancz.com/blog/liudy-z-diieslovamy-vykhodyt -nova-zbirka-virshiv-kateryny-kalytko-pro-viynu-doviru-i-pam-iat/. Accessed 21 November 2023.

Tutek, Hrvoje. *Social Imaginary and Narrative Form under Global Post-Socialism: Dubravka Ugrešić, Cormac McCarthy, Roberto Bolaño*. Doctoral Thesis, Ludwig-Maximilians-Universität München, 2022.

Walsh, Richard. "Narrative Theory for Complexity Scientists." *Narrating Complexity*, edited by Richard Walsh and Susan Stepney, Springer, 2018, pp. 11–25.

WReC (Warwick Research Collective). *Combined and Uneven Development: Towards a New Theory of World-Literature*. Liverpool University Press, 2015.

Yurchenko, Yulia. *Ukraine and the Empire of Capital: From Marketisation to Armed Conflict*. Pluto Press, 2018.

Zhadan, Serhiy. *Антена [Antenna]*. Meridian Chernowitz, 2018.

—. «Що буде потім?» ["What Will Come After?"]. *Майбутнє, Якого Ми Прагнемо [The Future We Want]*, edited by Vakhtang Kebuladze. Tempora, 2020, pp. 65–82.

—. *Хлібне перемир'я [A harvest truce]*. Meridian Chernowitz, 2020.

—. «Хай це буде текст не про війну» ["May This Text Be Not about War"]. Speech at the 2022 Frankfurt Book Fair, *Chytomo*, 23 October 2022, https://chytomo.com/ serhij-zhadan-khaj-tse-bude-tekst-ne-pro-vijnu/ Accessed 21 November 2023.

From "Feminist Lies" to "White Replacement": Digital Anti-Feminist Forums as Spaces of Collective Radicalization

Katharina Motyl[1]

Introduction

Most readers will associate the group Proud Boys with white nationalism: The "far-right extremist organization" (Mapping Militants Project) gained notoriety due to its participation in the storming of the U.S. Capitol on January 6, 2021.[2] The group first received mainstream attention in one of the presidential TV debates in 2020; when then-President Trump was asked whether he wanted to distance himself from white supremacist groups such as the Proud Boys, Trump answered by telling the group to "stand back and stand by" (Collins and Zadrozny). It is less well-known that the exclusively male group and their Canadian founder Gavin McInnes actually have their roots in anti-feminism. McInnes has stated that he founded the Proud Boys in response to the (alleged) feminist "war on masculinity" (Hall). In his online videocast *The Gavin McInnes Show* (2015–2017), the pundit regularly disparaged feminism while venerating heterosexual marriage and traditional gender roles (Nagle 95–96).[3]

In their ideological trajectory from anti-feminism to white nationalism, the Proud Boys are far from unique. In fact, as I argue in this paper, digital anti-fem-

1 I wish to acknowledge the crucial role Simon Strick's insights have played in my research on anti-feminism, which he published in his groundbreaking study Rechte Gefühle and continuously shared with me in conversations.

2 Of the 1,265 individuals who have, according to the U.S. Department of Justice, been charged or already sentenced due to their involvement in the attack on the U.S. Capitol as of January 2024 (Department of Justice), several are affiliated with the Proud Boys. Most prominently, Enrique Tarrio, former Chairman of the Proud Boys, was tried in court for his involvement in orchestrating this far-right attack on the epicenter of U.S. democracy and sentenced to 22 years in prison for seditious conspiracy in September 2023 (Wendling).

3 Angela Nagle's *Kill All Normies* has been critiqued for containing passages that were not fact-checked sufficiently (Libcom). The parts of the book I reference (that is, Nagle's taxonomy of the manosphere and her discussion of the red-pill metaphor in alt-right circles) have not been subjected to criticism.

inism functions as a gateway to alt-right ideologies at large: Anti-feminist forums on social media constitute a space in which users collectively radicalize—or are purposefully enticed to radicalize by alt-right activists—to embrace alt-right ideologies more broadly, notably white nationalism. I base this argument on the analysis of select written posts, memes and videos posted in anti-feminist/white nationalist online environments, particularly on Reddit, which stylizes itself as dedicated to free speech and introduced bans of hateful content much later than other social-media platforms.

I begin by briefly characterizing the four major groups constituting the manosphere: "The manosphere is an aggregate of diverse communities brought together by a common language that orients them in opposition to the discourse and rhetoric of feminism" (Marwick and Caplan 553). These communities include men's rights/fathers' rights activists, pick-up artists, incels (involuntary celibates), and MGTOW (Men Going Their Own Way). In the article's second part, I share three theses regarding the interconnections between digital media ecologies, anti-feminism, and the alt-right: First, the advent of the Internet, particularly of web 2.0 in the late aughts, has greatly radicalized anti-feminism and anti-genderism due to such technical affordances as anonymity and networked harassment. Second, anti-feminism and anti-genderism function as the ideological glue that binds together the various groups constituting the alt-right. Third, since the late 2000s, anti-feminism and anti-gender politics have moved from the margins of the Internet to the center of Western societies and polities—this migration has moved the boundaries of what is sayable in "offline" spaces of political discourse. These observations set the scene for my analysis of digital anti-feminism's mediated tactics, arguments and aesthetic as well as affective strategies. In the article's third part, I identify social-media affordances the alt-right exploits and media strategies it deploys to drive forth collective radicalization: While the circulation of humorous and irreverent memes with "more palatable" (Woods and Hahner 13) messages has emerged as a key alt-right strategy to attract users, once these users immerse themselves in "specialized" anti-feminist online environments, they are led to embrace more extreme views via so-called *redpilling*, that is, activists' concerted and media-savvy distribution of disinformation online with the aim of gradually habituating users to far-right ideologies. Next, I distill three key arguments alt-right activists make to wed anti-feminism to white nationalism. In addition to calling for immigration restriction, these arguments aim at containing white replacement by policing white women's sexuality and discouraging non-reproductive sexual activity in white men. In the fifth part, I analyze the aesthetic and affective strategies select anti-feminist and white nationalist social-media posts mobilize to conjure a sense of male domination and white hegemony, and to present anti-feminism and white nationalism as ideologically congruent. I conclude by suggesting that the alt-right succeeds in convincing users that their feelings of marginalization constitute "subversive

knowledge" (Bonefeld 8) regarding the true power dynamics in Western societies, which not only oppress men, but which also privilege racial minorities over white people, who will soon be replaced unless they start resisting.

The Manosphere

The manosphere denotes an assemblage of online groups united in their anti-feminist outlook; the term originated as a self-description, as it first surfaced in a 2009 Blogspot blog to describe a digital network of men's interest groups, and subsequently gained popularity via Ian Ironwood's 2013 publication *The Manosphere: A New Hope for Masculinity* (Ging 639–640). The manosphere is comprised of four major groups:

The first group, men's rights/fathers' rights activists,[4] alleges that men's interests are systematically neglected in contemporary Western societies due to feminism's dominance in the political and cultural realms. Common grievances voiced, for instance, on the subreddit r/MensRights include discrimination against men by the legal system in custody and alimony cases, anti-male bias in the job market, compulsory military service for men in several countries, the presumption of male guilt when allegations of sexual assault are made, domestic violence experienced by men, and the practice of male circumcision (Rafail and Freitas). The Proud Boys' founder McInnes has stated: "I would say that feminism was done in maybe 1979. [...] And since then, it's just been women inventing problems and lying to create a world where feminists are needed. Like saying one in four women will be sexually assaulted or raped in college—or saying that women earn less than men and there's a wage gap. Like just blatant lies to justify their existence" (qtd. in Hall). Moreover, McInnes has frequently proclaimed that working women "would be much happier at home with a husband and children" (qtd. in Mazza), thereby negating the key principle of second-wave feminism that women should be able to choose their lifestyles.

The second group, pick-up artists (PUA), was founded by Roosh V (civil name: Daryush Valizadeh) and exchanges advice on how to coax women into sexual intercourse. Roosh V started out sharing advice on how to achieve sexual success with women on message boards in the aughts, then went on to publish several manuals with such telling names as *GAME* or *BANG* on how men can transform themselves

4 Let me clarify that I recognize that men and fathers are entitled to civil rights—in April 2024, for instance, Germany's Federal Constitutional Court (*Bundesverfassungsgericht*) strengthened a biological father's right to be a parent to his child in important ways (Suliak). Unfortunately, anti-feminists frequently co-opt men's and fathers' legitimate concerns; the subreddit r/Men's Rights on Reddit, for example, is filled with anti-feminist and misogynist vitriol.

into "alpha males" and "score" with women in various countries. PUAs systematically treat women as sex objects. Roosh V eventually went on to fuse his anti-feminist agenda with advocacy for white nationalism (Strick, "The *Alternative Right*" 244–250).

The third group, incels (involuntary celibates), is comprised of straight men who vent online about women's refusal to have sexual relations with them, implying that women are obliged to fulfill men's sexual desires. Several recent massacres in the U.S. were carried out by men who were members of the online incel community. For instance, Elliot Roger killed six people and injured fourteen near the UC Santa Barbara campus in May 2014 after uploading a "manifesto" in which he expressed hateful views of women, ranted about interracial couples, and lamented his inability to find a girlfriend. Due to such massacres committed by incels, political debates are currently (spring 2024) underway in the U.S. as to whether incels should be labeled a terrorist group. For instance, Bruce Hoffman and Jacob Ware, both counterterrorism experts on the Council on Foreign Relations, have argued that "[l]aw-enforcement and counterterrorism agencies need to recognize" incels as "a real and growing threat." Several social-media platforms have banned incel groups; for instance, Reddit banned the subreddit r/incels in November 2017 because it was deemed to incite violence.

The fourth group, MGTOW, is made up of straight male separatists who avoid romantic relationships with women in protest against a culture allegedly poisoned by feminism; the group's self-described goal is to focus on individual achievement and independence from women, who are spoken of in misogynist terms. There are four levels of "going their own way" that members can achieve, ranging from level 1, which requires a member's vow to abstain from long-term relationships, to level 4, the highest level, where a man completely refuses to engage with a society poisoned by feminism (Nagle 94). In August 2021, Reddit banned the subreddit r/mgtow for inciting violence or promoting hate.

While all four groups are anti-feminist, they display misogyny to varying degrees. As the discussion above makes clear, incels and MGTOW overtly express hatred of women, while PUAs are misogynist in that they treat women as sex objects. On men's rights forums, some users articulate misogynist views, whereas others claim that their opposition is directed at feminism, not women. For instance, anti-feminist and white nationalist YouTuber The Golden One states: "I'm against feminism, because I love women" ("Manliness"). I should point out that there is no perfect overlap between the ideologies of the various groups that I just enumerated. There is, in fact, enmity between some of them: Roosh V., the founder of the PUA movement, has called MGTOWs "sexual losers" (qtd. in Nagle 89); in 2015, incel users created the website PUAHate.com to disparage (hetero-)sexually successful men (Hoffman and Ware). These groups' common ideological denominator is the belief that feminism is nefarious. While some men's rights activists profess that they are interested in true equality between the genders, arguing that feminism has taken things too far,

the overwhelming majority of anti-feminists active online today believe that feminism is an ideology that structures Western societies, as a result of which a) men are systematically oppressed, b) women are making false accusations of sexual assault against men to ruin their lives, c) women have been led astray from the role "nature" intended them to have, and d) the "natural hierarchy" between the genders has been inverted.

What is more, these groups "congeal[] and convert[] through [their] mediated tactics" (Woods and Hahner 4). Many user communities who celebrated themselves for creating "meme magic" and engaged in shitposting and trolling "for the lulz" on 4chan habitually targeted not only political correctness, but also feminism. Then the Gamergate controversy occurred, a 2014/2015 campaign in which male video gamers who thought that the gaming community had become too politically correct subjected female gamers to harassment and ridicule in organized fashion. Gamergate is widely identified as a watershed moment in the rise of the alt-right (Nagle 24); it marked the moment when part of a multitude of users who were shitposting crystallized into a collective which used specific digital tactics, notably creating and spreading memes, to recruit individuals and direct public discussion at large (Woods and Hahner 3–5). Before analyzing digital anti-feminism's medial, affective, and aesthetic strategies as well as the arguments that present anti-feminism and white nationalism as ideologically congruent, I would like to map this complex territory by sharing three theses on the interconnections between digital media ecologies, anti-feminism, and the alt-right.

Digital Media Ecologies, Anti-Feminism, and the Alt-Right: Three Observations

First, the Internet, particularly the advent of web 2.0 in the late 2000s, has tremendously impacted anti-feminism and the anti-gender movement. Angela Nagle observes: "[E]ven the most militantly anti-feminist forms of pre-Internet men's rights activism now seem supremely reasonable and mild compared with the anti-feminism that emerged online in the 2010s" (88). Two affordances of digital media ecologies have contributed to the radicalization of anti-feminist discourse, in particular: To begin with, social media allow users to remain anonymous. As Dignam and Rohlinger write, "[o]nline anonymous spaces such as Stormfront, Reddit, and 4chan are appealing because individuals can mask their identities and express agreement with extreme views without their friends and neighbors finding out" (592). Moreover, hurling epithets at other users anonymously is quite another thing than disparaging another individual face to face. The encounter with the other's face, as Emmanuel Levinas has argued, makes one aware of the other's vulnerability, inviting reflection on how one's words and actions will affect the other (Burggraeve 30). This

becoming aware of the other's vulnerability is absent in users' virtual engagement with one another. In addition, digital infrastructures have facilitated the networked harassment of targets of anti-feminist and anti-gender agitation. According to Alice E. Marwick and Robyn Caplan,

> groups like the ASJW[5] [anti-social justice warrior] YouTubers—and many others—regularly encourage, promote, or instigate systemic networked harassment against their targets [...]. While harassing behavior is certainly not confined to anti-feminists, many of the techniques used in networked harassment, such as doxing (publishing personal information online), revenge porn (spreading intimate photos beyond their origins), social shaming, and intimidation were refined by men's rights activists and anti-feminist gamers during [...] Gamergate. (544)

Second, anti-feminism and anti-gender politics are the ideological glue that binds together the various groups constituting the alt-right—in fact, right-wing populist movements across the globe are connected by it. According to Gabriele Dietze and Julia Roth, "a common feature can be observed in all current [2020] versions of right-wing populism: an 'obsession with gender' and sexuality in different arenas. Populist actors conjure up the heteronormative nuclear family as the model of social organization, attack reproductive rights, question sex education, criticize [...] so-called 'gender ideology,' reject equal marriage and seek to re-install biologically understood binary gender differences" (7). I would add that right-wing populists also disparage Gender Studies as pseudo-scholarship. Alt-righters also crusade against pornography, maintaining that it distracts men from finding a woman with whom to procreate and thus secure the survival of the "white race." An anti-pornography and anti-masturbation current runs quite prominently through anti-feminist and white nationalist circles. For instance, in his videocast *The Gavin McInnes Show* (2015–2017), the Proud Boys' founder encouraged his followers to pursue a "no wanks" agenda, meaning to abstain from watching porn and masturbation, and to "throw down bricks" instead, that is, to seek out relationships with women in real life (qtd. in Nagle 95–96). I will discuss this ideological position in more detail later; suffice it to say at this point that the embrace of an anti-pornography and anti-masturbation agenda functions as one of the key argumentative links between anti-feminism and white nationalism.

Third, since the late 2000s, anti-feminism and anti-gender politics have moved from the margins of the Internet to the center of Western societies and polities. To name but a few examples, not only did an endorser of alt-right ideological positions serve as U.S. president between 2017 and 2021, who among other things thought it

5 "Social justice warrior" is a disparaging term the alt-right uses to refer to individuals who lobby for causes such as equal rights for racial minorities, women, or the LGBTQ+ community.

was acceptable to grab women by their genitalia and who would appoint to the U.S. Supreme Court justices inimical to a woman's right to choose, with *Roe v. Wade* finally being overturned on June 24, 2022. Poland, an EU member, in January 2021 illegalized abortion except in cases when the pregnancy is a result of rape and/or incest or threatens the woman's life. The parliament of Hungary, another EU member state, passed legislation in June 2021 that discriminates against LGBTQ+ individuals.[6] According to Marwick and Caplan, "[i]n many ways, members of the so-called 'manosphere' pioneered harassment techniques that are now leveraged not only by individuals and online communities, but by governments and other state actors" (544).

To conclude these observations regarding the relationship of digital media ecologies, anti-feminism, and the alt-right: As anti-feminism has migrated from the fringes of the Internet to the core of Western societies and polities, so have digital anti-feminism's language and its harassment tactics. While there would probably still be outrage if a GOP Representative used an obscene expletive to refer to feminists while speaking on the House floor, digital anti-feminist and other alt-right discourses have moved the boundaries of what is articulable in political debate in "offline" spaces such as parliaments or political talk shows on TV. In short, the Overton window has shifted to the right on the political spectrum (Palberg). And while Trump did not state in the Oval Office that it was acceptable to "grab women by their p–," the documented fact that he had made this statement did not render him morally unfit for the office of U.S. president in the eyes of the millions of Americans who cast their ballot for him. On the contrary, it appears as though some voters were drawn to Trump precisely because of his misogyny. In a 2016 post entitled "'Sexual Assault' Is Why I'm Endorsing Donald Trump for President of the United States," a moderator of the Reddit forum *redpillschool* stated: "When somebody accuses a powerful or famous figure like Trump of 'sexual assault,' I don't look the other way. I don't denounce them or their behavior. Instead I run towards them, because there is no truer signal which side somebody is on, than when they're given a *bogus accusation* by *the establishment*. This is our beacon to find allies in the *war*" (qtd. in Dignam and Rohlinger 589; my emphasis). This post not only communicates a key belief of contemporary anti-feminism in the United States—that women make false accusations of sexual assault to ruin men's lives—and is clearly identifiable as right-wing populist in its proposition that "the establishment" is pro-feminist; it also points to affordances of social-media infrastructures that alt-right activists could tap into and to media strategies such as *redpilling* they deployed to integrate disaffected individual users into the alt-right collective.

6 The law prohibits sharing information with minors that "promotes" homosexuality or gender reassignment; it also bans content depicting LGBTQ+ subject matter from daytime television (Amnesty International).

Integrating Individual Users into a Radical Collective:
Anti-Feminist Media Strategies

Creating and spreading memes is a key strategy the alt-right uses in order to achieve "the radicalization of outsiders to far right advocacies" (Woods and Hahner 5). While "more palatable" (Woods and Hahner 13) memes that attract users due to their irony and irreverence will typically be spread on such platforms as Facebook and Twitter (now X), once users immerse themselves in more "specialized" social media environments such as Reddit forums or Telegram channels, they encounter more extreme views. Forums on Reddit, for instance, feature moderators, who wield considerable power in shaping forum discourse; moderators of anti-feminist subreddits are typically veterans of online anti-feminism, accordingly espouse particularly radical views, and are often politically organized (Dignam and Rohlinger 596; 607)—the aforementioned post by the *redpillschool* moderator who characterized allegations of sexual assault as evidence of political integrity is a case in point. In addition to moderators' personal backgrounds, the infrastructure's technical affordances come into play: For example, moderators can render a post with which they agree "sticky," which makes the post constantly visible to users (Dignam and Rohlinger 595); they can also punish users with whom "they disagree by deleting their posts, publicly dismissing their points of view, or labeling them as trolls and banning them" (596) from the forum for violating its code of conduct. In addition, Reddit users can "upvote" or "downvote" a post, which increases or decreases its so-called "karma." Content with positive karma becomes more visible to other users, while content with negative karma becomes less visible. The karma system "ultimately allows popular users [...] to dominate conversations, while obscuring posts that challenge popular views" (Dignam and Rohlinger 595). In sum, moderators' significant power, the available tools, and available drive collective radicalization on anti-feminist Reddit forums, while veiling or even excluding more moderate voices.

Redpilling has emerged as a central method Reddit moderators and other agitators use to effect users' radicalization—specifically, to tune disaffected male users, who may have turned to the manosphere due to a lack of dating success or a job setback, into white nationalist ideologies. The manosphere prominently deploys the metaphor of *the red pill* derived from the 1999 film *The Matrix*, in which protagonist Neo, portrayed by Keanu Reeves, is given the choice between taking the blue pill, and thus continuing to believe what he has been taught about the world, or the red pill, which will make him aware of the true character of the world, namely that it is a simulation called matrix created by intelligent machines. In digital anti-feminist circles, "taking the red pill" signifies coming to the realization that feminism is a lie around which Western societies are organized, and discovering "the truth," namely that men occupy an oppressed position. The following post on the subred-

dit r/MensRights illustrates common views on feminism exchanged in digital anti-feminist forums:

> Today, women are privileged over men. Women have more legal rights than men, they benefit from affirmative action, quotas, institutional discrimination and simple bias in their favor in things like hiring decisions, landlords renting properties, police deciding who to arrest & prosecute, etc.
>
> Feminists know they are lying and that women are privileged. The entire purpose of feminism is to entrench and extend women's privileges, benefits and special treatment. So they react violently to anything that threatens that outcome. Such as people speaking the truth and citing facts. (u/EricAllonde)

The term "the manosphere" came up with to capture this alleged systematic discrimination of men is "misandry" (Marwick and Caplan 544); one also finds concepts such as "female privilege," as the post quoted above underscores. The red-pill cosmology conceives of men as belonging to one of two categories: They are either alpha males or beta males. This taxonomy is epitomized by the expression "alpha fucks, beta bucks" (u/Spiritual_Age_4992), meaning that women allegedly throw themselves at the feet of "alpha males"—physically attractive men with dominant personalities—for sexual intercourse without making any demands of them in exchange for sex, while they expect "beta males" to finance their lifestyle, seek to change the behavior of a "beta male," and use sex as a reward when the "beta male" meets these assorted expectations. Red-pill forums commonly promulgate that while women like to engage in sexual promiscuity with "alpha males" in their twenties, they want to settle down in their thirties with a reliable "beta male" who will take care of them financially—and their children fathered by the "alpha males."

That anti-feminist forums may function as a gateway to alt-right ideologies at large, not least because alt-right activists agitate in these forums to recruit users for their cause, is underscored by the following post on the subreddit r/MensRights. This post constitutes a metadiscourse on the subreddit r/TheRedPill, which had, when the user posted this, already been quarantined by Reddit for featuring "shocking or highly offensive content" (Reddit, "r/TheRedPill").

> I think what theredpill did was more than giving dating advice. For many (like me) it served as the entry gate to discussion freed from political correctness.
>
> "If all media tell me a wrong picture of dating and women, *what else are they lying about?*" Is the thought process many newcomers will follow there. After that they crave for alternative view points also regarding politics.
>
> So to make my point short: To begin *redpilling normies* you need to operate in the egalitarian framework at first and demonstrate its inconsistencies. After that they will be more open to alternative ways to look at the world. (Post depicted in Strick, *Rechte Gefühle*, 261; my emphasis)

Media critique takes center stage in this post—legacy media are characterized as being in cahoots with political elites, whose ideology (for instance, political correctness) they disseminate; while legacy media, according to the user, spread false knowledge (the example the user references is incorrect information regarding women and the world of dating), social media allow male users to become cognizant of "the truth" by validating their lived experience. Once social media have made male users aware that legacy media are lying about gender relations/dating, the post maintains in its most crucial passage, users will question "what else are they lying about?" This post thus discloses digital anti-feminism as a gateway space in which users are radicalized to embrace alt-right ideologies more broadly. I use the passive voice purposefully here, for the post unabashedly acknowledges that alt-right activists seek to foster users' radicalization by "redpilling normies." While online anti-feminist agitators first devised the metaphor of "taking the red pill" to signify coming to the realization that Western societies are poisoned by feminism and oppress men (Nagle 88), the metaphor was eventually also used for white-nationalist purposes: Nagle found that "[o]n AlternativeRight.com 'the red pill' and 'being red pilled' was one of the central metaphors and favorite expressions [...] to describe their [...] racial awakening" (88). The social-media strategy of *redpilling* thus involves arguing why the epiphany that feminism is nefarious and men are oppressed ought to be followed by the epiphany that white people are discriminated against. In the following, I will highlight three prominent narratives on social media that fuse an anti-feminist with a white nationalist agenda.

The Discursive Establishment of a Link between Anti-Feminism and White Nationalism

The first narrative maintains that there is a need to police white women's sexuality so that they produce children in order to secure the survival of the "white race." This narrative abrogates central tenets of second-wave feminism and the sexual revolution, since it denies women the freedom to choose their sexual partners and espouses natalism, that is, the idea that it is every (white) woman's duty to have children. Consider the meme in image 1, found on ifunny, a website that allows users to create memes, which other users may then share: The image shows a woman holding a baby, both white and blonde, in a field of red poppies, the visual contrast highlighting the pair's whiteness. It is captioned with "White women of childbearing age: TWO PERCENT of the World's population. Gotta save the minorities ... right?" In a gesture of ironic appropriation regarding the left's political goal of minority protection, the meme suggests that two specific minority populations need to be protected: white women of childbearing age and the "white race," which cannot reproduce in sufficient numbers unless white women of childbearing age comply. In addition to

espousing the paternalistic view that (white) women need protection and the patriarchal politics that sexual choice ought to be abrogated from women, this meme allows viewers to associate its message with a broad range of right-wing political projects, ranging from criminalizing abortion to curbing immigration or even reversing the U.S. Supreme Court's decision in *Loving v. Virginia*, which endowed interracial marriage with constitutional protection.

Image 1

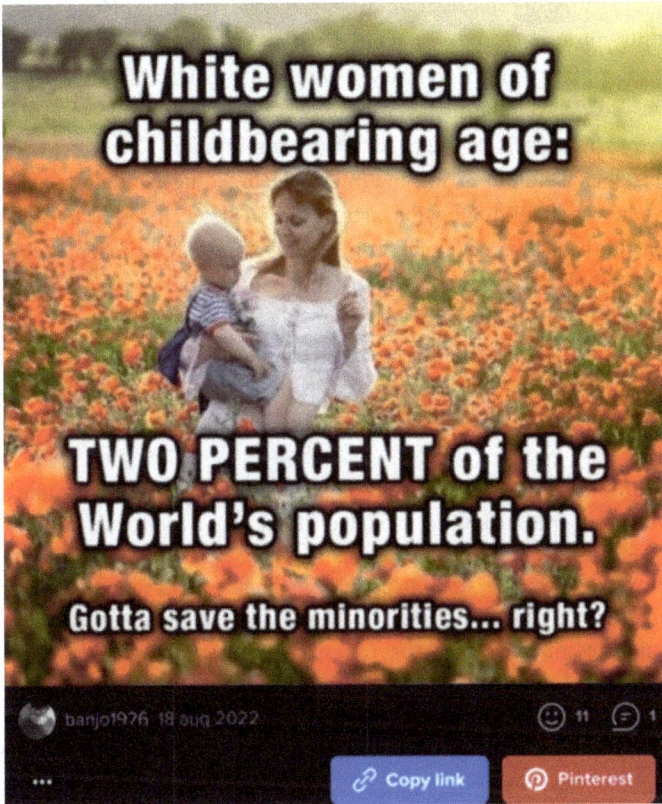

Source: https://br.ifunny.co/picture/white-women-of-childbearing-age-two-percent-of-the-world-y8tmT6kn9, accessed 4 January 2024.

The desire to police women's sexuality was manifested in law when the U.S. Supreme Court overturned *Roe v. Wade* in June 2022; the Supreme Court's decision in *Dobbs v. Jackson Women's Health Organization* stripped women seeking an abortion of constitutional protection and has, as of November 2023, led to near-total or very

restrictive abortion bans in sixteen states (Sherman and Witherspoon). I am not suggesting that the desire to police women's sexuality indexed by *Dobbs* is only rooted in right-wing anxieties regarding white replacement.[7] Forcing women to carry an unwanted pregnancy to term can certainly also be read as an expression of the lust to punish women by sexually frustrated incels or, as journalist Amanda Marcotte puts it, by men "who experienced nervous sweats during the #MeToo era." Not least, policing women's sexuality aligns with the political aims of Christian fundamentalists.

The second narrative fusing anti-feminism and white nationalism suggests that male migrants/men of color steal white women, who rightfully belong to white men, and commit "miscegenation" with them. Content promoting this narrative not only aspires to abrogate the right to freely choose their sexual/romantic partners from women; it also alerts to the alleged dangers of "race mixing" and at least implicitly, but often overtly so, calls for the need to curb immigration. "The white race is over-taken through male feminization and interracial breeding," stated the self-descrip-tion of the subreddit r/WhiteboyExtinction (qtd. in Strick, *Rechte Gefühle* 258), which has meanwhile been banned for violating the website's "rule against promoting hate" (Reddit, "r/WhiteboyExtinction"). The alt-right has coined the terms *cuck/cuckoldry* to suggest an analogy between a cuckold, that is, a husband whose wife is unfaithful, and a male citizen of a Eurocentric nation who allows his country to be invaded by foreigners. According to the "profascist" website rightrealist.com, which was deac-tivated in the spring of 2020 (Strick, *Rechte Gefühle* 258),

[t]he term "cuck" from an alt-right perspective began as a very simple analogy: Allowing foreigners to invade, exploit, or attack your nation or people is compared with cuckoldry. In other words, a cuck is a man who allows his wife (nation) to sleep with another man (foreign people), and who invests time and resources into raising a child that is not his own. The term can be used more generally either as a noun to describe a man who has emasculated himself, or as a verb for weak and submissive behavior. (qtd. in Strick, *Rechte Gefühle* 258–259)

The third narrative connects anti-feminism to white nationalism via an opposition to pornography. Anti-feminists who oppose pornography argue that it distracts men from the vital duty of containing white replacement by seeking a female partner

7 This dovetailing of racist and patriarchal politics is not new to the Internet age, but is deeply rooted in U.S. history: In the nineteenth and early twentieth centuries, anti-miscegena-tion laws were rhetorically justified with the need to protect white women's sexual purity (Botham). Likewise, perpetrators and defenders of lynchings of African American men be-tween the end of Reconstruction and the 1950s frequently accused the lynched party of hav-ing sexually assaulted, and thus besmirched the sexual and racial purity, of white women (Ore).

of European ancestry with whom to procreate. The YouTuber The Golden One (a Swedish bodybuilder and neo-fascist whose legal name is Marcus Follin) has 114,000 subscribers as of January 2024. He links a male fitness agenda and misogynist beliefs that women need to be dominated by men with a white nationalist agenda. Nordic history and mythology feature prominently in his content. For instance, he advises Western male followers to emulate Vikings. He is also an anti-porn activist: Porn and masturbation, in his logic, channel sexual energy that men had better invest in "productive endeavors," such as procreating with "fair maidens" to secure the survival of the "Nordic race." In his clip "Why I Hate Porn and Why You Should Stop Watching It," he in self-help fashion advises Western male followers to adopt the following mindset: "I'm going to get so confident, so physically dominant that I can attract [...] some sort of fair maiden instead of saying 'You know what, I give up and I'm just gonna watch porn.'"

In particularly extreme content pornography is linked to the narrative of a Jewish world conspiracy. Consider image 2, a meme posted on the subreddit r/ForwardsFromKlandma.[8] This graphics links the dissemination of porn to the conspiracy narrative of Jewish usurpation by highlighting that the company MindGeek, which owns/is the parent company of four porn-streaming websites, among them the heavily trafficked site Pornhub,[9] is steered by CEO Faras Antoon and COO David Marmorstein Tassilo. By underlining the names of Antoon and Tassilo, and by featuring the caricature of a Jewish man reminiscent of anti-Semitic propaganda in Nazi Germany, the graphics seeks to convey the message that Jewish individuals/individuals of Middle Eastern background foster degeneracy in Western societies and seek to get white men distracted from their responsibility of securing the survival of the "white race." Having introduced the major argumentative links alt-right content establishes between anti-feminism and white nationalism, I will now turn to select aesthetic and affective strategies alt-right posts deploy.

8 The ideological trajectory of the subreddit r/forwardsfromklandma is hard to determine; some posts feature headlines that seem to critique the far-right memes they share, while other posts affirm far-right content.

9 In October 2023, Pornhub was the 14th-most-trafficked website worldwide ("Top Websites Ranking").

Image 2

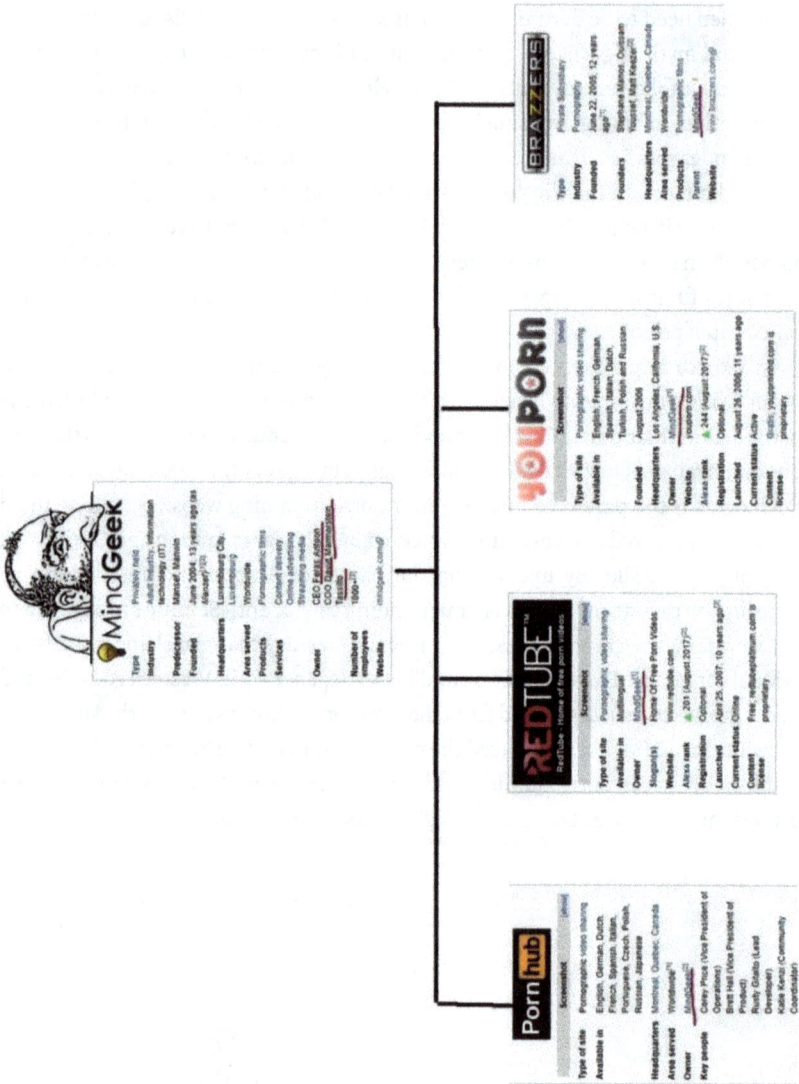

Source: https://www.reddit.com/r/ForwardsFromKlandma/comments/xsumk9/til_klandmas_antiporn_theories_are_rooted_in/ (accessed 4 January 2024).

The Aesthetic and Affective Strategies of Anti-Feminism and White Nationalism

Scholars often apply one of two frameworks to account for the rise of the alt-right since the late 2000s. The first framework explains the increasing pull that anti-feminism and white nationalism have exerted on white men by pointing to the latter's experience of economic and/or gendered *insecurity*, be this experience substantiated or unsubstantiated. One articulation of this framework maintains that white men who experience economic precarity due to neoliberalism, misidentify the source of their predicament and turn against women and/or ethnic minorities instead of blaming neoliberal capitalism (Hochschild). This argument does not explain, however, why college-educated men from the middle and upper classes are drawn to anti-feminism and white nationalism. The second framework maintains that anti-feminists and white nationalists are largely motivated by anger and hatred (Cole). Some scholars combine both frameworks, for instance, Michael S. Kimmel in his much-discussed study *Angry White Men: American Masculinity at the End of an Era.* Kimmel proposes that white men have increasingly turned to alt-right ideologies due to "aggrieved entitlement" (x)—they feel that the rewards that were traditionally reaped by white men, such as economic prosperity and "calling the shots" in the social and political realms, are increasingly being kept from them although they have worked hard. According to Kimmel, alt-right spin doctors such as Rush Limbaugh are alarmingly successful at transforming this sense of insecurity into outrage (31–46); white men then turn to anti-feminism and white nationalism, which promise to return America to a society where white men will again experience what they think is rightfully theirs: the economic and social privileges that have traditionally come with whiteness and masculinity (xi-xiii). While I find Kimmel's notion of "aggrieved entitlement" productive—being a white man, regardless of which class, still tips the scales into one's favor, just not as much as it did 30 years ago—and while it is evident that much anti-feminist and white nationalist social-media content spews hatred (edged on by right-wing spin doctors and meme wizards), I would like to propose a multicausal framework that additionally takes into account the perspective offered by Simon Strick. In his seminal study *Rechte Gefühle*, Strick contends that part of what makes alt-right ideologies attractive is that they offer users and voters options for identification they experience as positive, and for expressing affirmative affects such as love:

> Enmity towards foreigners and women is transformed into the perceived love of self, of the group and of the project of protecting and preserving "European peoples and cultures." White supremacy rearticulates itself as *empowerment* of white people; misogyny and defending male privilege are recoded as activism against discrimination. Such discursive recoding ultimately feels less like a totalitarian-

fascist version of politics and society, but more like a self-defense project for "white culture" and "real men." (Strick, *Rechte Gefühle* 126; original emphasis; my translation).[10]

Building on Strick's insight regarding the importance of alt-right agitators' projection of a sense of male pride/white pride, the first affective strategy I would like to identify is digital anti-feminists'/white nationalists' dissemination of an affirmative self-image. Aforementioned YouTuber The Golden One serves as a prime example of this strategy; to a large degree, his videos focus on "motivational and positive messaging" instead of "the tropes of right-wing paranoia" (Strick, "The *Alternative Right*" 251). For instance, in his video "White Man. Stop Letting Your Woman Trample You Down," he admonishes that "white guys" ought to stop "treat[ing] ourselves like some subservient slaves," encouraging his followers to adopt "self-respect" instead, and to demand "respect" from their female partners (The Golden One, "White Man"). Strick summarizes The Golden One's approach of white masculine self-empowerment as follows: "He proposes workouts, physical culture, abstinence from pornography, and the rediscovery of 'white' heritage, honor, and confidence. Instead of hate speech [...], The Golden One remakes 'white pride' as motivational language: He asks his audience to overcome the negative thinking and depression induced by feminism and multiculturalism" ("The *Alternative Right*" 253). In his video "The Women Question," The Golden One explains that nationalism is incompatible with misogyny (at least when it concerns white women): "If you are a nationalist, you cannot harbor anti-female sentiments. Nationalism means that you love your people, and if you hate half of your people, that's [...] not congruent with each other." While the Swedish influencer mobilizes the trope of migrant men as rapists and speaks of "multicultural hell" in this video, he also entices white male users to invest positive affect in their "people" and suggests that harboring hatred towards white women is inappropriate. (It bears mentioning that whereas the YouTuber considers white women as deserving of love, he casts them as undeserving of the vote in the same video.) More recently, select anti-feminists seem to have adopted the strategy of cathecting identities that the mainstream casts as problematic with positive affect. Social-media personality Andrew Tate, for instance, stylizes himself as the "king of toxic masculinity" (qtd. in Artsy), thus celebrating an iteration of masculinity that the leftist #MeToo movement identified as the root cause of systemic sexual assault of women by men. In his videos and posts, Tate has frequently glorified violence against women (Artsy). In December 2022, Tate was arrested in Romania on charges of rape and human trafficking. Many of his millions of followers—he has 8.6 million followers on X (formerly Twitter) as of January 2024—were "expressing support for

10 Strick builds on Sara Ahmed's insights, who argues that "fascism as a politics of hate is written in the language of love" (Ahmed).

his plight, arguing that Tate is a positive force on men and that the Romanian government is trying to silence him for telling the truth" (Artsy).

Again, as the example of Tate underscores, plenty of alt-right content deploys the politics of hatred. As mentioned earlier, some anti-feminist users engage in extreme forms of harassment—death threats; rape threats; doxing; revenge porn—to intimidate feminists or individuals perceived as such; other strategies include disparaging feminist women or men interested in gender equality in their bodily materiality or their gender performance.

In a meme user jedimentat posted on imgflip, a site that allows users to generate memes that can subsequently be shared by other users, an image of a woman whose body size does not conform to the Western beauty norm of slimness is captioned with the text "How do we destroy the patriarchy? It's simple. We eat it" (jedimentat). Adrienne Massarani and Shira Chess have argued that anti-feminist memes portray female social justice warriors—to reiterate, this is a term the alt-right uses disparagingly for individuals dedicated to social-justice causes—as monstrously feminine, as having non-normative bodies. By insinuating that feminists are "fat," this post suggests that feminism is practiced by women who are not "hot enough" to find a male partner, thus turning to feminism out of sexual frustration. Additionally, this meme intimates that feminists are cannibals who devour men, which renders them dangerous.

At the same time, anti-feminist users disparage men interested in gender equality—or more generally, men they perceive as politically progressive—as effeminate. For instance, a post that was widely shared on Reddit, both affirmatively and in terms of critique, features two images of young white men covering the lower parts of their faces with their hands in shock or distress. The meme is captioned "Progressive males are not men; they move and gesticulate like women. The 'hand-over-mouth' gesture is one example. Physically repulsive" (u/sulkilystage). The post not only chastises the men depicted for failing to perform hegemonic masculinity, but also instructs "non-progressive" users that disgust is the appropriate affective response to beholding progressive masculinity. Notably, the post does not specify at which occasion the images were taken—whether the young men depicted identify as progressive is unclear. Thus, the post also disciplines male users who identify as conservative/alt-right, by drawing a clear boundary between acceptable versus non-acceptable displays of masculinity. Content such as this suggests that men advocating for feminism and other progressive causes need not be taken seriously, as they fail to perform hegemonic masculinity.

Image 3

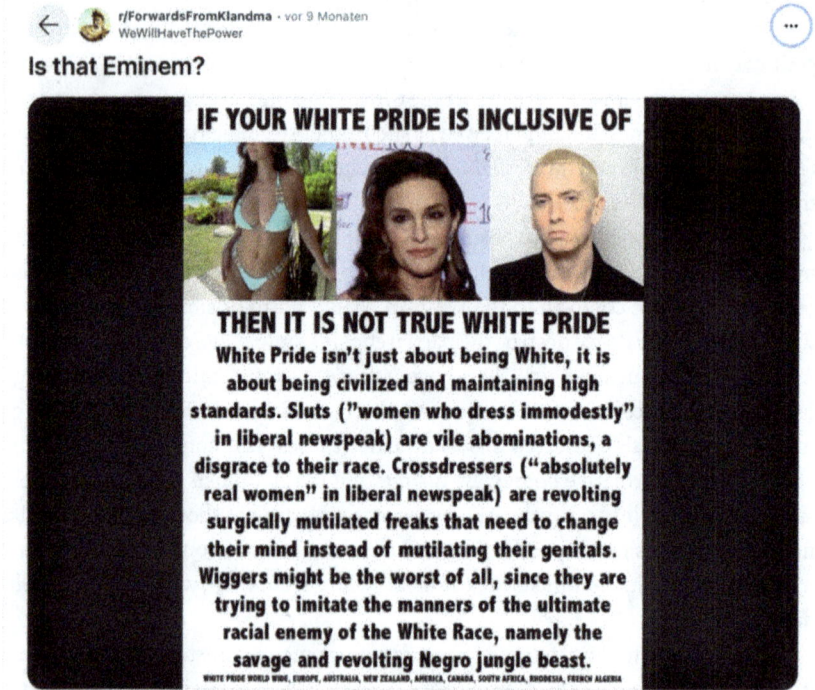

Little surprisingly, the alt-right also pathologizes being queer and being trans; what is analytically more interesting are the ways in which the alt-right defines normative whiteness as entailing heteronormativity, cisnormativity, modest femininity, and alpha masculinity. Consider the post found on the subreddit r/ ForwardsFromKlandma in image 3: The post maintains that "white pride" is incompatible, first, with articulations of femininity that insist on sexual liberation and a woman's right to wear whatever she pleases, and, second, with trans-inclusivity. The post mobilizes the bikini-clad woman in the left-most picture as an index for "[s]luts," who are characterized as "vile abominations, a disgrace to their race." The center picture shows Caitlyn Jenner, a celebrity trans woman who identifies as a Republican; tellingly, the post does not use the term "trans," but treats Jenner as an example of "crossdressers," whom it calls "revolting surgically mutilated freaks

that need to change their mind instead of mutilating their genitals."[11] By calling the bikini-donning woman a "slut" and by calling trans people "freaks," the post invokes a natural order, according to which the gender binary is natural, heterosexuality is natural, identifying with the gender (the alt-right would probably use the term "sex") one is assigned at birth is natural, and biology predisposes women to be subservient and modest (while it predisposes men to be dominant)—individuals deviating from this natural order are cast as degenerate and thus, harmful to the health and reproduction of the "white race."

While particularly extreme content mobilizes age-old racist, sexist, etc. stereotypes and frequently practices what amounts to hate speech (the meme linking pornography to the narrative of a Jewish world conspiracy and the "white pride" post are cases in point), less radicalized users might post content that communicates "milder" messages explicitly, but conveys more extreme messages as subtext. A photo of up-and-coming Democratic Congresswomen, published in *Vanity Fair* in January 2019, was shared on the subreddit r/ForwardsFromKlandma with captions (see image 4): Alexandria Ocasio-Cortez is described as "[living] with [a] 'partner,'" Ayanna Pressley as having "[m]arried a single father," Ilhan Omar as a "Muslim with hijab," Deb Haaland as a "[s]ingle mother of [a] lesbian daughter," Veronica Escobar as having "[o]fficiated a 'gay wedding,'" and, finally, Sharice Davids as a "LESBIAN." Except for one case, the assertions made with regard to these prominent Congresswomen all decry the deterioration of heteronormativity, traditional marriage, and the nuclear family; "only" the text pertaining to Ilhan Omar overtly taps into racism/Islamophobia by suggesting that Islam is un-American. Note that the post does not explicitly mention what the audience will certainly perceive: All depicted women are of color. This meme's visual subtext, I contend, carries a surplus meaning that exceeds the message conveyed by the captions; this subtext suggests that the depicted group, representing the vanguard of the Democratic Party, displays a microcosm of what the U.S. will look like if Democrats are allowed to run the country, thus instigating anxieties that "brown hoards" will take over the country, in addition to "sexual deviants" and women misled by feminism, whom the captions explicitly warn of. Most Americans right of center care about family values and believe in a heteronormative order; while some Republican voters may have scruples sharing content that unequivocally contains hate speech such as the meme linking porn to the narrative of Jewish usurpation, they might share this image, thus communicating anxieties about white replacement without having to articulate this explicitly. In addition to containing blatant misogyny and homophobia, this meme,

11 The third dimension of "flawed whiteness" the post references—via the rapper Eminem, shown in the right-most picture—concerns white people's cultural emulation of Black people, who are denigrated via vile slurs.

I submit, constitutes racist dog whistling in the age of web 2.0. Alt-right agitators deliberately use this strategy to radicalize users.

Image 4

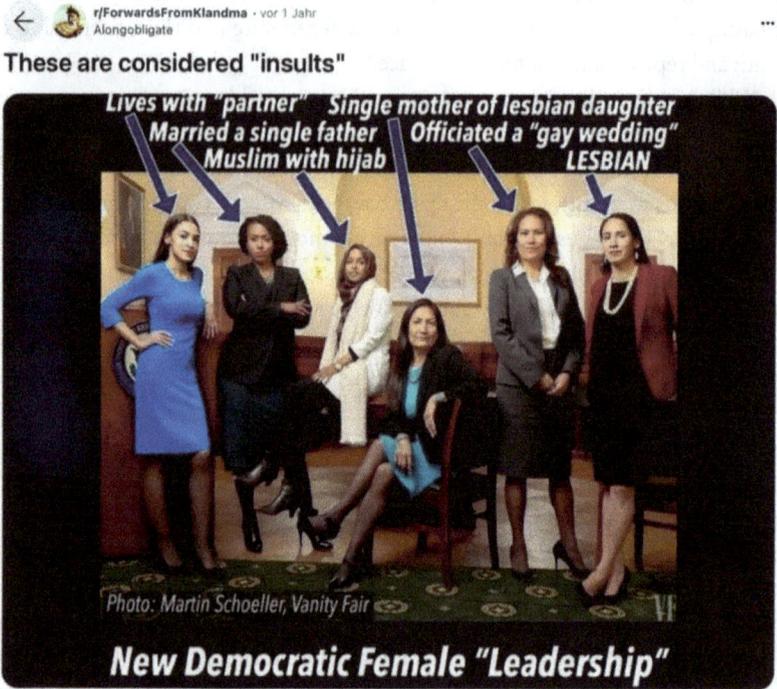

Source: https://www.reddit.com/r/ForwardsFromKlandma/comments/11jt7qi/these_are_consi dered_insults/ (accessed 4 January, 2024).

Finally, while scholars generally argue that the alt-right is defined more by what it is against—for instance, feminism, multiculturalism, and political correct-ness—than by a coherent ideology (Woods and Hahner 4; Nagle 12), select anti-feminist/white nationalist groups use social media to police who is part of the collective. In response to the emergence of social-media groups entitled "Proud Girls"—made up of women who ideologically support the Proud Boys' causes of white nationalism and male domination—the all-male group responded on its official Telegram channel with a post that read: "Proud Boy's [sic] Girls or Proud Girls are both ridiculous ideas. Fuck that. Don't ride our coattails. Want to support us? Get married, have babies, and take care of your family" (depicted in Proud Girls USA Official). Although the alt-right has a tendency to accept as spokespeo-

ple individuals such as Milo Yiannopoulous, who emerged as a crusader against political correctness in the 2010s, although he is gay, and as such, hardly meets the alt-right's norm of straight alpha masculinity, the Proud Boys' post serves as a reminder that a robust part of the alt-right will not march side by side with women in (violently) fighting white replacement due to its staunch anti-feminism—women may only further the cause by fulfilling the role the natural order assigns to them: reproducing and providing a home for their race-warrior husbands.

Last, I would like to point to the semiotic approaches the alt-right uses. First, the alt-right engages in appropriation and resignification vis-à-vis political discourse of the left. For instance, the post that I quoted to introduce anti-feminist views of feminism is actually a response to the anti-racist, feminist slogan "when you are privileged, equality feels like oppression." The user appropriates the slogan for his purposes, opens his post with the statement "Today, women are privileged over men," and proceeds to paint a picture of men as oppressed in contemporary society. The meme portraying "white women of childbearing age" as needing protection, is another case in point, as it appropriates the left's agenda of minority protection. This strategy of appropriation and resignification may have had its origins in alt-right shitposting and trolling "for the lulz," but, as Strick reminds us, the alt-right has in the meantime unironically adopted the rhetoric of white people and hetero-sexuals as minorities under threat. Second, the alt-right has mastered speaking in code. When platforms ban certain content because they deem it tantamount to hate speech and/or incitement to violence, anti-feminist and white nationalist users devise coded language to continue discussing their beliefs; to those who are not in the know, the new forum's name may seem innocuous, while the in-group has found a new online space for discussing its misogynist and/or racist beliefs. For instance, when Reddit banned the subreddit r/incels in November 2017, incel users created the subreddit r/braincels (which Reddit only banned in September 2019 for "content that harasses or bullies"). *Operation Google* represents a particularly stark effort to disguise hateful content: After Google introduced the tool Perspective, which allowed social-media platforms to identify and subsequently remove "insults and online toxicity" (Bhat and Klein 156), some 4chan users launched *Operation Google* to enable the expression of hateful content while circumventing such AI detection tools: "Googles" was used as a slur for Black people, "Skypes" as a slur for Jewish people, "butterflies" as a slur for LGBTQ+ individuals, among others (Bhat and Klein 156). In addition to disguising hate speech, this operation took "revenge on Google by [eventually] compelling it to censor itself," as the tech company's brand name had been turned into a racist slur (Bhat and Klein 156).

Conversely, the digital vanguard of the alt-right vigorously polices efforts to re-signify the collective's memes. As Woods and Hahner state, "[n]early any attempt to resignify an Alt-right meme by outsiders is often minimized by the subsequent proliferation of extremist memes. In this sense, the Alt-right fights back against at-

tempts to redeploy its imagery by inundating social media with memes. While radical possibilities of rhetorical invention remain with more general memes, Alt-right memes often iterate the advocacy of extremists" (12).

Crucially, by deploying the affective and aesthetic strategies just outlined, alt-right agitators have succeeded in enticing individual users, many of them disaffected and socially isolated, to experience empowerment by joining a virtual collective, as well as to drive that virtual collective from their gaming chairs to the voting booths in droves, thus transforming the virtual collective into a constituency whose voting behavior affects the political process 'offline.' Dignam and Rohlinger have analyzed over 1,700 anti-feminist Reddit posts from 2016 and conclude that

> leaders of the forum the "Red Pill" were able to move a community of adherents from understanding men's rights as a personal philosophy to political action. This transition was no small endeavor. The Red Pill forum was explicitly apolitical until the summer before the 2016 election. During the election, forum leaders linked the forum's neoliberal, misogynistic collective identity of alpha masculinity to Trump's public persona and framed his political ascendance as an opportunity to effectively push back against feminism and get a "real" man into the White House. (591)

Subversive Knowledge

Although my previous discussion confirms that scholars have been right to stress the crucial role *affect* plays in alt-right online content and thus, in users' collective radicalization, ironically, the alt-right stylizes itself as disseminating *knowledge* that is suppressed by both political elites and legacy media. To recall but three examples I discussed: The user arguing that women are privileged over men today on the subreddit r/MensRights stylizes the men's rights community as "speaking the *truth* and citing *facts*" (my emphasis). The meme appropriating the leftist agenda of minority protection to argue pro policing white women's sexuality emulates the scientific practice of citing empirical data by mentioning that white women of child-bearing age make up but "TWO PERCENT of the World's population." The Golden One refers to the self-help advice he shares on his YouTube channel as "teachings" and calls those "enlightened" who have realized that alpha masculinity is needed to contain the threat of white replacement.

The alt-right, I propose, conceives of itself as disseminating "subversive knowledge" (Bonefeld 8). This concept originated in the leftist critique of such structures as capitalism, racism and patriarchy. Werner Bonefeld, a Marxist political theorist, defines subversive knowledge as "what [...] we have to know to prevent misery" (8). In Bonefeld's usage, the notion aims at empowering those oppressed by the afore-

mentioned structures: By making sense of minorities' experience and theorizing their situation, the minorities and their allies, he suggests, will produce knowledge that can in turn inform political reforms designed to alleviate the "misery" experienced by those disenfranchised by capitalism or structural racism. While a plethora of empirical data exists that gives evidence of the reality of structural discrimination against people of color, women, or the poor, white men's feelings of marginalization voiced on anti-feminist and white nationalist forums are by and large not validated by empirical data garnered in scholarly studies, but are just that: *feelings*. The alt-right consistently portrays universities and scholars as perpetuating leftist ideology and as being in cahoots with the establishment to conceal the fact that the notions of female privilege and white oppression are not backed up by scholarship. Yet, despite this, alt-right activists recognize that knowing something and/or having proof of something carries higher credibility and constitutes a stronger call to action than merely having an ominous feeling. In light of the alt-right's strategy of appropriating and resignifying the left's concepts, it is somewhat fitting that a concept originating in leftist critique would be most appropriate to characterize the alt-right's self-image as disseminator of subversive knowledge: The alt-right has succeeded in convincing users that their feelings of marginalization constitute subversive knowledge regarding the true power dynamics in Western societies, which not only oppress men, but which also privilege racial minorities over white people, who will soon be replaced unless they start resisting.

At first glance, alt-right "knowledge" occupies a structurally similar position to schools of theory dedicated to emancipation and social transformation since Marx. As Geoff Shullenberger writes, "[w]hat is striking about the redpilling experience is that it resembles some of the most influential currents of modern intellectual life. Since the late nineteenth century, a series of new variants of the Platonic and Cartesian model of knowledge have arisen, in which radical suspicion is the first step in grasping counterintuitive truths that overturn the conventional understanding of reality." Yet, while alt-right subversive "knowledge" may share the liberating telos, and thus, the energizing impetus, of such leftist epistemic projects as Marxism, Gender Studies or Critical Race Theory, unlike scholars in these fields, producers of alt-right "knowledge" believe that knowledge generated at universities categorically serves the interests of the establishment. Since they view traditional locales and channels of producing and disseminating knowledge (the university and the media) as corrupt, purveyors of alt-right subversive "knowledge" feel a particular need for proselytizing and have mastered spreading their 'knowledge' via alternative channels such as social media.

Frieder Vogelmann proposes a framework that allows for distinguishing between mere truth claims (such as the alt-right's claims that men are oppressed in Western societies or that climate change does not exist) and such practices and statements that deserve the denomination *knowledge*. Whereas statements and

practices from which "truth emerges as a force and is thus irreducible" (Vogelmann 79; my translation) are aptly termed *knowledge* from an analytical perspective,[12] other truth claims merely simulate the emergence of truth (80), but can be shown to have cloaked another force (such as economic or political power) in the vocabulary of truth (83) or can be reduced to the individuals, objects or other forces involved in the promulgation of these truth claims (79). Alt-right truth claims belong to this latter category and, thus, do not qualify as knowledge from an analytical perspective.

What the alt-right disseminates, then, are *felt truths*, which confuse "affective force with truth" (Vogelmann 86; my translation), or *affective facts* (Massumi). The transformation of a feeling such as "[t]oday, women are privileged over men" into "knowledge" occurs in the manosphere, where this feeling is shared *collectively*. Whereas an individual man irritated by his dating experiences with women may have the feeling that "something is wrong with the system," but may occasionally still ask himself whether his lack of dating success can be attributed to a lack of compatibility between himself and the women in question, once he immerses himself in the manosphere, he meets other men who feel that "the system is rigged." Due to the belief that there is not only strength in numbers, but also truth, the crowd concludes that a feeling shared by so many must be indexical of a fact. As I have discussed above, this process is greatly abetted by alt-right agitators' social-media strategies such as redpilling and their exploitation of the affordances of digital infrastructures. While alt-righters profess to proclaim knowledge, the digital alt-right mass is *de facto* largely governed by the unconscious and by the affective (Le Bon), radically furthering the interests of the subject position the alt-right collective casts as normative: white masculinity.

Works Cited

Ahmed, Sara. "Fascism as Love." *Feministkilljoy.com*, 9 November 2016, https://femin istkilljoys.com/2016/11/09/fascism-as-love/. Accessed 28 June 2023.

Amnesty International. "Hungary: The Russian-Style Propaganda Law Violates Human Rights and Threatens LGBTI People." *Amnesty International*, 22 July

12 Vogelmann's approach holds great analytical benefit because it evaluates the actual statements and practices made in projects claiming to produce knowledge. This neither takes for granted that any scientific or scholarly project produces knowledge—although the great majority of scientific/scholarly statements and practices stand the test and qualify as knowledge—nor does it view science/scholarship as the only generator of knowledge: "Truth does not only emerge from scientific practices, and the latter had better acknowledge this" (Vogelmann 87; my translation). Vogelmann references patients' knowledge as an important epistemic field that medical research unduly ignored for a long time (87).

2021, https://www.amnesty.org/es/wp-content/uploads/2021/07/EUR27449220 21ENGLISH.pdf. Accessed 1 March 2024.

Artsy, Avishay. "How Andrew Tate sells men on toxic masculinity." *Vox*, 10 January 2023, https://www.vox.com/culture/2023/1/10/23547393/andrew-tate-toxic-ma sculinity-qa. Accessed 13 March 2024.

Bonefeld, Werner. "Subverting the Present, Imagining the Future: Insurrection, Movement and Commons." *Subverting the Present, Imagining the Future: Insurrection, Movement and Commons*, edited by Werner Bonefeld, Autonomedia, 2008, pp. 7–9.

Botham, Fay. "The 'Purity of the White Woman, Not the Purity of the Negro Woman': The Contemporary Legacies of Historical Laws Against Interracial Marriage." *Beyond Slavery: Overcoming Its Religious and Sexual Legacies*, edited by Bernadette J. Brooten, Palgrave Macmillan, 2010, pp. 249–64.

Burggraeve, Roger. "Violence and the Vulnerable Face of the Other: The Vision of Emmanuel Levinas on Moral Evil and Our Responsibility." *Journal of Social Philosophy*, vol. 30, no. 1, 1999, pp. 29–45.

Cole, Mike. *Trump, the Alt-Right and Public Pedagogies of Hate and for Fascism: What is to be Done?* Routledge, 2019.

Collins, Ben, and Brandy Zadrozny. "Proud Boys Celebrate After Trump's Debate Callout." *NBC News*, 30 September 2020, https://www.nbcnews.com/tech/tech-news/proud-boys-celebrate-after-trump-s-debate-call-out-n1241512. Accessed 13 March 2024.

Department of Justice. "Three Years Since the Jan. 6 Attack on the Capitol." *Department of Justice*, 5 January 2024, https://www.justice.gov/usao-dc/36-months-jan -6-attack-capitol-0. Accessed 13 March 2024.

Dietze, Gabriele, and Julia Roth. "Right-Wing Populism and Gender: A Preliminary Cartography of an Emergent Field of Research." *Right-Wing Populism and Gender: European Perspectives and Beyond*, edited by Gabriele Dietze and Julia Roth, transcript, 2020, pp. 7–23.

Dignam, Pierce Alexander, and Deana A. Rohlinger. "Misogynistic Men Online: How the Red Pill Helped Elect Trump." *Signs*, vol. 44, no. 3, 2019, pp. 589–612, https:// doi.org/10.1086/701155.

Ging, Debbie. "Alphas, Betas, and Incels: Theorizing the Masculinities of the Manosphere." *Men and Masculinities*, vol. 22, no. 4, 2019, pp. 638–57.

Hall, Alexandra. "Controversial Proud Boys Embrace 'Western Values,' Reject Feminism and Political Correctness." *Wisconsin Watch*, 26 November 2017, https://wis consinwatch.org/2017/11/proud-boys-group-wisconsin/. Accessed 13 November 2023.

Hochschild, Arlie Russell. *Strangers in Their Own Land: Anger and Mourning on the American Right*. New Press, 2018.

Hoffman, Bruce, and Jacob Ware. "Incels: America's Newest Domestic Terrorism Threat." *Lawfare*, 12 January 2020, https://www.lawfaremedia.org/article/incels-americas-newest-domestic-terrorism-threat. Accessed 4 January 2024.

jedimentat. "Fat feminist" meme. *Imgflip*, https://imgflip.com/i/18lslo. Accessed 4 January 2024.

Kimmel, Michael. *Angry White Men: American Masculinity at the End of an Era.* Bold Type Books, 2019.

Le Bon, Gustave. *The Crowd: A Study of the Popular Mind.* 1895. Cosimo, 2006.

Libcom. "5 Big Problems with *Kill All Normies*." *Libcom* 28 May 2018. https://libcom.org/article/5-big-problems-kill-all-normies. Accessed 16 April 2024.

Mapping Militants Project. "Proud Boys." *Standford University*, last modified September 2023, https://cisac.fsi.stanford.edu/mappingmilitants/profiles/proud-boys. Accessed 12 November 2023.

Marcotte, Amanda. "Trumpism before Trump: Misogyny remains the thread tying the right-wing coalition together." *Salon*, 15 July 2022, https://www.salon.com/2022/07/15/trumpism-before-trump-misogyny-remains-the-thread-tying-the-right-wing-coalition-together/. Accessed 13 March 2024.

Marwick, Alice E., and Robyn Caplan. "Drinking Male Tears: Language, the Manosphere, and Networked Harassment." *Feminist Media Studies*, vol. 18, no. 4, 2018, pp. 543–59, https://doi.org/10.1080/14680777.2018.1450568.

Massarani, Adrienne, and Shira Chess. "Attack of the 50-Foot Social Justice Warrior: The Discursive Construction of SJW Memes as the Monstrous Feminine." *Feminist Media Studies*, vol. 18, no. 4, 2018, pp. 525–42.

Massumi, Brian. "The Future Birth of the Affective Fact: The Political Ontology of Threat." *The Affect Theory Reader*, edited by Melissa Gregg and Gregory J. Seigworth, Duke University Press, 2010, pp. 52–70.

Mazza, Ed. "Gavin McInnes, Fox News Guest, Says Women Are 'Less Ambitious' and 'Happier At Home.'" *HuffPost*, 15 May 2015. https://www.huffpost.com/entry/gavin-mcinnes-women-happier-at-home_n_7289048. Accessed 13 March 2024.

Nagle, Angela. *Kill All Normies: Online Culture Wars from 4Chan and Tumblr to Trump and the Alt-Right.* Zero Books, 2017.

Ore, Ersula J. *Lynching: Violence, Rhetoric and American Identity.* University Press of Mississippi, 2019.

Palberg, Kyra. "Grenzziehungen: Kollektivsymbole und Metaphern in der Diskursverschiebung nach rechts." *Skandalisieren, stereotypisieren, normalisieren: Diskurspraktiken der Neuen Rechten aus sprach- und literaturwissenschaftlicher Perspektive*, edited by Steffen Pappert, Corinna Schlicht, Melani Schröter, and Stefan Hermes, Buske, 2021, pp. 67–89.

Proud Girls USA Official. *Telegram*, 23 December 2020.

Rafail, Patrick, and Isaac Freitas. "Grievance Articulation and Community Reactions in the Men's Rights Movement Online." *Social Media and Society*, vol. 5, no. 2, 2019, pp. 1–11, https://doi.org/10.1177/2056305119841387.

Reddit. "r/TheRedPill is quarantined." *Reddit*, no date, https://old.reddit.com/quarantine?dest=https%3A%2F%2Fold.reddit.com%2Fr%2FTheRedPill%2F. Accessed 13 March 2024.

—. "r/WhiteboyExtinction is banned." *Reddit*, no date, https://www.reddit.com/r/whiteboyextinction/. Accessed 13 March 2024.

Sherman, Carter, and Andrew Witherspoon. "Abortion Rights Across the US: We Track Where Laws Stand in Every State." *The Guardian*, 10 November 2023, https://www.theguardian.com/us-news/ng-interactive/2023/nov/10/state-abortion-laws-us. Accessed 13 March 2024.

Shullenberger, Geoff. "Redpilling and the Regime." *The New Atlantis*, no. 65, 2021, https://www.thenewatlantis.com/publications/redpilling-and-the-regime. Accessed 13 March 2024.

Strick, Simon. *Rechte Gefühle: Affekte und Strategien des digitalen Faschismus*. transcript, 2021.

—. "The *Alternative Right*, Masculinities, and Ordinary Affect." *Right-Wing Populism and Gender: European Perspectives and Beyond*, edited by Gabriele Dietze and Julia Roth, transcript, 2020, pp. 233–60.

Suliak, Hasso. "Karlsruhe stärkt Rechte leiblicher Väter." *Legal Tribune Online* 4 April 2024, https://www.lto.de/recht/hintergruende/h/1bvr201721-bverfg-vaterschaft-kinder-familie-vaterschaftsanfechtung-leiblicher-biologischer-vater/. Accessed 14 June 2024.

The Golden One. "Manliness, Feminism, Bad Male Role-Models, Anti-Female Sentiments." *YouTube*, 31 January 2023, https://www.youtube.com/watch?v=rw_6Iep3K7Q. Accessed 13 March 2024.

—. "The Women Question." *Altcensored*, 5 December 2016, https://altcensored.com/watch?v=Oaxy9mqxO-Y. Accessed 13 March 2024.

—. "White Man. Stop Letting Your Woman Trample You Down." *Altcensored*, 25 January 2018, https://altcensored.com/watch?v=dnE3mlQmeQE. Accessed 13 March 2024.

—. "Why I Hate Porn and Why You Should Stop Watching It." *YouTube*, 14 June 2017, https://www.youtube.com/watch?v=guck9gUOIls. Accessed 13 March 2024.

"Top Webites Ranking." Similarweb.com, October 2023, https://www.similarweb.com/top-websites/. Accessed 13 March 2024.

u/EricAllonde. Comment on u/[deleted]. "Equality Feels Like Oppression?" *Reddit*, 14 July 2022, https://www.reddit.com/r/MensRights/comments/vyojws/comment/ig3y3j6/. Accessed 13 March 2024.

u/Spiritual_Age_4992. "Scientific Proof of Alpha Fucks/Beta Bucks." *Reddit*, 15 May 2022, https://www.reddit.com/r/PurplePillDebate/comments/upxnu4/scientif ic_proof_of_alpha_fucks_beta_bucks/. Accessed 13 March 2024.

u/sulkilystage. "Progressive Males Are Not Men." *Reddit*, 15 August 2022, https://www.reddit.com/r/MurderedByWords/comments/wpc9le/progressive_males_are _not_men/. Accessed 13 March 2024.

Vogelmann, Frieder. *Umkämpfte Wissenschaften—zwischen Idealisierung und Verachtung*. Reclam, 2023.

Wendling, Mike. " Ex-Proud Boys Leader Enrique Tarrio Jailed For 22 Years for Capitol Riot." *BBC News*, 6 September 2023, https://www.bbc.com/news/world-us-c anada-66712589. Accessed 13 March 2024.

Woods, Heather Suzanne, and Leslie A. Hahner. *Make America Meme Again: The Rhetoric of the Alt-Right*. Peter Lang, 2019.

The Aesthetics of Oceanic Kinship in Climate Change Poetry and Activism

Katharina Fackler

Introduction

In our current historical moment, a deep sense of ecological crisis has generated a strong desire for different ways of relating to and with the natural world (Huggan and Tiffin 5–7). Activists, artists, and ecocritics alike criticize extractivist approaches that treat the environment as a mere resource "for the taking" and thereby "devaloriz[e]," as Macarena Gómez-Barris puts it, "the hidden worlds that form the nexus of human and nonhuman multiplicity" (5). Simultaneously, many people across the globe are searching and advocating for other forms of being in and with the more-than-human world. In this article, I consider how the notion of more-than-human kinship has become a highly productive and versatile trope in the artistic and activist quest for re-imagining human and nonhuman collectivity and agency.

This trope, I argue, provides an important complement to other forms of environmentalist discourse. Critical debates about the Anthropocene, for instance, have often emphasized the destruction that humans collectively wreak on the planet through anthropogenic green-house gas emissions (Crutzen and Stoermer). This framework has been criticized, among other things, for its totalizing conception of the human, which glosses over the logics and processes through which only some members of the species have driven ecological ruin, often to the detriment of others. Eve Tuck and Wayne Yang, for instance, have argued that anthropocentrism is deeply ingrained in settler colonialism. They write that "[t]he settler, if known by his actions and how he justifies them, sees himself as holding dominion over the earth and its flora and fauna." Thereby, certain (human) subjects are considered "more human, more deserving than other groups or species" (6). From this perspective, the ecological disasters of the "Anthropocene" are closely linked with dominant notions of what it means to be a human agent on this planet.

Racialized settler colonial logics also pervade certain forms of environmentalism and ecological governance. What Aimee Bahng calls "settler environmentalism"

denotes an approach that aims to protect "the environment" at the same time as it sees it "as something to be measured, contained, regulated, and [...] governed." Settler environmentalism "arises out of Euro-American notions of private property and Enlightenment Man as superior to nonhuman animals as well as other humans racially construed to be premodern and therefore unable to comprehend and hold the reins of self-governance" (48). The Indigenous philosopher and environmental theorist Kyle Powys Whyte (Potawatomi) thus argues that dominant responses to climate change are governed by a "crisis epistemology." By highlighting the crisis' perceived urgency and unprecedentedness, this epistemology justifies the perpetuation of settler colonialism through climate action (Whyte, "Against Crisis Epistemology" 55).

The language of ecological kinship, in contrast, helps register the agency of members of the nonhuman world at the same time as it provides impulses for a different notion of human agency that comes with obligations of care, stewardship, and reciprocity to the more-than-human. Such notions of ecological kinship, I will show, are often shaped by the material and metaphorical valences of water. As watery paradigms, logics, and aesthetics help throw into relief the interconnectedness of human and more-than-human bodies across time and place, they help recalibrate the meanings and implications of collective agency. More specifically, this article engages the widely viewed and discussed 2018 video poem "Rise," which resulted from a collaboration among the performance poets and climate activists Kathy Jetñil-Kijiner and Aka Niviâna with the international grassroots organization 350.org. Aiming to make visible Indigenous islander perspectives and to appeal to global audiences at the same time, the video develops a multiscalar language and aesthetics of kinship. This language is rooted in, celebrates, and adapts specific, place-based Indigenous notions of human and nonhuman kinship and interweaves them with an imaginary of transoceanic and trans-Indigenous sisterhood. By doing so, it frames its critique of fossil capitalism within an alternative notion of collective agency. While the video poem does not necessarily offer a full-fledged environmental ethics, I suggest that the language of kinship can help make legible and center Indigenous cosmologies and onto-epistemologies. It thus puts pressure on the ecological imagination, which has too often been shaped by settler colonial paradigms.

Kinship, Ecology, Water

The idiom of kinship is widely used in the scholarship on relationality and belonging among humans and, increasingly, between humans and the more-than-human world. Since the 1980s, the field of kinship studies has shifted its focus away from the nuclear family and towards a wider range of "affiliations, affinities, and belong-

ings" (Fackler and Schultermandl 197). Today, kinship is no longer understood as a linear and static biological relationship. Rather, the term registers complex social practices that involve a deep sense of mutuality. David Schneider's phrase "*doing* kinship" frames kinship as a cultural practice. For Marshall Sahlins, kinship is defined by a "mutuality of being" among "people who are intrinsic to one another's existence" (28). This mutuality of being "encompasses practices of mutual care which emerge from an understanding of interdependence, collectivity, and affiliation" (Fackler and Schultermandl 197). The nuclear family ideology, in turn, has come under intense scrutiny for its implication in processes of colonization and ecological exploitation. Mark Rifkin, for instance, demonstrates how linear and heteropatriarchal notions of family, in connection with the logics of private property, have served "as a key technology of settler imperialism" (24). By imposing nuclear family logics onto Indigenous people and lands, laws such as the Dawes Allotment Act helped further Indigenous erasure at the same time as they made land available for capitalist extraction.

Kinship, however, can also be part of an anti-imperial critical vocabulary when Native people use it to name and describe their own social formations as they differ from the privatized domesticity imposed by the liberal state. Mark Rifkin thus argues that "kinship" can serve as a "threshold concept" or "matrix of translation" that makes legible sociopolitical structures that are otherwise erased (15–17). Scholarship in Indigenous studies and Indigenous ecocriticism often honors Indigenous cosmologies that are founded on a sense of multispecies kinship extending far beyond the human (see LaDuke). Sometimes, such approaches run the risk of evoking the stereotype of the "noble savage" by simplifying the diversity and adaptability of Indigenous ways of being, thinking, and feeling (Tallbear 50). Settler scholars in particular need to be mindful of the fact that they cannot and should not fully access Indigenous "analytics and practices of existence" (Povinelli 6). Accordingly, this article does not aim to make claims about Indigenous onto-epistemologies. Rather, it observes how the language of kinship has acquired a mediating function in transnational environmentalist discourse, as Indigenous and non-Indigenous artists and thinkers have used it to make visible and legible, mostly to non-Indigenous audiences, forms of being in and with the world that exceed and resist the paradigms of extractive capitalism.

The language of kinship thus helps propel a move away from settler-capitalist understandings of the environment as a resource or inanimate object. Understanding the nonhuman as deeply entangled with human belonging, well-being, and survival, the idiom of kinship expands notions of collective agency beyond the human. Animals, bodies of water, or other elements of the natural world are often seen as relatives or ancestors that have enabled the current generations' existence and that, for the sake of future generations, must be honored, respected, and cared for. The recognition of kinship, Gavin van Horn writes, involves "a respect for the agency of

other beings and concerted efforts to treat them with dignity and even deference" (6). For Anja Kanngieser and Zoe Todd, drawing on Métis philosophies, "it is clear that lands, waters, and atmospheres in what is currently known as Canada and North America are agential beings understood through complex forms of interrelatedness and kinship with humans; they have histories that extend far beyond human existence" (389). In other words, agency is not understood as a prerogative of humans. Rather, the nonhuman world, too, consists of "agential beings." And such a more comprehensive understanding of agency is foundational to the ways in which humans collectively interact with the world that surrounds them.

In a 2018 piece on "Settler Colonialism, Ecology, and Environmental Injustice," Kyle Whyte provides one example of how the idiom of kinship can serve a mediating function between specific Indigenous ways of living and scholarly discourse in the environmental humanities. He defines the notion of Anishinaabe "collective continuance" as based on three concepts: "(1) interdependent relationships (or interdependence), (2) systems of responsibilities, and (3) migration" (126). In Anishinaabe traditions, Whyte explains, "reciprocity or mutuality between humans and the environment [are] a central feature of existence" (128). In contrast to the "'toxic relationship' that humans entertain with the planet through" extractive capitalism (Germanaz et al. 15), humans are to encounter the nonhuman world on eye-level, with feelings of care and responsibility that involve not just taking but also giving. According to Whyte,

> [r]eciprocity is understood through the gift-giving and -receiving relationship in which each party has a special contribution to make. But to become a party in a relationship, one must be transformed into a relative with reciprocal obligations, and transformation often occurs through ceremonies and other formal activities. Anishinaabe kinship relationships connected, via reciprocal responsibilities, humans with other humans, humans with nonhumans, whether spirits, plants, animals, or elements (e.g., water) and humans with particular places. ("Settler Colonialism" 131)

In other words, Whyte highlights how, in Anishinaabe culture, kinship responsibilities are systematized and coordinated through intricate, wide-ranging, and situated sets of practices and institutions. Such practices and institutions, Whyte emphasizes, are not immutable but have a high capacity for adaptation and for fostering resilience. With the notion of kinship, Whyte thus gestures towards a specific affective language of reciprocity, mutuality, and care that otherwise remains illegible to dominant, speciated, gendered, and racialized Western thought. Importantly, this language does not suggest full access to or knowledge of Anishinaabe lifeways.

Such Indigenous notions of kinship have deeply shaped conceptual thought in the environmental humanities. After years of working with Aboriginal peoples, Aus-

tralian-based ethnographer Debora Bird Rose suggested "the kinship mode" as a way of thinking about the ways in which life and survival on Earth are always already entangled. After all, Rose argues with Gregory Bateson, "the unit of survival is not the individual or the species, but is the organism-and-its-environment." The kinship mode therefore "situates us here on Earth, and asserts that [...] we are at home where our kind of life (Earth life) came into being, and we are members of entangled generations of Earth life, generations that succeed each other in time and place" (Rose 64; van Dooren and Chrulew).[1]

Donna Haraway's *Staying with the Trouble*, in turn, adapts the language of kinship to her idea of survival and thriving in a climate-changed world where long-standing relations have been ruptured through various forms of migration. She points out, with Anna Tsing, that climate change and the increasing pressures on ecosystems lead to the disappearance of refuges where human and nonhuman critters "sustain reworlding in rich cultural and biological diversity" (100). Our only hope to cope with the current crisis is to make "oddkin," i.e. "making kin non-biogenetically" ("Staying" 103), "by cultivating a sense of accountability and 'response-ability' beyond such too-often naturalized categories of gender, sex, race, nation, reproduction, or species" (*Staying* 28). "Oddkinship," according to Haraway, can lead us out of the Anthropocene into a time and place where refuges are replenished. What Haraway calls the "Chthulucene" is defined by "intense commitment and collaborative work and play with other terrans, flourishing for rich multispecies assemblages that include people" (*Staying* 101):

> "Kin" means cultivating response-ability for each other, whether one wants to or not. I have a relative; a relative has me. Let us recognize relatives as fast and well as "we" can. Let us start with welcoming refugees into innovative, robust, enduring, multigenerational kindreds in places where "we" live, cobbling together the needed home-making, city-making, and region-making practices. (Haraway, "Staying" 104)

While there are significant differences between Whyte's and Haraway's notions of kinship, they both posit our current ecological crises as entangled with dominant forms of collectivity and notions of collective agency. While the "idea of 'collective agency'" predominantly used in Western scholarship, "remains haunted by the

1 As Anja Kanngieser and Zoe Todd point out, the kinship mode also has important implications for scholarly research. Scholars "need to recognize and respect relationships imbricated through human interactions with specific places." They therefore caution against the classic academic "case study" that seeks to abstract and universalize. Instead, they advocate "kin studies," by which they mean a process of attunement that respects boundaries and first and foremost asks how to be good kin. In their words, kin studies "is a practice of accepting what you don't know and attending to what you are invited to know in more sensitive ways" (392).

framework of individualism" (Knewitz, in this volume, 24), the idiom of kinship not only puts into question the primacy of the human individual and the heteropatriarchal family. It also provides pathways toward re-imagining what collective agency can and should be in a more-than-human world.

This language of kinship, I argue, also has considerable confluences with the recent turn towards the oceans and water in the humanities. While many disciplines in the humanities have long been dominated by land-based concepts and paradigms, the Blue Humanities ask how basic assumptions may shift once we center the presence and force of the oceans and water more broadly (Blum; DeLoughrey, "The Oceanic Turn"; DeLoughrey, "Toward a Critical"; Howard; Oppermann; Mentz). By doing so, the Blue Humanities help us rethink landed concepts, including kinship. Thereby, land and ocean are not considered binary opposites. As archipelagic American studies and island studies scholars, such as Michelle Stephens and Brian Russell Roberts or Epeli Hau'ofa, have established, the land and the sea are inherently connected. The oceans' materiality is marked by fluidity, by incessant mobility, by constant mingling, and by circular moves rather than teleological linearity. As such, they have the potential to materially and metaphorically dissolve land-based notions of autonomous enclosed private property, passed on along vertical kinship lines, or autonomous individual personhood and agency.

In their recent volume on *Indigenous Pacific Islander Eco-Literatures*, Kathy Jetñil-Kijiner, Leora Kava, and Craig Santos Perez draw a direct connection between the place that water holds in Pacific Islander cultures and ecological ethics founded on principles of kinship. They state that an "ethics of movement and connection" derives "from our relationships to water, which we hold from our ancestral stories to the ways water lives in our everyday lives. Our waterways behave, adapt, and change in ways that teach us definitions of connection, kinship, and responsibility." They use the example of nuclear pollution and of the Nuclear Free and Independent Pacific movement to illustrate how water demands an ethics of connection rather than separation or enclosure. According to them, these ecological crises throw into relief the fact that "what happens to one part of our ocean affects all parts of our ocean. What happens to one part of our body affects all parts of our body" (Jetñil-Kijiner et al. 59).

In this, their position resonates with the aqueous posthumanism of philosophers Astrida Neimanis and Stacey Alaimo. They, too, highlight the myriad connections among human and nonhuman bodies of water. In Neimanis' words, "we leak and seethe, our borders always vulnerable to rupture and renegotiation. [...] Our wet matters are in constant process of intake, transformation, and exchange—drinking, peeing, sweating, sponging, weeping. Discrete individualism is a rather dry, if convenient, myth" (2). Considered from such a watery perspective, human bodies can hardly be imagined as separate from one another or the natural environment. Rather, the "flow and flush of waters" not only sustain individuals' bodies "but also

connect them to other bodies, to other worlds beyond our human selves" (2). Accordingly, Alaimo suggests that stories of humans' material connection with the ocean, such as Rachel Carson's *The Sea Around Us*, may "provoke a rich ethical sense of kinship between humans and other animals" as they embed human physiology in the ocean. They assert that humans "slosh [...] around with the rest of oceanic life [...] at the level of the gene," and "the sea surges through the bodies of all terrestrial animals, including humans—in our blood, skeletons, and cellular protoplasm" (116–25). From this angle, discreet individualism and purely *human* agency emerge as phantasies that in no way reflect that material realities in which our bodies are embedded.

"Rise": Climate Change, Poetry, and Transnational Activism

The idiom of oceanic kinship has made its way into climate change activism and poetry, such as the 2018 video poem "Rise." The video is the result of a collaboration between two performance poets and activists, Kathy Jetñil-Kijiner and Aka Niviâna, and the grassroots climate organization 350.org, which funded and launched the video for its global Rise for Climate campaign. Jetñil-Kijiner was born in the Republic of the Marshall Islands. Like many Marshall Islanders, she grew up in Hawai'i and was partly educated in California. She gained international attention when she opened the 2014 UN Climate Summit in New York with her poem "Dear Matefele Peinem" and she has been a prominent advocate of the Pacific Islands in the global climate and anti-nuclear movements. In 2017, she published her first poetry collection, titled *Iep Jāltok: Poems from a Marshallese Daughter*. Aka Niviâna grew up in a small town at the northern coast of Kalaallit Nunaat, Greenland. She is now based in Nuuk, the capital of Greenland, where she works on environmental issues as well as in various capacities in the creative industry ("Artist Profile"). Niviâna was introduced to Jetñil-Kijiner by glaciologist Jason Box after speaking at a climate protest in Copenhagen in 2018 (Faris 78). Together, they went on a "poetry expedition" to Greenland, accompanied by film makers Dan Lin, Nick Stone, Rob Lau, and Oz Go ("Rise").

350.org is an international environmentalist organization that seeks to end the use of fossil fuels. Using art, literature, and social media to appeal to a transnational audience, its campaigns bring together diverse grassroots activists and groups across the globe. Thereby, the organization serves as what Caroline Levine calls a "network of networks." It "acts as a hinge, encouraging, training, and linking local divestment groups as they build their own campaigns, and then sharing accumulated lessons and contacts with all new groups that emerge" (Levine 137).[2] By doing so, the organization operates in a field of tensions between a wide range of discourses, cultures, and ways of feeling. Climate change is a planetary problem,

2 I am grateful to Caroline Levine for sharing the unpublished book manuscript.

but its local meanings and implications, along with the capacities for mitigation and adaptation, vary greatly. 350.org aims to provide a platform for the experiences of frontline communities that are facing the worst effects of the climate crisis while having contributed least the least emissions. It also aims to appeal to diverse global audiences, most urgently to those people who are leading greenhouse gas-intensive lifestyles.

Jaimey Hamilton Faris has thus described the organization as an "'eco-cos-mopolitan' [...] platform" (77). Eco-cosmopolitanism or world citizenship, according to Ursula Heise, is both an imperative and a challenge. The planetary scales of the current ecological crises require us to "envision [...] ecologically based advocacy [...] formulated in terms that are premised no longer on ties to local places but on ties to territories and systems that are understood to encompass the planet as a whole" (10). Yet, in their attempts to speak to "global" audiences, cultural representations of climate change have often resorted to and adapted age-old simplifying, colonial tropes. The colonial impulses residing in certain environmentalist discourses have particularly affected the representation of people living on Pacific Islands, who are often depicted as exotic, voiceless victims helplessly drowning in a rising ocean. Elizabeth DeLoughrey describes the essentializing and de-historicizing represen-tations of Pacific Islanders that circulate in environmentalist films as a kind of "salvage environmentalism" whose critique of American petrocapitalism is based on a rendition of "Pacific Islanders as the harbingers of climate change," "as figures of an isolated, natural and nature-loving culture" (189). This mode of represen-tation not only erases the individual and collective agency that Pacific Islanders have displayed in the struggle against climate change. It also shrouds viewers' own complicity and agency in climate-warming practices (191).

Faris argues that 350.org, in its attempt to speak to a global problem by lend-ing visibility to local and Indigenous experiences and perspectives, "at times essen-tialises specific local environmental concerns, plays into exoticising tropes of [...] 'frontline' communities, while also enabling connections across translocal groups" (Faris 77; Heise). In a video on the making of "Rise," Jetñil-Kijiner relates that the original framework proposed by 350.org would have only her traveling to Greenland, but she felt uneasy representing someone else's homelands and asked to include an Inuk Indigenous artist ("Rise"). The result of her collaboration with Niviâna, in turn, is a performance of transoceanic kinship that speaks back against colonial tropes not only by centering Indigenous women and epistemologies but also by adapting and inserting them into the language of global climate change activism. In the pro-cess, they develop a multiscalar language and aesthetics of kinship that interweaves different models of and responses to collective agency.[3] Climate change emerges as

3 On the poetics of weaving in Jetñil-Kijiner's poetry, see Sipahi.

not only a problem of fossil fuel consumption but as a crisis of connection and care woven into (settler) colonialism and extractive capitalism.

The Aesthetics of Oceanic Kinship in "Rise"

Jetñil-Kijiner and Niviâna dedicate the first third of their poem to a performance of what Faris calls "Indigenous transoceanic solidarity" (76) and a "feminist hydro-ontological perspective" (78). They perform a kind of sisterhood that centers Indigenous women and that is founded on shared principles of reciprocity, mutuality, and kinship with land and water. The video opens with a panoramic view of the ocean, accompanied by a cello track. In contrast to Romantic nature imagery or touristic ads, the viewers are not looking down onto the scenery from a high angle that suggests mastery and control. Rather they are positioned at the level of Jetñil-Kijiner's feet, on eye-level with the sea and its ever-moving ebb and flow. Jetñil-Kijiner opens the poem by addressing Niviâna in verses that perform transoceanic connection at the same time as they emphasize rootedness: "Sister of ice and snow, / I'm coming to you / from the land of my ancestors, / from atolls, sunken volcanoes—undersea descent / of sleeping giants." The camera then shows a close-up of Greenlandic glacier ice whose colors resonate with the color of the Marshallese sea and Jetñil-Kijiner's dress, as Niviâna responds: "Sister of ocean and sand / I welcome you / to the land of my ancestors / —to the land where they sacrificed their lives / to make mine possible / —to the land / of survivors." The following stanza again uses parallelisms and references to "land," "ancestors," and water, as the Marshall Islands are described as "a country more sea than land" and Greenland as "the biggest island on earth."

Next, the two poets affirm their bond by performing a ceremonial exchange of gifts and traditional stories. Jetñil-Kijiner brings shells from the Bikini Atoll and Runit Dome, along with a traditional Marshallese story about two sisters "frozen in time on the island of Ujae." One of the sisters "magically turned into stone," leading the other to choose the same fate in order "to be rooted by her sister's side." Now they stand by the edge of the reef as two rocks, teaching people "a lesson in permanence" to this very day. Niviâna then offers stones picked from the shores of Nuuk, telling the story of Sassuma Arnaa, the "Mother of the Sea, who lives in a cave at the bottom of the ocean." Whales, streams, and icebergs are her children, whom she wants to see respected and treated well. Sassuma Arnaa watches over humans' feelings and behaviors towards oceanic beings, and she "sees the greed in our hearts/ the disrespect in our eyes." "When we disrespect them," Niviâna says, "she gives us what we deserve, / a lesson in respect." In other words, Sassuma Arnaa, the "guardian of the sea," has the powers to hedge in humans' collective agency.

These first scenes, along with the poets' paralleling verses, evoke a range of forms and genres of kinship. First, the poets anchor their sisterhood in their connected-

ness with their own home islands as places of multigenerational and multispecies belonging and nurturance. By sharing these stories and gifts, the two poets evoke their own specific Indigenous cosmologies and local forms of belonging among humans and nonhumans on the Marshall Islands and Greenland. The meaning of these stories within their respective oral cultures and their implications for their practices of existence remains beyond my purview as a non-Indigenous scholar. My focus is on the cultural work that these stories do in the context of transnational climate-change activism. By sharing them right at the outset of the video, I suggest, Jetñil-Kijiner and Niviâna frame their demand for climate change mitigation within Indigenous practices and worldviews. The combination of (performance) poetry, film, music, and storytelling allows them to inscribe Indigenous presence and agency onto the dominant environmentalist images of exotic Pacific Islands and melting glaciers. In contrast to dominant representations, which "rarely ma[k]e [such places] meaningful on their own" (Hobart 3), Jetñil-Kijiner and Niviâna's video performance begins to reclaim the sight of these lands and waters for and into Indigenous worldviews, yet without suggesting that viewers can or should fully access Indigenous epistemologies. The two poets thus not only share these stories with each other, they also offer the video's viewers an opportunity to begin to engage with specific Indigenous analytics of existence that posit crucial alternatives to both capitalist extractivism and settler environmentalism (Whyte, "Settler Colonialism"; Bahng 48–49).

As the poets insist in their first verses that their lives have been made possible by human and nonhuman "ancestors," they situate their own physical and spiritual existence within a temporality that far exceeds the lifespan, or agency, of the human individual. The term "ancestors," taken from Indigenous cultures and transferred into the language of global climate change poetry, thus references an imaginary of kinship in which the individual emerges from a multi-generational, multi-species collectivity, a dense web of life to which they also have obligations as ancestors of future generations. Whereas definitions of the environment as a resource under settler capitalism tend to operate within the short-term temporalities of individuals' or corporations' profit accumulation (Moore), the language of kinship insists that the function and value of the more-than-human world are neither limited to one generation nor to the paradigms of investment and profitability.[4] Clearly, the natural world is much more than a resource to be extracted. In other words, the video poem here begins its reasoning with an Indigenous onto-epistemology of place that posits ways of knowing and being as co-constituted by—and yet not limited to—specific environments.

Both stories shared by the poets display strong continuities between the human and the more-than-human worlds as well as between the land and the sea.

4 For a recent critique of the economist logics of current climate and environmental governance see Buller.

In the Marshallese story, rocks in the water possess a human history and identity that makes them ancestors and role models. Rather than individual advancement or (human) agency, the second sister chooses turning to stone for the sake of maintaining the communal bonds with her sibling. In other words, she uses her individual agency to choose collectivity. Notably, this form of collectivity and belonging crosses the boundary between what Western thought defines as the human and the inanimate. As a consequence, "inanimate" rocks emerge as more than objects or resources. Representing a deep sense of connectedness with and rootedness in the land and the water, they become teachers for future generations.[5] Niviâna's story, in turn, imagines the sea as a powerful mother who reminds listeners of their responsibilities across species boundaries. Caring for and respecting the nonhuman world is a mandate whose disregard will have consequences. In other words, humans' collective agency is to be guided by principles of ecological kinship among humans and nonhumans. If these are not heeded, natural elements, as animate, agential forces, will enforce limits on human agency.

By sharing these stories, Jetñil-Kijiner and Niviâna invite their viewers to immerse themselves in these storyworlds and their structures of feeling, which resonate, among others, with a language of animacy. Robin Wall Kimmerer has pointed out how the Potawatomi and most other Indigenous languages display what she calls a "grammar of animacy." When, for instance, pronouns do not distinguish between human and more-than-human agents and when verbs dominate over nouns, she writes, "[t]he language reminds us, in every sentence, of our kinship with all of the animate world" (56).[6] Whereas the English language draws clear lines between human actors and nonhuman objects, many Indigenous languages "use the same words to address the living world as we use for our family. Because they are our family" (55). The stories that Jetñil-Kijiner and Niviâna share may have been translated into English, but they both model ways of engaging the more-than-human world as agential forces that powerfully shape human lives and that deserve care and respect.

5 On animacies, also see Chen.

6 Kimmerer notes that seventy percent of Potawatomi words are verbs, compared to only thirty percent in the English language (55). Such basic grammatical structures, she argues, create a tendency towards objectifying the natural world in English while the Potawatomi language helps its speakers register the "unseen energies that animate everything" (49). As she writes: "A bay is a noun only if water is dead. When bay is a noun, it is defined by humans, trapped between its shores and contained by the word. But the verb wiikwegamaa—to be a bay—releases the water from bondage and lets it live. 'To be a bay' holds the wonder that, for this moment, the living water has decided to shelter itself between these shores, conversing with cedar roots and a flock of baby mergansers. Because it could do otherwise—become a stream or an ocean or a waterfall, and there are verbs for that, too. To be a hill, to be a sandy beach, to be a Saturday, all are possible verbs in a world where everything is alive" (55).

By doing so, "Rise" resists what Elizabeth Povinelli calls the geontopower of the lib-eral settler state. "Geontopower" denotes "a set of discourse, affects, and tactics" that "shape the coming relationship of the distinction between Life and Nonlife" (4). This means that the liberal state routinely attributes to colonized people an "inability [...] to differentiate the kinds of things that have agency, subjectivity, and intentionality" (5). Logics that do not adhere to the dominant geontological regime are marked as premodern or otherwise different. Through its vibrant visual and poetic language of kinship, "Rise" presents a persuasive alternative to geontological imaginaries.

The video poem's filmic structure similarly evokes notions of mutuality, reci-procity, and kinship. The language of sisterhood, the visit, and the exchange of gifts are equivocated by a steady back-and-forth of alternating scenes from the Marshall Islands and Kallaalit Nunaat. Different shades of blue in the sea and the ice, along with the organic shapes of the landscapes, resonate with one another, suggesting profound interconnections and a respectful encounter between the two sisters as well as the lands and the waters they belong to. As Faris points out, the opening verses establish not only the bond between the two poets but also a hydrological connection between "ice and snow" and "ocean and sand" (85). Just like Neimanis's aqueous bodies, their bodies, fates, and cultures are linked by ocean water.

Both examples throw into relief how (Indigenous) storytelling can serve vital so-cial and emotional functions by steering formations of collective agency away from settler onto-epistemologies and toward alternative meanings, geographies, and re-lationalities. Mishuana Goeman argues that "Native stories extend beyond a beau-tiful aesthetic and simple moral or fable." Rather, "Native people hold the power to rethink the way we engage with territory, with our relationships to one another, and with other Native nations and settler nations. And it is our stories that will lead the way as they have for generations." Stories thus can develop their own kind of agency by guiding and transforming forms of being-in-common with the human and the more-than-human world. Goeman points out that "stories" does not nec-essarily have to refer to Native "stories from time immemorial." Contemporary In-digenous cultural practices can acquire similar meanings and functions, in particu-lar when they tend "in a single breath or word to recall hundreds, even thousands of years back by employing community, personal, and historical stories in intertextual moments" which gesture beyond the relationships mapped out by the settler state (Goeman 39–40; Robinson 324). Jetñil-Kijiner and Niviâna's "Rise" may well be con-sidered such an "intertextual moment." As it interweaves references to traditional Indigenous oral storytelling with the language of contemporary climate change ac-tivism, the video poem articulates notions of community in a multigenerational, transoceanic web of life.

The two protagonists of the video poem thus do not meet as autonomous individuals but they come endowed with a culture and history that is entangled with multispecies relatives and place. This by no means involves an essentializing

notion of static, "Othered" Indigenous culture. On the contrary, on the homepage of 350.org, in a subsection titled "The Process of the Poem: Selecting the Legend," Jetñil-Kijiner relates a process of curation and creative adaptation. Her point of departure is not Marshallese cosmology that she is already familiar with but Niviâna telling her that "her legend would focus on a powerful woman of the sea." When Jetñil-Kijiner asked Marshallese elders at the Customary Language and Law Commission in Majuro about legends of powerful women, "they said they didn't know of any." Yet, luckily, she receives "a packet of legends transcribed by Marshallese teachers. They are in Marshallese, which she reads much more slowly than English, but eventually she finds two stories and discusses their meaning and their possible links with the Greenlandic stories, via Skype, while en route to Greenland, with their respective transcribers. This video thus presents Jetñil-Kijiner not as the passive carrier of an unchanging Indigenous culture but rather as an agential Indigenous woman who makes conscious use of Indigenous traditions by selecting certain elements of her culture that seem helpful to the current moment and adapting them to a global, twenty-first century context. In other words, while Pacific Islanders may often be cast as immobile, passive victims of climate change, Jetñil-Kijiner highlights mobility, collaboration, female agency, and active processes of transfer, translation, and adaptation. Along these lines, Jetñil-Kijiner and Niviâna's performance of transoceanic Indigenous sisterhood is constituted not through essentializing logics of biology and lineage but through a creative collage of oral storytelling, ritual, poetry, and activism.

The second third of the video poem adds another dimension to the performance of trans-Indigenous sisterhood: a shared sense of vulnerability to colonialism and climate change.[7] The poem's mood, along with the cello music, gets more somber as the two poets present their grievances to each other. Again centering island perspectives, their verses combine a performance of care and mutual listening across oceans with an activist stance demanding political and social change: "From one island to another / I ask for solutions. / From one island to another / I ask for your problems." Niviâna first mentions "the melting ice" and "the hungry polar bears." Jetñil-Kijiner then references "the tide / that comes for us faster / than we'd like to admit. [...] forcing us to imagine / turning ourselves to stone." As the two poets speak in turns to describe existential threats caused by climate change, the camera moves back and forth between the Marshall Islands and Greenland, alternating close-ups of sea water and ice, panorama shots of both islands, and longer, portrait-like images of smiling islanders. On the one hand, this sequence of scenes highlights the fact that the melting ice of one poet's home will flood the other's, destroying the lifeways and livelihoods of both. On the other hand, close-ups on the faces of proud, smiling

7 On trans-Indigeneity, see Allen and Somerville.

islanders, many of them children, emphasize their embodied presence, their liveli-
ness, and their will to survive.

Importantly, the poets articulate climate change and their own sisterhood in
the longue durée of Western colonialism and militarism, which have long under-
mined Indigenous sovereignty and collective agency. As they do so, their perfor-
mance interlaces their voices and perspectives, couching their references in affective
language that highlights their emotional bond with their environments. One stanza
is opened by Jetñil-Kijiner's voice stating "Sister of ice and snow, / I come to you now
in grief" and continued by both chorusing "mourning landscapes / that are always
forced to change." Then their voices alternate as they drop brief references to their
islands' respective histories, including "wars inflicted on us" (Niviâna) and "nuclear
waste / dumped / in our waters" (Jetñil-Kijiner), "on our ice" (Niviâna). Together they
conclude with "and now this" as viewers see a close-up of melting glacier ice and bar-
ren rock with a receding glacier in the background.

Their islands' colonial histories may not be identical but their performance high-
lights their similarities and interconnections. And both claim Indigenous counter-
stories to dominant Western narratives of modernity which can only be sketched
out here. Greenland was used as a strategic defense location by the United States
in World War II. After the war, the U.S. made an agreement with Denmark that al-
lowed them to continue military operations and, among others, go through with the
so-called "Project Ice Worm." In this context, the U.S. military built and launched
missiles using nuclear generators. When the project was abandoned in 1966, the
nuclear waste was buried underground in the Arctic. As global warming is chang-
ing local geologies, new risks of nuclear contamination have emerged (Hobart 8–9;
Faris 87). Dominant narratives have continuously linked the project of militarization
with the securing and spread of Western democracy and freedom, which have often
been associated with an American way of life embodied by nuclear, heteropatriarchal
families and settler notions of domesticity (Hobart 7–9). Yet, from an Indigenous
perspective, these projects have meant recurring and ever-changing forms and lay-
ers of settler colonialism that threaten Indigenous lifeways along with multispecies
health and survival.

Parts of the Marshall Islands, in turn, were used by the U.S. as a laboratory for
nuclear tests. Told that their removal would serve "the good of mankind and to end
all world wars" (Teaiwa 89), inhabitants of the Bikini and Ānewetak Atolls were co-
erced into leaving their land with false promises of a speedy return and a higher pur-
pose. Those who stayed were often not protected against the fallout of the over forty
atomic bombs launched between 1948 and 1958 (Rust). The nuclear waste was sealed
in the so-called Runit Dome. Named the "Tomb" by locals, it is built atop an unlined
crater left by a nuclear bomb in porous lime stone. Many locals, researchers, and
Marshallese officials have expressed concern that nuclear waste may still be seeping
into the Pacific. In some areas, researchers have measured radiation levels that "ri-

val those found near Chernobyl and Fukushima" and Marshall Islanders have experienced severe and ongoing health crises, including high rates of cancer, miscarriage, deformations, and thyroid disorders (Rust; Hobart 10; Faris 85). Long struggles with the U.S. government for full acknowledgment of the environmental damage along with the settlement of health and property claims, have eroded trust between both countries.[8] More recently, it has become known that, from 1968 onward, the United States used the islands as a test ground for conventional and bioweapons (Rust). The harms that nuclear pollution has inflicted on Marshall Islanders are an instance of what Rob Nixon calls "slow violence," which is a kind of violence that does not occur all at once but gradually, "dispersed across time and space," so that it is often not recognized as violence at all (2).

It is only after establishing the connections between each other, their home-islands, and their colonial histories that Niviâna and Jetñil-Kijiner launch their critique of carbon capitalism. They turn from the "we" of transoceanic connection and sisterhood to "colonizing monsters" that threaten their lifeways and livelihoods. These monsters, they continue, "to this day devour our lives / for their pleasure." And they "now decide, / who should live / and who should die." This figurative language avoids blaming specific subjects or groups of people. Rather, the "monsters" and "beasts" draw attention to biopolitical regimes that violate and rupture multispecies kinship through their differential valuation of (human) life forms.

Only in the antepenultimate and the penultimate stanzas, the two performers address a "you" that is not their respective transoceanic sister but an addressee that is implicated in and aware of the lethal effects of carbon capitalism without acting. Taking turns, Jetñil-Kijiner and Niviâna state in an increasingly agitated tone: "We have years. / We have months / before you sacrifice us again / before you watch from your tv and computer screens / waiting / to see if we will still be breathing / while you do nothing." As these verses establish a connection between the vulnerability of the performers' "we" and the passivity of the "you," they throw into relief not only the addressees' agency but also their moral obligation to act. Michael Rothberg's notion of "[i]mplicated subjects" describes the complex ethical role of people whose greenhouse gas-intensive lifestyles are disproportionately responsible for climate change, thus unintentionally wreaking havoc on other people's lives. Implicated subjects "are not direct agents of harm, as perpetrators, but neither are they innocent bystanders, for they inherit, inhabit, or benefit from regimes of domination—as citizens, for example, or, perhaps, as beneficiaries" (Whitlock 496; Rothberg). As "Rise" makes these regimes of domination and their impacts visible within the previously established framework of oceanic kinship, the climate crisis emerges as a global crisis of care

8 An international tribunal established by the two countries in 1988 ruled that the United States should pay $2.3 billion in claims, but Congress and U.S. courts have refused. According to research by the *Los Angeles Times*, the U.S. has paid just $4 million (Rust).

and responsibility. The performers demand that "the world see beyond [...] their oil-slicked dreams, beyond the belief / that tomorrow will never happen." Extending the logic of reciprocity, they suggest swapping perspectives with their addressees, imagining the reversal of the global biopolitics of petro-capitalism: "Let me bring my home to yours. / Let's watch as Miami, New York, / Shanghai, Amsterdam, London, / Rio de Janeiro, and Osaka / try to breathe underwater."

In the final stanza, the poem returns to the gesture of gift-giving and re-affirms its demand to expand core elements of its logic of oceanic kinship across the globe. It posits the affective language of valuing, respecting, and caring for multispecies life as an antidote to the capitalist valuation of power and profit ("our lives matter more than their power"; "life in all forms demands / the same respect we all give to money") and it again highlights the interconnectedness of all life forms across the globe ("these issues affect each and everyone of us / None of us is immune"). Eventually, the poem infuses its call to action with oceanic language, as Jetñil-Kijiner and Niviâna state: "each and everyone of us has to decide / if we/ will / rise." The titular and closing "rise" gestures toward a hydro-ontological connection between protesting human bodies and bodies of water. Protesters are not rising against the ocean, which settler logics would frame as a natural force that may be controlled and contained. Rather, "rising" suggests a sense of unity and of joining forces with the ocean. Protesters emerge not as individual or collective human agents but as agents that have recognized their role in the more-than-human world and act as part of an ecological collectivity.

Conclusion: Kinship, Collectivity, Agency

In her book on *Kānaka Maoli* (Indigenous Hawaiian) cartographies of abundance, Candace Fujikane posits Indigenous notions of multispecies kinship at the heart of a "profound epistemological shift" needed in order to secure "a planetary future." "Indigenous ancestral knowledges," she writes, "are now providing a foundation for our work against climate change, one based on what I refer to as Indigenous economies of abundance—as opposed to capitalist economies of scarcity. Rather than seeing climate change as apocalyptic, we can see that climate change is bringing about the demise of capital, making way for Indigenous lifeways that center familial relationships with the earth and elemental forms" (Fujikane 3). As I hope to have shown, Kathy Jetñil-Kijiner and Aka Niviâna's video performance "Rise" makes the idea of multispecies kinship resonate at different scales in climate change activism and poetry. In this respect, I suggest, the video poem presents an (Indigenous-centered) case in point for Ursula Heise's claim that "dynamic and interactive collage or montage," which uses "the infinite possibilities of zooming into and out of local, regional, and global views," may be a particularly productive form in current representations

of climate change (11). "Rise" performatively interweaves traditional Indigenous storytelling and cultural practice with the multimedia format of online poetry performance and the rhetoric of climate change activism. By doing so, it also conjoins different traditions, forms, and affective languages of kinship, beginning with the speakers' kinship with their island worlds, expanding to a space of transoceanic sisterhood between the Marshall Islands and Greenland, and then venturing to posit kinship logics as an alternative to extractive carbon capitalism and as a framework for reimagining climate change activism.

This expansion of Indigenous kinship logics thwarts a settler imagination that belittles and encloses islands. As Aimee Bahng has demonstrated, U.S. officials have persistently cast the islands as remote and deprived of resources, because they have failed to recognize how the Pacific constitutes a "sea of islands" (Hau'ofa) in which the oceans offer routes of connection and create abundance for Indigenous Islanders (Bahng 59). "Rise," in turn, inverts this gesture of belittlement. By interweaving various notions of kinship at different scales, it expands and adapts the language of kinship.

Evidently, these languages of kinship vary greatly, as they are more or less situated, (trans-)local, bounded, established, or formalized. And yet, as stories can model relationships and structures of feeling, "Rise" provides imaginative pathways toward an Indigenous-centered, hydro-feminist global climate change discourse. As climate change is framed as a crisis of care and responsibility in the longue durée of settler colonialism, the multiscalar language of kinship reworks not only stereotypes of islanders but also notions of human agency in the current historical moment. "Rise" holds implicated subjects accountable, demanding that they take action. However, it also suggests that climate action, and humans' capacity to effect change at large, needs to be embedded in and delineated by an awareness of the "entangled quality of life on Earth" (Rose 64), both locally and globally. As its watery aesthetics of relation defy all claims of enclosure, the poem invites its audiences to imagine agency within networks of care and responsibility across multigenerational and multispecies collectivities.

Works Cited

Alaimo, Stacy, editor. *Exposed: Environmental Politics and Pleasures in Posthuman Times.* University of Minnesota Press, 2016.

Allen, Chadwick. "A Trans*national* Native American Studies? Why Not Studies That Are Trans-*Indigenous*?" *Journal of Transnational American Studies*, vol. 4, no. 1, 2012, https://doi.org/10.5070/T841007097.

—. *Trans-Indigenous: Methodologies for Global Native Literary Studies.* University of Minnesota Press, 2012.

"Artist Profile: Aka Niviâna." Cove Park, https://covepark.org/artists/aka-niviana/. Accessed 29 February 2024.

Bahng, Aimee. "The Pacific Proving Grounds and the Proliferation of Settler Environmentalism." *Transnational American Studies*, vol. 11, no. 2, 2020, pp. 45–73, https://doi.org/10.5070/T8112049580.

Blum, Hester. "The Prospect of Oceanic Studies." *PMLA*, vol. 125, no. 3, 2010, pp. 670–77, https://doi.org/10.1632/pmla.2010.125.3.670.

Buller, Adrienne. *The Value of a Whale: On the Illusions of Green Capitalism*. Manchester University Press, 2022.

Chen, Mel. Y. *Animacies: Biopolitics, Racial Mattering, and Queer Affect*. Duke University Press, 2012.

Crutzen, Paul J., and Eugene F. Stoermer. "The 'Anthropocene.'" *IBGP Newsletter*, no. 41, May 2000, pp. 17–18.

DeLoughrey, Elizabeth. "The Oceanic Turn: Submarine Futures of the Anthropocene." *Humanities for the Environment: Integrating Knowledge, Forging New Constellations of Practice*, edited by Joni Adamson and Michael Davis, Routledge, 2016.

—. "The Sea Is Rising: Visualising Climate Change in the Pacific Islands." *Pacific Dynamics: Journal of Interdisciplinary Research*, vol. 2, no. 2, 2018, pp. 185–97.

—. "Toward a Critical Ocean Studies for the Anthropocene." *English Language Notes*, vol. 57, no. 1, 2019, pp. 21–36, https://doi.org/10.1215/00138282-7309655.

Fackler, Katharina, and Silvia Schultermandl. "Kinship as Critical Idiom in Oceanic Studies." *Atlantic Studies*, vol. 20, no. 2, 2023, pp. 195–225, https://doi.org/10.1080/14788810.2022.2079900.

Faris, Jaimey Hamilton. "Sisters of Ocean and Ice: On the Hydro-Feminism of Kathy Jetñil-Kijiner and Aka Niviâna's *Rise: From One Island to Another*." *Shima*, vol. 13, no. 2, 2019, pp. 76–99.

Fujikane, Candace. *Mapping Abundance for a Planetary Future: Kanaka Maoli and Critical Settler Cartographies in Hawai'i*. Duke University Press, 2021.

Germanaz, Axelle, Daniela Gutiérrez Fuentes, Sarah Marak, and Heike Paul. "Introduction." *To the Last Drop: Affective Economies of Extraction and Sentimentality*, edited by Axelle Germanaz, Daniela Gutiérrez Fuentes, Sarah Marak, and Heike Paul, transcript, 2023, pp. 13–21.

Goeman, Mishuana. *Mark My Words: Native Women Mapping Our Nations*. University of Minnesota Press, 2013.

Gómez-Barris, Macarena. *The Extractive Zone: Social Ecologies and Decolonial Perspectives*. Duke University Press, 2017.

Haraway, Donna. "Staying with the Trouble for Multispecies Environmental Justice." *Dialogues in Human Geography*, vol. 8, no. 1, 2018, pp. 102–05, https://doi.org/10.1177/2043820617739208.

—. *Staying with the Trouble: Making Kin in the Chthulucene*. Duke University Press, 2016.

Hau'ofa, Epeli. "Our Sea of Islands." *We Are the Ocean: Selected Works*. University of Hawai'i Press, 2008, pp. 27–40.

Heise, Ursula K. *Sense of Place and Sense of Planet: The Environmental Imagination of the Global*. Oxford University Press, 2008.

Hobart, Hi'ilei Julia. "Atomic Histories and Elemental Futures Across Indigenous Waters." *Media + Environment*, vol. 3, no. 1, 2021, https://doi.org/10.1525/001c.2 1536.

Howard, Jonathan. "Swim Your Ground: Towards a Black and Blue Humanities." *Atlantic Studies*, vol. 20, no. 2, 2023, pp. 308–30, https://doi.org/10.1080/14788810.2021.2015944.

Huggan, Graham, and Helen Tiffin. *Postcolonial Ecocriticism: Literature, Animals, Environment*. 2nd ed. Routledge, 2015.

Jetñil-Kijiner, Kathy, Leora Kava, and Craig Santos Perez, editors. *Indigenous Pacific Islander Eco-Literatures*. University of Hawai'i Press, 2022.

Kanngieser, Anja, and Zoe Todd. "From Environmental Case Study to Environmental Kin Study." *History and Theory*, vol. 59, no. 3, 2020, pp. 385–93. https://doi.org/10.1111/hith.12166.

Kimmerer, Robin Wall. *Braiding Sweetgrass: Indigenous Wisdom, Scientific Knowledge, and the Teachings of Plants*. Milkweed Editions, 2013.

LaDuke, Winona. *All Our Relations: Native Struggles for Land and Life*. South End, 1999.

Levine, Caroline. *The Activist Humanist: Form and Method in the Climate Crisis*. Princeton University Press, 2023.

Mentz, Steve. *An Introduction to the Blue Humanities*. Routledge, 2024.

Moore, Jason W. *Capitalism in the Web of Life: Ecology and the Accumulation of Capital*. Verso, 2015.

Neimanis, Astrida. *Bodies of Water: Posthuman Feminist Phenomenology*. Bloomsbury, 2017.

Nixon, Rob. *Slow Violence and the Environmentalism of the Poor*. Harvard University Press, 2011.

Oppermann, Serpil. *Blue Humanities: Storied Waterscapes in the Anthropocene*. Cambridge University Press, 2023.

Povinelli, Elizabeth A. *Geontologies: A Requiem to Late Liberalism*. Duke University Press, 2016.

Rifkin, Mark. *When Did Indians Become Straight? Kinship, the History of Sexuality, and Native Sovereignty*. Oxford University Press, 2011.

"Rise: From One Island to Another." 350.org, 1 January 2018, https://350.org/rise-fro m-one-island-to-another/. Accessed 12 March 2024.

Roberts, Brian Russell, and Michelle Ann Stephens, editors. *Archipelagic American Studies*. Duke University Press, 2017.

Robinson, Angela L. "Of Monsters and Mothers: Affective Climates and Human-Nonhuman Sociality in Kathy Jetñil-Kijiner's 'Dear Matafele Peinam.'" *The Con-*

temporary Pacific, vol. 32, no. 2, 2020, pp. 311–39, https://doi.org/10.1353/cp.2020 .0032.

Rose, Deborah Bird. *Wild Dog Dreaming: Love and Extinction*. University of Virginia Press, 2011.

Rothberg, Michael. *The Implicated Subject: Beyond Victims and Perpetrators*. Stanford University Press, 2020.

Rust, Susanne. "How the U.S. Betrayed the Marshall Islands, Kindling the Next Nuclear Disaster." *Los Angeles Times*, 10 November 2019, https://www.latimes.com /projects/marshall-islands-nuclear-testing-sea-level-rise/. Accessed 12 March 2024.

Sahlins, Marshall. *What Kinship Is—and Is Not*. University of Chicago Press, 2013.

Schneider, David Murray. *A Critique of the Study of Kinship*. University of Michigan Press, 1984.

Sipahi, Peri. "'not yet / under water': Rejecting Victimhood and Weaving Solidarity in Kathy Jetñil-Kijiner's Eco-Poetics." *Postcolonial Text*, vol. 19, no. 1 & 2, 2024, htt ps://www.postcolonial.org/index.php/pct/article/view/2887.

Somerville, Alice Te Punga. "Searching for the Trans-Indigenous." *Verge: Studies in Global Asias*, vol. 4, no. 2, 2018, p. 96–105, https://doi.org/10.5749/vergstudgloba sia.4.2.0096.

Tallbear, Kimberly. "All Our Relations: Native Struggles for Land and Life (Review)." *Wicazo Sa Review*, vol. 17, no. 1, 2002, pp. 234–42, https://doi.org/10.1353/wic.20 02.0009.

Teaiwa, Teresia K. "Bikinis and Other S/pacific N/oceans." *The Contemporary Pacific*, vol. 6, no. 1, 1994, pp. 87–109.

Tuck, Eve, and K. Wayne Yang. "Decolonization Is Not a Metaphor." *Decolonization: Indigeneity, Education, and Society*, vol. 1, no. 1, 2012, pp. 1–40.

van Dooren, Thom, and Matthew Chrulew, editors. *Kin: Thinking with Deborah Bird Rose*. Duke University Press, 2022.

van Horn, Gavin. "Kinning: Introduction to the Kinship Series." *Kinship: Belonging in a World of Relations*, vol. 5, edited by Gavin van Horn, Robin Wall Kimmerer, and John Hausdoerffer, Center for Humans and Nature, 2021.

Whitlock, Gillian. "Implicated Subjects." *a/b: Auto/Biography Studies*, vol. 35, no. 2, 2020, pp. 495–501, https://do.org/10.1080/08989575.2020.1738085.

Whyte, Kyle. "Settler Colonialism, Ecology, and Environmental Injustice." *Environment and Society*, vol. 9, no. 1, 2018, pp. 125–44, https://doi.org/10.3167/ares.2018 .090109.

—. "Against Crisis Epistemology." *Routledge Handbook of Critical Indigenous Studies*, edited by Brandon Hokowhitu, Aileen Moreton-Robinson, Linda Tuhiwai-Smith, Chris Andersen, and Steve Larkin, Routledge, 2020, pp. 52–64.

Appendix

Contributors

Natalya Bekhta is Senior Research Fellow at the Tampere Institute for Advanced Study, where she is working on a book project entitled "After Utopia: A World-Literary Reconstruction of the Former 'Second World.'" Her research interests combine utopia, narratology, world-literary theory and contemporary Ukrainian fiction. Her recent work includes a monograph on *We-Narratives: Collective Storytelling in Contemporary Fiction* (2020, winner of the Barbara Perkins and George Perkins Prize) and an essay on collective agency and futural imagination with the title "Narrating the Future: A World-Literary Take on the Crisis of Imagination and the Novel" (*Poetics Today*, 2023).

Martin Butler is Professor of American Literary and Cultural Studies at the University of Oldenburg, Germany. His research focuses on popular music, forms and figures of cultural mobility, and cultures of participation in new media environments. Apart from a broad range of articles in these fields, he has published a monograph on Woody Guthrie (*Voices of the Down and Out*, 2007) and co-edited a number of essay collections, including *Sound Fabrics: Studies on the Intermedial and Institutional Dimensions of Popular Music* (2009, with Patrick Burger and Arvi Sepp), *EthniCities: Metropolitan Cultures and Ethnic Identities in the Americas* (2011, with Jens Gurr), *Precarious Alliances: Cultures of Participation in Print and Other Media* (2016, with Albrecht Hausmann and Anton Kirchhofer), a special issue of *Popular Music and Society* on musical autobiographies (2015, with Daniel Stein) as well as a volume on *Resistance: Subjects, Representations and Contexts* (2017, with Paul Mecheril and Lea Brenningmeyer).

Marco Caracciolo is Associate Professor of English and Literary Theory at Ghent University, Belgium. Drawing inspiration from cognitive science, the philosophy of mind, and the environmental humanities, his work explores the forms of experience afforded by narrative in literary fiction and other media (especially video games). He is the author of several books, including most recently *Contemporary Fiction and Climate Uncertainty: Narrating Unstable Futures* (Bloomsbury, 2022) and *Contemporary Narrative and the Spectrum of Materiality* (De Gruyter, 2023).

James Dorson is Assistant Professor of Literature at the John F. Kennedy Institute for North American Studies, Free University of Berlin, Germany. He has been a visiting professor at Brown University and the Ludwig Maximilian University of Munich. His book publications include *Counternarrative Possibilities: Virgin Land, Homeland, and Cormac McCarthy's Westerns* (Campus 2016) and the co-edited volumes *Fictions of Management: Efficiency and Control in American Literature and Culture* (Winter 2019) and *Anecdotal Modernity: Making and Unmaking History* (De Gruyter 2020). Besides currently writing a book on competing forms of organization in American literary naturalism at the turn of the twentieth century, he has published widely in the fields of literary theory and history, economic criticism, and the environmental humanities.

Katharina Fackler is a Lecturer and Postdoctoral Researcher in the North American Studies Program at the University of Bonn. She is the author of *Picturing the Poor: Photography and the Politics of Poverty in the 1960s* (Penn State University Press, forthcoming) and co-editor of three essay collections, among them the 2023 special issue of *Atlantic Studies: Global Currents* on "Kinship as Critical Idiom in Oceanic Studies." She co-leads the DFG-funded research network "The Cultural Politics of Reconciliation" and is a member of the Bonn-Melbourne research group "Water as Method: Reading the Hydrocolony in Global Literature." Her second book project explores literary responses to large-scale resource extraction in the Pacific.

Matti Kangaskoski is a poet, scholar, and performer based in Helsinki, Finland. Kangaskoski's academic work concerns the cultural logic of digital media and their influence on thought and values. He is the author of three books of poetry and a novel. Currently, Kangaskoski is writing a cosmotechnical novel, endowed by a three-year artist grant from Arts Promotion Centre Finland, to be published in 2024. Both his recent academic and artistic work is an attempt at finding new approaches to the deadlock of the Anthropocene.

Simone Knewitz is Senior Lecturer of North American Studies at the University of Bonn, Germany. She has also taught as interim professor of American Studies at the Universities of Münster, Hamburg and Mannheim. Her research focuses on poetry and poetics, cultural aesthetics and rhetoric, and the intersections of law, economics, and culture. Her current projects explore collective agency in twenty-first century North American poetry and social movements, and the politics of whiteness in contemporary U.S. political discourses. She is the author of *The Politics of Private Property: Contested Claims to Ownership in U.S. Cultural Discourse* (Lexington, 2021) and *Modernist Authenticities: The Material Body and the Poetics of Amy Lowell and William Carlos Williams* (Winter, 2014). With Sabine Sielke and Christian Kloeckner, she has coedited the volumes *Knowledge Landscapes North America* (Winter, 2016) and *Beyond*

9/11: Transdisciplinary Perspectives on Twenty-First Century U.S. American Culture (Lang, 2013).

Katharina Motyl is an Assistant Professor of American Studies at the University of Mannheim and principal investigator of the research network "The Failure of Knowledge – Knowledges of Failure" funded by the German Research Foundation. Her second-book project investigates cultural, medical, and legal discourses surrounding drugs and social minorities in the U.S. Her publications include a co-edited special issue of *Studies in American Naturalism* on "Intimate Knowledge in American Naturalism and Realism" (2021) and the co-edited volumes *Who Can Speak and Who Is Heard/ Hurt? Facing Problems of Race, Racism and Ethnic Diversity in the Humanities in Germany* (transcript, 2019) as well as *The Failed Individual – Amid Exclusion, Resistance, and the Pleasure of Non-Conformity* (Campus, 2017). Articles have appeared in *Interconnections: Journal of Posthumanism* and *European Journal of English Studies*. She obtained her PhD with a dissertation on Arab American literature since 9/11 from Free University of Berlin in 2013.

Stefanie Mueller is Professor of North American Literature at Freie Universität Berlin, Germany. Her research areas include the environmental, legal, and economic humanities, with current research projects exploring citizenship in contemporary U.S. lyric poetry and law as well as the representation of the scales of climate change in literature. Her publications include *The Corporation in the Nineteenth-Century American Imagination* (Edinburgh University Press, 2022), *The Presence of the Past in the Novels of Toni Morrison* (Winter, 2013), and *Reading the Social in American Studies* (co-edited with Astrid Franke and Katja Sarkowsky, Palgrave Macmillan, 2022).

Regina Schober is Professor of American Studies at Heinrich-Heine-University Düsseldorf. She is author of *Unexpected Chords: MusicoPoetic Intermediality in Amy Lowell's Poetry and Poetics* (Winter, 2011), *Spider Web, Labyrinth, Tightrope Walk: Networks in American Literature and Culture* (De Gruyter, 2023) and co-editor of *Network Theory and American Studies* (with Heike Schäfer and Ulfried Reichardt, *Amerikastudien/American Studies*, 2015), *Data Fiction: Naturalism, Narratives, and Numbers* (with James Dorson, *Studies in American Naturalism*, 2017), *The Failed Individual: Amid Exclusion, Resistance, and the Pleasure of Non-Conformity* (with Katharina Motyl, Campus, 2017), and *Laboring Bodies and the Quantified Self* (with Ulfried Reichardt, 2020). She is part of the DFG research network "The Failure of Knowledge/Knowledges of Failure," the DFG research network "Model Aesthetics: Between Literary and Economic Knowledge" as well as of the BMBF funded project ai4all at HHU Düsseldorf.

Jan-Felix Schrape is Associate Professor of Organizational Sociology and Innovation Studies at the Institute for Social Sciences at the University of Stuttgart, Germany. In

2021–22 he served as Visiting Professor at the Chair of Society and Technology at the RWTH Aachen University. Jan-Felix Schrapes research focuses on the sociology of technology, media and innovation. Since 2018, he has been a member of the board of the Science and Technology Studies section of the German Sociological Association. Key publications include the volumes *Digitale Transformation* (transcript/UTB, 2021) and *Collectivity and Power on the Internet* (with Ulrich Dolata, Springer, 2018) as well as articles on "Platform Companies on the Internet as a New Organizational Form: A Sociological Perspective" in the journal *Innovation* (with Ulrich Dolata, 2023) and "The Logic of Digital Utopianism" in *Nano Ethics* (with Sascha Dickel, 2017).

Alexander Starre is Assistant Professor of North American Culture at the John F. Kennedy Institute at Free University of Berlin, Germany. He is a former Alexander von Humboldt Foundation fellow and has previously taught at the Universities of Göttingen, Münster, and Duisburg-Essen as well as at Brown University. His research interests include American cultural history, knowledge production, media theory, literary institutions, and print culture. He is the author of *Metamedia: American Book Fictions and Literary Print Culture after Digitization* (2015) and co-editor of several essay collections, including *Projecting American Studies: Essays on Theory, Method, and Practice* (2018), *The Printed Book in Contemporary American Culture: Medium, Object, Metaphor* (2019), and *Culture²: Theorizing Theory for the Twenty-First Century, Vol. 1*. (2022). He is currently finishing a book on knowledge institutions and epistemic styles in the United States around 1900.

Heather Suzanne Woods is a scholar, higher ed leader, and emerging tech strategist. She has been researching the relationship between technology and culture for over a decade. Woods is the author of two books: *Make America Meme Again: The Rhetoric of the Alt-Right* (with Leslie Hahner, Lang 2019) and *Threshold: How Smart Homes Change Us Inside and Out* (University of Alabama Press, forthcoming, 2024). Her research on emerging technology provides crucial insight for scholars, (non)governmental and advocacy organizations. As a leader, she empowers communities in higher ed to build resilient, adaptive, inclusive processes and structures in preparation for a changing technological future. Her work has been featured in *Wired*, *The New York Times*, *Atlantic*, *CBC's Spark*, *The Washington Post*, *The LA Times*, and more. She is presently Associate Professor of Rhetoric and Technology and Associate Director of Graduate Programs and Research in the A.Q. Miller School of Media and Communication at Kansas State University.

GPSR Authorized Representative: Easy Access System Europe, Mustamäe tee
50, 10621 Tallinn, Estonia, gpsr.requests@easproject.com